Stalin's Englishman

Stalin's Englishman

*Guy Burgess, the Cold War,
and the Cambridge Spy Ring*

ANDREW LOWNIE

Guy Burgess's drawing for the Eton College magazine,
'The Phoenix', 30 November 1931.

St. Martin's Press 〽 New York

www.stmartins.com

The Library of Congress Cataloging-in-Publication Data is available upon request.

ISBN 978-1-250-10099-3 (hardcover)
ISBN 978-1-250-10101-3 (e-book)

Our books may be purchased in bulk for promotional, educational, or business use. Please contact your local bookseller or the Macmillan Corporate and Premium Sales Department at 1-800-221-7945, extension 5442, or by e-mail at MacmillanSpecialMarkets@macmillan.com.

First published in Great Britain by Hodder & Stoughton, an Hachette UK company

First U.S. Edition: October 2016

10 9 8 7 6 5 4 3 2 1

Contents

Preface

Ever since Guy Burgess and Donald Maclean fled to the Soviet Union in 1951, there has been a plethora of books on the Cambridge Spies, each one attempting to fill in another part of the jigsaw, to try and understand how not just these two men but others – names gradually revealed over the years – were drawn, in spite of their privileged backgrounds and Establishment positions, to spy for a country whose values were so different from their own.

Of the members of the Cambridge Ring, Burgess has exerted perhaps the greatest fascination, not least because no one has known how seriously to take him. Reviewing *A Chapter of Accidents*, the memoir of Guy Burgess by his friend Goronwy Rees, the novelist Isabel Quigley felt him to be:

> A fictional-sounding character, Burgess: attractive, brilliant, amusing, outrageous, living in a dream world and enacting his own fantasies there; also a drunkard, smelly, grubby, exhausting, munching garlic or barbiturates as if they were humbugs, and sexually so promiscuous and so voracious that he sounds like some strip-cartoon character, a traitor to his country yet, in his devious subterranean way, true to principles it must have been hard to discern under Stalinism. A modern tragic hero or just a contemporary clown?[1]

Goronwy Rees himself admitted: 'I am very far from thinking my story tells the whole truth about him; it would be impossible for any one person to give anything except a very partial and incomplete account of a character so complex and so contradictory and with such a passion for devious and obscure ways.'[2]

Burgess is certainly the most complex and enigmatic of the Cambridge Spies, a man of enormous contradictions and complexities.

Regarded as louche, unreliable and often unemployable, he neverthe-less managed to penetrate such bastions of the Establishment as the BBC, the Foreign Office and MI6, to earn the respect of Winston Churchill, Neville Chamberlain and Anthony Eden, and to use his position to pass on crucial secrets over a period of fifteen years. For every person who was repelled by his scruffiness and selfishness, there was another who was enchanted by his charm, intelligence and kindness.

Yet while there have been several full biographies of the other members of the Cambridge Spy Ring – Kim Philby, Donald Maclean and Anthony Blunt – there has been little specifically on Burgess. The gap in the literature is understandable. Burgess died some twenty-five years before his fellow spies, few in the West had any contact with him after 1951 and little of his correspondence has survived. He has, therefore, hitherto been a mystery, the joker in the pack of the Cambridge Spy Ring.

Drawing on over twenty years of research in archives around the world, interviews with over a hundred people who knew Burgess – most of whom had never spoken before and are now dead – and secret files released under Freedom of Information requests on both sides of the Atlantic, this book presents a completely new picture of Guy Burgess the idealist, the spy, the traitor and the man, arguing he was the most important of the Cambridge Spies.

It charts the story of the rich, well-connected and brilliant Cambridge student from his childhood in Hampshire to his tragic-comic exile in Moscow. It covers his excessive drinking, outrageous behaviour, promiscuous private life, as well as his friendships with, amongst others, John Maynard Keynes, Cyril Connolly, Isaiah Berlin, W.H. Auden, E.M. Forster, Dylan Thomas, Stephen Spender, Christopher Isherwood, Lucian Freud, George Orwell, Michael Redgrave and Frederick Ashton. An Englishman at heart, and in some ways (mostly sentimental ones) a patriot, he is now remembered simply as a spy and a traitor to his country.

Many questions intrigue about Guy Burgess. Why did a man from the very heart of the British Establishment seek to betray it by becoming a Soviet agent? How was he recruited and run? Why was he not discovered until after his flight in 1951? What information

did he provide? How far did he change the course of twentieth-century history? Are there still further spies to be revealed? The answers to these questions and many more can be found in this book.

Prologue:

Full Circle: Saturday, 5 October 1963

In the descending gloom of an autumn evening, a small funeral party has gathered in the graveyard of the church of St John the Evangelist, a Gothic edifice faced with knapped, squared flints and roofed in blue slate, which stands in the Hampshire village of West Meon. It is a pleasant, sleepy, ancient spot, where a succession of churches have stood since the twelfth century.

Around the funeral party stand lichened gravestones dating back more than four centuries. The buried include William Cobbett, the radical pamphleteer, and Thomas Lord, the cricketer and founder of the cricket ground in St John's Wood that bears his name. To the north of the church and about three-quarters of the way up a shallow embankment is a low grave with a cross, and it is here in the evening darkness that the funeral party stand.

There are just five of them. The Reverend John Hurst has been vicar here since 1950. Beside him is a slim man of fifty wearing spectacles, and with him, his wife and his son who is in his early twenties. There are three wreaths – the largest reads, 'For my darling, dearest boy with all my love, from Mum'. The elderly mother is too ill to attend. Another is from the man's brother, Nigel, who is at the graveside, and the third is from a group of friends. It is a simple service with no music, hymns or sermon.[1]

They have gathered in darkness to bury quietly the ashes of a son of West Meon – a man as English as this place in which he spent his childhood, a man proud and fond of his country, yet a man who was also a traitor, a man so unwelcome here that even in death his remains must be interred in secret.

'There was such strong feeling aroused,' the Reverend John Hurst would recall many years later, 'that I thought some reporter might

have followed Nigel down to West Meon when he brought the ashes, so I did not dig the hole for the casket till ten minutes before he was due to arrive.' As he places the small casket into the hastily prepared hole, the vicar experiences an awkward moment: it isn't quite deep enough for the ornate vessel. 'There was a plaster spike on top, of which the tip was just level with the grass, so I broke off the tip and put it in my pocket.'[2]

The dead man's ashes are placed in the family plot besides those of his father, who had died almost forty years earlier. On the front of the cross is inscribed: *Malcolm Kingsford de Moncy Burgess died 1924.* To it would now be added: *Guy Francis de Moncy Burgess d. 30 August 1963.*

Guy Burgess had finally had his wish and returned home.

I

Beginnings

Guy Burgess's roots were in Kent, but the family were originally Huguenot. This ancestry was to be important to him and he was to equate the flight of his Huguenot forebears to Britain for conscience's sake in the seventeenth century to his own journey to Moscow some three centuries later.[1]

Abraham de Bourgeois de Chouilly, with a minor title and connections at court, had arrived in Canterbury in 1592, aged thirty-five, to escape religious persecution in France. The family quickly assimilated themselves into Kent life, where, during the Napoleonic wars, the family prospered as bankers in Ramsgate and Margate.[2]

More immediately, Guy Burgess came from a family with a strong tradition of military service. His paternal grandfather Henry Miles Burgess had joined the Royal Artillery aged fifteen in 1854 and spent much of his career abroad.[3] In August 1865 he had married Amelia Kingsford, the daughter of a rich merchant who had settled in Lewisham, and they had five children, of whom the youngest, Burgess's father, Malcolm Kingsford de Moncy, was born on 13 August 1881 in Aden.

Little is known of Malcolm's early life – the 1891 census has him at St Mary Bredin, near Canterbury in Kent – but his career path was clear: he was destined for the navy. In January 1896, at the age of fourteen, he joined the HMS *Britannia* training ship, then moored on the River Dart near Dartmouth. Here he undertook a mixture of naval training and school work, ranging from navigation to French, but his school career was undistinguished with reports describing him as 'inclined to be lazy but improving'.[4]

In January 1898 Malcolm entered Dartmouth as a midshipman third class, at a time when the Royal Navy boasted three hundred

and fifty ships and almost a hundred thousand sailors and the British navy was larger than the navies of France, Russia, Germany or the United States. It was also a prestigious career, as the navy enjoyed close links with the royal family – the future King George V had been at Dartmouth fifteen years earlier.[5]

Malcolm's progress was solid, but not inspiring. He was just a junior officer on a large ship, which made it difficult to stand out. His position was not helped by the fact that he lacked social cachet in a fashionable service with a number of aristocratic officers and that a court of enquiry in 1902 had found him responsible for a collision between his own vessel *Thrasher*, and another, *Panther*. Though the court only admonished him 'in view of his inexperience', his career was never to recover. His captain's damning comment on his service record read: 'This officer's deficiencies in seamanship render him unfit for service in destroyers.'[6]

Then in March 1904 a court martial found him in neglect of duty when the flotilla signal book was lost from the battleship *Prince George* while the Channel Fleet was in Vigo.[7] The navy were prepared to give him another chance 'in any other class of vessel' and Malcolm thereafter served on a succession of battleships and cruisers where his reports began to improve. They were still not, however, the reports for a future senior officer and in 1907 he returned for shore training with the reserve – the kiss of death to a naval career – in Devonport.

It was in Portsmouth that the twenty-six-year-old naval officer married Evelyn Gillman in December that year. Four years younger than her husband, Evelyn was the daughter of William Gillman, a partner in a small family bank, Grant, Gillman & Long, based in Portsmouth and Southsea, which had been sold to Lloyd's in 1903 and had left William a rich man of leisure.

W.G. Gillman, named after the cricketer W.G. Grace, had himself already married money. His wife, Maud Hooper, whom he had met while travelling in North America, was an heiress from Scottish pioneer stock and came from a prominent Canadian family. A freemason, a senior magistrate, and a director of both the Portsmouth Gas and Water Companies, Gillman was a man of some standing in Hampshire. Evelyn, the youngest of his three children, had been brought up in a large home with servants at Rutland House, on the

2

north side of Southsea Common looking out to sea, before being sent to boarding school in Hendon.

Malcolm and Evelyn Burgess's first married home was 2 Albemarle Villas, one of a series of detached three-bay, stucco, two-storey houses, with wrought-iron balconies looking out over Stonehouse Creek in Devonport, built in about 1825 to accommodate retired sea captains. It was there that their first son Guy Francis de Moncy Burgess was born on 16 April 1911, to be followed two years later by another son, Nigel.

Malcolm was often away from home – some three-quarters of his career was spent either at sea or in a foreign naval outpost – so it was very much a female household with a housemaid, Bertha Oliver; a cook, Alice Poole; and a maid, Emily Harte – all under thirty. It meant that from an early age the young Guy Burgess began to develop a very close relationship with his mother and it was one without a balancing masculine influence.

Just after his thirtieth birthday in September 1911, Malcolm was promoted to lieutenant commander and at the beginning of 1914 he took command of the torpedo gunboat *Hebe*, which had been converted to a submarine depot ship, based on the Tyne – not the most glamorous of commands. It was on *Hebe* that he was to spend the first part of the First World War – in port, rather than at sea – servicing the submarines hunting German U-boats in the North Sea.[8]

In June 1916 Malcolm was promoted to commander and given command of the 6th Submarine Flotilla, based in Harwich, a post he held until the end of the war. The remarks on his naval record from his superiors are generally good – 'Very zealous and able and has been of the greatest assistance . . . a capable executive officer & good organiser' – but it had been a modest war.[9]

With the cessation of hostilities in Europe, Malcolm was made second-in-command of HMS *Hannibal*, a depot ship for auxiliary patrol craft at Alexandria, supporting forces operating from Egypt and those in the Red Sea, but this was not a prized seagoing command. Subsequently he was appointed to serve on the staff of the Rear-Admiral in Egypt, as the maintenance commander, living in Ismailia, Malta and Egypt until the summer of 1920. Guy Burgess

would later claim that as a small boy of eight he had lived in a villa at Ismailia, the main station on the Suez Canal, in the European quarter on the east side of town.[10]

Malcolm's next posting was a few months on HMS *Benbow* as the commander dealing with supply and administration, which included maintaining discipline and dress. His commanding officer was to write:

> The appearance of the ship has been very creditable considering the reduced complement . . . Is of good physical and smart appearance, dances and is fond of social life. Is leaving this ship at his own request and I wish to place on record that he has continued to perform his duties satisfactorily.[11]

Realising, however, his chance of reaching flag rank was now impossible, at his own request in July 1922, Malcolm was placed on the reserve list. His early retirement may also have been on health grounds and possibly disillusionment with the navy. His younger son had a faint memory that his father had been in dispute with a senior officer in Malta and, though in the right, had come off on the losing side. If true, this may have unconsciously affected the attitude of his first-born to authority.[12]

Not needing to be near the coast, the Burgess family moved to West Meon, a pretty Hampshire village of about two hundred people and a favourite of retired naval officers. The Burgess home, West Lodge, was a large, elegant, Georgian, bow-windowed house, with a roof of blue-grey slate and faded red brickwork, and a moulded portico with pretty fanlight. It comprised a dozen well-proportioned rooms, including a study and music room, elegant hall, five bedrooms, walled kitchen garden, a groom's cottage and yard, and eight acres of rear lawn, paddocks and woodland. The family knew everyone in the area and the children were often to be seen with their nursemaid, Olive Dearsley, spending their pocket money at Mr Tully's general stores.

Guy Burgess's early schooling is unknown, though it's almost certain he was taught at home by a governess, but in September 1920, aged nine, he left home for a boarding preparatory school. This was traditional for boys of his upbringing, but perhaps a

spur was his mother's ambitions for her clever son, and his father's wish for him to be subject to stricter discipline and have more masculine influences.

Lockers Park was a small prep school that had been founded in the early 1870s as a feeder school for Rugby, and was one of the earliest purpose-built prep schools in England. Situated on a twenty-three-acre site near Hemel Hempstead, it boasted a chapel, library, swimming pool, gym, squash court and rifle range, and was less than an hour by rail from London. It quickly became very popular, in part because of its healthy situation, and also due to its positioning on the route from London to Rugby.

At a time when even rich children often died from epidemics, it benefited from an endorsement from Queen Victoria's Physician-in-Ordinary Sir William Jenner. 'I have never been over a school more healthily situated or one in which the drains were more perfectly constructed', stated a letter which was proudly printed in the school prospectus, like a Royal Warrant, for the next three decades.

The most expensive prep school in England, it had also become fashionable in aristocratic circles, with the majority of boys going on to Eton, Harrow, Winchester and Wellington.[13] The school was run in a partnership by Tommy Holme and Norman Wood Smith, who had taken on the school only the year before Burgess came up. Lockers Park was a small school with just eighty boys and a strong naval tradition – one of Burgess's contemporaries was the Hon. Peter Beatty, son of the First Sea Lord, Admiral David Beatty. Another pupil, just before the First World War, had been Prince Louis Mountbatten, son of the Second Sea Lord and great-grandson of Queen Victoria. Burgess's father's attainments seemed modest in comparison. The boys were split between houses, called sets – the Navy sets wore blue blazers (Beatty, Cradock and Jellicoe) and the Army sets (Haig, Roberts and Kitchener) wore red blazers. Burgess, in Kitchener, was even at this stage a 'Red'.

Dress was flannel suits or black coats with dark grey trousers, Eton collars to be worn outside the jacket, and boaters, and the clothes list included two pairs of braces, a tweed cap, a straw hat and eighteen handkerchiefs. Fees were fifty guineas a term with music, boxing, shooting, dancing and carpentry extra. Parents were not allowed to

visit within the first three weeks and could only then visit on Saturdays and the first Wednesday of every month. Nor were they allowed to send sweets, but instead were 'to limit their generosity to *occasional* gifts of cake and fruit.'

It must have been a shock for a young sensitive boy. A Burgess contemporary, Peter Coats, heir to a Scottish cotton fortune, remembered:

> The masters at Lockers Park were at that particular time a repellent lot . . . One seemed to be a downright sadist and delighted in reducing small boys of nine, who had never been away from home before, to tears. He would give one what he referred to as 'clips over the head', which were cruelly hard blows, his tiny eyes gleaming and flecks of froth gathering in the corners of his mouth, making one cry with fear and impotent rage.[14]

Brought up in a female household, and, according to his brother, with an 'unhealthily close' relationship with his mother, Burgess found it hard to adjust.[15] A contemporary, Stanley Christopherson, remembered, 'I just kept away from him. He wasn't the kind of boy I wanted as a friend. He wasn't quite right.'[16]

The forms were arranged partly by age and partly by ability, ranging from the top A1 through to C3 for the youngest boys. Burgess began in C1 and immediately shone academically, with a final placing of second in his class. In his second term, he was moved up into B2, this time graduating at the end of the summer as top of the class.

After two terms in A2, where he had been second in the whole school, he moved into the top form A1 in the summer of 1922. He was just eleven and was to spend the next five terms there until he left at the end of 1923, second in the class. He was a conscientious pupil, consistently awarded VG for effort. And it was not just academically that he excelled. He took up the piano, performing a solo, 'The Spirit of Your Race', at a school concert in November 1922, and played at half in the school's second XI football in winter 1922 and in the first XI in winter 1923.

It was clear that Burgess, aged twelve, had outgrown Lockers Park intellectually, but he couldn't start at Dartmouth, where his father wanted

him to go, until he was thirteen and a half. A compromise was found to please his mother. He would fill in a year at Eton, so at Christmas 1923 Burgess swapped his tiny prep school of eighty pupils for over a thousand at Britain's most famous public school.

2

Schooldays

Founded in 1440, Eton is the Establishment school *par excellence* and one based on a cult of success. Former pupils, whilst Burgess was there, included the then Viceroy of India, the King of Siam, the Lord Chancellor, Speaker of the House of Commons, Chief Commissioner of Police, Lord Mayor of London, Director of the National Gallery, Governor of the Bank of England, Editor of *The Times*, Chairman of the BBC, plus over a hundred Members of Parliament.

The school that he entered in January 1924 had over a thousand boys, divided between twenty-six houses, and must have appeared daunting to a boy not yet thirteen. His own house of about forty boys, at 7 Jourdelay's Place, was a large ivy-covered Queen Anne house and included several new boys from Lockers Park, including a young Irish boy, Dermot McGillycuddy of the Reeks, who was to become a close friend.

It was run by a mathematician, Frank Dobbs, a quiet, amusing, tall, red-faced man with a hooked nose and moustache, who was then in his late forties, and the author of a well-known arithmetic book for schools. Burgess had his own study bedroom, with a bed folded against the wall by day and pulled down by a maid just before evening prayers, a bureau, a wash stand and a Windsor chair. He rose at 6.45 a.m. and the school day began at 7.30 a.m., followed by breakfast at 8.20 a.m., and the last class was at 5 p.m., with three afternoons a week devoted to sport. As a junior boy, he was required to 'fag' for older boys, cleaning, cooking and running errands.

A picture of Eton only a few years earlier can be found in Cyril Connolly's memoir of arrested development *Enemies of Promise*. Connolly was to write that all his contemporaries 'were broken under the strain of beatings at night, and bullying by day; all we

8

could hope for was to achieve peace with seniority and then become disciplinarians in our turn'.[1] Burgess coped with the hierarchies of boarding-school life with a mixture of offhand bravado, charm, humour and apparent conformity, but the seeds of his rebellion against authority were already being sown.

The school was divided into classes, or divisions, through which one progressed on intellectual merit until one reached the heights of division one. Burgess began in division twenty-seven and quickly flourished academically, being awarded W.T. Webb's edition of *Lays of Ancient Rome* for a first-class result in trials in April, and being runner-up for the Geoffrey Gunther Memorial Prize for art the same month. The following term he moved up to division twenty-six, where a highlight of the summer term was the visit of King George V and Queen Mary to the College Chapel. His Eton career had begun well, but then tragedy was to strike.

On the night of 15 September, he was later to recount, he was woken by anguished cries from his parents' bedroom. When he went to investigate, he found his mother trapped by her husband, who had died of a heart attack in the course of making love, and the young boy had to separate the two bodies. Malcolm was just forty-three. It was an experience that Burgess later claimed had determined his homosexuality, but which he told to very few people; his brother Nigel had never heard such an account, nor did it figure in his KGB debriefings. In any case, Evelyn was a fit, young woman and her husband of average weight. Whatever the truth – and Burgess was a fantasist from an early age – the suddenness of Malcolm's death, described as being caused by 'atheroma of the aorta and valvular disease of the aortic valve', was devastating for his family and not least for a boy of thirteen.

A week later Burgess returned to Eton, still in shock from his father's death, but he was not to be there long. The plan had always been that he would start at Dartmouth as soon as he reached the minimum age of thirteen and a half, so just over three months after his father's death, Burgess found himself leaving Eton, the friends he had made and a promising academic school career, to train as a naval officer.

★

Dartmouth Naval College stands majestically above the charming Devon town of Dartmouth, with commanding views over the River Dart. When Burgess entered in January 1925, the buildings were only twenty years old, built to replace the training ship *Britannia*, on which his father had been trained. Dartmouth, with its six hundred cadets, was a public school almost as prestigious as Eton – but one with a difference, in that its sole purpose was to prepare boys for a naval career and it was run like a ship. Staff under the command of Captain Dunbar-Naismith, who had won a Victoria Cross as a submariner during the Dardanelles Campaign, were responsible for the naval side and discipline, and a civilian headmaster for teaching.

In front of the main building, a long three-storeyed building with a clock tower in the middle, was a parade ground with a figurehead of Britannia, and behind it a flagstaff on which the White Ensign was raised at sunrise and lowered at sundown to the mournful sounds of a bugle. The big hall, where parades were held, was called the quarterdeck and the officers' rooms were cabins, whilst the officers lived in wardrooms and the cadets in gunrooms. Instead of tailcoat, top hat and white bow tie, Burgess now wore a blue naval uniform or white flannel trousers, reefer, collar and tie and lanyard, plus cap in summer. 'The cap was vital, since every time one passed an Officer or Master one had to salute,' remembered one contemporary, William O'Brien.[2]

Burgess was one of just over fifty cadets joining in the St Vincent Term, and was assigned an Admiralty number 205. Each term or class, further sub-divided into Port or Starboard – Burgess was both, which is unusual – was named after an Admiral, and the cadet would remain within their class, i.e. St Vincent, throughout their eleven terms at the college.[3]

Each term was under the command of a naval lieutenant, assisted by two cadet captains drawn from the senior terms. The cadets spent the day in the gunroom – a big room with lockers, tables and benches – and slept in dormitories of about twenty-five, where the hard-sprung iron beds were arranged in two parallel rows also named after admirals (Burgess was in Keppel), with windows on the north and south sides. Each evening the windows had to be opened

uniformly according to the weather, so with cold north-westerlies and showers in the offing, the order might be, 'Half-open south, quarter-open north, close all fanlights.'[4]

A wooden sea chest at the end of his bed held the cadet's clothes. 'Undressing was not the simple matter of throwing off clothes and rumpling them into a drawer,' recollected O'Brien. 'All garments had to be folded to a regulation size and arranged to a standard pattern on the drop-flap of the chest. The cap on top, dead centre, badge exactly in the middle of the peak, shoes in line, bed squared off with the blue rug precisely folded at its foot, its owner's embroidered initials centre.'[5]

Cadets were punished for the most modest of dress imperfections, constantly shouted at and forced to do everything at the double. They were trained to obey orders so eventually, once in the navy, they could give them. 'We could find no kindness or affection: only constant chivvy, nag and menace,' later wrote one contemporary, Charles Owen. 'We longed for the end of every day, for the privacy of bed, for a brief escape through sleep from the shouts and threats and orders which right into our dormitories, right up to lights out, still pursued us.'[6]

Ambrose Lampen remembered that:

Everything was 'regulation', all was uniformity; every movement was carried out in strict time with everyone else, and usually 'at the double'. We got up in the morning to the order, 'Turn out at the double!' and we went to bed at night to the order, 'Say your prayers!' We were not allowed to walk about. We ran from classroom to classroom. We ran when passing rooms allocated to our seniors. We ran to or from the mess-hall, or the playing fields. However sick we felt, we ran to the Sick Bay.[7]

Discipline was enforced by caning, was arbitrary, frequent, and entirely at the whim of the Term Officer or his underlings. Caning was restricted to six strokes and applied just before bedtime to pyjamas. 'The cane caused weals which persisted for as long as six weeks,' recollected Arthur Hazlett:

Sometimes when two strokes landed in the same place they were likely to draw blood. What was worse was that the beatings were given

for very minor offences such as talking after lights out or being late for Divisions or some other function. There was also a 'tick' system, in which a 'tick' was awarded for some small oversight such as an untidy sea-chest or leaving books about. When four 'ticks' had been amassed, the offender was beaten. Although the usual punishment was only three or four strokes, they were given extremely hard and a beating was a very painful experience.[8]

For more serious offences, there was a modern version of the cat-o'-nine-tails, with the culprit's Term drawn up on three sides of a square, and the victim being strapped to a frame in the middle and then beaten. According to Burgess, 'he rebelled against the barbarous ceremonial of corporal punishment known as "official cuts": he and three of his friends turned ostentatiously away in order to avoid seeing this performance, which the cadets were paraded to witness'.[9]

The rules were rigid. Cadets did not speak unless spoken to, 'did not mix with another term, except for college games, and were not allowed (by custom) to speak to a senior cadet and did not speak to a junior', another contemporary, Michael Creagh-Osborne, remembered. The cadets would rise at 6.30 a.m. and take cold plunge baths before prayers in the dormitory. After dressing there would be a fifteen-minute talk in the gunroom on seamanship and an hour of lessons, before falling in outside the gunroom and marching into breakfast in rows of four for 8 a.m. This was followed at 9 a.m. with a general parade called 'Divisions' followed by drill, before marching off to morning lessons.[10]

Every afternoon there would be games and then another parade called 'Quarters', tea, and prep in the gunroom before retiring to bed at 9.20 p.m. Sundays involved 'a succession of meticulous inspections by progressively higher ranking officers' with a march past straight into Chapel and a further service in the evening.[11]

Alongside normal school lessons with an emphasis on maths, physics, science and naval history, the cadets were taught seamanship, navigation, astronomy, engineering, and the spirit, customs and traditions of the Royal Navy. Long hours were spent learning 'bends and hitches', splicing heavy wire ropes, learning and hoisting flag signals, using Morse code with flashing lights, and memorising the complex system of navigation lights used internationally. Cadets were taken

out on a minesweeper HMS *Forres*, owned by the college, for a week's cruising, and there were also sailing races – either at Dittisham Reach up the River Dart, or on the open sea.[12]

Teaching tended to be unimaginative and learning by rote, the emphasis on how and what, rather than why, and the only school subject that was of real importance was mathematics. For naval officers on the staff it was just another posting – generally two years – and the job was regarded as a penance before returning to sea, more excitement and promotion. The impact on a sensitive and independently minded young boy, who was far from home, had just lost his father and was restricted to one visit per term from his mother, must have been considerable. Burgess learnt to conceal his feelings, to adapt and try to belong to the prevailing orthodoxy, but the discipline was also good for him, giving him structure and imbuing qualities that he would carry through his whole life, such as punctuality, leadership and an ability to work with others.

He was immediately marked out as a high-flyer, his reports describing him as 'excellent officer material' and 'a zealous all-rounder'.[13] From the second term he was either second, or more often first in his class, and in the summer of 1926 he won prizes for science, history and geography, which included the three volumes of Sir Julian Corbett's *Naval Operations: History of the Great War*. He was an accomplished draughtsman and map-drawer and known as a skilled artist, contributing a drawing of West Meon to *The Britannia Magazine* shortly after he arrived. He played for his term in both junior rugby and football, eventually gaining a place at right half in the second football XI. A contemporary, Bernard Ward, remembered how 'he excelled at any activity or lesson'.[14]

A particular interest was history, and inspiration was Alfred Mahan's *The Influence of Sea Power upon History* (1890), and its sequel dealing with the French Revolution and Napoleonic Empire, in which Mahan argued that commercial prosperity and security depended on naval dominance. It was an early introduction to the sort of determinist and materialist interpretation of history that Burgess was to find so attractive in later life. One element of Mahan's argument – the growth of American power at the expense of the Royal Navy – was to resonate particularly with the schoolboy and be influential

in shaping his views of the United States. In his mind, American policy had led directly to the cuts in government spending in the early 1920s, cuts which fell especially hard on the navy, and had curtailed his father's naval career.

Nigel Tangye, the cadet captain for the St Vincent term, remembered Burgess as being 'cast in a different mould to his fellow cadets in that his manner was sophisticated in the same sense that an intelligent fifteen-year-old with the upbringing of an aristocrat is alarmingly at ease in any social situation. He was tall for his age, bright eyed but with a cool, lazy manner and this trait was reflected in his uniform which was faintly sloppy, nothing one could put one's hand on, but not smart'.[15]

Tangye sat beside him at meals and recollected:

I was very glad to have him as one of my meal companions, for his intelligence ensured that although it made him appear more my age group than his own, in the sense of outlook and commentary, his sense of diplomacy ensured his always managing to restrain any familiarity with me, and he had charm. By the end of the term, having had two hundred and fifty-two meals with him sitting next to me, I knew him no better than the first time I met him. He remained an individual in a community from whom he kept an unobtrusive distance, never causing offence by actually being conceited but failing to conceal the fact that intellectually he was their superior'.[16]

The only blemish on Burgess's record was his 'slowness' in navigation, a sensitive subject given his father's experience in 1904. Examination by the principal medical officer, and then a specialist, showed the problem was Burgess's eyesight. Executive officers required perfect eyesight and though Burgess could have continued in the engineering branch, it effectively meant the end of what could have been a promising naval career.

As with much in Burgess's life, the truth is not always clear and confusion surrounds his departure. Poor eyesight was often a euphemism for dishonesty or homosexuality. There were rumours of theft – traces of the Winslow Boy, subsequently rigorously denied and certainly not in character – and homosexuality being the real reasons. According to a classmate, Robin Tonks, 'I have heard, but merely hearsay and from a source which I do not regard as entirely reliable,

that Burgess was found wanting in some respects as a potential officer and that his withdrawal on the grounds of defective vision was perhaps more diplomatic than medical.'[15]

His contemporaries, perhaps influenced by his subsequent life, all give slightly different accounts. John Gower thought 'Burgess was a misfit and his eyes an excuse to return to a life with less pressure',[16] whilst Michael Creagh-Osborne remembered, 'that in his last term he was in some sort of trouble and looked very sullen and disgruntled. I think he got beaten for it – or the sullenness was because of it. I know I was not surprised to learn he had left.'[17]

David Tibbits thought he had stolen a fountain pen. In any case, 'We all looked at him as very tiresome. He was not popular and had no close friends. He was left-wing.'[18] Meanwhile Captain St John felt he was 'different as ex-Eton . . . he was mostly a LONER. I suspect Guy left Dartmouth as a HOMOSEXUAL . . . My impression was that Guy was not popular, nor was he any good at games. I have no evidence about his being beaten, but add that I am sure that every member of the term had been beaten more than once. It was a method regular and much used.'[19]

According to John Carmalt-Jones, 'Burgess was known to be sexually attractive with boys and that's possibly why he left. He was not particularly good at games but clever, very artistic and a good cadet. He conformed.'[20] Tibbitts agreed: 'He was a very strange chap. He did not have the same sort of views as us. He was an amusing chap. He wasn't ordinary at all . . .'[21]

It seems strange that the problem of poor eyesight was not discovered at his medical examination, but there is certainly evidence in later life that it was not good. The likelihood is that Burgess was not happy and did not fit in and it was generally felt his academic talents might better be served by a return to Eton. If Burgess wanted to go to Cambridge, he would have needed Latin, which was not taught at Dartmouth.[22]

Burgess's departure in July 1927 appears, therefore, to be entirely honourable – not least as Eton was happy to have him back. His Russian controller Yuri Modin later wrote, 'Personally I never noticed the slightest defect in his vision . . . he loathed Dartmouth and despite his extreme youth was sufficiently independent and tough-minded

to tell his parents that it would be too great an honour for the Royal Navy to receive Guy Burgess into its rank.'[23]

Dartmouth was simply the wrong school for him. He was cleverer than his contemporaries – his final term had him fourth in order of merit, with further prizes for history and scripture – but unpopular with many of them, and not really cut out for a naval career. Lonely and a loner, he must have been relieved to be returning to Eton.

If Burgess had stayed at Dartmouth, his life would have been very different. He would have become a naval officer rather than go to Cambridge and, if he had survived the Second World War, might well have made the flag rank – the term produced twice as many admirals as normal, even though eight were to be killed in the Second World War – which had eluded his father.

that Burgess was found wanting in some respects as a potential officer and that his withdrawal on the grounds of defective vision was perhaps more diplomatic than medical.'[15]

His contemporaries, perhaps influenced by his subsequent life, all give slightly different accounts. John Gower thought 'Burgess was a misfit and his eyes an excuse to return to a life with less pressure',[16] whilst Michael Creagh-Osborne remembered, 'that in his last term he was in some sort of trouble and looked very sullen and disgruntled. I think he got beaten for it − or the sullenness was because of it. I know I was not surprised to learn he had left.'[17]

David Tibbits thought he had stolen a fountain pen. In any case, 'We all looked at him as very tiresome. He was not popular and had no close friends. He was left-wing.'[18] Meanwhile Captain St John felt he was 'different as ex-Eton . . . he was mostly a LONER. I suspect Guy left Dartmouth as a HOMOSEXUAL . . . My impression was that Guy was not popular, nor was he any good at games. I have no evidence about his being beaten, but add that I am sure that every member of the term had been beaten more than once. It was a method regular and much used.'[19]

According to John Carmalt-Jones, 'Burgess was known to be sexually attractive with boys and that's possibly why he left. He was not particularly good at games but clever, very artistic and a good cadet. He conformed.'[20] Tibbitts agreed: 'He was a very strange chap. He did not have the same sort of views as us. He was an amusing chap. He wasn't ordinary at all . . .'[21]

It seems strange that the problem of poor eyesight was not discovered at his medical examination, but there is certainly evidence in later life that it was not good. The likelihood is that Burgess was not happy and did not fit in and it was generally felt his academic talents might better be served by a return to Eton. If Burgess wanted to go to Cambridge, he would have needed Latin, which was not taught at Dartmouth.[22]

Burgess's departure in July 1927 appears, therefore, to be entirely honourable − not least as Eton was happy to have him back. His Russian controller Yuri Modin later wrote, 'Personally I never noticed the slightest defect in his vision . . . he loathed Dartmouth and despite his extreme youth was sufficiently independent and tough-minded

to tell his parents that it would be too great an honour for the Royal Navy to receive Guy Burgess into its rank.'[23]

Dartmouth was simply the wrong school for him. He was cleverer than his contemporaries – his final term had him fourth in order of merit, with further prizes for history and scripture – but unpopular with many of them, and not really cut out for a naval career. Lonely and a loner, he must have been relieved to be returning to Eton.

If Burgess had stayed at Dartmouth, his life would have been very different. He would have become a naval officer rather than go to Cambridge and, if he had survived the Second World War, might well have made the flag rank – the term produced twice as many admirals as normal, even though eight were to be killed in the Second World War – which had eluded his father.

3

Eton Again

In the autumn of 1927, Guy Burgess returned to Eton – Nigel had started the previous autumn – after a gap of almost three years. Frank Dobbs was only too happy to have him back and obtained special leave for him to do so from the Provost and Fellows, writing, 'I am most awfully sorry to hear of the way your career in the navy has been made impossible by your eyesight. I shall be delighted to have you back again.'[1] With his intelligence and charm, Burgess's return to Eton appeared to go well, but this constant changing and abandoning of friendships must have been difficult, and contributed to what would become a growing sense of being an outsider.

He was playing football for his house, running the quarter-mile, and was rowing. He had also joined the Eton College Officer Training Corps, a popular choice though not compulsory, which took place several times a week with drill and field days and an annual camp, usually on Salisbury Plain; Burgess would remain in the ECOTC until his penultimate term, rising to the rank of lance corporal.

At the end of his first term back he took his school certificate – a general exam taken by all pupils aged sixteen and requiring six passes. He was now a history specialist, studying for a history essay question, general paper, divinity, a translation paper – he did both French and Latin – and one on civics or economics.

An important mentor was to be a history teacher, Robert Birley, only eight years older than Burgess, and known as 'Red Robert' for his liberal opinions. Birley, an imposing six foot six tall, had arrived straight from a glittering career as a Brackenbury scholar at Balliol a few terms earlier, and was to prove an important influence on

Burgess with their shared interest in literature and history. A school contemporary, Nigel Nicolson, remembered how everyone looked forward to his classes. He would say:

> Today we are going to talk about one of the most extraordinary events in history – the Sicilian campaign – and would then describe the ships, the armour, the politics, the battle, the danger, the glory, all with such emotion and sense of fun (he adored speaking of war oddly enough) that we felt we were actually in Sicily in 420 BC, rowing in the galleys, slaving in the mines, speaking in the Assembly.[2]

Birley ran the Essay Society, where each member, who had to be invited to join, read an essay on a subject of their choice over cups of cocoa. Burgess was to give several talks on subjects ranging from Ruskin to Mr Creevey, an eighteenth-century politician best known for the Creevey Papers on the political and social life of the late Georgian era.

Another strong influence was the art master, Eric Powell, a talented watercolourist who had rowed for Cambridge and in the 1908 summer Olympics.[3] Burgess had developed into an accomplished artist and received numerous art and drawing prizes throughout his Eton career. He had a keen interest in art and was a regular visitor to art galleries, being especially 'bowled over' by Cezanne's 'Black Marble Clock' at the French Exhibition at Burlington House. His own drawings, though, were caricatures in the style of Daumier or the political caricatures of 'Spy'. David Astor remembered him as forever drawing cartoons of masters and others in authority, and using that as a means of channelling his growing rebelliousness, a view confirmed by Michael Berry, and many of his pictures can be found in Eton's ephemeral magazines, to which he continued to contribute even after he left Eton.[4]

Roland Pym, later a painter and book illustrator, who took extra studies in literature and art with Burgess, 'didn't like him, but can't really say why. Bumptious and cocky?' adding, 'He would hold forth in front of the whole class. He must have been sensitive because he blushed easily.'[5]

Burgess continued his intellectual ascent of the school. In Lent 1928 he was first in the Remove and by July 1928 he was ranked

Burgess's illustration in 'A Mixed Grill', 4 June 1930

twentieth of the First Hundred – boys who were the academic elite of the school.[6] He was now a member of the Sixth Form with its special privileges of a butterfly tie and being able to walk on Sixth Form grass, though he claimed he took no pleasure in another perk – attending birchings.[7]

In November 1928 he had an 'honourable mention' with the future philosopher A.J. Ayer in the Richards English Essay Prize and in April 1929 he was second in the school's premier history prize, the Rosebery.[8]

At Christmas 1928, Robert Birley wrote to Burgess's housemaster, Frank Dobbs:

> At the moment his ideas are running away with him and he is finding in verbal quibbles and Chestertonian comparisons a rather unhealthy delight, but he is such a sane person, and so modest essentially, that I do not feel this very much matters. The great thing is that he really thinks for himself. It is refreshing to find one who is really well read and who can become enthusiastic or have something to say about most things from Vermeer to Meredith. He is also a lively and amusing person, generous, I think, and very good natured . . . He should do very well.[9]

After Malcolm's death, the family had continued to live in West Meon, though they had briefly moved to the Old Barn at Chiddingfold at the beginning of his Eton career. Holidays tended to be spent in Hampshire, though there was some excitement at the beginning of April 1929 when Burgess, his brother, then known as Kingsley, and their mother sailed from Southampton, via Tangier, to escort a relation, a sugar refiner called John Bennett Crispin Burgess, to Indonesia, returning three weeks later with a stop at Colombo.[10]

It is not clear when Burgess realised he was homosexual or the extent of his sexual experiences at Eton. He later claimed to the Russians that he had become homosexual at Eton, where it was common and even masters were seducing boys, and a later screenplay, *Influence*, by Goronwy Rees, has him beaten for sexually assaulting a boy. Homosexuality was certainly prevalent – many Old Etonian memoirs for the period discuss it – and it seems unlikely that Burgess, with his good looks, would have gone unnoticed. Burgess later told

a boyfriend that a scion of the aristocratic brewing family Guinness was totally infatuated with him. Outside the door of the younger boy's tiny room in Dobbs's house, he attached an advertising sign as proof of his devotion. It read: 'Guinness is Good For You'.[11]

But the accounts of contemporaries suggest that, if he was homosexual, he was very discreet. Dick Beddington, one of Burgess's closest friends at Eton, saw no indication of it, but felt he was a very private person who kept his life very compartmentalised. Michael Berry told Andrew Boyle that he thought Burgess had indulged in homosexuality,[12] whilst Evan James suggested, 'He may have done, but if he had been in any way notorious for this I should possibly have heard wind of it.'[13]

Lord Cawley, who was in his house, said, 'Burgess always appeared to be an affable character and I never heard any rumour about his homosexuality.'[14] Lord Hastings thought 'he was probably homosexual but so were a great many boys (some twenty per cent in my tutor's) who indulged in mild sexual practices (never oral for instance), but who subsequently grew up as perfectly normal adults'.[15]

Memories of him from his contemporaries vary. Many refer to his unpopularity, his sense of inferiority and being a loner, whilst others speak of his kindness and warmth. Diametrically opposing views of Burgess were to be a pattern that was to repeat itself throughout his double life. Lord Hastings wrote, 'It is difficult to analyse a boy's character if you are not in the same house, but I gather that Guy was lacking in self-confidence and trying to ingratiate himself with everybody, and that seldom leads to popularity!'[16] Michael Legge remembered him as 'an amusing man, totally unselfconscious and a strong personality',[17] whilst David Philips, another contemporary, thought him 'a bit of a loner and a bit of a rebel. He was looked on as a bit left-wing and an outsider in his social and political views.'[18]

William Seymour, a neighbour in West Meon, liked Burgess and remembered a flamboyant figure who flouted his house colours, wrapped his scarf around his desk, and was keenly political.[19] Another classmate, Mark Johnson, simply remembered him as 'being kind and friendly to small boys'.[20]

Evelyn had taken her husband Malcolm's death hard and remained a recluse for four years, but in late 1928 she met a retired army officer, John Bassett, and the following July they were married at St Martin-in-the-Fields church in Trafalgar Square. Guy and Nigel Burgess learnt the news of the forthcoming marriage not from their mother, but from their housemaster.[21]

Her new husband, John Bassett, was seven years older than Eve, and had retired as a lieutenant colonel in his early forties in 1920. The couple shared a love of racing, which extended in Bassett's case to horse betting. When asked what his new stepfather did, Burgess would reply in a solemn voice, 'I'm afraid he's a professional gambler.' Bassett was, in fact, rather more than that, and he'd had a distinguished military career. Commissioned into the Royal Berkshire Regiment in 1898, he had served in East Africa, the Sudan, where he had governed a province, Abyssinia, and in the Boer War, and later he worked alongside Lawrence of Arabia. For his services in the First World War he had earned a Légion d'Honneur, OBE, and DSO, which rather eclipsed Malcolm's Order of the Nile 4th Class.

Burgess returned to Eton for his final year in September 1929 and was one of six boys chosen to give speeches on 5 October. He had picked a piece from H.G. Wells', 'Mr Polly's reflections on the plump woman', to which the *Eton College Chronicle* commented: 'he brought out the climax well [but] his enunciation is too much slurred to allow him always to be audible'.[22]

Burgess had always read widely, but now his reading became increasingly politicised, with Arthur Morrison's *The Hole in the Wall* and *Tales of Mean Streets* and Alexander Paterson's *Across the Bridge*, with its exposure of conditions in London's East End, being particularly influential. Burgess's own political views were also being shaped by his history teacher Robert Birley's concern for social justice. A visit by a dockers' trade union organiser to the school, where he talked about inequalities between rich and poor, only helped to reinforce a growing interest in radical politics.[23]

He had joined the Political Society, which met on Wednesday evenings in the Vice Provost's Library, hearing talks from Hilaire Belloc on 'The Decay of Parliament in Central Europe', G.K. Chesterton on 'Democracy' and Paul Gore-Booth, a Colleger, on

'Russian Bolshevism'.[24] In July 1929 he was elected to the committee, of which his friend Dick Beddington was secretary, though clearly something had happened by May 1930, when it 'was decided that Mr Burgess should be deposed from the Committee' and his appeal to be reinstated was rejected, suggesting some sort of disagreement. Burgess was later to claim that the election of the Labour government in 1929 'made some impression' on him and he would argue 'in favour of socialism with the son of an American millionaire', Robert Grant.[25]

He was also active in the newly resurrected debating society, which met on Monday evenings. On 3 October 1929 they met to discuss whether the English public school system was a good idea or not, and on 10 October it was 'Russia – Country of the Future?' On 25 October, with police riot squads forced to deal with crowds on Wall Street, he attended a debate on 'whether radical changes are needed at Eton in view of the rise of Socialism'. It was proposed by David Hedley and Burgess supported the motion, though it was lost with 38 for and 50 against.

According to Dick Beddington, the fair-haired six-foot Hedley was a brilliant student and with Burgess 'undoubtedly the two most interesting chaps at Eton at the time'.[26] Hedley was school captain, a 1st XI footballer, gregarious, amusing, popular, good-looking, Keeper of the Wall, winner of the Newcastle Prize, Editor of *Eton College Chronicle*, and a rower. He also had supposedly become one of Burgess's sexual conquests.

By January 1930, Burgess was ranked second after Hedley in the Sixth Form, which comprised the top ten scholars and top ten Oppidans – Oppidans are the non-scholars at Eton – and that month he sat and won a history scholarship to Trinity College, Cambridge, with Hedley winning a scholarship in classics to King's College, Cambridge.

According to Burgess's own later account:

> when he met the examiners later, they told him that they had never before given an open scholarship to anybody who knew so little as he did. Apparently they decided in his favour largely on the strength of one exceptionally promising paper in which, referring to the French Revolution, he expressed energetic disapproval of Castlereagh.[27]

Burgess, who so much wanted to belong, had achieved most of Eton's Glittering Prizes. He had been awarded his house colours, was a highly regarded member of the 1st XI Football and probably the best swimmer in the school. He was also a member of the self-elected Library (the house prefects) in his house, where one blackball excluded, which suggests he wasn't that unpopular, although as a member of Sixth Form he should have been captain of the house.[28]

However, one distinction still eluded him – membership of Pop, a self-elected elite of between twenty-four and twenty-eight boys, which conferred special privileges such as wearing coloured waist-coats, carrying umbrellas, and caning other non-Pop boys. Between September 1929 and May 1930, Burgess's name was put forward unsuccessfully several times, sponsored by, amongst others, David Hedley and Michael Berry. There were good reasons for his failure. His house already had two members of Pop, the president of Pop, Robert Grant, an outstanding racquets player, and Tony Baerlein, who kept wicket for the Eton 1st XI for three years.[29] Burgess was clever, but Pop tended to recognise sporting rather than academic achievement, and to prefer aristocrats rather than the sons of naval officers.

It didn't surprise another Eton contemporary, Peter Calvocoressi: 'I don't think it was very strange that he never got into Pop. There were three kinds of Pop members: ex officio, good at games, an exceptionally "good chap". He was none of those things!'[30] As Berry was later to admit, 'When it came to getting Guy in, I discovered to my surprise how unpopular he was. People just didn't like him.'[31]

Pop notwithstanding, Burgess's final days were ones of glory. He played a prominent role in the school's 4th June celebrations, graced that year by the presence of the King who presented the Officer Training Corps with new colours. At speeches in the morning, dressed in breeches and black stockings, he read Southwell's 'Good Things', though the *Eton College Chronicle* noted, 'Only two of the prose passages suffered from being spoken too low. In the case of Burgess the trouble was, perhaps, rather a failure to enunciate clearly. A catalogue of "good things" is a difficult idea to manage. He expressed well, however, the minor key of his passage.'[32] He played Sir Christopher Hatton in Sheridan's *The Critic* and several of his

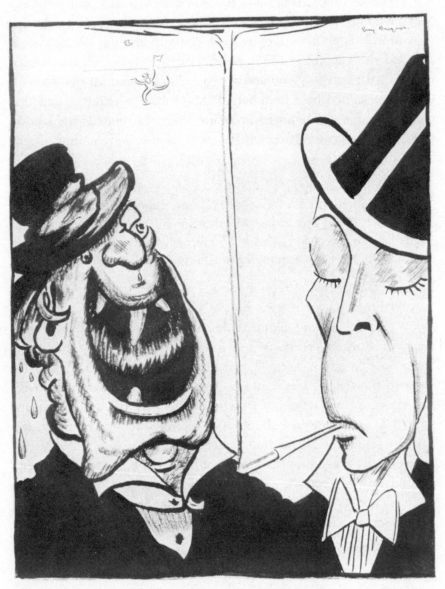

Guy Burgess's cartoon in Eton ephemeral magazine 'Motley', 10 July 1931

cartoons were in *The Mixed Grill*, a magazine produced for the day. That evening he rowed in *Monarch*, the senior boat in the Procession of Boats made up of school celebrities, alongside Hedley, McGillycuddy, and Robert Grant.

A month later, his career at Eton came to an end. He had been awarded the Gladstone Memorial Scholarship based on the results of the final exams – £100 and a two-volume set of Morley's life of Gladstone, signed by a member of the Gladstone family – and the Geoffrey Gunther Memorial Prize for design. His time at the school had been a success. Robert Birley was later to tell Andrew Boyle that Burgess:

> had a gift for plunging to the root of any question and his essays were on occasion full of insights. He went through Eton without a blemish. V. gifted and affable, articulate, never in trouble. No hint of any fault or defect in character. Member of the Essay Society and a good one. He had a natural feel for history and did well at Eton.[33]

Burgess's feelings about the school were complex. Steven Runciman, an Old Etonian who taught him at Cambridge, later claimed, 'He enjoyed Eton without liking it. He used to laugh about it,'[34] but many of Burgess's contacts and much of his identity came from being an Old Etonian, and he retained a strong emotional attachment to the school. He would later say that though he disapproved 'of the educational system of which Eton is a part', as an Old Etonian, he had 'an enduring love for Eton as a place, and an admiration for its liberal educational methods'. He continued to wear his OE tie – he proudly boasted of being 'one of the few Old Etonians to wear an Old Etonian bow-tie throughout his life' – and often returned to the school to see Dobbs and Birley, attend chapel services and, as he later recollected, 'spend summer weekends in a punt moored by Luxmoore's Garden'.[35]

4

Cambridge Undergraduate

After a month visiting relations in Canada with his mother and Nigel, Burgess went up to Trinity College, Cambridge at the beginning of October 1930, and was given rooms in 14 New Court, just off Great Court. Trinity, founded by Henry VIII in 1546, was the grandest – it was said God was a Trinity man – richest and largest of the Cambridge colleges. Burgess was one of only thirteen scholars in his year across all subjects, and at nineteen and a half, he was slightly older than most of his contemporaries. He certainly appeared more sophisticated and glamorous. Cambridge was perfect for him. It allowed him to reinvent himself in certain circles, he relished the intellectual stimulus and the sexual freedom, and with a generous allowance from his mother, he was also richer than many of his contemporaries.

He immediately joined the socially exclusive Pitt Club, a haven for aristocrats and public school men, in Jesus Lane, lunching there each day on a bottle of Liebfraumilch '21.[1] He had come up with a number of Etonians, but according to Michael Vesey, a contemporary at both school and Cambridge, although he 'tried to get in with the Old Etonians . . . they weren't interested . . . My lot generally regarded him as a conceited unreliable shit.'[2] By contrast, Michael Grant, who was reading Classics, described Burgess as 'popular, especially with those who had been at school with him (as I was not), chiefly because he was good company and amusing'.[3]

Trinity had several history dons: J.R.M. Butler, who had just published his *History of England 1815-1918* and would later become Regius Professor of History, another nineteenth-century specialist, George Kitson Clark, as well as Outram Evennett, an expert on the Counter-Reformation. Finally, there was the Reverend Frederick

Simpson, elected a Fellow of Trinity in 1911 and destined to remain one until his death aged ninety in 1974; Simpson was the acclaimed author of two volumes of a proposed four-volume life of Napoleon and was to become particularly close to Burgess.

A tall, dark, stooped, craggy-faced man, he was often to be seen in a cloth cap and a dangling grey scarf. In his younger days he had flown the Channel in his own Gypsy Moth, whilst in later days, as Dean of Chapel, he questioned the divinity of Jesus. Unmarried, he was a frequent observer at the university bathing pool, where under-graduates swam naked.

Steven Runciman, who also taught Burgess, found his pupil, 'A very clever boy. An interesting mind but rather undisciplined. He was a type that Eton sometimes produces. The Young Revolutionary . . . In those days he was always good company but a bit grubby. I often had to send him back to clean his fingernails.'[4]

Burgess's interests remained historical and literary. At the end of his first term he was elected to the Trinity Historical Society, which was limited to the most promising twenty-five undergraduate and postgraduate members. Burgess would become a regular attendee at the club. Among the other members was Kim Philby, who had come up the year before to read History from Westminster School, where he had been a scholar. Membership of the club would increasingly shape Burgess's political views.

Elected alongside him was Jim Lees, an ex-miner from Nottingham, who had won a trade union scholarship to Trinity, and who would become a life-long friend and strong radicalising influence. Lees had left school at fourteen and was one of a small group of former coal miners at Cambridge supported by the Miners' Welfare Fund. Baldish and spectacled, he was a member of the Independent Labour Party. Burgess later admitted that Lees 'taught him a lot and troubled his conscience'. Lees would tell Burgess despairingly that he would 'get a First because your energies are not exhausted by life, because of the class-prejudice of the examiners, and because you got here easily and aren't frightened by it. I shall do ten times as much work as you – and get a good Second.'

Burgess accepted that though Lees knew far more history than he did, that was the likely scenario. 'He was interested in truth, I in

brilliance. I made epigrams: he got the right answers.'[5] Lees proved right. Whilst he managed a Second, Burgess in his first-year college exams was awarded a First – the only one of the thirteen Trinity historians in his year to do so.

Gervase Markham, reading English in the year above and secretary of the Trinity Shakespeare Reading Society, which met fortnightly in each other's rooms to read through a Shakespeare play, later wrote about Burgess:

> He was fat, coarse and untidy. The adjectives that come to my mind are 'epicene' and 'apolaustic': and I have just looked them up in my Shorter Oxford and find that their dictionary meaning fits him aptly.[6] I think he rather despised those of us who played traditional games and sports. I cannot connect him with any outdoor physical activity. Rather, I see him in my mind's eye in an over-comfortably furnished room, that smelt of incense (or was it cannabis?) . . . I remember a bronze figure of a Buddha, which he induced to make smoke come out of its navel which he thought amusing and I found disgusting. I cannot recall ever discussing politics with him, though it would fit in well with my memory of him if he had been associated with those undergraduates who were sympathising with Communism. But I cannot think of him as having 'high ideals' or working for the greater good of humanity. I thought him a selfish lout, caring most for his own rather dubious pleasures.[7]

Burgess's lover during his first year was Jack Hunter, an American who was reading English in the year above at Trinity. His father was the Hollywood film director T. Hayes Hunter, though Jack himself always claimed to be the illegitimate son of Douglas Fairbanks.[8]

The Eton art master, Eric Powell, had told Burgess to give up exercise on leaving Eton, saying, 'If you go on taking exercise now, you'll always have to', advice which the young man took with gratitude, only making an exception for swimming. But he had continued his interest in art, and in May Week 1931 he had a small part and designed the set for Dadie Rylands' Amateur Dramatic Club modern-dress production of Bernard Shaw's *Captain Brassbound's Conversion*. The production starred Michael Redgrave, then President of ADC, David Hedley and the future broadcaster Arthur Marshall. Redgrave remembered them as: 'Very good sets, too. Burgess was

one of the bright stars of the university scene, with a reputation for being able to turn his hand to anything.'[9]

It was also that summer that he first met Anthony Blunt, who had graduated with a First from Trinity the previous year and was now a graduate student. They met surprisingly late, given that they mixed in similar circles – either through Michael Redgrave, who had edited an undergraduate magazine *The Venture* with Blunt, or the King's don, Dadie Rylands.[10]

'On that occasion I did not take to him, because he began immediately to talk very indiscreetly about the private lives of people who were quite unknown to me,' Blunt recalled:

> but as I got to know him better I became fascinated by the liveliness and quality of his mind and the range of his interests. There was no subject in which he did not have something stimulating to say and although his ideas were not always supported with full evidence or carefully thought out reasons, there was always something in them to provoke thought and set one's own mind working along new lines.[11]

In many ways Burgess was the antithesis of Blunt – outrageous, loud, talkative, indiscreet, irreverent, overtly rebellious – but they shared many artistic interests. 'I relied a great deal on discussions with Guy,' Blunt later recalled. 'I often visited the exhibitions concerned with him and I have known few people with whom I have more enjoyed looking at pictures or buildings . . .'[12]

They were also drawn together by their mutual homosexuality, though it's unclear if they were ever lovers. Peter Pollock and Jack Hewit, who slept with both Burgess and Blunt, said it was impossible as they both preferred the 'feminine' role in lovemaking, but Blunt's brother Wilfrid told a friend that Anthony had been seduced by Burgess and this was confirmed to Andrew Boyle.[13]

Burgess, open about his own sexuality, often played the role of pimp and father confessor to his friends, liberating them sexually either by sleeping with them himself or introducing them to partners, and certainly in Blunt's case he introduced him to the joys of 'rough trade'. Blunt was charmed by this bright, amusing, liberated young man, who could talk knowledgeably on a range of subjects. Geoffrey

Wright, who had become friendly with Blunt through Cambridge's gay circles, felt that Burgess liberated Blunt and 'Guy represented all the things that Anthony kept bottled up.'[14]

Robert Birley, visiting Burgess that summer, was shocked to find a collection of pornography and Marxist tracts on the bookshelves in his rooms. Clearly something had changed with his former pupil.[15]

After the summer vacation, Burgess returned for his second year to a Cambridge that was increasingly politicised by the world situation. Unemployment had reached nearly three million, there had been a naval mutiny at Invergordon, Britain had been forced off the gold standard, and Ramsay MacDonald had been required to form an all-party coalition National Government. At the same time there was increasing political instability on the Continent, particularly in Germany. Cambridge was not isolated from these developments and its response was reflected in both overt and covert activities. During the summer of 1931, the Cambridge University Socialist Society had been formed by Harry Dawes, another ex-miner, and it became the focal point for left-wing radicalism in the university and was increasingly infiltrated and used by the communists.

An important figure was David Haden Guest, the son of a Labour politician, who had come up to Trinity a year ahead of Burgess, to read Philosophy and Mathematical Logic at the feet of Ludwig Wittgenstein. After only two terms, he had gone to the University of Göttingen, attracted by its advanced teaching of philosophy. There he had seen at first hand the beginnings of Nazi violence, which persuaded him that only communism could stand up to Hitler. On his return to Cambridge, after spending a fortnight in solitary confinement in prison in Germany in 1931 for joining in a communist demonstration, he had very publicly marched into college hall wearing a hammer-and-sickle emblem. Guest, whose sparsely furnished college room was dominated by a portrait of Lenin, became the first secretary of the university branch of the Communist Party, which included two dons, Maurice Dobb and Roy Pascal, together with Jim Lees.[16]

The son of a prosperous Gloucestershire landowner, Dobb had become interested in Marxism as a schoolboy at Charterhouse and had joined the Communist Party in 1922. He had visited the

USSR several times and frequently gave speeches at the Cambridge Union on the achievements of Soviet society. He had a flat in The Lodge in Chesterton Lane; the other two flats in the building were occupied by Roy Pascal and a fellow of St John's, Hugh Sykes Davies, both Marxists, and The Lodge therefore became known as 'The Red House'.[17]

On 2 November, at a meeting in George Kitson Clark's rooms, Burgess was elected to the committee of the Trinity History Society and heard Dobb, a Fellow of Pembroke, talk about 'Communism: a Political and Historical Theory'. Burgess had gradually become more interested in Marxist teachings, shaped by discussions with contemporaries such as Lees, who argued that compromise with authority did not work and that the Left had to become more radical. He was also influenced by his reading, most notably of Lenin's *The State and Revolution*, lent to him by David Haden Guest. His tutor F.A. Simpson's two volumes on Napoleon had now been replaced by Karl Marx's *The XVIIIth Brumaire of Louis Bonaparte* and *Class Struggles in France*.

Burgess would later claim his interest in communism had 'an intellectual and theoretical rather than an emotional basis'. As one of the subjects for the History Tripos, he had to study 'the theory of the Modern State – what the state is – the point at which the general study of history touches real life most closely' and he found Marxism had something to say to him. On 30 May 1932, that was put to the test when he sat the first part of his History Tripos with papers in General European, English Constitutional and English Economic History. Three weeks later, the Class lists were published. He was one of fifteen Firsts in Part I History across the university.[18]

A growing friendship had been developing with the Trinity bachelor don Steven Runciman, an Old Etonian eight years older, whose rooms in Nevile's Court were famous for their French 1820s grisaille wallpaper, depicting Cupid and Psyche, his exquisite bric-à-brac and his 'green parakeet called Benedict, which he used to spank with a pencil for misdemeanours'.[19] The two men had a great deal in common, sharing an interest in history, literature and gossip. Burgess and Runciman met almost every day from the autumn of 1932 through to 1934, and it is almost certain that they became lovers.[20]

Runciman was concerned about Burgess's personality problems

and his behaviour and would recall how the undergraduate's friends tried to restrain his drinking. He believed that Burgess lacked self-confidence and that 'drink gave him the confidence to behave badly'.[21] He later claimed that he had saved him from being sent down and in gratitude Burgess had given him two little black-and-gold Regency candlesticks made of ebony and ormolu.[22]

During the summer holiday of 1932, Runciman invited Burgess to stay on the Scottish island of Eigg, which the Runciman family owned and where Runciman remembered him as 'a lively and pleasant guest'.[23] The group included Burgess's devout Catholic history tutor Outram Evennett and his wife, with the glamorous Anne Barnes (there without her husband George) and various other undergraduates, most of them homosexual, who spent the holiday reading, sunbathing and exploring the island. Amongst them was Geoffrey Wright, a member of the Cambridge Footlights Club, who didn't like Burgess:

> He was a very dirty man, jolly clever and sharp but he had a harsh tongue . . . He had a keen eye for the main chance . . . He certainly wasn't insecure for a moment and I don't think he had any difficulties about his homosexuality . . . Anything that gave him a thrill. He loved being on the edge. He was a curious, fantasy figure[24]

In October 1932, Burgess returned to Cambridge for his third year to M2, a set of grand rooms in Trinity's Great Court. He now possessed a college history award, the Earl of Derby Studentship, awarded to the member of the college who had most distinguished himself in the Historical Tripos.

A month later he was elected a member of the Apostles, sponsored by Anthony Blunt, in a meeting in Blunt's room.[25] The Apostles, one of the best-known secret societies in the world, had been founded in 1820 as the Cambridge Conversazione Society, a discussion group which drew in some of the cleverest of Cambridge students, though most members came from only two colleges, King's and Trinity. It had passed its high point at the beginning of the twentieth century, when members included the philosophers G.E. Moore and Bertrand Russell and mathematician G.H. Hardy, but it was still regarded as a super-intellectual elite, electing only a couple of members each year.

The Apostles, like many such societies, had its own rituals and language, which helped sustain a sense of being special. Potential recruits – called 'embryos' – were spotted first by an Apostle and then if considered 'Apostolic' were sponsored by a member called his 'father'. The first meeting for a new member was his 'birth', where he would take an oath, and after being elected he would address his fellow Apostles as 'brother'.

The society met on Saturday evenings in either King's or Trinity, where members took turns to stand on the hearth rug and deliver a paper on some philosophical question that had been agreed the previous week. Once the speaker, known as 'moderator', had finished his essay, other Apostles commented. Following this intellectual prelude, sardines on toast, known as 'whales', would be served. The society also held annual dinners in London attended by current Apostles and by 'Angels' – members who had 'taken wings' and left Cambridge.

Members in this period, many of whom were homosexual, included the Regius Professor of History G.M. Trevelyan; the writer E.M. Forster; the literary critic Desmond McCarthy; Churchill's private secretary and close friend of Rupert Brooke, Edward Marsh; the economist John Maynard Keynes; and the philosopher Ludwig Wittgenstein.

It is perhaps not surprising that Burgess should be elected, as many of his friends, such as Anthony Blunt's lover, Julian Bell, and the King's English don, Dadie Rylands, were already members, but it was still a great acknowledgement of his intellectual abilities. Burgess was to be an active undergraduate Apostle, attending most of the weekly meetings, sometimes hosting them and providing supper in his rooms, acting as moderator and eventually, in June 1933, becoming secretary.

The Apostles appealed to his love of ideas and intelligent conversation and also gave him the opportunity to network – a resource which he ruthlessly exploited for the rest of his life. Many writers have suggested that it was the Apostles that politicised Burgess and Blunt, but an examination of its minute books shows that in the early 1930s it was simply a society exploring abstract ideas. It's certainly true that of the thirty-one Apostles elected between 1927

and 1939, fifteen were communists or Marxists, but most of those were members during the latter half of that period, after Burgess's time. Indeed, it was not the Apostles that politicised Burgess, but rather the reverse. He and Blunt brought in fellow sympathisers as part of a strategy to infiltrate communists into important university societies. Victor Rothschild was to write despairingly to Keynes: 'We talk endlessly in the society about communism, which is rather dull.'[26]

Rothschild had been elected to the society at the same time as Burgess and also with the support of Anthony Blunt. Coming up to Trinity from Harrow in 1929 to read Natural Sciences, he had quickly switched to a pass degree in English, French and Biology, in which he'd taken a triple First. Darkly handsome, highly intelligent, a talented sportsman – he had played cricket for Northamptonshire and Cambridge – and an excellent jazz pianist, as the heir to the Rothschild banking fortune, he was also extremely rich.

He was a glamorous figure who drove a Bugatti, collected paintings, English silver and rare books, and was a generous friend – in 1933 he had 'lent' Blunt £100 to buy Poussin's *Rebecca and Eliezer at the Well* from Duit's in Jermyn Street, which Burgess had collected on his behalf – but there were also dark secrets.[27] In the autumn of 1931 he had killed a cyclist whilst driving from Cambridge to London and was put on trial for manslaughter. He was defended by St John Hutchinson, whose daughter he would marry shortly afterwards.[28]

The Apostles created a strong sense of being special and separate, with a different set of allegiances to those who were not members. Apostolic virtues included the importance of sexual and emotional honesty, truth, beauty and friendship, which were placed above conventional sexual morality and orthodoxy. Many of the Apostles were also part of the Bloomsbury Group, a collection of writers, philosophers, economists and artists, who were generally left-wing, atheists, pacifists, lovers of the arts and each other. The group was influenced by the philosopher and Apostle G.E. Moore, who believed that 'affectionate personal relations and the contemplation of beauty were the only supremely good states of mind'. It is perhaps not surprising that the Apostles should prove to be so open to communist infiltration.

It's clear from the topics on which Burgess chose to speak that by the spring of 1933 he was interested in Marxism. Whilst topics

over the term included, 'Me or Us?', 'Is Art more than a Craft?' and 'Is Reality Absolute?', Burgess's talk on 28 January was a Marxist analysis, 'Is the Past a Signpost?' It is also clear that Marxism was taking root in the university.

On 3 March the 'Letter from Cambridge' in the *Spectator* noted that 'politics and religion, so recently mere supers in the drama of discussion, have achieved a startling come-back; Dr Buchman and Karl Marx bask in the warm limelight of interest from which so suddenly and so decisively they have elbowed Proust and Picasso . . . much of the gay froth has gone'.[29] Two months later, the same correspondent was struck by how the Socialist Society was moving to the left and communists 'comprised the intellectual side of undergraduate opinion'.[30]

Over the course of 1932 the Cambridge University Socialist Society (CUSS) had grown and was now affiliated to the Communist Party of Great Britain (CPGB). It still had only twenty-five members, but was especially strong in Trinity, where its members included Kim Philby, who handled finance and publicity, and a Trinity philosopher, Maurice Cornforth, who acted as secretary of the town branch of the CP, while Haden Guest was secretary for the university.

Another organisation the communists had penetrated was the Trinity Historical Society, where on 8 May Philby, but not Burgess, heard John Strachey on 'Communism & Fascism: The Historical Alternative', drawn from his forthcoming book *The Menace of Fascism*. Victor Kiernan, the year below Burgess, was determined to make the society 'very much a Marxist debating ground with its emphasis on the economic interpretation of history' and it, likewise, was to prove as fertile for the communists as the Apostles.[31]

In his third year Burgess continued to work hard, but there were signs that his political activity was interfering with his academic work. Tom Driberg in Burgess's authorised life was to write that Burgess 'in his third year was given another First in Part II of the Tripos, even though illness prevented him from completing his papers. This illness was one that has afflicted him constantly since the age of sixteen: insomnia, sometimes aggravated by severe headaches.'[32]

The strict truth was Burgess received not a First, but an *aegrotat* – an ungraded degree awarded to those too ill to take finals but

deemed to have deserved honours. It is not clear whether his 'illness' was a genuine nervous breakdown, as his friend Goronwy Rees later claimed, or one staged because he had done no work. According to one Trinity contemporary, Michael Grant, 'Guy thought all you had to do was work fourteen hours before the exam and have a lot of strong coffee. He cracked up on it.'[33] Another, Lord Thurlow, claimed that Burgess had taken amphetamines before the exam and then had to be carried out in the middle of it: according to another contemporary it was Benzedrine and that after the Trinity dons retrieved his papers, they found that they were first class.[34]

Shortly after finishing his exams, at a party given by Eric Duncannon (later Earl of Bessborough), Burgess noticed a good-looking young man wearing a Brooklands tie-clip. Micky Burn was writing a book on the racing track and the two were immediately drawn to one another by a love of cars and mutual admiration for A.E. Housman, becoming lovers that very night. Burn was eighteen months younger than him and had dropped out of Oxford after a year; he remembered how Burgess:

> made no secret of being homosexual and a Marxist . . . He had blue eyes and tight wavy hair, was a good swimmer and looked menacingly healthy. I have seen his looks described as 'boyish'; he did convey a dash of pertness and sham-innocence, as if he had just run away after ringing some important person's doorbell . . . he was in love with Marxism; more precisely with the Marxist interpretation of history . . . 'History' had taken the place of God, (as Bertrand Russell hoped that mathematics would). The Marxist testaments explained all that had ever happened, all that was happening, and all that would happen, and what each person should do to help it all along. Everything was related once one had the key . . .[35]

The affair spanned that summer and would continue in a desultory way for several more years. Burn spent several weekends with Burgess in Cambridge, where they spied over a wall on A.E. Housman reading in a deckchair in a college garden and Burn was introduced to F.A. Simpson, whom Burgess conspiratorially informed him had been in love with Rupert Brooke.[36] The two young men stayed in Grantchester, drawn there by its association with Brooke, and swam in the Cam, going to lunch with E.M. Forster, where Burn made the

faux pas of asking if he agreed that Somerset Maugham was 'the greatest living English novelist'. Burgess took Burn to meet his mother Eve and one romantic evening they drove to Oxford in Burgess's MG to see Max Reinhardt's OUDS production of *A Midsummer Night's Dream* in Magdalen deer park.[37]

That summer Burgess went on holiday with Anthony Blunt, Victor Rothschild, Anne Barnes and Dadie Rylands, Rothschild driving the four of them in his Bugatti to Monte Carlo, where they stayed for the weekend with Somerset Maugham at his Villa Mauresque.[38]

From the South of France Blunt went on to the British School in Rome, where his school-friend Ellis Waterhouse had recently been appointed librarian, to work on his thesis 'The History and Theories of Painting in Italy and France from 1400 to 1700'. Burgess joined them there later that summer.

The holiday was most notable for Burgess's politicising of Blunt. The three men visited museums, bars and went for long walks around the city, and Waterhouse noticed that Burgess seemed to have gained an ascendancy over Blunt, using arguments about the importance of the state in supporting the arts to shape Blunt's Marxism. The Young Marxists were about to extend their reach and consolidate their influence.[39]

"Rain" (in the '20s)

Drawing perhaps inspired by Somerset Maugham's short story 'Rain'

5

Cambridge Postgraduate

In spite of his *aegrotat*, Burgess returned to Trinity in the autumn of 1933 as a research student, preparing a thesis on the intellectual background of the Puritan Revolution, and doing a little supervising, at which he seems to have been rather good. One of his pupils, Lord Talbot de Malahide, Milo Talbot, later testified that it was only Burgess's teaching that had lifted him from a 2:2 in Economics to a First in History and had enabled him to pass the Foreign Office exam.[1]

External events had created increasing politicisation within the university, but it was the arrival in Trinity of two new young men that transformed the student communist movement: John Cornford, as an orator, and James Klugman, as organiser. This also coincided with a change of tactic of the Communist Party to recruit amongst the intelligentsia and especially students rather than workers.

Cornford, whose father was a Trinity classics professor, and his mother a poet and granddaughter of Charles Darwin, had won a major open History scholarship to Trinity the previous year, aged just sixteen. He came up to Cambridge, having spent a few terms at the London School of Economics, already a committed Marxist and experienced agitator, and he was now living openly with a working-class girl called Ray Peters. Tall, handsome, high-cheeked, with a shock of curly black hair and dark piercing eyes, dressed in his trademark outfit of stained trousers, black shirt, dirty sweater and ragged raincoat, he became the glamour boy of the Cambridge Left. He injected a new sense of purpose into the Marxist membership of the two-hundred-strong CUSS, eventually effecting a communist takeover by ousting the more moderate Labour supporters. His call that action must be taken, if not by politicians then by students, to

prevent war, stop fascism, and cure unemployment was as potent as it was naïve.

The other galvanising force in left-wing Cambridge politics was James Klugman, who had been at Gresham's School with Donald Maclean. Several years ahead of Cornford, chubby, bespectacled and softly spoken, he stood in contrast to the more glamorous and confrontational Cornford. He had already taken a first-class degree in French and German at Trinity and had stayed on to do research. He was, Blunt remembered, 'the pure intellectual of the Party . . . the person who worked out the theoretical problems and put them across. He ran the administration of the Party with great skill and energy and it was primarily he who decided what organisations in Cambridge were worth penetrating and what were not.'[2] Klugman especially targeted the high flyers, proudly claiming he'd 'managed to recruit all but three of one year's intake of scholars'.[3]

Whilst Cornford's politics were painful and austere, Klugmann made communism appear attractive and simple, a combination of the best of Christianity and liberal politics. This chimed with the Soviet Union's new policy of creating a 'Popular Front' against Nazi Germany, bringing together all those who were concerned about fascism and the Depression. The communists thus cleverly took charge of various campaigns that might unite the Left – notably resistance to war and fascism. They actively sought to recruit new members in late-night discussions, focusing on those who might subsequently have influential careers, and cultivating foreign students who might take their radicalism back to their own countries.

Philby and Maclean were already communists. Now Burgess, avowedly a socialist since school, made the final leg of his political journey and became part of the communist cell and a member of CUSS. It had been a gradual progress from schoolboy socialist, through his historical study, the Apostles, the Trinity Historical Society, and long political discussions with Cornford, Klugman and Haden Guest.[4]

Blunt was later to claim that Burgess's conversion had occurred during the winter term of 1933 and considered that the crucial influence was probably James Klugman and that John Cornford 'may have had a hand in it'.[5]

By 1934 CUSS, largely centred in Trinity, numbered about two hundred members, of whom a quarter belonged to CPGB cells, and was one of the most active student groups in the university. Categories of membership varied, from those who kept it secret for career reasons to more overt members.[6]

The Trinity cell met weekly in student rooms, or at Sunday afternoon teas in town cafés, to discuss the political situation, organise demonstrations, raise funds, target other societies to infiltrate and liaise with other sympathetic Cambridge groups such as the Majlis, a debating forum for colonial students that Burgess addressed. Members were given books to read, elaborate lists were kept of sympathisers and near-sympathisers, and indeed virtually everyone a socialist student knew, which were then followed up with attempts to convert and recruit.

The abiding memory of fellow member of the Trinity cell Francis Hovell-Thurlow-Cumming-Bruce, later Lord Thurlow and a distinguished diplomat, was Burgess's sense of mischief:

> He liked breaking things. He was very irresponsible . . . He had enormous energy, mental energy, every kind of energy. He was very amusing. He was the most wonderful, amusing talker on anything. I always thought of him as a kind of court jester. He was not likeable, because he hadn't got any roots. He certainly had no morals . . . No one in their senses would ever have given him a sensible job. He was far too indiscreet . . . He had a need to commit himself to something.[7]

The young rebel without a cause had now found one.

Burgess joined Communist Party campaigns to support striking city bus drivers and sewage workers, and against high rents for council house tenants. He helped organise a strike on behalf of Trinity waiters against the casual labour system, which laid most of them off during vacations – though Nigel Burgess later remembered that 'nobody was more trouble, more demanding to my mother's servants, than he was'.[8]

In November 1933, *Granta* carried an editorial which observed that 'the sports field, the beer glass and the loud guffaw still play a part in the average undergraduate's life. But there has grown up

alongside of these interests a very real concern for, and understanding of, contemporary problems and events.'[9]

That month the Anti-War Council staged a large meeting in the Guildhall, addressed by the German dramatist Ernst Toller. They also mounted a major Anti-War exhibition, organised by Maurice Dobb and Julian Bell, in St Andrew's Hall. However, the argument wasn't all going their way. On Friday 10 November there was a large attendance at a debate between the Cambridge communists and the university Liberal Club on the motion 'That democracy can develop no further under Capitalism; the only hope for man lies under a Communist system'. The motion was heavily defeated.[10]

In early November the Cambridge communists had organised a protest outside the Tivoli cinema near Jesus Green, which was showing a recruitment film *Our Fighting Navy*, that led to fights between left-wing students, who claimed to be protesting against military propaganda, and 'patriotic' undergraduates. Though the anti-war group came off worse, the management withdrew the film, so the protest had achieved its purpose.

Emboldened by the publicity achieved, the Socialist Society, in conjunction with the Student Christian Movement, now organised another demonstration for Saturday 11 November, protesting against the growing militarism of the Cenotaph celebrations. The Students Anti-War Council, chaired by Alistair Watson and comprising a variety of groups from pacifists to communists, organised a three-mile anti-war march through Cambridge to the town war memorial, where a wreath would be placed bearing the inscription: 'To the victims of the Great War from those who are determined to prevent similar crimes of imperialism'. The police insisted that 'of imperialism' be removed, as it was not conducive to maintaining public order. The idea for the march had supposedly come from Burgess.[11]

Hundreds of students joined the procession through the town and the police were forced to make repeated baton charges to break up the fighting between the rival groups. Amongst those taking part was Julian Bell in his battered Morris, which had been 'armoured' with mattresses, with Burgess acting as his navigator to clear a path for the procession – not least after an attempt was made to stop the marchers with a barrier of cars.

Despite the hearties pelting them with tomatoes, eggs, flour and even fish, the pair made a couple of good charges before they were ordered to leave by the police, whereupon Julian Bell merely changed his tactics, drove round through a circuitous route and rejoined the march towards its head, to allow the wreath to be safely laid. The Armistice Day demonstration was to mark a major turning point in the recognition and organisational ability of the Cambridge communists. As Miranda Carter put it, 'Thus the erstwhile literary aesthetes began to fall in love with the idea of themselves as men of action.'[12]

Cambridge had now been thoroughly politicised. A few weeks after the march, Julian Bell wrote that in the Cambridge he had first known in 1929 and 1930:

> the central subject of ordinary intelligent conversation was poetry . . . By the end of 1933 we had arrived at a situation in which almost the only subject of discussion is contemporary politics and in which a very large majority of the more intelligent undergraduates are Communists or almost Communists . . . It is not so much that we are all Socialists now as that we are all Marxists now.[13]

In February another public milestone in the growth of the Cambridge communists came when many students – over a hundred from Trinity alone, including Burgess – joined a contingent of hunger marchers, groups of unemployed men who were walking to London to draw attention to their plight. For many students it would be their first encounter with the realities of unemployment, poverty and hunger, and the Cambridge communists were keen to publicise and exploit the march as part of a strategy of heightening student consciousness of the political situation.

An advance party of CUSS was responsible, as one of the 'United Front Committees', for feeding them and raising funds. The students met the marchers on the main road a few miles outside Cambridge and accompanied them into the city. 'The undergraduate group fell in with them,' recalled Kenneth Sinclair-Loutit, a member of the CUSS party, 'a Buchmanite Peer, Lord Phillimore, beating the hunger marchers' own big drum. They had a brass band and, shades of 1914–18, they marched in fours to the tunes many of them had known

44

in France. The column paraded over Magdalene Bridge and on through the town to the Guildhall.'

That evening Sinclair-Loutit washed and dressed blistered feet, applying Dr Scholl's patches supplied free by a local chiropodist, whilst local doctors gave free medical help to the many marchers who were in poor shape. 'A number were wearing their war medals,' Sinclair-Loutit remembered, 'which engendered a sense of remorse amongst those who remembered that the men who returned in 1918 had been promised "a land fit for heroes to live in". Though I did not then realise it, this was my baptism into socio-political activity.'[14]

The town authorities provided a bivouac for the marchers in the Corn Exchange and the next evening there was a public meeting on their behalf that Burgess attended. The next day he marched with them to Saffron Walden, before joining them again later in the week in Hyde Park. Margot Heinemann, who had known Burgess from before Cambridge and was now the girlfriend of his school-friend David Hedley, had a clear memory of Burgess. 'He was wearing a Pitt Club yellow scarf, singing, "One, Two, Three, Four. Who are we for, We are for the Working Class",'[15] whilst Alan Hodgkin, a fellow member of the Apostles also on the march, noticed how he had 'a zipped-up cardigan which he could zip down to reveal an Old Etonian tie. He said this would come in useful if he were arrested by the police.'[16]

Burgess was by now an active member of the Trinity cell, which numbered about thirty – Cambridge communists were organised by college, with separate groups for dons and scientists and a town branch run by Kitty, the sister of James Klugman, and her husband Maurice Cornforth. The poet Gavin Ewart, a Cambridge contemporary, claimed Burgess would say, 'If you want to know about dialectical materialism come to see me.' Steven Runciman agreed. 'Communism sat very strangely on him. But one didn't take it very seriously. But he was the only person who managed to explain Marxism to me in a way that made sense.'[17]

Victor Kiernan, who came up to read History just after Burgess and was in the Trinity cell, said it was Burgess who had helped to induct him into the party. He remembered him as:

a rather plump, fresh-faced youth, of guileless, almost cherubic expression. I heard him spoken of as the most popular man in the college, but he must have suffered from tensions; he smoked cigarettes all day, and had somehow imbibed a notion that the body expels nicotine very easily. He told me once a story that had evidently made a deep impression on him – of a Hungarian refugee who had been given shelter at his home, a formerly ardent political worker reduced to a wreck by beatings on the soles of the feet. I came on Burgess one day in his room sitting at a small table, a glass of spirits in front of him, glumly trying to put together a talk for a cell meeting that evening; he confessed that when he had to give any sort of formal talk he felt foolish.[18]

Having spent six months researching his doctoral dissertation 'Bourgeois Revolution in Seventeenth-Century England', Burgess was shattered to discover in March 1934 that the subject had already been covered comprehensively in Basil Willey's forthcoming *The Seventeenth Century Background*. All he could do was review it expertly, favourably and generously, which he did in the *Spectator* – Blunt was its art critic – and abandon the subject in favour of a monograph on the Indian Mutiny of 1857-8, but it was a bitter blow.[19] The dominant themes of Burgess's life had hitherto been poised between academia and communism. This setback tipped it towards the latter.

Francis Hovell-Thurlow-Cumming-Bruce was to recall, 'Burgess, we had been told, was going to make a very valuable and serious contribution to human knowledge.' But when his thesis was forestalled, 'he was absolutely crushed. He had put all his eggs in one basket. And now he was left high and dry. From then on, he went from bad to worse. He became more irresponsible and just drifted. I have no doubt that this disappointment changed his personality.'[20] Communism was no longer a mere student enthusiasm: it began to replace his academic studies, giving him a new sense of purpose, identity and a focus and he increasingly lost interest in his academic career. As his tutor and friend Steven Runciman accepted, 'He wasn't really capable of settling down to steady research.'[21]

A week after his review of Willey's book appeared, a depressed Burgess wrote to Dadie Rylands – partly in French – to say he couldn't go on holiday with him to France, because of lack of money. 'I am

very depressed indeed and with no news of any kind and reading Blake about the man in the wood.' He was reading Willey's book again and thought it 'so much a better thing than I could ever have attempted that I am in one way glad but in another sorry, because if I do try and do anything on the subject, his work is so good that it will be impossible not to think in his terms (having come near his matter)'.[22]

The letter was sent from Ascot Hill House, where his mother was now living in an eleven-bedroom rambling Victorian house in twenty acres on the hill above Ascot station. A previous occupant had been Rajah Brooke's daughter, who had given numerous parties in the ballroom with its linenfold panelling, and even by the standards of the day, it was a large house, with servants' quarters for half a dozen. Its primary attraction, however, was its proximity to Ascot Racecourse, at which the Bassetts were assiduous attendees.

Through Dadie Rylands, Burgess had been introduced to Maurice Bowra, a Fellow of Wadham College, and he would often visit Oxford. Bowra, who liked to portray himself during this period as the leader of an 'immoral front' of communists, homosexuals and non-conformists, who stood for pleasure and conviction and enjoyed the company of young men, took a particular shine to Burgess. A witty conversationalist, a homosexual and radical, he was a man of wide-ranging interests, who had travelled in Russia as a young man and spoke the language. The two men got on famously and Bowra was to open numerous doors for Burgess at Oxford and elsewhere.

Whilst staying with Bowra at the beginning of the summer term, Burgess renewed an acquaintance with a young don, who was to become one of his closest friends. Goronwy Rees, eighteen months older than Burgess, had been born in Aberystwyth, the son of a clergyman, and educated at Cardiff High School for Boys. He had graduated with a First in PPE (Philosophy, Politics and Economics) from New College in 1931 and immediately been elected a Fellow of All Souls.

Rees had already met Burgess in Cambridge, but it was at a dinner party given by Felix Frankfurter (later a justice of the US Supreme Court and then spending year in Oxford as a visiting professor) that they cemented their friendship. Other guests included Isaiah Berlin,

another All Souls Fellow, and the philosopher Freddie Ayer, who had been at Eton with Burgess.[23]

Rees was later to recount:

> I had heard of Guy before, because he had the reputation of being the most brilliant undergraduate of his day at Cambridge, and I looked forward to his visit with some interest . . . Indeed, he did not belie his reputation. He was then a scholar of Trinity and it was thought that he had a brilliant academic future in front of him. That evening he talked a good deal about painting and to me it seemed that what he said was both original and sensitive, and, for one so young, to show an unusually wide knowledge of the subject. His conversation had that more charm, because he was very good looking in a boyish, athletic, very English way; it seemed incongruous that almost everything he said made it quite clear that he was a homosexual and a communist.[24]

Rees invited him to All Souls for after-dinner drinks, where Burgess couldn't help making a pass at Rees. 'At first he made tentative amorous advances, but quickly and cheerfully desisted when he discovered that I was as heterosexual as he was the opposite; he would have done the same to any young man, because sex to him was both a compulsion and a game, which it was almost a duty to practise.' The two men discussed painting and its relation to the Marxist interpretation of history, and the busmen's strike, which Burgess was then helping to organise in Cambridge.

They arranged to visit the Soviet Union during the summer vacation, but in the end Rees, for unspecified 'personal reasons', was unable to go, so Burgess went instead with a communist Oxford friend, Derek Blaikie. Guy Burgess's momentous first visit to the proving ground of world communism occurred in June 1934. He and Derek Blaikie sailed from Harwich, armed with introductions from David Astor of the *Observer*, whose mother Nancy Astor had visited Russia with George Bernard Shaw three years earlier. They travelled Intourist 'hard class' costing a pound a day, including travel, meals and excursions, breaking their outward journey at Hamburg, where they met a German communist in a bar, who asked if he could escape to Russia, as the Gestapo apparently had 'blood lists' of Hamburg activists who were being arrested.

As they talked, there was a disturbance outside and fighting broke out between the two Nazi factions: the SS and SA. Burgess returned to his ship to the sound of distant shooting, but his eyes had been further opened to the European political situation on a practical level. It was 30 June 1934 and the conflict he had witnessed had been one act in the 'Night of the Long Knives', when the SS, on Hitler's orders, settled its accounts with the SA, culminating the next day in the execution of the SA leader, Ernst Roehm.

Leaving this political carnage behind, Burgess and Blaikie sailed on to Russia. From Leningrad the two young men took the train to Moscow, where they are said to have been received by Ossip Piatnitski, a member of the Western bureau of the Soviet propaganda organisation Communist International, known as the Comintern; it has also been suggested that Burgess met Nicolai Bukharin, the former Secretary of the Comintern and editor of *Pravda*.[25] They flitted around Moscow, meeting Russian officials and English exiles, including Alexander Wicksteed, who had arrived as part of Quaker Relief during the Volga famine of 1921 and 'gone Russian', growing a long beard and giving up western clothes. Burgess also met the former anarchist Novomirsky and an assistant to Lunacharsky, minister of education, who showed him a list of English and French books then being translated for publication in the Soviet Union. One was Celine's *Voyage au bout de la Nuit* to which Burgess objected, calling it 'a fascist book'. He argued the point so convincingly that the official agreed that Celine should be struck off the list. For the first time, a Soviet official had acted upon Guy Burgess's advice.[26]

Burgess also challenged the Russians' preoccupation with publishing John Galsworthy – the Russians thought *The Forsyte Saga* a faithful account of the English bourgeoisie – an intervention that didn't endear Burgess to Blaikie, who was related to the writer. Burgess's first impressions of Mother Russia were mixed. Whilst he loved the paintings in the Hermitage in Leningrad, he found Moscow 'just a Balkan town – you know, pigs in the trams'.[27]

He would later claim he had been rebuked by a militiaman for walking on the grass in the Park of Rest and Culture, which didn't tally with Wicksteed's claims 'that Soviet Russia was the freest country he had ever lived in'.[28] However, according to a later account, based

on Blaikie, Burgess had not been rebuked for walking on the grass, but for being dead drunk.[29]

On his return to Britain, Burgess gave a lukewarm report to the Cambridge communists. He did not think Russia would go to war, given domestic undertakings, believed that there were greater tensions with Trotsky than had been realised in the West, and that Western communists must not look at living conditions in Russia through rose-tinted glasses. There was, indeed, no unemployment, but housing conditions were appalling. However, he was impressed by the success of the Soviet authorities in dealing with national minorities, such as the Uzbeks, the Georgians and the Kazakhs, where the policy should be 'Socialist in content, national in form'. It would be a mantra he would later repeat in his Foreign Office career.[30]

What most struck his friend Goronwy Rees, however, was that – apart from 'a long and brilliant disquisition on the pictures of the Hermitage' – he never heard Burgess talk about his experiences in the Soviet Union, 'and I do not think they ever affected his beliefs one way or another. It was as if his communism formed a closed intellectual system which had nothing to do with what actually went on in the socialist fatherland.'[31]

Guy Burgess's parents
Evelyn and Malcolm soon
after their marriage in 1907.

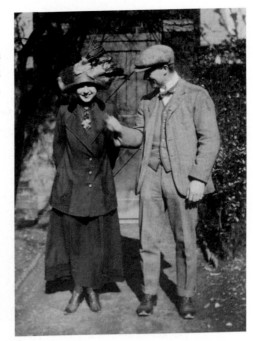

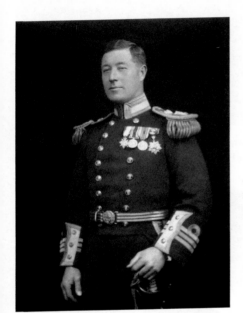

Malcolm Burgess in ceremonial
naval uniform shortly before his
retirement in 1922.

Evelyn with her second
husband Lt-Col John
Bassett, who had served
with Lawrence of Arabia
during World War One,
at the marriage of Guy's
brother Nigel, July 1937.

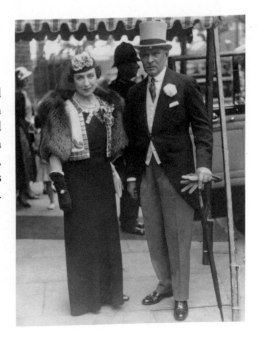

Locker's Park, near Hemel Hempstead, then the most expensive and fashionable prep school in Britain, which Burgess attended from 1920-1923.

An angelic Guy Burgess, back row third from right, in Locker's Park
1st XI Football team, winter 1923.

Guy Burgess, standing second row, 7th from left, attended the Royal Naval College, Dartmouth, from January 1925 to July 1927. He excelled as a naval cadet and was expected to become an admiral.

Third from left, as a house prefect at Eton, 1930.

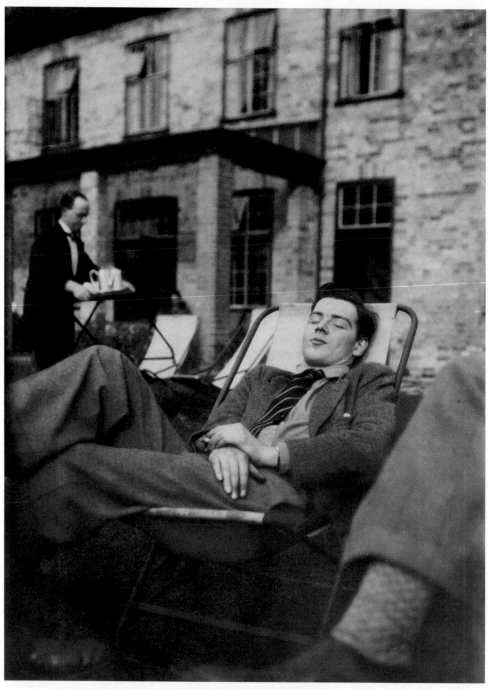

Enjoying the trappings of wealth whilst staying with
Steven Runciman on Eigg, summer 1932.

Burgess with his Cambridge history tutor Outram Evennett, Eigg, summer 1932.

Burgess with his Trinity boyfriend Jack Hunter, on a punting picnic, 2nd June 1932.

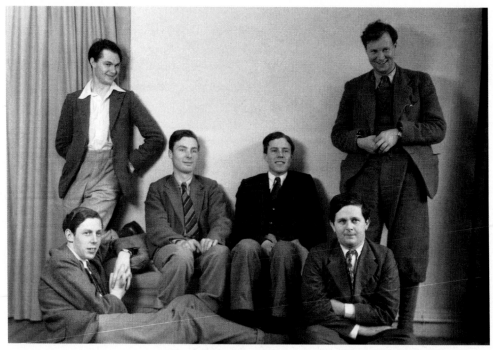

The Apostles Society, one of the best known secret societies in the world, in 1932, the year Burgess was elected, sponsored by Anthony Blunt, sitting bottom left. Blunt's lover Julian Bell stands right.

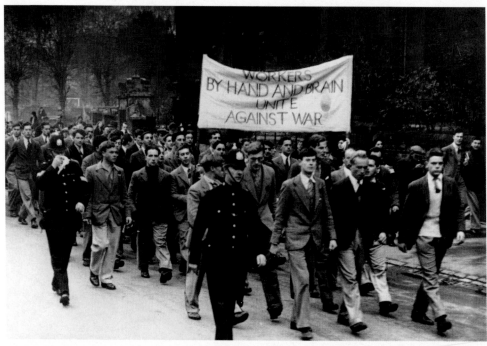

Cambridge Armistice Day March November 1933, supposedly Burgess's idea, with Donald Maclean second row under the flag.

The first of the Cambridge recruits, Harold 'Kim' Philby, and a fellow member with Burgess of the Trinity History Society, 1933, shortly before his recruitment as a Soviet agent.

The second of the Cambridge recruits, Donald Maclean, key ally of Kim Philby in the Cambridge University Socialist Society and sexual conquest of Guy Burgess.

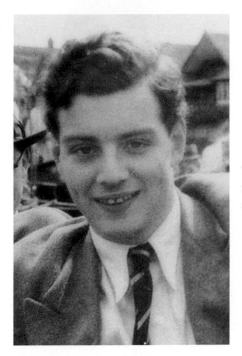

The third of the Cambridge recruits, Guy Burgess shortly after his recruitment.

Anthony Blunt on a steamship en-route
to the Soviet Union, summer 1935.

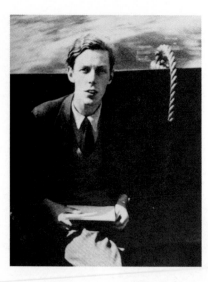

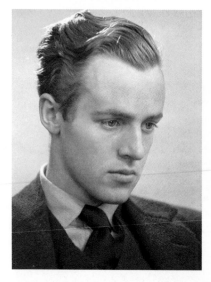

Michael Straight, Trinity undergraduate,
President-elect of the Cambridge Union
Society, who Burgess recruited with
Anthony Blunt's help.

John Cairncross, who passed top of his year
in the Civil Service exams in 1936, who
Burgess also recruited with Blunt's help.

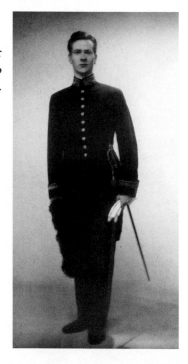

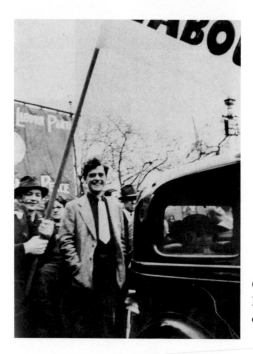

Goronwy Rees, another of Guy
Burgess's recruits, at a Hyde Park
demonstration 1935.

6

The Third Man

Returning to Cambridge for a fifth year, Burgess was back at M2 in Great Court, supposedly working on his thesis and supervising first-year students, but he was more involved than ever in political activities. The dispute with the Eastern Counties Omnibus Company, over union recognition and conditions, had come to a head in October 1934 and Burgess continued to be involved in organising early morning pickets of the bus garages and supporting the striking busmen. Such activity gave him a focus, when he had lost purpose in his professional life and lacked a feeling of belonging in his private one.

His relations with his family, never easy, were becoming steadily worse. He complained to Dadie Rylands in August 1934 that, rather than go on holiday with Victor Rothschild and a fellow Cambridge communist, Gerald Croasdell, he was having to stay at home 'with my family with whom I do not get on'.[1] Jack Bassett, an archetypical retired colonel, was an honourable man but rather old-fashioned, and the two men had little in common. There was a strong element of jealousy on Burgess's part towards this man who had taken the place of his father and he took every opportunity to annoy him, deliberately passing the port the wrong way and giving toasts to 'Uncle Joe'. 'The relationship with the stepfather was absolutely intolerable,' Nigel Burgess remembered. 'It was very bad indeed and very much encouraged by my mother – the friction – she enjoyed the friction between the two of them – Guy could do absolutely no harm in her eyes.'[2]

Eve indulged Burgess, who was her favourite, and he manipulated her shamelessly. His relationship with his younger brother was more distant and the two brothers saw little of each other. Though Nigel

had followed his brother from Lockers Park and Eton to read History at Trinity, they were very different. A talented musician, Nigel was a leading member of the Cambridge Footlights, writing the lyrics and music for many productions and acting as musical director for the 1933 and 1934 reviews. Kenneth Sinclair-Loutit remembered how he 'had a nice, easy manner with the piano and really had a tunesmith's talent'.[3]

'Guy was highly intelligent and I wasn't. I think this was one of the reasons why we were not close,' remembered Nigel. 'And he was very socially aware – which I wasn't. He would pick as friends useful people,' adding that despite 'great charm, wit and high intelligence . . . you never knew with Guy what was true and what was invented'.[4]

Kim Philby had spent the year since leaving Cambridge acting as a courier for the underground Austrian Communist Party, after an introduction from Maurice Dobb. There he had met and married a young communist divorcée, Litzi Friedmann. On his return from Vienna in May, he had tried to join the CPGB, but the party was still wary of middle-class members and told him it would take five weeks.[5]

At tea with a contact of Litzi's, Edith Tudor Hart, an Austrian communist who ran a successful photographic studio specialising in children's portraiture, Philby expressed his desire to continue his work for the party. Unknown to Philby, Tudor Hart worked as a courier and access agent for Soviet intelligence and reported back favourably.[6]

There would normally have been careful checks before a first covert approach to an agent, but Soviet intelligence in London was operating under a policy of making contacts with promising students that did not require approval from Moscow Centre. A meeting was arranged in Regent's Park the following month for Philby to meet Otto. In reality 'Otto' was Arnold Deutsch, a Soviet 'illegal' agent – he was not a member of the Soviet trade delegation or embassy – who had arrived in London in the spring of 1934, ostensibly to carry out research in psychology at University College, London.

A member of the Austrian Communist Party since 1924, Deutsch had graduated with a distinction from the University of Vienna four

years later with a doctorate in chemistry – though he had also studied physics, philosophy and psychology.

A handsome man, blue-eyed with fair curly hair, and a notable linguist – he spoke German, French, Italian, Dutch, Russian and English – Deutsch had subsequently worked as a clandestine part-time courier for the Comintern's 'International Liaison Department' in Romania, Greece, Syria and Palestine, before being recruited by the Foreign Section of the NKVD as an 'illegal' and working underground with the resistance in Vienna.[7]

Soviet intelligence had charged Deutsch with its new policy of targeting brilliant young students from Britain's leading universities, who might then move as sleepers into positions of power, and he did so spectacularly, recruiting some twenty agents between 1934 and 1937, most of whom remain unknown to this day.[8]

At that first meeting with Deutsch, in which the two men spoke German, Philby agreed to work for the Soviet Union. The recruitment, as with all the future recruitments, was a false-flag operation in which the recruits merely thought they were working for the international communist movement, though it must have been quickly clear to Philby that his work involved more than that. He was later to write, 'One does not look twice at an offer of enrolment in an elite force.' He was given the codename SÖHNCHEN and one of his first tasks was to report back on his father.[9]

He was told to have nothing to do with British Communist Party headquarters, which gave him quiet satisfaction given their reaction to his application, to publicly renounce his flirtation with communism, and to find a job that might prove useful. Given his political record, a career in government service was unlikely but, using his father's contacts, Philby managed to secure a job on a respectable small-circulation news journal, *The Review of Reviews*.

Deutsch then asked Philby to recommend some of his Cambridge contemporaries and some Oxford contacts who might be amenable to cultivation and, though members of a university cell, had not joined the CPGB.[10] Top of his Cambridge list was Donald Maclean, who had just graduated with a First in German and, having abandoned ideas of postgraduate study and going to teach in Russia, was studying for the Foreign Office. Almost six feet four, handsome,

clever, athletic – he had played rugby for his college and captained its cricket team – Maclean had been one of Philby's closest allies in CUSS.

At a further meeting with Philby in October, Maclean agreed to work for the Russians and shortly afterwards became an agent. Ignaty Reif, a Soviet illegal, codenamed MARR, reported, 'that SÖHNCHEN has contacted his friend [Maclean], the latter has agreed to work, wants to come into direct contact with us. MARR asks for consent.' Maclean, whose father had recently died, was given the codename WAISE, meaning orphan.[11]

Burgess was the last of the seven names on Philby's list of potential recruits. Reif reported back to Moscow Centre in October, 'Burgess is the son of very well-off parents. For two years he has been a party member, very clever and reliable (ideologically speaking), but in 'S's opinion somewhat superficial and can occasionally make a slip of the tongue.'[12]

According to his later KGB memoir, Philby had such strong reservations about the suitability of his friend that he had put a row of four question-marks after Burgess's name. 'While Burgess is, of course, a very ideologically strong man, his character is that of an "enfant terrible".'[13] But Guy Burgess's flamboyance was in many ways his greatest strength. His NKVD file reveals that as early as the summer of 1934, during his visit to Russia, a Soviet intelligence officer, Alexander Orlov, had considered him as a strong possible recruit. The Soviet intelligence service had discovered that the penalties for homosexuality in Britain meant that homosexuals had to live part of their lives in secret and formed a tight and loyal network, which if penetrated, could be very fruitful. It was felt that Burgess's knowledge of, and contacts within, the homosexual world could prove very useful, and this assessment was proved to be correct.[14]

Philby later wrote:

Burgess was a very special case . . . I was not so worried about discretion, since his sense of political discipline would probably look after that. His drawback was his unfailing capacity for making himself conspicuous . . . But we reckoned without Burgess himself. While we were talking, he was drawing conclusions and acting on them. He convinced himself that Maclean and I had not undergone a

sudden change of views, and that he was being excluded from something esoteric and exciting. So he started to badger us, and no one could badger more effectively than Burgess. He went for Maclean and he went for me . . . He might well be more dangerous outside than inside. So the decision was taken to recruit him. He must have been one of the very few people to have forced themselves into the Soviet special service.[15]

By revealing to Burgess, an inveterate gossip, that he was secretly working for Moscow, Maclean had made himself hostage to Burgess's discretion and created a potentially dangerous situation for the new network. The Russians had no choice but to recruit Burgess to keep him quiet. Late in December 1934, Maclean arranged for Deutsch to meet Burgess and sound him out. Burgess, who loved intrigue, couldn't have been more delighted by this new adventure and opportunity to serve the party, and said he was 'honoured and ready to sacrifice everything for the cause'. Guy Burgess was now officially the Third Man, after Philby and Maclean, and given the codename Madchen, meaning Girl.[16]

Burgess's recruitment had been made unilaterally by Deutsch and because of difficulties in communication, the Centre knew nothing until Deutsch's January 1935 report. They were, however, concerned that the three members of the Cambridge network knew each other – a serious breach of the rules of Konspiratsia that required agents to be compartmentalised from each other – and Orlov was ordered not to proceed with Burgess's recruitment.

Deutsch defended his decision, explaining that Burgess 'was recommended by SÖHNCHEN [Philby] and WAISE [Maclean], who describe him as a very talented and adventurous chap, capable of penetrating everywhere' and he himself vouched for his new probationary agent as 'a former compatriot of a Cambridge group [i.e. member of a university Communist Party cell], an extremely well-educated fellow, with valuable social connections, and the inclinations of an adventurer. Though I rate him lower than SÖHNCHEN and WAISE, I think he will come in useful.' Below, someone had handwritten: 'MADCHEN is a pederast but he works on both fronts.'[17]

The ban lifted on the cultivation of Burgess as a probationary agent, Deutsch began his training. He found Burgess an enthusiastic

recruit – and in a psychological profile written in 1939, Deutsch later concluded:

> Many features of his character can be explained by the fact that he is a homosexual. He became one at Eton, where he grew up in an atmosphere of cynicism, opulence, hypocrisy and superficiality. As he is very clever and well-educated, the Party was for him a saviour. It gave him above all an opportunity to satisfy his intellectual needs. Therefore he took up Party work with great enthusiasm. Part of his private life is led in a circle of homosexual friends whom he recruited among a wide variety of people, ranging from the famous liberal economist Keynes and extending to the very trash of society down to male prostitutes. His personal degradation, drunkenness, irregular way of life, and the feeling of being outside society, was connected with this kind of life, but on the other hand his abhorrence of bourgeois morality came from this. This kind of life did not satisfy him.[18]

The first assignment given to probationary agents was to supply a list of friends and contacts and Burgess responded enthusiastically, supplying over two hundred names in a four-page letter, ranging from Cambridge acquaintances such as G.M. Trevelyan, Dennis Robertson and John Maynard Keynes, and Foreign Office contacts such as Peter Hatton and Con O'Neil, to the Conservative MPs Harold Nicolson, Jack Macnamara and Angus Hambro, and various London prostitutes. There was also a separate list of homosexuals, which included Tom Wylie at the War Office, and Werner von Fries, an attaché at the German embassy.[19]

The Soviets immediately tried to exploit these connections, focusing on Dennis Proctor, a fellow left-wing member of the Apostles, who by 1935 was a private secretary to the Prime Minister, Stanley Baldwin. Soon, however, their attentions moved to someone they felt to be a more promising cultivation – Tom Wylie, private secretary to the Permanent Under-Secretary of War, Sir Herbert Creedy.

Wylie, a brilliant classicist, had been a King's Scholar at Westminster with Philby, before going on to Christ Church, Oxford. In 1934 he had joined the War Office and Philby had renewed contact, with the view of cultivating him as a useful source.

The following summer Wylie, now a resident clerk in the War Office, had given Philby a secret internal review of the British military

intelligence organisation prepared by the War Office, which revealed the names of officers assigned to intelligence duties. Philby then decided that, with his heavy drinking and homosexuality, Burgess might be a more suitable agent runner for Wylie. He later wrote how he had 'arranged a (small) cocktail party, inviting both Wylie and Burgess. I introduced them and left them to it, drifting from guest to guest as a good host should. Soon loud voices were raised in the Burgess-Wylie corner; all was clearly not well. I caught Burgess's eye and he bounced aggressively across the room. "Who," he asked loudly, "is that pretentious young idiot who thinks he knows all about Proust?"'[20]

Wylie was given the codename HEINRICH and then MAX and did supply Burgess with information, including the identity of the head of MI5 − as a result, the Russians put a tail on him and identified other senior MI5 officers − but his recruitment was halted when it was decided that he was too heavy a drinker and homosexual philanderer to make a trusted and effective Soviet agent. Wylie was soon after transferred to the Ministry of Works, due to his alcoholism, from which he died aged thirty-eight.

The NKVD files disclose that during his probationary period, the puritanical chiefs in the Lubyanka also had their own reservations about Burgess. Deutsch noted:

MADCHEN has imagination and is full of plans and initiative, but he has no internal brakes. He is, therefore, prone to panic easily and he is also prone to desperation. He takes up any task willingly, but he is too unstable to take it to its conclusion. His will is often paralysed by the most insignificant of difficulties. Sometimes he lies, not maliciously, but because of fear of admitting some minor error on his part. In relations with us he is honest and does everything without objections and sometimes produces an impression of a person who is too readily subdued. Though he dresses very scruffily, he still likes to attract attention. This is a generally characteristic feature of his. He craves to be liked and only reluctantly acknowledges his weaknesses.[21]

The Russians quickly realised that this craving for acceptance held part of the key to running their new agent.

7

London

Burgess returned to Cambridge for the Lent term 1935, and continued to play a full part in the Apostles. On 8 February he hosted a supper for the brethren and the following week he acted as a moderator in the discussion 'Anthony or Lenin', with Grey Walter, David Champernowne and Alister Watson supporting Lenin, Burgess supporting Anthony, and Victor Rothschild supporting both.

Burgess had now reinvented himself, not the first time he would do so in his life, resigning from the Communist Party, much to the bemusement of his friends, and disgust of his Cambridge communist contemporaries, who regarded him 'as a traitor, because he took care to advertise his alleged conversion to right-wing views as soon as he had gone down'.[1]

Burgess, now almost twenty-four, realised that his future lay outside academia, in spite of an attempt by G.M. Trevelyan to secure a Fellowship at Pembroke for him.[2] Too old to take the Foreign Office exams, he applied for a job teaching at Eton, but when the head-master wrote to Dennis Robertson for a reference, Burgess's former tutor supposedly replied, 'I would very much prefer not to answer your letter.'[3] There were also approaches to the Conservative Research Department run by Joseph Ball, a wartime MI5 officer, and through Victor Cazalet to Conservative Central Office, which ostensibly came to nothing in terms of a full-time job, but introduced Burgess to Ball – a man who was to play an important future role in his life.

By April, Burgess had abandoned Cambridge and his academic research and come to London, where he first took rooms at 21 Talbot Square, near Hyde Park, and then rented a flat at 38 Chester Square, near Victoria Station, financing himself through an allowance from the family trust and the odd payment from the Russians. For

example, in June 1935 he was paid £12 10s, compared to Maclean's £10 and Philby's £11, suggesting Burgess was regarded as a more valuable asset.[4] Burgess had been writing for *The Cambridge Review* since the beginning of 1933. Now, under the pseudonym Guy Francis, he was also reviewing a wide range of history books regularly for the *New Statesman*: on 8 June, *The Life and Letters of Admiral of the Fleet Lord Wester Wemyss*; on 22 June, *Japan and the Pacific, Militarism and Fascism in Japan* and *The Puppet State of Manchukuo*.

His flat was on the top floor of an elegant white stucco terrace, looking on to St Michael's Church, and consisted of two rooms, with a bath at the back of the kitchen. Burgess decorated it patriotic-ally in red, white and blue, though there is some debate about the exact combination. Goronwy Rees suggested white walls, blue curtains and a red carpet, blue sheets and a red counterpane – whereas another account describes it as 'painted white and Guy had a blue carpet, curtains white with blue backing, and a blue settee with red cushions', a decor, which he claimed, was 'the only one which any reasonable man could ever live with'.[5] Here he often spent weekends in bed – he claimed the carved wooden headpiece had once belonged to Stendhal – reading and living off red wine and a saucepan filled with porridge, kippers, bacon, garlic and onion. When asked, he would reply that all he needed to be content was wine, books and the *News of the World*.

His affair with Jackie Hunter continued and through him he met the actor and director Frith Banbury. 'I'd say I met Guy about seven or eight times in all over a span of eighteen months. When that relationship broke up and my friend decided to go straight and get married, Guy went out of his life and out of mine at the same time. I never saw him again. I have to say that I found Guy both charming and amusing and had he chosen to continue the acquaintance, which in those circumstances he did not, I'd have been glad to do so.'[6]

He was seeing old friends such as Kim Philby, now living with Litzi in Kilburn. Tim Milne, a Philby school friend, meeting Burgess for first time at the Philbys, remembered how, 'He made an imme-diate impact – as he did, I imagine, on everyone who met him. I once nourished a theory that Evelyn Waugh's Basil Seal was partly based on Guy, if one ignores Guy's homosexuality, but the dates

do not fit well. Kim and Lizzy's scuffy little dog was called Guy after him.'[7]

He was returning to Cambridge to see Rylands and Blunt, where on one trip in May he met the poet Louis MacNeice, who immediately wrote to Blunt, 'As for Guy B, he is quite the nicest of your pals by a long way.'[8] Burgess had also renewed his friendship with Goronwy Rees, who had resigned his All Souls Fellowship and was now an assistant editor on the *Spectator*, and lived only a few minutes' walk away in Ebury Street. At one of Rees's parties Sally Graves, the niece of the poet, met Burgess, who was showing off a pair of American trousers with a zip fly – a novelty in those days. She could not make out whether he was on the Left or on the Right, she told Rees. He replied that Burgess had described himself as a 'Conservative Marxist'.[9]

In June, the Russians had instructed Burgess to apply to London University's School of Slavonic Studies to study Russian and try to befriend fellow pupils, who might be MI6 officers, and also Elizabeth Hill, a relative of General Miller who led the anti-Bolshevik Russian General Military Union based in Paris, as 'MADCHEN sure knows how to make friends'.[10] Burgess went to the Institute of Slavonic Studies, asking them to recommend him a teacher, and by good fortune he was sent to Hill, who gave him one lesson privately.

Burgess soon built up a good relationship with her and learnt that the Institute did indeed teach a large number of MI6 officers, the school's director was a former MI6 officer who was planning to return to the Soviet Union, and his secretary was known to be a communist. Burgess was quickly showing that he could deliver useful intelligence.

Burgess, a regular visitor to the Rothschild home at Tring, had impressed Victor's Hungarian mother, Ruzsika, with his knowledge of current events and how they fitted into an historical framework. He had once told her that railways in a Latin-American republic were going to be nationalised and that the Rothschilds should sell. He was proved right when New Court, the family stockbrokers, had said no. A year earlier he had anticipated the rise in the value of armaments shares and suggested to Victor he should invest in Rolls-Royce, which he did with great success. Distrustful of the advice

she was receiving from her advisers, Lady Rothschild put Burgess on a retainer of £100 a month, a large sum if true, in return for a monthly report as an informal personal financial adviser.[11]

Victor's sister Miriam, however, claimed the monthly retainer owed more to her mother's kindness than Burgess's financial skills.

'I cannot tell you exactly how long my mother discussed finances with Burgess, but I would not think more than a few months. He never <u>acted</u> for my mother, he merely discussed the gold standard with her and gave her information about investment in Brazil. Burgess was not employed by my mother, she was a very generous person and <u>sympathised</u> with young men who found it difficult to make both ends meet and she, therefore, gave Burgess some help in this direction, as indeed she did to many other people.' She added, 'I never got the impression he was remotely interested in the gold standard, but [he] appreciated good cooking and had a weakness for claret!'[12]

This sort of allowance was quite unnecessary, as Burgess benefited from a trust fund and was not impoverished. According to a Cambridge contemporary, Michael Straight, there was perhaps rather more than met the eye about the arrangement:

My assumption became that it was the Rothschilds who launched G.B. on his career of espionage. They sent him into the Conservative Right to spy on the developing liaison with the Nazis, which was a matter of intense concern to the Zionists and to all Jews. The payment, nominally for financial advice, was of course for some very different services. G.B. proved to be very successful in his infiltration, and this was promptly used by the USSR. This tie between the Rothschilds and the Soviet intelligence service was, in my opinion, the skeleton in the closet which drove V.R. to fund Wright, in writing a book in which the role of the Rothschilds would be wholly excised.[13]

Burgess had also met Harold Nicolson, probably through his son Ben and mutual friends at Oxford, who was to prove an influential mentor and probably an occasional lover. Cherubic, urbane, slightly portly, and with a neat moustache and twinkling eyes, Harold Nicolson was an author and former diplomat who had just been elected as the National Labour MP for West Leicester. Though married to Vita Sackville-West, Nicolson was homosexual and was

immediately attracted to Burgess, who was the same age as his sons and with whom he shared similar interests.[14]

From the spring of 1936, Nicolson's diary is filled with references to lunches and dinners with Burgess, including with John Maynard Keynes on 17 March. There were even plans to appoint Burgess as Nicolson's private secretary. 'He will look up a few things for Daddy and get political experience in exchange – no money transactions,' wrote Ben Nicolson in his diary.[15]

It was either through Harold Nicolson or Joseph Ball that Burgess was introduced to Jack Macnamara, a former army officer, who had just been elected as the Conservative MP for Chelmsford in the November 1935 General Election. Macnamara, six years older than Burgess and gay, took him on as a mix of secretary, travelling companion and personal assistant, or as Rees put it, his 'duties combined those of giving political advice and assisting him to satisfy his emotional needs'.[16]

Macnamara had an intelligence background, having been arrested on charges of espionage by the French in Tunisia in 1926, before serving in India between 1927 and 1933 with the Royal Fusiliers, where his knowledge of Hindustani and Assamese proved useful. A man of strong pro-German views, on his return he had become secretary of the Anglo-German Club. He was also involved with the Anglo-German Fellowship, which had been formed in October 1935 and whose objectives were 'to promote good understanding between England and Germany and thus contribute to the maintenance of peace and the development of prosperity'.

The Anglo-German Fellowship was financed by a group of Conservative businessmen, who saw Germany as a bulwark against communism, and drew its membership from businesses such as Unilever and ICI, as well as large numbers of aristocrats and members of both Houses of Parliament. Though it claimed not to approve of National Socialism, its purpose was to exert German influence in Britain, which it did through lavish receptions at the German embassy and the Mayfair Hotel, and by September 1936 it had 347 members.[17]

Burgess brought Philby into the Fellowship, and he soon began to ghost speeches and articles for prominent members such as Lord Mount Temple and Lord Redesdale, and to edit the Fellowship's magazine.[18]

Burgess's association with Macnamara and the Anglo-German Fellowship, useful for gauging Germany's international intentions and disguising his communist past, in turn brought him into contact with Edouard Pfeiffer, secretary general of France's Radical Socialist Party and chef de cabinet to Edouard Daladier, subsequently French war minister from January 1936 to May 1940, and prime minister from April 1938 to March 1940.

Pfeiffer, a sado-masochist and leading member of the French scouting movement, in turn introduced Burgess not just to useful contacts in the world of European politics, but also to the homo-sexual delights of Paris and boy scout rallies in Cologne.[19] Burgess would regale friends with stories – some of them perhaps true – of ping-pong matches played in evening dress with a naked young man as the net, and orgies in Parisian brothels.[20]

Through Pfeiffer, Burgess began to contribute articles to a 'controlled' newspaper financed by Otto Abetz, a German later appointed as the Nazi's ambassador to Occupied France. It's been suggested that Burgess also contributed to a City newsletter produced by Rudolph Katz, who worked for the Rothschilds, but the timings are unclear.[21]

Goronwy Rees described him during this period as 'acting as a correspondent for various papers though what they were I did not discover. But his work took him abroad a good deal. He spoke vaguely of trips to Paris and, as always, he seemed to have plenty of money.'[22]

Paris was a centre for both Soviet intelligence and the Comintern, and it was at this time that Burgess met Willi Muenzenberg, the Comintern's leading propagandist in Western Europe. A short, squat man with a large forehead and deep-set eyes, he was to inspire the character of Bayer in Christopher Isherwood's novel of Berlin in the 1930s, *Mr Norris Changes Trains*. Born in Thuringia in 1898, he had been a newspaper proprietor and German Communist MP. Fleeing Germany, on the night of the Reichstag fire, he proceeded to organise the world crusade against fascism, using various popular front commit-tees from his new base in Paris.

One of Muenzenberg's aides was Otto Katz, who operated under the cover name André Simon. A talented writer – he had written a

book on the Reichstag fire, published by Gollancz – his job was to plant pro-communist stories in the press. Fluent in French, English, Russian and Czech, Katz was often in London, where his movements were closely monitored by MI5.[23] Within a year of leaving Cambridge, Burgess had therefore found himself in the twilight world of Comintern spies, agents of influence, and international diplomacy.

It was about this time, through Christopher Isherwood, that he met Gerald Hamilton, the Arthur Norris confidence-trickster figure in Isherwood's *Mr Norris Changes Trains*, a man sometimes regarded as 'the wickedest man in Europe'. Hamilton, who had met Isherwood while working for *The Times* in Germany, was working as a fixer for Katz, though it was never clear where his allegiances lay beyond his own immediate self-interest.

Incarcerated during the First World War for his pro-German and anti-British sentiments, Hamilton had also spent time in French and Italian prisons for swindling a Milanese jeweller out of a pearl necklace, and served sentences in Britain for, amongst other things, bankruptcy, gross indecency, and being a threat to national security.

At one time he had lived with the 'Great Beast', the occultist Aleister Crowley, the two men informing on each other – Crowley supplying information on communists, German nationalists and Nazis to British intelligence, whilst Hamilton reported on Crowley's activities to the Nazis. It was Hamilton who introduced Crowley to Burgess, who drew information from both of them.

Interviewed by MI5 in 1951, Hamilton would claim, though he could never be totally trusted, that he saw much of Burgess in the four years immediately before the Second World War, describing him as 'one of the most dirty and untidy people' he had ever met, with 'deplorable table manners'.[24]

Hamilton later wrote of one meeting with Burgess in Belgium at this time. 'Though dissipated, Burgess was never violent; he could drink the whole night through without becoming aggressive. I remember one Sunday morning he turned up, very early indeed, at the villa which I occupied at Ucce, looking, even for him, peculiarly grubby and dishevelled.' Hamilton understood he had just come from Mass, which surprised him, until Burgess made clear 'he was

referring not to Holy Mass but to Maas, a singularly louche night haunt, near the Gare du Nord in Brussels'.[25]

Burgess appeared to take on his new political colours with relish. As his friend Cyril Connolly noted, 'Still sneering at the bourgeois intellectual, he now vaunted the intensely modern realism of the Nazi leaders: his admiration for economic ruthlessness, and the short cut to power, had swung him to the opposite extreme.'[26]

Edward Playfair, a few years above Burgess at Eton and Cambridge, and now working in the Civil Service, wrote to Julian Bell on 15 November 1935:

> I met Guy Burgess for a couple of moments the other day; he has not got his job at the Conservative Central Office, but is eking out a livelihood by writing political reports about England for the Comite des Forges. He tells me that he still thinks that Marx is right, but that the only way that collectivism is likely to come to England is through the Conservative Party. He is a queer fish.[27]

Running into Goronwy Rees in the London Library at about the same time, Burgess explained to him that:

> The only people who really believed in holding India, and had the will to do so, were the Right of the Conservative party, led by Mr Churchill . . . Their only hope of success was in alliance with the extreme Right in Europe, as represented by the German National Socialists and the Italian Fascists, who had no objection to a strengthening of British rule in India, so long as they were given a free hand in Europe . . . It was as if Guy, like a deep-sea diver, had plunged into the great ocean of communist dialectics and come up with weapons which would enable him to demonstrate the precise opposite of what he had previously believed and now professed to deny.[28]

Though Burgess had now made a complete public volte-face renouncing his student communism, it deeply upset him. Blunt was later to write in his diary:

> The intellectual somersault that Guy had then to perform, his pretence of sympathy with Nazism and his joining the Anglo-German Fellowship, have been described, but it has not, I think, been brought out how much agony he went through in performing them. He would much rather have remained an open party member . . . But

his belief in the cause of communism was so complete that he accepted without question that he must obey the order . . .'[29]

Throughout 1935 Burgess had been exploring various job options and had secured a month's trial in January 1936 as a sub-editor on *The Times* – the standard method of entry in those days. A colleague, Oliver Woods, later remembered how 'he conscientiously travelled by tube from Victoria to Blackfriars station every afternoon to take his place at the very bottom of the subs' table. Burgess behaved impeccably for once, wearing a suit and staying sober, but . . . after four weeks in the frigid gloom of Printing House Square, he was told that *The Times* considered him unsuitable.'[30]

In the spring of 1936, Burgess made a trip to Germany, under the auspices of the Foreign Relations Council of the Church of England, ostensibly looking at the persecution of Jews in Germany. The trip was organised by John Sharp, the heir to a Dundee jute-mill fortune and newly appointed Archdeacon in South-Eastern Europe, who served on the Council and whom Burgess had met through Macnamara. Burgess and Sharp were accompanied by Macnamara, who had been taken up by Sharp as a child, and Tom Wylie.[31]

Burgess didn't hesitate to exploit the opportunities the trip presented, both for his own personal pleasure and his espionage career. Compromising photographs of the MP and the Archdeacon, with their arms around a succession of handsomely endowed speci-mens of Aryan manhood, were later delivered by Burgess to Deutsch. They are preserved to this day in the MADCHEN file in the Soviet intelligence service archives.[32]

8

The BBC

In November 1935, Oswald Guy, secretary of the Cambridge University Appointments Board, put forward three candidates for a vacancy as an assistant in the BBC Talks Department based in Bristol:

G.F. de M. BURGESS would appear to be much the likeliest of these three candidates. The College describes him as a man of first-rate ability, who might have been expected to be a strong candidate for a Trinity Fellowship but he decided against an academic career, being really more interested in current affairs than in learning. Burgess went through the communist phase, I think; I do not think he has any particular politics now, but I expect they are rather towards the left. He is a somewhat highly-strung fellow, too, but gets on uncommonly well with people . . . including a close friendship with an ex-miner here. He has done a good deal of journalistic work. Burgess is a man of considerable self-assurance and a fellow for whom it is easy to feel both admiration and liking.[1]

Burgess was immediately called for an interview and found himself up against fourteen others, including two other recent Cambridge graduates, Gilbert Harding and Philip Milner-Barry.[2]

The BBC selection panel met at the beginning of December and Burgess had the benefit of a letter of recommendation from a fellow Apostle, the Cambridge Regius Professor of History, G.M. Trevelyan.

I believe a young friend of mine, Guy Burgess, late a scholar of Trinity, is applying for a post in the BBC. He was in the running for a Fellowship in History, but decided (correctly I think) that his bent was for the great world – politics, journalism, etc. etc. – and not academic. He is a first-rate man, and I advise you if you can to try him. He has passed through the communist measles that so many of

67

our clever young men go through, and is well out of it. There is nothing second rate about him and I think he would prove a great addition to your staff.[3]

On 12 December Burgess was interviewed but, though only runner-up, he had clearly made a good impression, and later in the month he was asked if he wished to be considered as a Regional Talks Assistant in Manchester. On 17 January he was interviewed for the job in Manchester, the Northern Region Director minuting:

> At first he appeared anxious not to leave London for a period even of two years. After considering the matter, he began to take a different point of view. Both Mr Harding and I, however, eventually came to the conclusion that his personality was too metropolitan and insufficiently cosmopolitan, and his character not sufficiently formed for him to take over Talks in the Northern Region. On the other hand, we were impressed with his intelligence and alertness, and would record as our opinion that he would do valuable work on Talks or Feature Programmes at Head Office'.[4]

In July 1936 Burgess applied to the BBC for a second time, but claiming he didn't want to go to the regions, as he had an invalid mother. He was now invited by the BBC to join a 'reserve from which to fill certain future programme appointments. The reserve is to consist of twenty people and will start on October 1 next.' In his application he claimed, with characteristic embellishment, that his hobbies included 'motor cars and motor racing, rock climbing, the stock exchange (academically), and playing squash and association football' and that he spoke and wrote French 'both moderately to bad'.[5]

Burgess came armed with a host of references. His tutor at Cambridge, John Burnaby, later Regius Professor of Divinity at Cambridge, wrote:

> Guy Burgess is an exceptionally able young man, with perhaps the liveliest mind I have known in any of my pupils for five years . . . He is very good company, and I like him personally. But there is no doubt that he has the faults of a nervy and 'mercurial' temperament, and if by 'taking him without qualms' you mean taking him with complete confidence in his reliability – well, he is not that sort of

man. I do not mean that he is untrustworthy in the sense that you could not be sure of his doing what he was told. But if you take him, you will be getting quite first class and extremely fertile brains, and a most vigorous personality; and you will be taking risks. On the whole I think that if I were in your place, I should think it worthwhile to take them.[6]

Below, someone has added, 'I think we need not worry any more about this man.'

There were also references from Jack Macnamara and Dennis Proctor.[7] This time Burgess was in and at the top of the list. His various attempts to penetrate the Establishment had at last succeeded.

On 1 October 1936 he reported at 9.30 a.m. to Gerald Beadle, Director of Staff Training, at 4 Duchess Street in Central London, for the three months' training course learning basic studio and production skills. A portrait of Burgess appears in a memoir, *BBC*, by a fellow member of the training cohort, Paul Bloomfield, as de Montmorency: 'a comic character with an air of patronage towards his instructors and a habit, which even his superiors respected, of going to sleep during lectures', but whom occasionally, 'started out of his slumbers and asked an intelligent question' and 'at the end of the course is given a report so flattering that he blushed'.[8]

Burgess was indeed making good progress. His chief instructor's confidential report at the end of his three-month training period noted:

Probably has better brains than any other member of the present course. He is extremely well informed on all historical and political subjects. Can write a very good broadcast talk, topical talk or eyewitness account. His editorial ability has shown itself to be of a high order in the News Bulletins which he has framed for the school programmes. He seems to be well qualified for a talks assistant or news editor or sub-editor. Unfortunately his diction is bad and it is this defect alone which prevents us recommending him as an O.B. assistant. In addition, he could probably fill a good many positions in Public Relations and some in Programme Administration, but he would be more valuable to us in the long run if he were started as a programme assistant doing practical work on the floor of the studios'.[9]

At the beginning of January 1937, Burgess started as an assistant in the Talks Department, which was responsible for most of the factual programming on the BBC's only domestic radio station, the BBC National Programme. The Talks Department was run by Sir Richard Maconachie, a former member of the Indian Civil Service who had served as ambassador in Afghanistan in 1930, prior to joining the BBC in 1936.

Maconachie's deputy was George Barnes, whom Burgess already knew and with whom he had much in common. Barnes was only seven years older than Burgess, had been educated at Dartmouth and, like Burgess, had been forced to leave because of his poor eyesight. After taking a First in History at King's College, Cambridge, he had returned to teach at Dartmouth in 1927 just as Burgess was leaving. Prior to being recruited personally by Lord Reith to the BBC in 1935, he had spent five years as assistant secretary of Cambridge University Press, and it was during this period that he and Burgess had got to know each other.[10]

The real power, however, rested with the Talks Producers, who chose the speakers, arranged the voice tests, negotiated the contracts and edited their texts. For the next few months, Burgess worked on various miscellaneous talks and readings. One of his colleagues in Talks was Gorley Putt, whose abiding memory was of a 'cartoonist with dimples . . . a snob and slob'. He was not impressed with his colleague. 'It gave me no pleasure to show him the ropes in matters like rehearsals and advance programme notes for future issues of the *Radio Times*. It amazed me, much later in life, to learn that he had been irresistibly attractive to most people he met.'[11]

BBC producer Frank Gillard was more complimentary:

> Burgess was opinionated and conceited. But for a time he was regarded as the blue-eyed boy by some of the senior people in the department. He threw his weight around no end. I was in Bristol producing talks for the various networks and found him intolerable. But you have to recognise that he had a great deal of ability and a kind of charisma. Among the producers he stood out and he knew that. And he didn't hesitate to make use of it.[12]

At the end of March 1937 and his six-month probationary period, Burgess's appointment was confirmed at a salary of £300 per annum. 'An extremely able young man. Prolific as regards ideas and a quick learner,' said his report. 'While he has his own opinions, he is available to discipline and is extremely pleasant to work with. Strongly recommended for confirmation and for service in the Talks Department.'[13]

But relations with his superiors, who tended to operate on Civil Service lines, were never easy. On 21 June 1937 he requested a rise to take into account the fact that he was twenty-six and older than the others who had just completed training, and that 'at least one of my own contemporaries now in the Civil Service is already drawing more than £675 per annum', pointing out that he had been earning more than £300 from his freelance work before joining the BBC. The following day a memo records it had been agreed to raise his salary to £400: 'Mr Burgess is pulling his weight in the Department, and is by no means the least valuable member . . . and that he be given an undertaking that, provided his work continues to justify it, annual increments will bring it up to £600 by the time he is thirty.'[14]

To which Maconachie had added, 'Mr Burgess is a man of outstanding ability. He gained First Class Honours in History at Cambridge, and was Research Scholar and Research student at Trinity. He is working hard and well. I strongly support this recommendation which does not seem to me at all extravagant. The proposed increase in Mr Burgess's yearly salary after all amounts to less than the cost of three hour's broadcast talks.'[15] But a BBC memo dated 25 June argued this raise of salary was not justified, as he had accepted an offer of £260 and it had already been raised to £300 in April. 'We also graded him B1 – I think he is the youngest member of staff to have this grade, with the substantial corollary of £40 increment.'[16]

It was to be the beginning of long-running tensions on Burgess's BBC pay and entitlements. Burgess's disregard for conventional housekeeping was already apparent in his failure to produce a suitable staff security photograph, which had occasioned a stiff rebuke from the General Establishment Officer in July, after four reminders from the

Photograph Section had gone unheeded. Burgess responded indignantly that he had 'already supplied two which have been rejected'. It subsequently transpired these showed 'him sitting on the sands at Margate' and eventually a more suitable one was provided.[17]

The range of programmes he worked on varied enormously – four talks on 'Food and Exercise'; 'Your Handwriting and Your Character'; 'Tramping Through the White Sea'; a talk by Sir William Bragg on Science; 'Adventures in Afghanistan'; and a book programme with Desmond McCarthy – but Burgess made the job very much his own, subtly introducing subjects of personal interest, not least Russia, and bringing in several friends. In August 1937 a Midlands school teacher, J.E. Whittaker, spoke of his visits to Russia in 1930 and 1936, whilst in November he produced a talk on 'Soviet Russia is a New Civilization'.

In February, Burgess had commissioned Roger Fulford, a journalist he knew from his month on *The Times* and through Steven Runciman, for a talk on 'When George IV was Crowned', based on his book on the coronation of George IV, to go out on 3 April. He then invited him to write a series called 'They Came to England', on the experiences of travellers such as Erasmus and Caesar 'of first setting foot on this wretched island'.[18] John Betjeman, whom Burgess knew through Oxford friends, agreed to talk in a series on Eccentrics, Kim's father St John Philby spoke about Mecca and the Arabs, and Keynes's wife, the ballerina Luydia Lopokova, read some Russian short stories. Harold Nicolson was already a frequent broadcaster on the BBC, but now Burgess became his producer. Frequently the two would then dine afterwards, with all the high-level gossip dutifully relayed to Moscow.

Some requests initially came to nothing, such as an invitation to Christopher Isherwood for some short stories. 'I have seen a certain amount of Wyston, Wiston, Wistin A. [W.H. Auden] since I saw you & I must say became devoted at once', wrote Burgess to one friend.[19] Burgess had met Isherwood, a history scholar at Cambridge just ahead of him, through Rudolph Katz, a homosexual German Jewish communist, with whom Burgess had edited a financial magazine on behalf of the Rothschilds for a short period before joining the BBC, and whom Isherwood had known in Berlin at the beginning of the 1930s.[20]

It was his friend Anthony Blunt, however, who was to benefit most from his patronage, giving talks on the Winter Exhibition at the Royal Academy, the Sistine Chapel, Modern Art (with William Coldstream) and on the rescue of works of art from the Nazis. The talks did much to establish him as an authority on modern art and raise his public profile. Burgess was now to give his friend a new role.

9

Russian Recruiter

As a young don who mixed with bright left-wing students, Anthony Blunt was ideal for the role of talent spotter. Burgess recognised that, like him, Blunt was able to compartmentalise his life, there was the same desire to *épater le bourgeois* (shock the middle classes), the same dogmatism and stubbornness, the same desire to find a creed, the same feeling of being an outsider and desire to be part of an elite.[1]

Like Burgess, Blunt was drawn to a double life on many levels, ranging from the teachings of Bloomsbury to Apostolic bonds, and a sexuality that was not recognised by society. Their loyalties were not to the state, but to individuals. Forster's statement about how, if faced with a choice between betraying his country or his friends, he would opt for the former, resonated with both men. 'Love and loyalty to an individual can run counter to the claims of the state. When they do – down with the state, say I.'[2] It's a view best exemplified in a famous essay, 'The Cleric of Treason', by the critic and academic, George Steiner, who has argued, 'the homoerotic ethos may have persuaded men, such as Blunt and Burgess, that the official society around them, whatever prizes it might bestow on their talents, was in essence hostile and hypocritical. It was, consequently, ripe for just overthrow, and espionage was one of the necessary means to this end.'[3]

Blunt was not an obvious recruit – he called himself a paper Marxist – but Burgess could be very persuasive. Stuart Hampshire later thought, 'Anthony was bullied by Guy into some moral position. He was persuaded that it was his duty to back the communist side.'[4] A major factor in Blunt's decision to accept Burgess's approach was the Spanish Civil War, which had broken out in the summer of 1936. For many intellectuals, the generals' rebellion against the

democratically elected Spanish Popular Front government brought into sharp relief the choice between democracy or fascism. Whilst Western European governments refused to intervene, the Soviet Union sent aircraft, tanks and 3,000 'volunteers'. Blunt was to claim in his 1979 interview, 'I was persuaded by Guy Burgess that I could best serve the cause of anti-fascism by joining in his work for the Russians', because, 'the Communist Party and Russia constituted the only firm bulwark against fascism, since the Western democracies were taking an uncertain and compromising attitude towards Germany'.[5]

John Cornford had gone to Spain in August to fight for the Republic. At the end of December 1936, shortly after his twenty-first birthday, he had been killed by a sniper on a rocky ridge, whilst fighting on the Cordoba front. His sacrifice resonated with many of his contemporaries. It was an opportunity for Blunt, too, to become a man of action rather than just an observer. Shortly afterwards, Blunt was introduced to Deutsch, who impressed him, and he was given the codename TONY.[6]

Blunt's first recruit, working with Burgess, was a rich American who had been with Blunt on his 1935 Intourist trip to Russia and was a fellow Apostle. Michael Straight, who had come up to Trinity in 1934 from the LSE to study Economics, was a glamorous figure of the Cambridge Left and was president-elect of the Union for autumn 1937. Burgess had given the Soviet agent Theodore Mally the following assessment:

> He is the party's spokesman and also a first-class economist. He is an extremely devoted member of the party . . . Taking into account his family connections, future fortune and capabilities, one must suppose he has a great future, not in the field of politics but in the industrial and trading world.[7]

Straight knew both Burgess and Blunt well, not least through meetings of the Apostles. In June they had both been invited to his family home, Dartington Hall, in Devon, where Burgess had played cricket in the garden with Straight's seven-year-old brother Bill. In November 1936 James Klugman, as part of the softening-up recruitment policy, had arranged a dinner for Straight at which both Burgess and Blunt were present. Straight was so 'enthralled' and 'flattered' by the 'worldly

brilliance' of Burgess and Blunt that on returning to his rooms, at almost midnight, he wrote to his mother claiming he had 'learned to love the Communist students, even if I don't love Communism itself . . . The vision they held out was that the world was at the dawn of a New Age. The old age was dying – disintegrating economically and socially.'[8]

Clever, handsome, and an important contributor to revolutionary literature, Cornford made an easy martyr and rallying cry for the young recruiters. Burgess suggested that Cornford's memory was best served by Straight taking up his baton and working for the Comintern. Burgess reported to Moscow Centre that, through Blunt, he had informed Straight 'that it was necessary to use America and his family as a means to disappear. He could show how John C's death had crushed him, could spend the rest of the semester sitting alone in his room . . . behave like someone who has been physically crushed. With regard to politics, to go no further than to say "did any good come of John's death?"'[9] Straight agreed, pretending that Cornford's death had left him broken and disillusioned and, abandoning his chance of becoming president of the Union, he returned to the US seeking to penetrate a government agency. It was Burgess who came up with the codename NIGEL.[10]

The next recruit was John Cairncross, who had come up to Cambridge in 1934 to read Modern Languages at Trinity, after taking his first degree at the Sorbonne. He had passed top of his year in the Civil Service exams in 1936 and was working at the Foreign Office. Occasionally he ran into Burgess at parties and he soon noticed that he was being discreetly cultivated. 'I have no doubt, looking back, that the KGB had arranged to bring us together,' he later wrote. 'He moved in exalted circles, was well-informed, and expressed himself with ease and wit on a wide range of subjects. I must admit that I was somewhat flattered by his attention.'[11]

Burgess introduced him to his friend Harold Nicolson and to Wolfgang von Putlitz from the German embassy, and then arranged on the last Sunday in February 1937 for him to meet Louis MacNeice in Blunt's rooms at Trinity. Burgess and Cairncross returned together to London by train and continued their political discussions at further meetings. On 1 March Burgess reported to Moscow Centre:

Cairncross: He came yesterday evening and spent the whole evening with me. It seems to me that I managed to interest him in my person. That is already clear from our conversations. He promises to come again . . . I had long talks with him on French and English ideas, on French history etc. From discussing these questions we moved to politics (I pretended to be a supporter of Kautsky) [the German Social Democrat theorist], we spoke about revisionism, super-imperialism, conservatism and Marxism. I formed a few preliminary opinions about him. For what reasons did he join us? He was led by purely cultural considerations, in contrast to social and radical ones.[12]

When Cairncross mentioned he was going to Paris, Burgess said that he would be there at the same time and suggested they met at a homosexual café called *Le Select*. The choice surprised Cairncross, who had assumed Burgess was heterosexual after once calling unexpectedly at his flat to be greeted by a tousled Burgess, who 'apologised for having been so long. I was with a girl.' Cairncross failed to turn up at the café, but was shortly afterwards recruited, using James Klugman as a cut-out, and given the codename MOLIERE.[13]

The next recruit was Goronwy Rees. In November 1937, after reading his review in the *Spectator* of James Hanley's *Grey Children: A Study of Humbug and Misery in South Wales*, Burgess used the opportunity, one evening in Rees's flat over a bottle of whisky, to make an approach to Rees, telling him he thought he had 'the heart of the matter' in him. Rees remembered how his eyes were 'oddly empty and expressionless, he looked as if he were considering some immensely important decision, with a seriousness and gravity which were so unusual in him'. Burgess continued, 'I want to tell you that I am a Comintern agent and have been ever since I came down from Cambridge.'[14]

Rees, used to Burgess's fantasies, told him he didn't believe him. '"Why not?" he said again. "Why else do you think I've behaved as I have since I left Cambridge? Why should I have left Cambridge at all? Why should I have left the party and pretended to become a fascist?"'[15]

Burgess, fixing him with 'a long look, at once challenging and appraising, then said, "I want you to work with me, to help me",' and gave him the name of one other agent to prove his credentials – Anthony Blunt. '"But you must never speak to him about it," Guy

said . . . "I shouldn't really have mentioned his name to you. It's essential, in this kind of work, that as few people as possible should know who is involved. You must promise never to mention the subject to him." So I promised.'[16]

No further mention was made of Burgess's work or what Rees was expected to do, but he did recount at length his anguish at having to break with the Communist Party and his friends, of how he had wanted to continue working for a fellowship and:

> how much he envied those open communists who were not condemned to a life of concealment and subterfuge. His account of the sacrifice he had made for his convictions seemed to me both sincere and painful, and it also seemed to me that perhaps the strain of it might do much to explain the extraordinary aberrations and excesses of his private life.[17]

Rees immediately confided in his lover, the writer Rosamond Lehmann, who also knew Burgess, and sought her advice. 'Goronwy told me that Guy was a Comintern agent and that he had been asked to join him. I didn't think it was such a shocking announcement,' she later said. 'All the young men were going off to fight for the International Brigades in Spain and I thought that this was just Guy's way of helping . . . I asked Goronwy if he was going to help Guy. He just huffed and puffed.'[18]

In his account of his attempted recruitment, Rees leaves open about whether or not he accepted Burgess's approach. The Soviet intelligence archives help clarify this omission. Rather than being the passive recipient of an unexpected approach, Rees had expressed a desire to join the Communist Party and Burgess had made his recruitment pitch explaining how Rees could do more by remaining outside the party.[19]

The NKVD case officer in contact with Burgess reported to Centre that Burgess saw Rees as a key part of his Oxbridge recruitment strategy:

> The kind of work which he would do with great moral satisfaction and with absolute confidence in its success and effectiveness is the recruitment by us of young people graduating from Oxford and Cambridge Universities and preparing them to enter the civil service.

For this kind of work he has such assistants as TONY [Blunt] in Cambridge and GROSS [Rees] in Oxford. MADCHEN [Burgess] always returns to this idea at every meeting . . .[20]

In 1938 Rees was recruited 'to help the party', operating under a series of cover names FLEET, FLIT and GROSS. His knowledge of Oxford high table gossip, particularly from All Souls, where several Cabinet ministers were Fellows, was to prove invaluable. The Centre were also interested in one of his contacts, 'a woman who was connected by marriage to the Churchill family, lived during the Munich period in Prague, and was allegedly an intermediary between Churchill and Benes. Flit and [name omitted] were close friends of a friend of Benes.'[21]

There is continuing debate about the degree of Rees's involvement. The Soviet intelligence officer and historian, Oleg Tsarev, told Rees's daughter Jenny that GROSS never 'realised' himself in the role that Burgess singled out for him. 'We know he did not, because the talent-spotter was somebody else . . .' and suggested he 'could not be described as an "agent" – with his consent, he was a "source" and "operational contact" – although he knew what the cause was and he knew that any information he gave Guy would go to the Soviet Union.'[22]

Tsarev added, 'We don't actually know what happened between 1938 and 1939 because reports never reached Moscow. Rees may have told something to Burgess, he may have provided him with something more substantial, but there was a chance he would not report it to Moscow and if he did not report it, we don't know.'[23]

However he is designated, Rees proved to be an important informant for his friend. He was also to become his biggest threat.

IO

Jack and Peter

In the autumn of 1936, Burgess met a young man who was to be his on-and-off lover and general manservant for the next fourteen years. Jack Hewit had been born in Gateshead in 1917, the son of a tinsmith working for the Coke and Gas Company, making and repairing gas meters. His mother had committed suicide when he was twelve by swallowing aspirin in a park and he had come to London in 1932, working first as a page-boy and then a telephone operator at Ilchester Chambers, a hotel in St Petersburgh Place, Bayswater, before becoming a dancer. At five feet seven inches, however, he was too short to make a regular living as a chorus-line dancer and he had picked up only the odd job in provincial theatres.

Hewit later recollected:

> When I first saw him, although then I didn't know who he was, he was sitting in a car outside the stage door of the South London Palace, a rundown theatre in the Walworth Road in South London, where I was appearing in the chorus of a twice-nightly version of *No, No, Nanette.* I wondered what this very good-looking man was doing there. I thought maybe he's waiting for one of the girls in the show, so, being nosy, I waited inside the stage door to see who it was he was waiting for. I was very attracted. Then one of the boys came down from the dressing room and went out and straight into the car, which then drove off. The next day I asked Douglas, the boy who had gone off in the car, who the handsome stranger was. A friend from the BBC, he said. 'Keep your eyes off.' The man in the car was Guy.[1]

Shortly afterwards Hewit was in a pub popular with homosexuals, The Bunch of Grapes, in the Strand, but generally known as 'The

45' from its address, where he was picked up by a man who suggested Hewit accompany him to a party. The two men walked the few hundred yards to a side door in Whitehall:[2]

There were about twenty people, all men, plenty to drink, but nothing to eat, alas. Brian Howard and Anthony Blunt were there, though I didn't know them then. Suddenly I spotted the person who'd been waiting for Douglas. He came over while I was being cornered by a vast man called Rudolf Katz and said, 'Is this old bugger pestering you?' Katz moved off, I said I must go, and Guy said, 'I'll give you a lift, if you wait a minute' . . . we drove to Chester Square where Guy had a flat and that was the beginning of it . . . he drove me to a coffee stall on the Embankment, where I had a meat pie and a cup of tea, and then to Chester Square. He lived on the top floor of a tall house opposite St Marks. We went to bed together for the first time.

That was how I met Guy Burgess and that was the start of a relationship which was to last some fourteen years. I didn't move into Chester Square right away, I kept my room in Oxford Terrace, but I used to go to Chester Square every day. It got to be a sort of routine. I would tidy the place, see that his shirts had buttons on them, brush his clothes, which were always crumpled and covered in cigarette ash, and look after things generally. He was the untidiest man I have ever known . . . In the beginning, our relationship was more like manservant and master.[3]

In turn, Burgess, who called Hewit 'Mop', tried to interest him in literature, encouraging him to read Jane Austen and Mrs Gaskell, though attempts to politicise him came to nothing, with Hewit claiming he couldn't afford to be a socialist. With £700 a year from a Canadian trust fund, Burgess could afford to be generous and would buy Jackie clothes, including a suit from Hawes and Curtis.

Burgess had always had a thing for working-class men and Jackie remembered how 'He wore me like he wore a badge. I was Jackie Hewit from Gateshead-on-Tyne . . . but it didn't stop him taking me everywhere. One night he gave me an Old Etonian tie to wear, telling me to tell people I was at College . . . He assumed that no one you would meet would have been at College. We both went out with OE ties – of course, no one asked.'[4]

Though Hewit didn't move into Chester Square until 1937, he did all the domestic chores and cooking:

I was a keen cook. Guy liked kedgeree or shepherd's pie, nursery food. I'd make shepherd's pie, using smoked eel that Guy would get from Fortnum's. He had his own dish, which he'd make when he decided to have a day in bed. First he'd order a dozen bottles of red wine from the Victoria wine shop. He'd put a kipper or smoked haddock and baked beans with oatmeal or rice, all in the same pan, and cook it up. It smelt horrid, but he'd say, 'This is the sustenance I need for the day – go away!' Then he'd stay in bed with all the papers, his books and cigarettes and his pot of stuff, which had no name, drinking red wine all day.[5]

Hewit also had to organise him. 'He never opened letters. No bills, no bank letters. I always had to open them and tell him when they had to be paid. The letters at the flat were always bills – his own personal mail went to the [Reform] club. The telephone, gas, electricity – and Coutts – never opened. The phone was often cut off, if I didn't pay it. He was a great telephoner, he never stopped. We had a lovely number Regent 1530.'[6]

Though Burgess now had a regular partner, it did not curtail his sexual exploits and the men often fought. 'He was the most promiscuous person who ever lived. He slept with anything that was going and he used to say anyone will do, from seventeen to seventy-five.' Hewit added, 'He didn't have a type, but I suppose they had to be attractive and come from a working-class background . . . If anyone invented homosexuality, it was Guy Burgess.'[7]

Goronwy Rees was later to write:

Side by side with his political activities, Guy conducted a very active, very promiscuous and somewhat squalid sexual life. He was gross and even brutal in his treatment of his lovers, but his sexual behaviour also had a generous aspect. He was very attractive to his own sex and had none of the kind of inhibitions which were then common to young men of his age, class and education . . . In this he was unlike his friends at Cambridge, who were nearly all homosexual, but a good deal more timid than Guy, a good deal more frustrated, and a good deal less successful in their sexual adventures . . . At one time or another he went to bed with most of these friends, as he did with

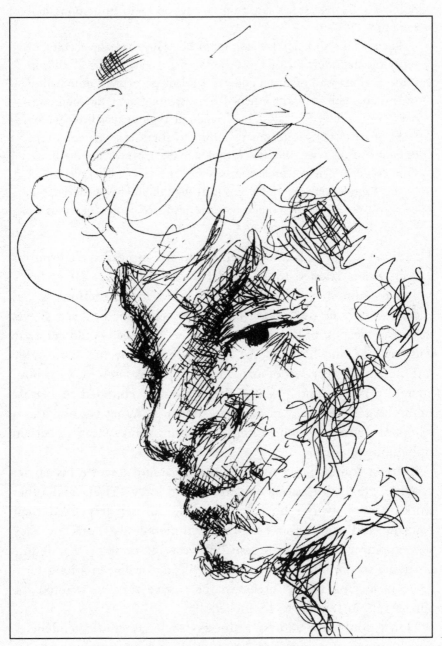

Burgess's cartoon of an unknown boy.

anyone who was willing and was not positively repulsive, and in doing so he released them from many of their frustrations and inhibitions.

Such affairs did not last for long; but Guy had the faculty of retaining the affection of those he went to bed with, and also, in some curious way, of maintaining a kind of permanent domination over them. This was strengthened because, long after the affair was over, he continued to assist his friends in their sexual lives, which were often troubled and unsatisfactory, to listen to their emotional difficulties and when necessary, find suitable partners for them . . . One could not help wondering whether the services he performed for his friends were genuinely given, as they themselves believed, out of altruism, or whether they were the result of some conscious or unconscious wish to dominate.[8]

There seemed to be another element to his success, apart from his boyish charm, attested to by two of his former lovers. James Lees-Milne recounted how Stuart Preston 'told me Guy Burgess was endowed with an asset which had to be seen to be believed. It was the secret weapon of his charm. Anyone so endowed could get away with murder, and he did. "Yes," I said, "but surely not with every sort of man." "Every sort of man," S said. "He was surely very grubby," I said. "Very," he said.'[9] Whilst Brian Howard confided to Harold Acton 'that his equipment was gargantuan – "What is known as a whopper, my dear" – which might account for his success in certain ambiguous quarters.'[10]

'Burgess found lovers in every social category,' wrote his Soviet handler. 'He had a strong preference for lorry drivers and other working men, whom he habitually paid for sex. He liked their company and would cross-examine them mercilessly about how they were coping with the Depression.'[11] What is interesting is that despite his desire to dominate and control in life, according to a long-term lover, in lovemaking he preferred the passive role, 'he wanted the female role in sex . . . to be fucked'.[12]

Hewit could not address Burgess's sado-masochistic tendencies, which were often indulged on trips abroad. In August 1937, for example, Burgess was amongst a group that included Brian Howard, who went to Salzburg, where the whole party dressed up in lederhosen

with 'Brian lashing Guy all the way down the table with purple-paragraph whips. Brian used Guy by alternately laughing with him and then lashing out to smash him. Sitting there at the head of the table, he was like the driver of a ten-mule team, his cracking whip lashing out all down the table, encouraging some, crushing others. To Guy, above all, Brian was unsparing, but Guy loved it . . .'[13] Burgess's promiscuous sex life, however, caught up with him. In January 1937 he had contracted a bad dose of syphilis and had to be hospitalised for a painful course of mercuric chemotherapy, regarded as the only effective treatment at the time.[14] The following year Burgess's doctor Pierre Lansel wrote a medical certificate to the BBC stating that 'Mr Guy Burgess has been to see me this afternoon and I suggest that he . . . have a holiday considering the state of his nerves.'[15] The background was that he had been arrested and charged with soliciting at Paddington Station. As members of his Chester Square coterie told each other, half amused and half fearful for themselves: 'Guy's met his Waterloo − at Paddington Station!'[16]

The plaintiff had claimed that a suggestive note had been pushed under the partition of the cubicle he was in. Burgess responded with his usual combination of panache and hauteur that he had been minding his own business reading George Eliot's *Middlemarch*, when someone had passed him an indecent note. All he had done was glance at it and send it back. He was cleared after an examination of the handwriting, but the episode had triggered a nervous breakdown, and it was felt prudent he leave the country. He spent the first part of his convalescence staying with Blunt at the Hotel Recamier in the Place St Sulpice in Paris, before he moved on later in the month with his mother and Blunt to the Miramar Hotel in Cannes.[17]

It was there that he met the seventeen-year-old Peter Pollock, whom Hewit was to describe as 'ravishing . . . the most beautiful boy I have ever seen'.[18] Pollock, the part-heir to an engineering company, Accles and Pollock, had just left public school and was staying with his widowed grandfather in the same hotel. 'He was blown away by me. So was Anthony,' remembered Pollock, 'but Guy got there first.' Burgess and Pollock immediately began a love affair,

even though the inexperienced Peter 'had not realised that this sort of thing went on after school'.[19]

It was to be the beginning of probably the most important of Burgess's many love affairs and Pollock would often stay at Chester Square. Pollock later admitted that he had not enjoyed sex with Burgess, but he 'adored all the people he could pour into my lap – all the people I'd read about – Ros Lehmann and E.M. Forster. And I was fascinated by his brain. He was the best conversationalist I ever knew, apart from Francis Bacon.'[20]

On 8 April Dr Lansel wrote again to the BBC, explaining that Burgess would not be returning from his convalescence in the south of France in the near future:

> Mr Guy Burgess's mother, Mrs Bassett, came to see me today on her return from the south of France, where she has been looking after her son. She informs me that he is better, but she did not think him well enough to return just yet. He is still in a very nervous state and suffering from insomnia.[21]

Burgess was, in fact, now back in Paris, where he was to remain until the end of April. On 9 April, on Hotel Ritz notepaper, he wrote to Rosamond Lehmann, who was in the city with her brother John, talking at a conference organised by the Société des Intellectuels Antifascistes. He was sleeping most of the day and deeply upset about the political situation, admitting to 'the most appalling political schizo-phrenia . . . I am spending half my time here and half with Eddy Pfeiffer (see enclosed cutting from Populaire, which I boastfully send all round) helping to form French Cabinet. I've known about Daladier for 1½ years – there may I think be trouble . . . I'll be back when I'm well. At the moment London and people seem impossible.'[22]

There was more to Burgess's extended sojourn in France than his nerves. On 11 March German troops had marched into Austria and two days later the country had been annexed. By taking himself off to Paris, Burgess had been able to obtain from Pfeiffer a detailed account of the French Cabinet's discussions and the positions taken by its various members with regard to action against the Anschluss – information he immediately passed back, not just to Moscow Centre, but also to his new employer – British intelligence.

11

British Agent

In October 1936 Donald Maclean had reported that an MI6 officer, David Footman, had come to see him, and Burgess was asked to befriend him through his literary activities. After some delays, on 25 May 1937, Burgess, having just read Footman's *Balkan Holiday*, wrote to him at his literary agents, Cristy & Moore, inviting him 'to give some travel talks of a rather personal nature, in the style of – though, of course, not out of – your book'.[1]

The two met at what is now the Langham Hotel, but was then an annexe of the BBC. Reporting to Moscow Centre afterwards, Burgess wrote:

> He's an intelligent, quiet man of the English type, but quick, smart and elegant . . . I learned something of his past. Approximately in 1920-24 he was a vice-consul in Egypt. Then he was doing the same job in Belgrade. Later he left the consular service and was a representative of a number of large companies in the Balkans. He was doing this for some years, and then again joined the Civil Service, where he is working now, that is in the Passport Control Office. We talked for a while about this organisation. The Passport Control Office, according to him, keeps watch over foreigners and complications in the passport service. I've checked that through another civil servant, Proctor. F[ootman] is always on his guard. But I think he liked me, and this is what I was after.[2]

Not content with his report, Burgess enclosed a pencil sketch and the MI6 officer's home address, written on the notepaper of a Mayfair car dealer, which remains in the Foreign Intelligence Service Archive to this day. Burgess was not yet fully trusted by Moscow Centre and another of their agents, Kitty Harris, was brought in to observe Burgess's meeting with Footman – the first serious operation by a

Soviet agent to penetrate MI6 – and corroborate his version of events, which it did.[3]

Several lunches followed and the two men became friends, with Footman giving several radio talks, beginning on 17 June with 'They Came to England'. Burgess now found himself 'off the books', working for Joseph Ball on behalf of the Prime Minister, Neville Chamberlain, but also for MI6 and the Foreign Office, who wanted to know what Chamberlain and his merry men were doing behind their backs.

Ball had served as an officer in MI5 from 1915 to 1926, before joining Conservative Central Office where, though ostensibly the party's research director, he had a shadowy intelligence and propaganda role. He was close to Chamberlain – they went fishing together – and had his own direct lines with the Italian ambassador in London, Count Grandi, through the Anglo-German Fellowship. He was the point man for Burgess in his new role as a secret courier between No. 10 Downing Street and the French government, via Edouard Pfeiffer.

Chamberlain thought his Permanent Under-Secretary at the Foreign Office, Sir Robert Vansittart, was a hard-line anti-fascist and preferred to bypass him in favour of his foreign affairs adviser, Sir Horace Wilson, as they secretly tried to appease Hitler. But 'neither the principals nor Pfeiffer and his opposite number knew that, on the way, Guy would call at a flat in the St Ermin's Hotel in Westminster and meet there a man who took photostatic pictures of the letters while he waited'.[4] That man was Burgess's MI6 contact, David Footman, who then passed the exchanges to Vansittart. The secret exchanges were also going to Burgess's Russian masters, concerned about any appeasement that might allow Hitler to turn his full energies on them.

Burgess was to be of service to David Footman again only weeks later in May 1938, when he learnt from Jack Hewit, then working as a switchboard operator at the Goring Hotel, that Konrad Henlein, the Nazi leader of the Sudeten Germans, was staying at the Goring Hotel for discussions with the British government about Hitler's claims to northern Czechoslovakia. Jack Hewit later wrote:

I happened to mention this to Guy, because Henlein had been having rather strange telephone calls from quite a lot of well-known people, who wanted to see him but would not come to the hotel. For instance, Randolph Churchill made an appointment to meet him in a taxi outside the Victoria Palace. Brendan Bracken made an appointment to see him in a remote riverside pub. When I told Guy about these appointments, he was very interested. He made a telephone call to someone and made an appointment with the person he had called to meet us for a drink. We went to a pub behind St James's Park station, near Broadway, and we met the man who was introduced to me as David . . . I worked from 8 a.m. to midnight for the next three days and logged all the numbers called by Henlein . . . Guy was very pleased, which pleased me. The following week, he handed me an envelope containing four five-pound notes and a slip of paper on which was written 'Thanks'. My first payment for 'Services Rendered'.[5]

British monitoring of Henlein continued. On 13 May Nicolson threw a tea party for Henlein at 4 King's Bench Walk – ostensibly at the behest of Vansittart, but possibly also that of Guy – with various MPs, including Jack Macnamara. Henlein repeated his desire for greater autonomy from Czechoslovakia and in turn received assurances that Britain would not interfere by supporting Czechoslovakia – information of great interest to the Russians.[6] That month Burgess learnt through Footman that there 'was a job' in the Passport Control Office and was introduced, at a lunch at the RAC club, to Commodore E.P.G. Norman, the former MI6 head of station in Prague, one of the key centres of British intelligence operations against the Soviet Union. 'During the lunch it emerged that Norman was sizing up Burgess for a mission to Italy. His task would be to discover what Mussolini's attitude to Spain would be, now that Franco's forces appeared to be winning the Spanish Civil War.'[7]

Burgess suggested he ask Victor Rothschild to give him a cover job working for the Italian branch of the family bank in Rome, which appealed to Norman, who revealed that Rothschild was already working on a secret scientific project for the War Office in Cambridge. Footman told Burgess he had made a good impression, but his cover as a banker might not be convincing, and Burgess then suggested he

pretend to be an academic. Adopting, he told his Soviet control officer, a 'casual matter-of-fact manner', he then confessed to Footman that he had been a communist at university.

Far from putting Norman off, he felt it offered other possibilities and he promised to arrange a meeting with the head of the MI6 counter-intelligence section. Shortly afterwards, Burgess was introduced to Major Valentine Vivian, the chief of Section V, who impressed him with his greater knowledge of Marxist theory and Comintern politics. 'It was unpleasant for me,' Burgess reported back embarrassingly to his Soviet masters, 'that, with the exception of the account of the Seventh Comintern Congress, I had read very little about the current trends in Marxist theory since 1934, when I left the Party.'[8]

Burgess was now tasked by MI6 with improving his knowledge of Marxist theory and then cultivating people such as the publisher Victor Gollancz, who were considered 'very important and very dangerous'. Vivian told Burgess that 'both in Oxford and Cambridge there is a secret party membership that has to be uncovered' and 'in the BBC there was an underground communist organisation' and instructed, 'You will have to find out who its members are.' Burgess relished the irony of the situation, especially when he was told he should penetrate the party and arrange to obtain a Communist Party post in Moscow connected with cultural affairs.[9]

'Does F[ootman] suspect me? I think he doesn't,' Burgess asked rhetorically. 'Why? Class blinkers – Eton, my family, an intellectual. I must stress that I have always told you: "Avoid people like me. We are suspect for historical reasons." Now I say, "Only people like me are beyond suspicion." '[10]

Though Burgess now found himself as a British intelligence operative, he was still not entirely trusted by Moscow. With all the 'Great Illegals' liquidated, imprisoned in the gulags or in hiding, there was no one to approve Burgess's coup, which Centre thought too risky for the mercurial Burgess and a distraction from the main target of penetrating British intelligence. Burgess dutifully complied, explaining that he had excused himself with MI6 arguing that the communists would distrust him too much, given he had 'very successfully in the last five years built up a reputation for myself as a drunk, trouble-maker, an intellectual and a fascist renegade.'[11]

Burgess now presented another idea to his Russian controllers, ostensibly from Vivian, that he approach the Russian embassy in London seeking help from Ambassador Maisky in writing a book on Russian terrorism. 'Then I could go to Moscow, if the British wish and the Russians invite me, to go on with my work.'[12]

Moscow had the measure of their man, as Deutsch's psychological profile of Burgess in his file demonstrates:

> At first he dissipated his activity, often acting on his own initiative without asking us, and because he was inexperienced he made mistakes. We tried to slow him down and therefore it seemed to him that he was doing very little. If he does something wrong in his work for us, he will come and tell us everything. There was such a case. Until November 1935 I was on holiday in the USSR. He has a very good friend, an American comrade [unidentified], who at that time came to London for his holiday and he [Burgess] told him that he was doing special work. When MADCHEN met me he told me about that and was in very low spirits, because he was tortured by remorse for what he had done. First he tried to explain what he did by the despair that he experienced because of the lack of contact with us. But later he acknowledged that he had done it because of his desire to boast.

Deutsch concluded with the observation:

> MADCHEN is a hypochondriac individual and always thinks that we do not trust him completely. That can be accounted for by a principal feature in his make-up — internal instability. It should be stated that in the time he has been working for us he has improved immensely in this regard. He has repeatedly tried to persuade me that we are his saviours. Hence his alertness and fear of making a mistake that could bring his dismissal from our work. I demonstrated my trust to him by the fact that I do not consider him a stranger, but our comrade.[13]

12

Meeting Churchill

Burgess's career was going from strength to strength at the BBC. In his end of year report, Maconachie provides a snap shot of the young producer:

> Brilliantly able, widely read and with a keen sense of humour, he's delightful company. Has produced some admirable programmes and is always likely to do so when really interested. Seems to be rather lacking in self-confidence when faced with an awkward situation, and owing to natural impatience with routine is inclined to make slips in matters of detail. He realises this and has improved a great deal in this direction recently. Is keen on his work and with more experience will be of even more value than he is now.[1]

Against the backdrop of the increasing international crises, Burgess was now pressing the BBC to have a diplomatic correspondent with close access to the Foreign Office and with a room in Broadcasting House, security cleared, which could receive diplomatic telegrams. Though Burgess modestly put himself forward, nothing came of the idea. He now proposed to influence events using his mentor Harold Nicolson.[2]

Harold Nicolson was a regular contributor to *The Past Week*, in which the speaker would deal discursively with events over the previous week. He was due to broadcast on 5 September and proposed to discuss the Sudeten crisis – the previous day President Benes of Czechoslovakia had accepted the demands for autonomy by the country's German minority. George Barnes felt Nicolson's script, which advocated standing by Czechoslovakia to the point of going to war, and not giving in to Hitler's demands, a policy which would have suited the Russians, should be first approved by the head of

the Foreign Office's News Department, Rex Leeper. Concerned that the talk might appear provocative at a delicate moment in international relations, Leeper showed it to Sir Alexander Cadogan, recently appointed Permanent Under-Secretary at the Foreign Office, who recommended that the talk not be broadcast. Eventually a compromise was found by Nicolson agreeing to modify the talk, with Barnes ready to cut him off if he strayed across the agreed line.[3]

On 19 September, at the height of the Czech Crisis, Nicolson confided to his diary, 'I am met by Guy Burgess and deliver my talk in a voice of ironic gloom. I then go to the Café Royal with Guy, where we meet James Pope-Hennessy, who is almost in tears over England's shame.'[4] Burgess's own views on the need to stand up to Hitler were clear, informed, and influential on his mentor. He knew from his own clandestine trips between Paris and London that the British government would continue to appease Hitler and had no intention of coming to the aid of Czechoslovakia. This had been confirmed by John Cairncross, reinforcing Soviet suspicions that Britain and France would do a deal to leave Germany free to attack Russia.[5]

Only public opinion might change the government's mind and Burgess had a potent weapon at his disposal – his influential current affairs programme, *The Past Week*. A few days after Nicolson had been muzzled, Burgess wrote to him:

> from now onwards, since parliament has stopped sitting, the only talks we are having on world affairs are, in fact, yours, and I am thus able to encourage you to do (what I know you would like to do) – to discuss rather seriously and for most of the talk the various political events of the past week – i.e. to do exactly what you did in your talk about Czechoslovakia ten days ago. I hope we may meet on Monday. Incidentally, you may remember what you said to me about Hitler making a great peace speech? From one or two comments that I have heard, this does seem portentously likely, even going to the extent of coupling it with demands for a conference of the allied powers (? excluding Russia) to make a new settlement to take the place of the Treaty of Versailles for the whole of Southern and Eastern Europe, as well as the colonies.[6]

The likelihood of war grew more likely as Hitler demanded an immediate occupation by Germany of the German areas of

Czechoslovakia. In London, trenches were prepared in parks and gas masks issued. The Soviet Union confirmed its mutual assistance treaty with Czechoslovakia, which mobilised on 23 September, followed by a partial mobilisation by France the next day. On the 26th, Britain warned Germany that if she invaded Czechoslovakia, then Britain and France would go to her assistance, and the next day the British fleet was mobilised. The world held its breath as Chamberlain flew to meet Hitler in Munich. Two days later he returned, having secured 'Peace in our Time'.[7]

Though Burgess had not originally commissioned it, he had become involved in one of the most ambitious series put out by the BBC at the time. *The Mediterranean* was to be a multi-part series on the historical importance of the Mediterranean, broadcast on Thursday evenings from 8.30 to 9 p.m. between October and December, 'chosen to illustrate the chronic danger of fascist aggression that formed the real background of the wars in Abyssinia and Spain'.[8] It was to be anchored by the academic E.H. Carr, with other influential contributors such as Hugh Seton-Watson on the Adriatic, Arnold Toynbee on Turkey, and Sir Ronald Storrs. The series was to be introduced by Winston Churchill on 6 October. In the light of the mounting crisis, Churchill asked to cancel his talk. Burgess, who had met him socially at dinner with Venetia Montagu, telephoned him to try and persuade him to change his mind, and Churchill invited him to come and discuss it.[9]

On Saturday 1 October, Burgess drove down to Churchill's country home, Chartwell, twenty miles south of London, in his open-top Ford V8. Burgess's account of his meeting with Churchill was one he told often and differently – to his biographer, Tom Driberg, he claimed to have been met by the statesman in the garden with a trowel, whilst in an earlier recorded version, he simply stated the butler had taken him to Churchill's study. Churchill showed Burgess a letter from Benes asking for his advice and assistance. 'What advice can I return?' he asked Burgess rhetorically, to which the young man, then still in his twenties, replied, 'Offer him your eloquence. Stump the country. Make speeches. Awaken people to the issues at stake.'[10]

Energised, Churchill then told Burgess he wanted to give him a book 'to celebrate this conversation, which has sustained me'.[11] It

was a collection of his recent speeches, *Arms and the Covenant: While England Slept*. In the flyleaf he wrote: 'To Guy Burgess from Winston S. Churchill to confirm his admirable sentiments. September 1938', adding that if war broke out and Guy brought him the book, he would remember the conversation and find a job for him.[12]

The meeting was to be a high point of Burgess's life. The two men talked alone for hours, united by their common opposition to the policy of appeasement; and Burgess felt he had been taken seriously by a politician he respected. That evening, on Ascot Hill notepaper, Burgess wrote to Churchill with his own analysis of the situation:

Dear Mr Churchill,

I've put the broadcast position officially on another sheet. I cannot help writing more personally to thank you for the way you received me today and for your book and the inscription. The one unfortunately is already historic for the world, the other will be for me. I feel I must in the situation we now find ourselves, and since I myself try to feel as a historian (I was a scholar at Cambridge, where I taught for a while), put what I feel on paper to you who listened so sympathetically this morning and on whom, as I see it, so much now depends . . . Traditional English policy since the reign of Elizabeth, the policy of Marlborough, of Pitt, of Eyre Crowe, of Vansittart, has been blindly set aside to suit the vanity, the obstinacy, and the ignorance of one man, no longer young. We shall be told he has saved the peace, that anything is worth it. This is not true. He has made war inevitable and lost it . . .

Reviewing Hitler's rise to power, Burgess continued:

He has tried Force once – and it failed. The Hitler-Ludendorff putsch. He has never forgotten the broken shoulder & the fear of that fiasco. Hitler uses force only against fear, he has been right in that till now, for the odds were against him. Soon they may be against us. That is the simple truth of this crisis – he took what he thought he could get . . . What is to be done? . . . you alone have the force and authority to galvanise the potential allies into action . . . The guarantee of the new Czech Frontier must be made absolute & gun tight . . . the French must reaffirm the Franco-Soviet pact & Russia must be induced to do this by the promise of consultations with us . . . I'm sure you will not have read as far as this – if you have and would

be prepared to meet again I wish you'd get your secretary to drop me a line. I'm in the London telephone book – or at the BBC. With all wishes for your success. Yours very gratefully, Guy Burgess.[13]

Back at the BBC on Tuesday, Burgess reported to Barnes in an internal memo:

Mr Churchill complained that he had been very badly treated in the matter of political broadcasts and that he was always muzzled by the BBC . . . He went on to say that he imagined that he would be even more muzzled in the future, since the work at the BBC seemed to have passed under the control of the Government. I said that this was not, in fact, the case, though just at the moment we were, as a matter of courtesy, allowing the Foreign Office to see scripts on political subjects.

Burgess had scrawled below, 'The point is W.S.C. seems very anxious to talk.'[14] On 23 November Harold Nicolson recorded in his diary:

I go to the Reform to have a talk with Guy Burgess, who is in a state about the BBC. He tells me that a technical talk by Admiral Richmond about our strategic position in the Mediterranean (which had been definitely announced) was cancelled as a result of a telephone message from Horace Wilson to the Director-General. This has incensed him, and he wants to resign and publish why. I urge him to do nothing of the sort.[15]

This was the second time within a month that the BBC had tried to thwart him. Increasingly frustrated by government interference and censorship, Burgess handed in his resignation, which Maconachie was not unhappy to receive: '. . . he is capable of excellent work, but his successes are spasmodic, and, as he admits himself, he is very unmethodical and forgetful. I recommend that his resignation be accepted, and understand that in his case only a month's notice is required.'[16]

But Burgess's move was not simply pique and on a point of principle. His BBC personnel file on 11 January reported his last day of BBC service: 'Resigned. To undertake MI activities for the War Office.'[17]

Burgess had finally secured himself a full-time job in British intelligence, the first of the Cambridge Spies to do so.

13

Section D

After Hitler's annexation of Austria, several overlapping irregular and clandestine organisations had been set up. One of them was Section D of SIS, created in April 1938 'to provide lines of communication for covert anti-Nazi propaganda in neutral countries and to direct and harness the efforts of the various anti-Nazi organisations then working in Europe'.[1] Its role was to organise and equip resistance units, support anti-Nazi groups, sabotage, covert operations, and subversive propaganda. Indeed, it had already 'organised secret propaganda during the Munich crisis'.[2]

Through David Footman, Burgess had obtained an introduction to its head, Major Laurence Grand. A Cambridge graduate, Grand was then thirty-nine, a Royal Engineers officer who had experience in irregular warfare in Russia, Iraq, Kurdistan and India. A tall, handsome man with a heavy dark moustache, always with a red carnation in his well-tailored suits, and a chain smoker, he was a man full of ideas and he quickly came up with plans for subversive operations, ranging from sabotage and labour unrest to propaganda.

Burgess had a vague brief over the next two years, which included acting as liaison between Section D, the Ministry of Information, and a 'black ops' propaganda organisation based at Electra House on the Thames embankment. It meant Burgess was, in his own words, 'buzzing about doing a lot of things' without anyone being sure who had authorised his schemes or what he was doing. It also meant he had access to highly confidential information about the preparations for war.[3]

His main focus, where his skills as a talks producer came in most useful, was the Joint Broadcasting Committee, set up a few months earlier by the Foreign Office, which recognised that a counteroffensive was

needed against Hitler. As broadcasting directly into Germany was forbidden by the 1936 International Broadcasting Convention, a secret broadcasting organisation was required.[4]

MI6, working with Joseph Ball and Gerald Wellesley, later 7th Duke of Wellington, had already engineered the transmission of Chamberlain's speeches on the Munich crisis over Radio Luxembourg. Broadcasting mainly popular music, this commercial operation was one of Europe's most popular stations, and the British government had paid for the air time through the secret agency of the Travel and Industrial Association of Great Britain and the Hendon Travel Bureau. Now the operation was expanded, with a brief to spread positive information about Britain, its way of life and values.[5]

The JBC was very much a BBC operation. It was run by Hilda Matheson, who had been in MI5 during the First World War and was the BBC's director of Talks and News between 1926 and 1932 – and incidentally was a former lover of Harold Nicolson's wife – assisted by Isa Morley, the foreign director of the BBC from 1933 to 1937. Burgess was number three and represented Section D's interests. In March 1939 Harold Nicolson joined the Board. The JBC's overt programmes were sent free to neutral and friendly countries in the languages of those countries by telephone, on disc, or sometimes the scripts were sent to be produced locally. A strong focus was securing British propaganda broadcasts on the American networks.[6]

The covert side, where Burgess largely worked, produced programmes for distribution in enemy countries, working with Electra House. Burgess was responsible for a variety of programmes that were recorded on large shellac discs and then smuggled in the diplomatic bag or by agents into Sweden, Liechtenstein and Germany, and broadcast as if they were part of regular transmissions from the German stations themselves.

One of Burgess's jobs was producing anti-Hitler propaganda broadcasts, using clandestine transmitters from radio stations in Luxembourg and Liechtenstein, which were then beamed into Germany. The work was similar to his work in the Talks Department – preparing scripts and producing the recordings, giving a picture of life in Britain. JBC staff were authorised to use BBC studios and the recording facilities of commercial firms such as J. Walter Thompson. They also

had mobile recording units, which could be contained in a couple of suitcases and moved by car.

Though scripts were prepared by JBC staff, many were read by prominent exiles such as the writer Thomas Mann, or later by well-known actors such as Conrad Veidt, shortly to star in the film *Casablanca*. Amongst those Burgess persuaded to broadcast was J.D. Bernal on 'The British Contribution to Science' and President Benes, now an exile in Britain, who recorded a talk on 19 September 1939.[7] Thanks to his international contacts, gained ironically through his work for the Comintern, Burgess quickly found sites for transmitters, and the radio stations began broadcasting in the spring of 1939.

Among his colleagues was the writer Elspeth Huxley, whose abiding memory 'is of Guy Burgess going downstairs to lunch about 12.30 and staggering back quite drunk and reeking of brandy at about 3.30 or 4 p.m.'[8] Another colleague was Moura Budberg, until MI5, who had kept her under surveillance since the 1920s, asked for her to be moved elsewhere. Budberg had an exotic past. She had been the lover of the former Russian prime minister Alexander Kerensky, Maxim Gorky and H.G. Wells, imprisoned in the Lubyanka during the First World War accused of spying for the British, and was probably correctly suspected of having being a Russian agent. She was to become a close friend of Burgess.[9]

Few of the JBC records have been released, but tantalising glimpses of Burgess's work can be gleaned from Harold Nicolson's diary. On 5 May he recorded that Burgess 'wants us to get Geneva to broadcast foreign news from the L[eague] of N[ations] station regularly each hour'. On 13 June, 'He tells me dreadful stories about his childhood and in the interval, we discuss foreign broadcasts.' On 26 July, 'Guy Burgess comes to see me. He is organising his wireless very well.'[10]

Section D used a series of front organisations, such as the news agency United Correspondents, which produced innocuous but anti-Nazi articles for circulation to newspapers around the world, and Burgess worked with writers such as the Swiss journalist Eugen Lennhof and the Austrian writer Berthe Zuckerkandl-Szeps.[11]

As war grew more likely, new organisations were created and Burgess was now transferred from Grand's budget to the Ministry of Information and appointed as the JBC Liaison Officer with the

Ministry of Information, which had taken on many of the responsibilities for wartime propaganda.[12]

In March 1939 Britain and France had agreed to guarantee Poland's sovereignty and two weeks later the Soviet foreign minister had proposed a triple alliance against a German attack. Throughout the summer, British and French diplomats had been trying to agree terms with the Soviet Union. Burgess proved invaluable to the Russians, reporting to Moscow that the British Government remained distrustful of the Soviet Union and was continuing to talk to Germany.

In July, Burgess had contacted John Cairncross, who had moved from the Foreign Office to the Treasury, saying that he was working for a secret British agency and was in touch with some anti-Nazi German generals linked with an underground broadcasting network. He needed information for them on British intentions towards Poland, but for various bureaucratic and personal reasons was unable to obtain it from the Foreign Office. Could Cairncross perhaps talk to some of his former colleagues, by giving them lunch, and he offered him £20 for his expenses. Cairncross duly obtained the information and wrote up some notes adding 'a personal description of my "sources" designed to enable the recipient of my notes to make some kind of assessment of their reliability'. He also signed a receipt for the expenses, as Burgess thought he might be able to claim the monies from his employers. It was to prove a fateful mistake for him.[13]

On 3 August 1939, Burgess reported to the Russians that the British chiefs of staff felt that 'a war between Britain and Germany can easily be won' and that therefore the government did not need to conclude a defensive pact with the Soviet Union. Such inside information only reinforced Stalin's suspicion that the British and French governments were not seriously interested in a treaty and Russian interests might best be served by a pact with Germany.[14] Two days later, Burgess had dinner with Major Grand, who had that day met members of the military mission to Russia to discuss some sort of Anglo-Soviet agreement to guarantee Poland's sovereignty, and was shocked by Grand's response that 'they had no power to reach agreement, and indeed their instructions were to prolong the negotiations without reaching agreement'.[15]

Three weeks later, Burgess wrote that, 'In Government departments and talks with those who saw the documents about the negotiations, the opinion is that we have never intended to conclude a serious military pact . . . with the Russians.'[16] The consequences were momentous. On 23 August the Soviet Union and Germany signed a ten-year non-aggression pact, which included a secret protocol to divide Poland and the Baltic states between them. It was a seismic moment for British communists, who had placed their faith in the Soviet Union to stand up to Hitler, and undermined all they had been fighting against over the previous six years.

Burgess and Blunt were on a month's holiday and in the south of France, en route to Italy, when news of the non-aggression pact broke. Burgess, according to Blunt, 'got a telegram ordering him back to London from "D", the organisation within MI6 for which he was working', and immediately drove back from Antibes, left his treasured car at a Channel port to be shipped back later, and caught the night boat back.[17]

Anthony Blunt remembered:

> During the day [Burgess] produced half-a-dozen justifications for [the Russo-German pact] of which the principal argument was the one which eventually turned out to be correct, namely that it was only a tactical manoeuvre to allow the Russians time to rearm, before the eventual and inevitable German attack. He also used an argument which he had frequently brought up during the previous months, that the British negotiations which had been going on for an Anglo-Russian pact were a bluff . . . Whether this was true or not I had and have no means of knowing, but Guy certainly believed it at the time – and no doubt passed on his opinion to his Russian contact.[18]

According to one of the Russian handlers:

> The Group organised a meeting in London, with Philby present. They analysed the pact with precision, considering its articles one by one and gauging its probable consequences. The discussion was calm but uncompromising. After several hours of argument they concluded that the pact was no more than an episode in the march of revolution; that in the circumstances it might easily be justified; and that in any event it did not constitute sufficient pretext for a break with the Soviet Union.[19]

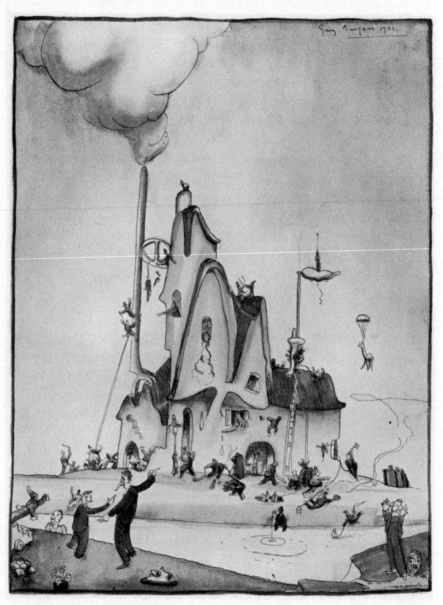

Burgess's cartoon from the Eton ephemeral magazine 'Motley', 10 July 1931

The next day Burgess appeared at Goronwy Rees's flat in Ebury Street. 'He was in a state of considerable excitement and exhaustion; but I thought I also noticed something about him which I had never seen before. He was frightened', Rees later wrote. Burgess appeared accepting of the volte-face, claiming 'that after Munich, the Soviet Union was perfectly justified in putting its own security first and indeed that if they had not done so they would have betrayed the interests of the working class, both in the Soviet Union and throughout the world', but Rees noticed he was strained and apprehensive.[20]

Burgess asked him what he wanted to do and Rees replied, "'I never want to have anything to do with the Comintern for the rest of my life. Or with you, if you really are one of their agents."

"The best thing to do would be to forget the whole thing," he said. "And never mention it again . . . as if it had never happened."

"I'll never mention it," I said. "I want to forget about it."

"That's splendid," he said with obvious relief. "It's exactly what I feel. Now let's go and have a drink."'[21]

Burgess, in order to ensure Rees wouldn't betray him and Blunt, pretended to his friend that he, too, had become disillusioned by the Nazi-Soviet Pact and given up his illegal work for the Communist Party. Rees seemed to be reassured, but he was to prove to be a ticking bomb.

14

'Rather Confidential Work'

The Imperial Calendar and Civil List for 1940 shows G. Burgess as a specialist in the Ministry of Information's Foreign Division Directorate, working in the Broadcasting section. He was based on two floors of the Institute of Education, beside the Senate House, and reported first to E.H. Carr and then to Ivone Kirkpatrick, as part of the Foreign Publicity Division. One of his responsibilities, together with a colleague, Peter Smollett, was an overseas propaganda radio bulletin to be produced alongside the BBC's overseas press bulletin. 'Roughly the first quarter of the bulletin will be a survey of the German radio . . . The remaining three-quarters will be a survey of neutral opinion, with particular reference to political questions of the day and to the American broadcasts from Germany.'[1]

Division A, in which Burgess worked, dealt with neutral countries, but also had a Russian section in which Smollett, whose real name was Smolka, was attached. Smollett had been born in 1912 in Vienna, into a wealthy Jewish family who had made their money from manufacturing an early ski binding. A friend of Litzi Friedman, he had arrived in London in 1933 as the representative of the paper *Neue Frei Presse*, and in the autumn of 1934 had briefly been involved with Kim Philby in setting up a small press agency, London Continental News.

He had made his reputation in the summer of 1936 with a series of travel articles in *The Times*, which he turned into a book, *Forty Thousand against the Artic: Russia's Artic Empire*. Two years later he had become a naturalised British subject under the name Harry Peter Smollett. Philby had recruited Smollett at the end of 1939 – his NKVD cover name was ABO – but had lost touch with him while he was in France, resuming contact only upon his return

in 1940. Burgess now worked with him as an agent of influence, to help shape public opinion in favour of the Soviet Union.[2]

Another colleague at the Ministry of Information, whom Burgess cultivated, was the Princess Dilkusha de Rohan, who headed the Swiss desk. This was an influential job, given Switzerland's neutrality and the ability of its papers to reach readers in Germany, France, Italy and the Balkans. She herself had an excellent network of European contacts, including Georges Scapini, the Vichy 'ambassador' to Berlin.

Born Alis Wrench in India in 1899, she had gained her title through marriage to an Austro-Hungarian aristocrat, Carlos de Rohan. After he was killed in a motor accident in 1931, she had moved from Berlin, first to Paris and then London. Here she had set up as a dress designer, 'Dilkusha de Rohan Ready-To-Wear-de-Luxe', at 4 Savile Row, with Nancy Mitford as a director. Dil Rohan lived with her new lover, Mary Oliver, and the art collector Douglas Cooper in a wing of Pembroke Lodge, a fifty-two-roomed Georgian mansion in Richmond Park, another part of which was used as the mess for the 'Phantom' reconnaissance unit, and here Burgess would often go for parties with Anthony Blunt and Moura Budberg.

Burgess's principal role was liaison between the Ministry of Information, now based in Senate House in Central London, and the Joint Broadcasting Committee, which was now operating from two locations in Sussex: Renby Grange, the farmhouse home of Roger Eckersley, and Rook's Farm, Hilda Matheson's cottage. The latter was in the grounds of Penns in the Rocks, her lover Dorothy Wellesley's estate near Tunbridge Wells, originally the home of William Penn, the founder of Pennsylvania. Peter Eckersley's son, Miles, remembers seeing Burgess there and being told he was making programmes for South America.[3]

He seems also to have been the liaison with the BBC, because in May 1940 J.M. Rose-Troup from the BBC had complained to SOE about his unreliability. Burgess was hurt by the accusation and took it up with Maconachie, claiming his unpopularity with the BBC was 'through attacking departments from the Ministry of Information'.[4] It's likely, too, he continued to liaise with the black ops organisation Electra House, which received 'a great deal of intelligence from secret, diplomatic, military and service sources',[5]

and continued to have a roving commission for Section D, including acting, under the name Mr Francis, in an MI6 plan to enlist Labour Party support for fomenting a Swedish miners' strike, to deprive Germany of coal supplies.[6]

By the beginning of 1940, the JBC employed about forty people including seven agents abroad, and was sending regular programmes, ranging from a history of the Irish Guards to a dramatisation of one of Somerset Maugham's Ashenden spy stories, to more than a dozen countries from Bulgaria in Eastern Europe to Uruguay in South America.[7]

In March 1940 Burgess took Rosamond Lehmann, one of the few contemporary English writers well-known in France, to Paris, ostensibly to broadcast on behalf of JBC from a radio station in Paris. When she arrived, she found the staff at the radio station had no idea who she was or why she was there, and Burgess turned up only briefly, muttered a quick apology and disappeared. She spent most of her stay in the cellars of the Hotel Crillon awaiting an air raid, before returning home. It looked as if Burgess had simply used his friend as cover to meet some of his old contacts, most probably Pfeiffer and members of the Communist Underground.[8]

In mid-May 1940 Burgess moved from liaising with the Ministry of Information to work full-time for Grand at a salary of £600 p.a. His new title from 15 June was Temporary Civil Servant, Civilian Assistant, War Office, MI6.[9] He was now based on the fifth and sixth floors of 2 Caxton Street, just around the corner from SIS head-quarter at Broadway Buildings. It meant he was back at the heart of Section D, which had grown enormously since the outbreak of war and not only had access to highly secret exfiles but was also able to discover 'the names of the agents who were sent abroad and establishing contacts with the officers of SIS and MI5'.[10]

Burgess now lobbied for a job in Section D for his old Cambridge friend Kim Philby, just back from France, where he had been a *Times* correspondent attached to the British Army HQ. Burgess tipped off a colleague, Leslie Sheridan, a former night editor of the *Daily Mirror*, who ran a section known as D/Q responsible for black propaganda. The intelligence services were needing to recruit quickly and Philby, as a journalist with foreign experience and good German, fitted the

bill admirably. As one of the senior SIS officers, Valentine Vivian, had known Philby's father, only perfunctory checks were made. Nothing Recorded Against was the laconic response from MI5. Moscow Centre, six months after the declaration of war, now had two of its agents in a branch of British intelligence.[11]

One of the ironies is that just as Burgess and Philby were in key positions to reveal the inner workings of government, the London *rezidentura* – the base for Soviet spy operations – closed. After the purges in Russia, which had claimed the life of one resident Adolph Chapsky (alias second secretary 'Anton Shuster') and sent his successor Grigori Grafpen (alias Attaché 'Gregory Blank') to a labour camp, there were few people who knew much about the agent network. Following the trials of the Percy Glading spy ring, Arnold Deutsch had returned to Moscow. The only remaining officer was Anatoli Gorsky, who was poorly briefed about the Cambridge Ring, and who had only taken over from Leonard Eitingon in running Burgess in March 1939.

Moscow Centre remained distrustful of their star agents, worried they might be *agents provocateurs*, whilst Litzi Philby (MARY) and Edith Tudor Hart (EDITH), who were used by Burgess and the others to make contact with the NKVD in the period immediately before the war, complained that their expenses were not being paid. In February 1940 the London residency was temporarily shut down and Gorski recalled to Moscow. The Cambridge Ring were left to fend for themselves.

One reason was the defection of a high-ranking Soviet military intelligence officer, Walter Krivitsky, shortly before the outbreak of war, bringing details of Soviet intelligence's Western European network, including the London *rezidentura*, and several spies within the Foreign Office. John King, a cipher clerk in the Communications Department, was quickly arrested, but Krivitsky remained vague about the other spy, suggesting he was an aristocrat, a young man, probably under thirty, who had been educated at Eton and Oxford and was 'the secretary or son of one of the chiefs of the Foreign Office'. To the good fortune of Donald Maclean and John Cairncross, there were countless young men in the Foreign Office at the time who fitted that description more closely than them.[12]

★

The reasons behind Burgess's attempted trip to Moscow in the summer of 1940 have generated all sorts of theories. His role, according to his own later account, was an extension of his Section D brief to organise underground resistance. His idea was to persuade the Russians to provide arms and supplies to non-communist guerrillas in Eastern Europe, whilst in return the British would assist communist-led units in Western Europe. Burgess wanted to put the idea to the Russians and help co-ordinate it. However, according to one Russian source, it wasn't Burgess's idea but that of Valentine Vivian in SIS, who thought it might be useful to have Burgess work under diplomatic cover at the British embassy. In fact, far from being his idea, Burgess was not keen, saying he preferred to go abroad only on short holidays and to warmer climates such as Tangier and Spain.[13]

Whatever the truth, Burgess left at the beginning of July for Vladivostok, via America, accompanied by Isaiah Berlin, now a member of Section D. Burgess appears to have lobbied Gladwyn Jebb at the Foreign Office for Berlin, who spoke Russian, to be appointed a press attaché at the British embassy in Moscow and Burgess had wangled to join him, travelling as a diplomatic courier.

At Foreign Office expense in first-class cabins, the two men crossed the Atlantic on the SS *Antonia*, crowded with child evacuees. After a nerve-racking journey, with escort destroyers, they arrived in Quebec on 20 July. They caught a train to Montreal and then flew to New York, where they remained for two days, before going on to Washington. There they stayed with John Foster, legal adviser at the British embassy, and met the journalist Joseph Alsop, who took an immediate dislike to Burgess 'because he wasn't wearing socks'.[14]

Burgess arranged to see his old Cambridge friend Michael Straight, perhaps the primary purpose of his trip. After regaling him with such diverse topics as how 'he and Pfeiffer and two members of the French Cabinet . . . had spent an evening together at a male brothel in Paris, dancing "around a table, lashing a naked boy, who was strapped to it, with leather whips"', and in the same breath reminiscing about the Apostles, Burgess came to the point telling Straight 'I am completely out of touch with my friends. Could you put me in touch', and that Straight needed to get back into the State

Department to monitor Krivitsky, who continued to reveal further details of the Russian espionage network in Europe.[15]

On 27 July, Fitzroy Maclean, Burgess's schoolboy rival, now a junior diplomat, cabled Lord Lothian, the British ambassador, that 'it is not desired that either Berlin or Burgess should proceed to Moscow. Burgess should return to the United Kingdom immediately. Berlin, who is not in the employ of His Majesty's Government, must do what he thinks best.'[16]

According to Miriam Rothschild, then living in Washington, the trip was stopped by Foster, who 'considered Burgess a totally undesirable and untrustworthy character but did not suspect him as a spy'.[17] Burgess returned by air on 30 July and Nicolson noted in his diary after dining with him at the Wyndham Club, 'He is just back from America. He is still determined to get in touch with the Comintern and use them to create disorders in occupied territory.'[18]

Burgess's responsibilities in Section D for 1939 and 1940 remain unclear. There were sightings of him by Kenneth Younger, dealing with regional security in Kent. He later claimed he organised 'underground resistance to Hitler through the international trade union movement' recruiting 'the famous seamen's leader, Edo Fimmen, for this work' and gave 'valuable help in organising the transport of anti-Nazi agents and refugees'. Fimmen had played a key role in organising international courier services for the Comintern and Soviet military intelligence.[19] Now, possibly through Burgess's intervention, he found himself working for the British as well.[20]

One of Burgess's responsibilities was running the training section DU in Section D, which Philby later wrote he turned into 'a sort of ideas factory. He regarded himself as a wheel, throwing off ideas like sparks as it revolved. Where the sparks fell he did not seem to care.'[21] Another colleague in Section D, Bickham Sweet-Escott, remembered him at various inter-departmental meetings on propaganda in the summer of 1940 at Caxton Street chaired by Grand, with representatives from the Joint Broadcasting Committee and Ministry of Information, but with no agenda and minutes, and thought he might be working for Electra House. At one meeting he 'nearly convinced the meeting that the way to end the war was

to wait for a westerly wind and then send large numbers of balloons in the direction of central Europe, hoping that incendiary bombs attached to them would set the cornfields of the Hungarian *puszta* on fire and starve the Germans out'.[22]

The previous year he had, however, come up with another idea which was taken up – a school for training agents and saboteurs, which he jokingly christened Guy Fawkes College. Brickendonbury Manor, a seventeenth-century mansion and former school, some twenty miles north of London, had been requisitioned by the War Office in late 1939. 'The object of the school was to train men of different nationalities as instructors and recruiters, who would be equipped and returned to their own countries, in order to raise organisations to counter enemy interests and commit specific acts of sabotage. In addition, the establishment acted as a general-purpose school and undertook the special operational training of raiding parties.'[23]

He brought in Philby, who had been a *Times* correspondent in the Spanish Civil War and then with the British Expaditionary force, and together they produced a series of memos on the components of the course, which was to include organisation of subversive cells, the art of spreading rumour and propaganda, the use of arms and explosives, wireless telegraphy, security, and counter-espionage.

The commandant of the school was a highly-decorated Naval commander, Frederick Peters, who had known Burgess's father, and Philby remembered how 'He often took Guy and me to dinner at the Hungaria, to listen to our views on the new project . . . Against all the odds, he took a great and immediate fancy to Guy, who ruthlessly swiped the cigarettes off his desk.'[24] Peters was supported by an adjutant, Major J. Barcroft, and four teaching staff: Burgess, Philby, George Hill – a veteran SIS officer, who had worked in Russia during the First World War and had just returned from France, where he had been supplying the Belgian resistance with explosives and detonators – and E.J. Paterson, an academic in adult education, who had somehow become an expert on codes, ciphers and secret inks.[25]

Burgess had also brought in a friend, Tomas 'Tommy' Harris, and his wife Hilda, as housekeepers. Harris was a painter and dealer specialising in Spanish art and, through his sister Enriqueta, who

taught at the Courtauld Institute of Art, was a friend of Anthony Blunt. He had worked for Burgess in Section D – one of his duties had included escorting Benes – and now he also had a role in looking after the welfare of the agents at the camp.[26]

There were about twenty-five students at Brickendonbury including 'Norwegian seamen and Breton onion-sellers, fishermen and ex-servicemen from several European countries, a Belgian cavalry officer, and at least one intellectual.'[27] These men were to be sent into Occupied Europe against the Germans and set Europe ablaze. With Philby and Burgess as instructors, details of all of them were probably passed back to their Russian masters and henceforth possibly to her ally Germany.

What actually happened at Brickendonbury was vague. 'Perhaps they picked up some useful tips at Brickendonbury, but I doubt it', Philby later wrote. 'We had no idea what tasks they were supposed to perform, and neither Guy nor I had any success in digging the necessary information out of London headquarters. Otherwise, we had little to do, except talk to the Commander and help him draft memoranda for headquarters, which seldom vouchsafed a reply.'[28]

It was something that R.T.B. Cowan, teaching volunteers at Brickendonbury ways of disrupting telecommunications, noticed, '. . . of all the "instructors", the strangest were Kim Philby and Guy Burgess. What they did I don't know, but it was probably instruction in political incitement. Philby seemed to be quite respectable, but Burgess was of scruffy appearance and rather fond of the bottle.'[29]

For security reasons the instructors did not use their real names, so Peters was Thornley, Hill was Dale, and Burgess, for some reason, simply D/U. Philby should have been D/UI, but as Philby later noted, 'Guy explained, with heavy delicacy, that the symbol DUI might have implied some subordination of myself to him; he wanted us to be regarded as equals. He solved the dilemma by giving me a third letter instead of a final numeral, and he chose the letter D. Thus he launched me on my secret service career branded with the symbol DUD.'[30]

The first of the six-week courses ran from 29 August to 12 October. Burgess was the school's political adviser and lectured on how to collaborate with subversive parties and militant trade unions,

though his style wasn't always to the tastes of his senior officer. 'To the distress of the Commandant, who had the traditional naval officer's horror of the very idea of mutiny anywhere, he showed the students the Soviet film of the revolt of the cruiser *Potemkin*.'[31]

Within the first few weeks Burgess was in trouble, when a corporal complained that he had been 'trying to muck about with him'.[32] The corporal was transferred to another unit and, shortly afterwards, Burgess himself was transferred. Perhaps this was as a result of the corporal incident, or some disciplinary trouble in the French section, where 'a member of the staff was removed' and 'The Commandant made a specific request for a better type of man to carry out the underground political warfare.'[33]

Philby recounts in his memoirs how, after reports came in of German parachutists in the area, a machine gun had been set up in the French window. Peters instructed Burgess to ascertain the exact facts of the case, and then to telephone the result to the duty officer in London. 'Guy went about the business with a wicked conscientiousness. I heard snatches of his subsequent telephone report. "No, I cannot add to what I have said . . .You wouldn't want me to falsify evidence, would you? Shall I repeat? . . . Parachutes have been seen dropping in the neighbourhood of Hertford in numbers varying from eighty to none . . ."' The alarm went up the chain of command through Eastern Command to the War Office, with troops roused from their beds. Burgess was gleeful at the upset he had created. In reality, a single land mine attached to a parachute had fallen and draped itself harmlessly round a tree.[34]

J. McCaffery, then serving at Brickendonbury, remembered a match between staff and trainees, where he was:

Confronted with one of the most polished pairs of full-backs I had ever played against. On and off the field, these two men were complementary, because they were so different. One very controlled, clear-headed, elegant, the other aggressive, almost wild in a cheerful sort of way, the sort who could not drive a car without flattening the accelerator onto the floor. I realise how ridiculous this is, but to this day it is their brilliant football which for me makes their treason seem so hard to accept. Their names were Kim Philby and Guy Burgess.[35]

In September 1940 Burgess was charged at Marlborough Street Magistrates Court, in his absence, with driving a War Office car under the influence of drink. Driving a friend home from Grand's flat, he had been stopped and arrested because of his condition. The charge was dismissed on payment of costs, after the defence solicitor said, 'I do not want to introduce too much hush-hush, but the accused is doing rather confidential work, which necessitates travelling to a station thirty miles out of London. He has been working fourteen hours a day and he had just been in an air-raid.'[36] Burgess was ordered to pay five guineas costs. 'Judging by the rank of your chief,' said the magistrate, 'he is an older man than you; and it was very wrong of him to send a young man out with a car, having given him more drink than was advisable.'[37]

When Rees met him the following year, Guy admitted the drunken driving, '. . . as to the War Office, he fell impressively silent and said he could tell me nothing, because matters of the highest security were involved. Somehow I began to feel that the war and Guy were on a converging course, towards a point at which the distinction between fantasy and reality totally disappeared.'[38]

Following the surrender of France and the Netherlands in the summer of 1940, there was a growing recognition that a larger single organisation was needed to take the fight into Occupied Europe, reporting directly to a Cabinet minister. As a result, the Special Operations Executive was formed in July 1940, under Hugh Dalton, the Minister of Economic Warfare, and the decision taken to fold Section D into the new organisation.

Shortly afterwards, Grand was dismissed, Philby was moved to Beaulieu, SOE's 'Finishing School' in the New Forest as an instructor in propaganda, and Harris was recruited to MI5's Iberian section. Burgess continued within the new organisation until the end of the year but thereafter there was to be no role for him. Conveniently forgetting his recent court case, he claimed he had fallen 'victim to a bureaucratic intrigue'.[39]

15

Bentinck Street

In October 1940, with the onset of the Blitz, Victor Rothschild and his pregnant wife Barbara decided to move to the country. He leased his three-storey maisonette at 5 Bentinck Street, just off Oxford Street, to a Cambridge friend, Tess Mayor – who would the following year become his assistant in MI5 and, in 1946, his wife – and Patricia Rawdon-Smith, whose marriage had just broken up. The girls had been bombed out of a flat in Gower Street and were grateful to be rehoused. Anthony Blunt joined them to help with costs and Burgess would often sleep over, eventually moving in just before Easter 1941, after he was ejected from Chester Square for not paying the rent and briefly staying with Kim Philby at his home in Addison Road.[1]

'The flat was a maisonette on three floors of a purpose-built office block, the ground floor of which was occupied by a medical magazine, *The Practitioner*,' Rawdon-Smith, later Baroness Llewellyn-Davies, remembered. 'On the first level were the kitchen and sitting-room. On the second floor were Blunt's bedroom and a dressing room-cum-bathroom. Guy's rooms – a bedroom and a bathroom – were on the same floor . . . There was a housekeeper, an Irish girl called Bridie, who came in every day to clean and cook for whoever happened to be in the flat.'[2]

Gail Pollock, sister of Burgess's lover Peter Pollock, often visited it and remembered 'a nice comfortable place, like someone's home', with lots of books and cushions and a bath in one corner of the kitchen with a cover on it, whilst her brother remembered it 'as a place of light and sunshine; particularly because Barbara (R) had always insisted that the many mirrors should all have pink glass – We all looked very glamorous.'[3]

Because of its central London position and the fact that it had a bomb shelter in the basement, there were always plenty of overnight visitors stranded by air raids or late night duties. Burgess, writing to Pollock in autumn 1941, noted, 'there seem to be even more people to breakfast than usual . . . 8 the other day (not counting someone who left at 5 a.m.)'.[4] Amongst those who passed through were Blunt's occasional lover, Peter Montgomery, Kim Philby, Louis MacNeice, Victor Rothschild, Clarissa Churchill and Donald Maclean, who had been evacuated from Paris as France fell.[5]

A constant visitor was John Strachey, a regular broadcaster for Burgess at the BBC, who later claimed he received from Burgess 'one lasting benefit: a concern for music, of which previously he had been ignorant: Burgess lived in a perpetual atmosphere of Mozart and late Beethoven quartets'.[6] One benefit Burgess may have received in return was knowledge about RAF deployments, plans and capacities, as for part of the war Strachey also served as the public relations officer to the Assistant Chief of Air Staff at the Air Ministry.[7]

'Everyone who was there was working eighteen hours a day and we scarcely saw each other. I left at 8 a.m. and came back at night. I never socialised with Anthony. One came home and went to sleep. I know what people have said about the orgies, but I never saw anything like that,' said Patricia Rawdon-Smith.[8] It's a view that Hewit confirmed, saying there were 'no orgies while I lived there – more's the pity. I wish there had been.'[9]

But the sleeping arrangements could be complicated. After Pollock was posted by the Army outside London, Hewit, who had enjoyed a brief fling with Isherwood in 1938 after being introduced to him at the cinema by Burgess, divided himself between Blunt and Burgess. 'When Guy and I had one of our flaming rows . . . I said to Anthony, "I can't stand this man anymore." Anthony and I were lovers for the whole of the war. I adored him.'[10] Meanwhile Blunt and Rawdon-Smith had begun an affair, and Burgess told Hewit he had also slept with her. 'A lord and lady, I have had them both.'[11]

Writing just after Blunt's *Artistic Theory in Italy 1450-1500* was published in August 1940, and whilst still an occasional visitor, Burgess described the set-up to Peter Pollock. 'Anthony is very much *maître-en-titre* tho' Tess is living there too, so the bed problem when I sleep

there in the basement is complex. Varied also are the names people murmur in their sleep.'[12]

Pollock had been posted to Grantham, but whenever he had leave, he would come to London. In December Burgess wrote to say how much he had enjoyed their time together:

> What with bombs & Spearheads we neither of us know when, or if, we shall have another. And, whether it's war or old age, it does mean more to me than ever it did. I think it's war – there are so few nice or good things left that one becomes dependent more than usual on what one has that's worthwhile. And if we make it so, what's between us is and can be.'[13]

Burgess was uncertain about his future and talked of how his mother was thinking of buying a farm for him as an investment for after the war. He often wrote to Pollock on 'Sunday Duty' using stationery from a succession of London clubs, some of which he even belonged to, using a variety of affectionate nicknames – Headache, Floosie, Pudd, Polly, and signing off Dotty or Boo. 'There's not much news', he wrote from the Reform Club. 'I've been out razzling only with the usual crowd – but I really think you must get to know some of my nicer friends better – particularly Patricia Rawdon-Smith and Kim and Aileen.'[14]

He was seeing Rosamond Lehmann, either at her home in Oxfordshire or Bentinck Street, who had just started an affair with the poet Cecil Day Lewis. 'Also Rosie was here and I dined with her and Cecil Day Lewis. That is all going very well and Rosie sends you her love. Cecil, who I didn't know well before, is very nice and quiet and sardonic and Irish and good looking and in love. So what could be nicer than that?'[15]

Though he remained in love with Pollock for the rest of his life, Burgess himself wasn't monogamous, relishing the sexual opportunities provided by lonely visiting servicemen and the blackout. As Hewit pointed out, 'If Guy fancied someone, he'd go up to him in the street and proposition him.'[16] His letters to Pollock are full of references to various encounters from a 'young naval officer who had been at Dartmouth with me (three years junior) who has become a most agreeable companion', to 'an amusing time (which I look

forward to telling you) with a 2nd Loot in the First battalion of your regt'.[17]

One sexual partner of this period was Paul Danquah, later a presenter of *Play School*, who after the war would become the painter John Minton's lover, and go on to become Pollock's partner in a relationship of over fifty years, until Pollock's death in 2001. Another was James Pope-Hennessy, with whom Burgess often went pub-crawling on the lookout for sex, and who briefly lived with him at Chester Square at the beginning of the war. Pope-Hennessy's father was a rather dull major general, but his mother Una Pope-Hennessy, a well-known writer and authority on Charles Dickens, had brought up her two sons to have wide intellectual and artistic interests. Pope-Hennessy had been at Balliol with Nigel Nicolson, who was in love with him, but soon after coming down had begun an affair with Nigel's father, Harold.

Exotic – he was part Malay – with jet black hair and heavy eyelids, Pope-Hennessy was clever, charming, and a brilliant raconteur with a great sense of fun. After six months as an ADC to the governor of Trinidad, he had returned to London in the autumn of 1939 and it is probably then that the two men embarked on the start of an on-off affair, which was to last eighteen months. He was very similar to Burgess, sharing his dependence on alcohol, a liking for rough trade, self-centredness, and a preference for others to pick up the bill, which inevitably led to conflict.

Through Pope-Hennessy, Burgess met the intellectually precocious Clarissa Churchill. Clarissa, born in 1920, was the daughter of Winston Churchill's younger brother John, who after studying at the Sorbonne was now mixing in artistic and literary circles in London. 'I got the impression he wasn't keen to meet me, but he had to because of James,' she later remembered. According to her, James 'adored' Burgess. 'Emotionally it was a very serious thing.' She found Burgess 'courteous, amusing, nice and good company', but was wary of him. 'I was very aware that he was very aware politically and socially and he treated me very carefully . . . He was always rather standoffish with me. He didn't wish any friendship to develop between us. It didn't suit him for some reason.'[18]

Pope-Hennessy was writing his first book about this time – a journey around historic London landmarks threatened with destruction, based

on excursions he made with Clarissa. The central character is based on Clarissa and the book, *London Fabric*, which won the Hawthornden Prize in 1940, is dedicated to her. He also sent Guy an inscribed copy.

When not working, Guy would spend his evenings in the pubs of Soho and Fitzrovia, gay clubs such as the Moonglow Club in Percy Street, Le Boeuf sur le Toit, and The Ladder in Orange Street, or more respectably the Reform Club, followed by the Gargoyle. A favourite haunt was drinks in the basement bar of the Ritz hotel, which was illuminated by makeshift chandeliers formed from old champagne bottles with candles stuffed in their necks, and regarded as one of the safest places during air raids. According to Robert Harbinson, he tended to pick up young servicemen in pubs or public lavatories – the one near Lambs Conduit Street was a favourite – and then take them to seedy lodging houses.[19]

'Guy brought home a series of boys, young men, soldiers, sailors, airmen, whom he had picked up among the thousands who thronged the streets of London at that time', Goronwy Rees was later to write:

> The effect was that to spend an evening at Guy's flat was rather like watching a French farce which had been injected with all the elements of a political drama. Bedroom doors opened and shut; strange faces appeared and disappeared down the stairs, where they passed some new visitor on his way up; civil servants, politicians, visitors to London, friends and colleagues of Guy's, popped in and out of bed and then continued some absorbing discussion of political intrigue, the progress of the war and the future possibilities of the peace.[20]

One of those who got to know him at this time was Mary Hardy, who was the sister of Goronwy Rees's wife Margie and saw him at Bentinck Street and after the war:

> It would have been impossible not to notice GB in any assembly. He was a dominant figure and obviously popular, but I did not take to him at all. I found him unattractive in appearance and intent on being the most important person in the room, delighting in knowing everything and everybody, making the most noise, making himself felt. He was often amusing with his outrageous tales and knowledge-able gossip, and he could be very charming, but somehow, if one wasn't exactly hanging on his words, joining in the show, his eyes would slide past to someone more receptive. There was no impression

of genuine warmth or interest. People laughed or applauded, but his words often contained a malicious sting and one was left feeling uncomfortable'.[21]

Later Mary Hardy added:

He hero-worshipped his mother and was always talking about her. He had a mummy complex. What an amazing person she was etc. He called his father 'The Commander' and minded terribly about his death. He would go into the horrific details about finding him. Jack Bassett was always 'The Colonel' and Burgess seemed indifferent to him, neither scornful nor affectionate. He called Jack Hewit "Jimmy" and though fond of him, treated him like a manservant. Clarissa Churchill was a close friend and often at the parties. She mothered him though she was much much younger. And there was often a young woman called Elaine, a pattern cutter and leg model, who could have been a girlfriend.[22]

Burgess's thirtieth birthday on 16 April 1941 was a time for reflection. He wrote to Peter Pollock of his dream. 'To have a small villa by the sea (the Mediterranean of course) & a woman to cook, & a small & gay servant, a fisher boy & the friend of fisher boys, in a vest and faded blue trousers & bare feet – is what this war makes look like what one wants (tho' it isn't).'[23]

Burgess found it impossible to be monogamous. A few weeks later he wrote to Pollock, perhaps trying to make him jealous, saying that James Pope-Hennessy had 'totally and violently and very sweetly but also embarrassingly fallen for me'. When Pollock appeared unworried by the attention, Burgess and Pope-Hennessy began an affair, which was to continue throughout that summer.[24] Sending a picture of Pope-Hennessy to Pollock in April, Burgess playfully wrote, 'you must let me know what you think of the photograph and also what you feel about my having taken what looks like a war wife – it's only as you know because the war has temporarily made me a war widower. Anyway J (who has now a commission in the Intelligence) may be going off to Oxford for training. I shall be v sorry but not heartbroken.'[25]

The course of the affair can be charted through the diaries of Harold Nicolson, who was also having an affair with Pope-Hennessy

at the same time, and from Burgess's letters to Pollock. 'I am trying to go to some concerts in London and there are good ones coming on. J fell off his motor bike in Oxford High Street and wasn't strong enough to turn it the right way up.'[26]

The summer of 1941 marked the end of Burgess's affair with Peter Pollock, which had lasted, if not completely faithfully on either side, for the previous five years. The two had been meeting as often as Pollock's army leaves would allow. Pollock recalled, 'Whenever I got a long weekend leave, I would book a suite at Claridges and we would (Guy & I) have a Friday night to Sunday night stay. I always paid and I always got a suite for the price of a double room – I had a friend in reception. Sunday lunchtime we would give a rather grand party.'[27]

But by July the affair was over. Burgess wrote to Pollock, still stationed in Grantham, that he hoped 'to be able to see each other as friends who are fond of each other (as Jackie and I do)'.[28] They did continue to see each other, and some indication of the circles Burgess was now moving in can be gleamed from his correspondence with Pollock, ranging from Frederick Ashton – 'he is most civilized and sweet' – to Laurence Olivier, 'who I am at last getting to know'.[29]

Burgess remained deeply in love with Pollock. A few months later he wrote:

> I love you and apart from saying this I want to say something else that may irritate you. It's this. I've been talking to A and I don't think you should volunteer, at any rate, not just yet, to go abroad. It will be a nuisance to have to stop you – But the point & do understand this – is that you have begun to do useful work that very few cld do. This is understood and appreciated and for the moment at any rate, you ought to be at hand in case there's more to be done and to carry on if possible with what has been begun . . . It's not a mere question of 'us' – if it were as I said I should have no right to interfere.[30]

Neither was Burgess's affair with Pope-Hennessy going well. On 21 July Nicolson noted in his diary, 'I then meet James and Guy at the Travellers and we have a good dinner at Boulestin and go on for a moment to the Boeuf. James, I feel, is not very happy.'[31] The following

day Burgess, Harold Nicolson and James Pope-Hennessy dined. 'I do not think that that affair is going very well, and James looks white and drawn. I am seeing him alone on Wednesday and he will tell me all about it. Guy is a bit of a scamp, and James is far too sensitive and affectionate for that sort of relationship.'[32] Burgess meanwhile had switched his affections to a seventeen-year-old from Bermuda, the Shakespearian actor Orford St John now in MI5, and later to Oliver Messel's lover, a huge foul-mouthed man known as 'The Great Dane'.[33]

He often stayed for weekends with Gavin, Lord Faringdon, an effete Old Etonian homosexual Marxist, at his eighteenth-century country house Buscot Park, in Oxfordshire. Faringdon, who would preface his remarks in the House of Lords with 'My Dears', rather than 'My Lords', had briefly served in a Republican field hospital during the Spanish Civil War. Kenneth Sinclair-Loutit remembered how Faringdon combined:

> Party discipline and the aristocratic vie du chateau. It seems that his butler had become convener of the Party cell and had the responsibility for the agenda of its meetings, which took place in the library of Buscot Park. Legend had it that the butler would say at the end of dinner, 'May I draw to his Lordship's attention that this evening there is a meeting in the library,' but once the meeting started the forms of speech became more appropriate. The butler would ask Comrade Henderson to read the minutes of the last meeting. I am not clear about the membership of this Party branch; the butler chaired the meetings, and Comrade Henderson was the branch secretary.[34]

For many years Burgess had gone to the Gargoyle Club as a guest, but in 1943 he joined – Maclean joined in August 1950 – proposed by David Tennant and seconded by the club secretary, Miss Ransley. The club had been started in 1925 by Tennant, then just down from Cambridge, and his wife, the actress Hermione Baddeley, and soon became one of the smartest nightclubs in London. Its president was Augustus John, Edward VIII as Prince of Wales was a regular, and it's said that on one night alone two princes, three princesses and the King of Romania were there together.

Situated at 69 Dean Street, but entered from the adjacent Meard Street, it occupied the top three floors of a building designed by Sir Edwin Lutyens. A mouse-trap lift took guests up to a panelled reception, which led to a long mahogany bar that ran the width of the building and up further to a roof garden. The downstairs ballroom had been designed by Henri Matisse, who was an honorary member, and had a Moorish theme with some 20,000 tiny mirror squares, rescued from the salon of a French chateau, which cast reflections on the dance floor. The band, led by the pencil-moustached Alec Alexander, was not very good and played almost continuously either 'Bye-Bye Blackbird' or 'Melancholy Baby'.

By day a sober luncheon club, patronised by politicians and civil servants, at night it attracted London's Bohemian society, including Philip Toynbee, Cyril Connolly, Tom Driberg, Barbara Skelton, Lucian Freud and Francis Bacon. Burgess became a regular. Teddy Kollek, later mayor of Jerusalem, but then in Europe on various intelligence missions, 'recalls with evident delight a "fabulous" night out with Burgess and Maclean at the Gargoyle. Both Dylan Thomas and Michael Foot were there, not actually with Burgess and Maclean, but in the same large, and I deduce, merry group. Foot and Thomas were reading poetry aloud until 6 in the morning.'[35]

David Tennant's wife, Virginia, often encountered Burgess in the Gargoyle and remembered him with great affection. 'He had these marvellous dimples and a little boy lost look. He never danced but we would hold hands whilst the band played and he would make a pass at me when particularly drunk.'[36]

It became a favourite networking and pick-up spot for Burgess. It was at the Gargoyle that Burgess met the interior designer Geoffrey Bennison and brought him back to Bentinck Street, where he did strange things to him with coat hangers and where he tried to seduce the painter Johnny Craxton. '"Would you like to come back to my flat?" he asked. "Would you like to be whipped – a wild thrashing? Wine thrown in?"' Craxton said no, he didn't want to be whipped at all and only the intervention of Philip Toynbee saved Craxton. 'That scene ended with a tussle between Guy and Philip rolling about on the floor amongst the dancers, threatening Alexander's drum.'[37]

16

Back at the BBC

Out of Section D and liable for military service, Burgess decided the best option was to try and defer his call-up by returning to the BBC which, lacking experienced staff, were only too happy to have someone with good contacts across government and especially the service departments, someone 'who knows the working routine of the Department and the snags to avoid in dealing with the speakers and their scripts' and 'has to an extent not perhaps possessed by other members of the Department "the propaganda mind"'.[1]

On 15 January 1941, W.R. Baker at the BBC had written to S.D. Charles at the Ministry of Information, following a conversation with Burgess, 'in the hope that you may be able to take urgent steps with the Ministry of Labour to obtain a deferment of military service for him. Meanwhile, we have decided to take the risk of bringing him back on to our staff, and he will probably begin his duties with us before the weekend.'[2] He added:

> I understand that there has been some reorganisation in the MI branch where he was employed, and that by agreement with his chief, Burgess can be – in fact has been – released from his duties and is free to start work with the Corporation . . . The work of our Home Talks Department in wartime has become very much more important, owing to the propaganda aspect of their output, and the importance of helping to maintain morale by suitably prepared and balanced programmes. In addition to general talks, Burgess will be concerned in supervising a series of talks in our Army Educational Service . . . I am sure that you will appreciate that there are many pitfalls and difficulties to be met in producing talks under wartime conditions, and we are extremely fortunate in finding that Burgess is available to resume his previous occupation

with us, subject to our being able to secure his reservation from military service.[3]

The new job was a drop in salary from £600 tax free p.a. to £540 p.a. and did not qualify him for membership of the BBC permanent staff or staff pension scheme. It also carried certain restrictions. 'You agree to devote the whole of your time and attention to the service of the Corporation . . . You further agree not to undertake work for any other person or firm whatsoever during the continuance of this engagement without the previous written consent of the Corporation.'[4]

But Burgess had little option – the new job had saved him from being called up – but it didn't prevent him being as difficult as possible or simply inefficient. By late April he had still not signed his contract letter. 'You have been asked five times to return your signed contract letter, the last request being my memo dated 9 April', his personal file notes. He finally signed it on 9 May.

Burgess's new office – he called it 'the hutch' – was on the second floor overlooking Portland Place, with a secretary called Miss Winkle, who insisted it be pronounced 'Winkol'. One of his first commissions was to ask Aileen Furse, pregnant with Kim Philby's first child, 'to give two broadcasts to housewives on Community Kitchens from the personal point of view – i.e. how she built up the ones that she started and how they work'.[5] This was for a popular programme *Can I Help You?*, broadcast twice a month, aimed 'at helping ordinary listeners to solve some of their wartime problems. In particular, we try in this series to interpret official regulations to people who have difficulty with what must be an intimidating mass of official instructions to the ordinary man.'[6] John Green, a BBC colleague, remembered Burgess as:

A most amusing colleague amidst the intellectual effervescence of Talks Department in those days, and throughout the war he (and Norman Luker) and I had coffee together most mornings at Yarners (by the old Queens Hall). This must have gone on for two or three years. Guy drew brilliant cartoons, which he showed us before passing them under the table at the Talks meeting in the afternoon. Sir Richard would usually see and ask for the paper to be passed up, and after a good-natured reproach, proceed with the meeting.[7]

Sir Richard Maconachie trusted Burgess and one of Burgess's first tasks was to keep an eye on Maconachie's behalf on the Religious Affairs department and, in particular, a discussion programme, *Three Men and a Parson*. The Reverend Eric Fenn, the assistant director of Religious Broadcasting at the time, remembered how Maconachie had 'got it into his head that the whole of the Religious Affairs department was a nest of fellow-travellers. So he insisted that whenever we held a policy meeting, one of his own men would attend and report back direct what had been decided.'[8]

Burgess was therefore sent to Bristol to help produce the programme. Fenn later recollected, 'He was scrupulously fair, entirely uninterested in what was going on, and outside the studio extremely vitriolic.'[9] But Fenn thought Burgess a strange choice. 'We knew Burgess was a spy. Whenever he was drunk – which was most of the time – he used to tell us all about it. I remember one night when he said to me, "When we get into power after the war you, Fenn, will be one of the first to hang from a lamppost."'[10]

Burgess, always highly strung, now often inebriated and increasingly bolshie towards authority, was beginning to crack up under the pressures of his various BBC responsibilities and his spying. One episode, after his secretary mistakenly took home the key to his office, triggered a particularly public outburst, as his BBC file reveals. On 29 May 1941, just before 8 p.m., BBC security were called:

> to interview a gentleman who was complaining in a high-pitched voice of being unable to enter his room, 316, Langham Hotel. He complained that he had been waiting for an hour to get into his room, and carried on with a long story of complaint that the doors had no right to be locked . . . Fortunately at that moment a Defence Patrol Officer came along, and told me he was endeavouring to obtain the master key, and would open the door as soon as he had contacted the Patrol who held the key. Mr Burgess then turned to the Patrol Officer and said, 'Well, go and get on with it!' in such a domineering manner that the Patrol Officer took exception and passed the comment, 'You cannot talk to me like that. I am not a dog!', and proceeded towards the Langham Hotel followed by Mr Burgess.[11]

The two went in search of the patrolman who had the master key.

> However he would not wait for the keys to be obtained and started to break his door down with a fire extinguisher – he has done a lot of damage to the door, made the extinguisher useless, and swamped all the carpet with liquid. Myself and my two Patrolmen are of the firm opinion that Mr Burgess had had too much to drink and his behaviour was objectionable in the extreme.[12]

The next day Burgess was seen by George Barnes and told to apologise. 'I said that the importance of the papers which he wanted did not justify him either in being rude to the officers or in taking action into his own hands by trying to raise the fire alarm and to break down the door.'[13]

On 4 June Burgess apologised, but gave his own version of events, pointing out that the previous month he had raised concerns about locked doors at the Langham, complaining it was a fire risk, that it was difficult for speakers after 6 p.m. to enter the building, and it had taken almost an hour to locate the master key. Burgess was on notice only months after returning to the Corporation.[14]

An internal memo of 9 June noted, 'There is no previous record on Burgess's file of any behaviour of this kind, though in fact we know his conduct was not altogether satisfactory when he was in our service before (see my memo of 10 January 1941 . . . I recommend that he should be severely reprimanded, required to make a written apology which would be shown to those concerned, and to pay for the damage, and warned that if there is any further trouble he will be terminated.'[15]

The episode doesn't appear to have blotted his copy book, because at the beginning of June, he was mooted for the post of European Liaison Officer, as 'he certainly has a first-class mind and an unrivalled political knowledge'.[16]

For two weeks in the middle of June Burgess was away on compassionate leave – it's unclear exactly why – during which Germany suddenly invaded the Soviet Union on 22 June. The BBC thought there would be a new interest in Russian matters and on his return Burgess was asked to come up with ideas of possible speakers and

subjects. The result was a memo 'Draft Suggestions for Talks on Russia', which, amongst many disclosures, showed his knowledge of Russian literature, perhaps gleaned from friends such as Isaiah Berlin, Moura Budberg and Alexander Halpern.

'I have had several informal conversations with John Strachey and Professor Bernal and one or two people at the M of I and the Foreign Office, but what follows is not intended to be in any sense a worked-out scheme', he wrote. He agreed there should be something on *War and Peace* as:

> An illustration of great Russian literature and topical, the crossing of Beresina, Kudenov, Borodin, the burning of Moscow, etc . . . There is also the famous hunting scene, which is probably the most beautiful description of old Russia and which was Lenin's favourite passage in Tolstoy . . . Modern literature: The obvious name here is Zoschenko. This man's satires are extremely popular in Russia today . . . There are also young Soviet writers, such as Nicholai Tikhonov and Ilya Ehrenburg.[17]

He had further suggestions for science and culture, adding rather disingenuously, 'Dr Klingender, Dr Blunt are possible speakers on art – neither are communists. Christopher Hill (a Fellow of All Souls) is a communist, but is also probably the best authority in England on Russian historical studies.'[18] In fact the Marxist art historian Fred Klingender, an active communist at the LSE with John Cornford, and mutual friend with Anthony Blunt, had been under Special Branch observation for many years.[19]

There were suggestions for speakers on economic planning, Soviet foreign policy, ethnic nationalism, where he put forward 'John Lehmann, who has written a certain amount of interesting stuff on Trans-Caucasia for the Geographical Magazine and should be safe on this topic.' Burgess was subtly using his broadcasting position to shape public opinion towards the Soviet Union.

17

MI5 Agent Handler

In September 1939, Blunt, who had joined up as soon as war broke out, had been withdrawn from the intelligence course at Minley because his communism had come to light. Burgess came to his rescue and arranged for Dennis Proctor to visit Brigadier Martin, deputy director of military intelligence at the War Office, to intervene. Blunt was accepted and was posted to military intelligence, returning from France in the summer of 1940. At the suggestion of Victor Rothschild, he was then successfully taken on by MI5.[1]

At the beginning of 1941, to save Burgess from being called up, Blunt repaid the favour and suggested to Guy Liddell, for whom he was working, that Burgess should join MI5. Liddell agreed, but was vetoed by a colleague, Jack Curry, who thought Burgess too unstable, promiscuous, and was 'not satisfied that his claim to have abandoned Communism could be accepted at its face value'.[2]

Burgess, whose brother Nigel had joined MI5 and was working in F Branch monitoring the activities of the Communist Party, managed to wangle his way into MI5, however, not as an officer but as an agent and was given the codename 'Vauxhall', reporting to Blunt and a Trinity contemporary, Kemball Johnston.[3] 'Burgess has been working for us for some time and has done extremely valuable work – principally the running of two very important agents, whom he discovered and took on,' noted Blunt. The two agents were Eric Kessler and Andrew Revai.[4]

Kessler, whom Burgess had met in 1938 had been the London correspondent of the Swiss paper *Neue Zurcher Zeutung* and, though married, was one of Burgess's lovers. Now a press attaché in the Swiss embassy, he proved a valuable source, with useful political and diplomatic gossip from the various London embassies and, in

particular, German dealings with the Swiss. He also supplied infor-
mation to both the Russians and British from Marian Kukiel, who
had been the vice-minister of war in the Polish government in exile
until 1940, was then the general officer commanding the First Polish
Corps, and from 1943 was minister of war of the Polish government
in exile.

Kemball Johnston later remembered:

> Guy was a very good source for me of rather useful agents – I used
> to look after the neutrals, the Swiss and the Swedes. He produced a
> very high-ranking agent, who was a Swiss diplomat – can't divulge
> his name, known as Orange – he was frightfully good at telling one
> if some top Swiss chap was coming over, if he was any good or if
> he was making a separate peace. Orange was absolutely marvellous,
> he knew exactly what they had done: he once wrote a report which
> was absolutely lauded to the skies. He said that if by hook or by
> crook you keep up some sort of relationship with your new allies,
> the Russians, you needn't become a communist country, but it would
> be the clever thing to do – if you don't, you will be kicked around
> by the Americans, and that is precisely what has happened.[5]

Burgess had supposedly met Kessler whilst trying to set up a radio
station in Liechtenstein, though it's likely they had met before – it's
thought Kessler had lent Burgess his Ford V8 to visit Churchill in
October 1938. According to Hewit, Kessler was 'very nice and very
bright . . . I was given to him by Guy . . . I think Eric was helping
Guy because of his (K's) anti-Nazism before the war.'[6] What Burgess
had failed to tell MI5 was that Kessler had already been recruited
by him in 1938 on behalf of the Russians and given the codenames
OREND and SHVEYTSARETS (Swiss).[7] All the material he
collected served two masters.

In November 1942 Burgess had also recruited, on behalf of MI5,
another journalist and former lover, who reported back on foreign
journalists, particularly Hungarians and Swedes. Andrew Revai, some-
times known as Revoi, had been the London correspondent of the
Hungarian paper *Pester Loyd* and from 1942, under the name Canidus,
an occasional commentator for BBC's Hungarian Service. He was
active within the various Hungarian exile groups and in 1941,
following the breaking off of Anglo-Hungarian diplomatic relations,

he and a group of other exiled compatriots had formed the National Federation of Hungarians (later Free Hungarians), of which he became president in 1943. Burgess, who had met him whilst working at the Ministry of Information, had also previously recruited him to work for the Russians and he had been given the codename TAFFY (Toffee).[8]

Burgess was therefore simultaneously running agents for both British and Soviet intelligence, but his loyalties always remained ultimately to the Soviet Union. During 1941 London was easily the NKVD's most productive legal residency and, according to Moscow Centre's records, during this period the residency forwarded to Moscow 7,867 classified political and diplomatic documents, 715 on military matters, 127 on economic affairs and 51 on British intelligence.[9]

Burgess's Soviet handlers had a good measure of his strengths and weaknesses. They noted he had a wide circle of contacts and made friends easily. 'But his initiative must be contained almost all the time and he must be controlled very rigidly. Every assignment which is given to him should be defined in every minor detail.' There were also concerns about his private life. 'He understands that we must know this and willingly tells us about that . . . He needs unconditional discipline, authority and adherence to principles. It is necessary to teach him all the time the rules of security.'[10]

Boris Kreshin, also known as Krotov, who had taken over from Gorsky as Burgess's Russian case officer, reported that Burgess was better than expected but, 'His distinguishing feature in comparison with other agents I meet is bohemianism in its most unattractive form. He is a young, interesting, clever enough, cultured, inquisitive, shrewd person, reads much and knows much. But at the same time with these qualities he is untidy, goes about dirty, drinks much, and leads the so-called life of the gilded youth.' But he accepted that Burgess was 'well-grounded politically and theoretically' and 'in conversation quotes Marx, Lenin and Stalin'.[11]

A new friend was Adam de Hegedus, whom he would often meet at the Ritz Bar. Born into a wealthy family in Budapest in 1906, de Hegedus had worked as a journalist and writer in Hungary and France, where he was a friend of André Gide, until settling in Britain

and becoming naturalised in 1935.[12] Burgess had met him whilst the two were working at the Ministry of Information, and Pollock had been instructed to get close to him as part of Burgess's MI5 remit, given Hungary was allied with Germany, of keeping an eye on Hungarians in London. Pollock's new job was to befriend mildly suspect, usually gay, Hungarians, watch the contacts they made, introduce carefully planned questions into the lunchtime conversation, and see if he could persuade them to send messages to Germany. 'He was one of the first men I was supposed to watch while I was doing my various MI5 stints,' Pollock later remembered. 'He fell in love with me and was rather a nuisance, but quite a nice man.'[13]

Jack Hewit had also been kept from active service by being taken onto the books of MI5, where he worked for Blunt on Triplex – this was material taken illicitly from the diplomatic pouches of neutral missions – seducing the couriers on the train from King's Cross. He was also used to collect gossip from an informer, the landlady of the Dover Castle in Portland Place, just around the corner from the Swedish embassy.

In October 1942, the London *rezidentura* asked Moscow permission for Burgess to try again and recruit his Cambridge friend Dennis Proctor, now at the Treasury. Proctor had already unwittingly supplied political and financial information to Burgess on the Bank for International Settlements. He now in 'all innocence, revealed details of the secret talks between Roosevelt and Churchill during the January 1943 Casablanca conference, supplying one priceless nugget of information, that the Allies were definitely planning a landing in Sicily in June of that year, but had postponed any major invasion of France until 1944'.[14]

It's unlikely that Burgess did try again – though Jenifer Hart when questioned about her spying named Proctor, subsequently chairman of the Tate Gallery and Permanent Secretary at the Ministry of Power, but there was a good reason. Interviewed by MI5 in 1966 in retirement in Provence, Proctor admitted, 'He didn't need to. I held no secrets from him,' which Blunt in his MI5 interviews confirmed. 'I can tell you that Dennis was the best source Guy ever had for the Russians.'[15]

The extraordinary amount of intelligence supplied by the

Cambridge Five rather than pleasing the Centre, however, only fed into their paranoia. A young intelligence officer, Elena Modrzhinskaya, was asked to evaluate the information provided and determine its reliability. She knew through Blunt of the Double Cross system, whereby Britain had played back agents against Germany, and concluded by November 1942 that a similar deception was being undertaken against the Soviet Union by the Five acting as double agents. How possibly, given their communist past, could the Cambridge Spy Ring have been allowed to work for British Intelligence? The only conclusion she could come to was 'that SÖNCHEN and MADCHEN, even before their contact with us, were sent by the British Intelligence Services to work among students with left-wing sympathies in Cambridge'.[16]

The Centre couldn't believe the Five's access and how much secret material was being supplied, nor could they believe that British intelligence were not targeting the Soviet Union. 'Not a single valuable British agent in the USSR or in the Soviet embassy in Britain has been exposed with the help of this group, in spite of the fact that if they had been sincere in their co-operation they could easily have done', one report noted.[17] The explanation was much simpler. The Foreign Office had banned covert activity against Britain's new ally, and all intelligence energies were being focused against Nazi Germany and winning the war. There were no secret agents to report.

So suspicious was Moscow Centre about their star agents that the London residency was ordered to create a separate independent agent network. An eight-man surveillance team, none of whom spoke English and all dressed in conspicuously Russian clothes, was sent to try and catch the Cambridge Spies meeting their non-existent MI5 case officers. Failing to discover any such contact, the surveillance team simply reported various innocent visitors to the Soviet embassy in London as suspected MI5 *agents provocateurs*.[18]

Distrust of the Cambridge Ring continued through 1943, with concern over the recruitment of Peter Smollett. Philby had originally been advised against recruiting him by Gorsky, who was furious to learn his advice had been ignored and suggested to Moscow Centre that all contact be broken with the Ring. Worried that Burgess might

turn up at the Russian embassy or seek help at the offices of the CPGB, it was decided to let events play themselves out and find new ways of supervising the Ring, but Burgess was severely reprimanded by Gorsky.

Philby was then judged to have held back what was perceived to be an important part of a telegram from the Japanese ambassador to Berlin, though in fact Bletchley had simply failed to decipher that part, which prompted a seven-page memorandum addressed to the head of the NKVD. In it Modrzhinskaya argued that since both fathers of Burgess and Philby had a background in intelligence – St John Philby had briefly served in the Indian Intelligence Bureau, whilst John Bassett had been an army intelligence officer in the Middle East during the First World War – then it was likely that both agents had been long-time British agents directed to penetrate Soviet intelligence. The fact that Burgess had suggested recruiting both David Footman and Kemball Johnston was seen as further evidence of an attempt to introduce further penetration agents against the Russians.

Theirs was not the only paranoia. Burgess had continued to be terrified that Rees might go to the British authorities. On 20 July 1943, at a meeting with Gorsky, he had explained that Rees was an 'hysterical and unbalanced person', who in spite of 'personal friendship and attachment' could 'at any moment' betray them. In Burgess's opinion 'the only way out of the situation was the physical liquidation of FLIT' and, as the person who had recruited him, he was prepared to carry out the task himself.[19]

Such behaviour raised further worries in Moscow Centre about Burgess's rationality. Already in October 1942 the London *rezidentura* had concluded that 'Madchen is a very peculiar person and to apply ordinary standards to him would be the roughest mistake'.

18

Propagandist

Burgess, operating from Room 201 of Broadcasting House, was now responsible for two consumer series, *Signpost* and *Can I Help You?*, which went out during 1943-4, covering such subjects as clothes rationing, changes in insurance, advice for old-age pensioners, war service grants, road safety in the blackout, war raid damage, and liaising with organisations such as the National Council of Social Service, Citizens Advice Bureau, and government departments such as Health and Labour. The series generated a huge post bag and was widely popular. It also gave him confidential information on the realities of life in Britain during the war, which he was able to pass to his Soviet masters.

An early champion of the broadcasting of parliament, at the beginning of October 1941, he also took on responsibility from Norman Luker for *The Week in Westminster*, the flagship political talks programme of the Home Service. Broadcast every Saturday evening, it commented on the past week in parliament. Burgess dealt with technical as well as editorial aspects – from timing scripts to editing them, as well as nominating, preparing and evaluating speakers.[1]

The speakers were selected in consultation with his BBC bosses, the Ministry of Information and party whips, but the new job gave him terrific contacts in parliament, as well as journalists and academic experts. He was now in the House of Commons several times a week and became a crucial liaison figure between the House of Commons and the BBC. Burgess broadened the range of speakers from politicians to journalists such as the *Daily Herald's* Maurice Webb, chairman of the parliamentary correspondents, and brought in representatives from the *Manchester Guardian*, the *Star*, Australian

News Service, *Daily Express* and *Daily Telegraph*, though the programme eventually reverted back to politicians.

Lord Hailsham, a regular contributor, remembered Burgess as 'a charming, sensitive and civilised person . . . he made no secret of his pronounced Left Wing opinions and frequently expressed his distaste of the Right Wing elements of the Labour Party'.[2] Leonard Miall, who had been at Cambridge with Burgess and joined the BBC in 1939, had similar memories. 'He was very open about his communism and homosexuality, but one didn't believe most things Guy said. A very amusing talker, but he was a natural liar.'[3]

In December 1941, the BBC informed Burgess he would be released for military service after 31 December and his contract would expire on 14 March 1942, but 'if you have not been called up for military service on the expiry of the notice your engagement with the Corporation will be continued temporarily on a week to week basis, until such time as you are called up'.[4]

His freelance work for MI5, as planned, however, saved him from being called up. According to a BBC memo, Burgess claimed to have no personal objection to military service 'but that he was at present "reserved" by the War Office . . . The position is that Burgess still does work for the War Office in his spare time, which does not interfere with his Corporation duties. He is extremely useful to Talks Department and they are anxious to keep him as long as possible.'[5]

Though he remained as a temporary BBC employee, Burgess's salary was raised to £580 p.a. in February and Barnes gave him a good report:

> Mr Burgess is a very useful member of the Dept. He is fertile in ideas, and if he lacks the insistence to carry them out, his exposition of them is a tonic to the rest of us. He is a good editor of scripts but is inclined to be lenient with speakers. He is not a tidy office worker, but lately he has clearly tried to 'grow up' and to improve this side of his work. He has earned his increment.[6]

Burgess's reputation amongst his colleagues was high. In June he was one of a select number of BBC producers, another was Eric Blair (George Orwell), and MPs such as Harold Nicolson, invited for dinner by Stafford Cripps, the Leader of the House of Commons,

to discuss 'the place of the artist in society' as part of Cripps's planning for the post-war world.[7]

Through Norman Luker and E.H. Carr, who were now advisers to Stafford Cripps, Burgess heard that Cripps, who wanted a War Planning Directorate instead of the Chiefs of Staff Committee, had sounded out press support and was considering resigning. Cripps, back from Moscow and in the War Cabinet, was seen as Churchill's chief rival and such a resignation would have created a political crisis. Burgess alerted Harold Nicolson, who then arranged for Churchill to be warned through Violet Bonham Carter, 'the only outside person I know who is on terms of intimate friendship with Winston and also has the confidence of Stafford and Lady Cripps'. Cripps agreed to delay his decision, the following month Churchill removed him from the War Cabinet and the crisis was averted, but it was a strange intervention, given Burgess's own views were closer to Cripps, a very public champion of opening a Second Front, than of Churchill.[8]

Burgess had become increasingly exercised by the need for a Second Front and had started lobbying anyone he could, including Clarissa Churchill, who had been working for Smollett at the Ministry of Information as a research associate on a propaganda paper *Britansky Soyvznik*.[9] Just as he had used his broadcasting position during the Munich Crisis to shape public opinion, Burgess now marshalled his influence on the need to take pressure off the Russians on the Eastern Front.

In January 1942, he arranged a talk by Ernst Henri, which the intelligence expert Christopher Andrew has described as 'probably Burgess's most remarkable coup within the BBC, on behalf of the NKVD'.[10] Henri was a Soviet illegal and propaganda associate of Muenzenberg, working under journalistic cover.[11] Now, as part of a series of 'active measures' co-ordinated by Burgess and Smollett to shape British public opinion, he broadcast on the importance of opening the Second Front as soon as possible.

BBC coverage of Russia worried Harold Nicolson, who wrote to Maconachie that all the public 'think about is the glory of Russia and they have a completely distorted and legendary idea of what Russia really is' and there needed to be more balance in coverage of the Soviet Union.[12] However, whilst his friend continued as the

Talks Department expert on the Soviet Union, that was unlikely to happen, and Burgess continued to slip in speakers with a communist background, arguing they simply reflected the growing public interest in Russia. These included the independent MP Willie Gallagher and in February 1943, Sir Archibald Clark Kerr, the British ambassador to the Soviet Union in London and former lover of Harold Nicolson, refuting suggestions that the Soviet Union was an ideological enemy.[13]

Burgess's enthusiasm for all things Russian continued unabated. Jack Hewit remembered going to the premiere of Shostakovich's Seventh Symphony, often known as the Leningrad Symphony and regarded as a symbol of resistance to Nazism, as part of the Proms at the Albert Hall at the end of June 1942. He went with Blunt and an emotional Burgess 'with a cigarette in his mouth smoking with tears streaming down his face'.[14]

He also continued to use his position to put forward friends such as Jack Macnamara. Burgess had successfully kept his lover Peter Pollock safe and in London for the first part of the war by employing him to befriend and, if required, sleep with various refugees of interest to MI5. Now he tried to interest the BBC in using him as a contributor to John Hilton's popular advice series *Forces Problems Answered*.

Burgess had known Hilton since attending his inaugural lecture as the first Cambridge Professor of Industrial Relations in 1931 and the two worked closely together on the series, which covered every facet of army life as it affected ordinary soldiers and their families. Burgess used his position to deal with the various Army departments including the Adjutant-General, not least on questions of morale, without them knowing how far he had strayed from his BBC brief and was using the information to influence what listeners thought.[15]

Hilton wrote in August:

My dear Guy . . . I don't think I ever wrote to say how much I like young Pollock. Whether he personally would be regarded as allocatable to the task of working with me in these matters I do not know, but he is just the type . . . I feel sure that if the talks are to open out in the way we have in mind, it must be in part by my having in parallel with me some young officer of the Pollock type, who volunteered or was called up in the ordinary way for military service

as a unit of the New Army, who did his turn as a private, went to an OCTU, got his commission, and therefore is able to see the needs and problems of the great multitude of the Forces personnel from personal experience first-hand.[16]

A week later Burgess returned to the fray, using Hilton's response, to propose Pollock fill a requested position as an army officer to advise the BBC, though the request was for officers over forty. 'The name of Lieut. Pollock, 5th Battalion, Gordon Highlanders has been suggested as the type wanted. He is known to Hilton, Major Sparrow of the Army Morale Committee, and myself.'[17]

Throughout 1944 Burgess continued to push friends. In January 1944 he brought Pollock in for a voice test, and proposed an old friend from Cambridge to broadcast for *Forces Problems Answered*:

I have also in mind Jim Lees, now working with Nottingham University as an extension lecturer and an area organiser for WEA. This man is an ex-coal miner, a Trinity open scholar, and of the possible future Hilton type. I think you knew him; he and I were contemporaries and friends at Cambridge, though he is considerably older than I . . . Pollock should be coming up, if Glasgow agrees, for a voice-test . . . As might be expected the note in Radio Times has produced a long list of applicants for the post. Interviewing and voice-testing them would be almost a whole-time job for a week or two – I do not propose to undertake it till the candidates I have mentioned, all of whom I think are better than anybody who have written in, have been disposed of.[18]

He was also using his broadcasting contacts to lead him to others. The political journalist Maurice Webb, later elected as a Labour MP in 1945, and chairman of the Parliamentary Labour Party from 1946, was one of his regular broadcasters and would often drink with him after broadcasts at the various pubs near Broadcasting House. 'He was a great cadger of small change and an enthusiast for a quick drink,' Webb remembered, adding that he became worried when 'Burgess began to make frequent calls on me at the House of Commons. He pressed me for introductions to all kinds of important people. Most of all, he tried to get me to supply him with private reports on war conferences that were passed on to certain journalists.'[19]

The Week in Westminster gave Burgess huge powers of patronage and influence, as ambitious MPs saw the advantages an appearance could bring, and Burgess was only too happy to exploit them, though he tried to produce balance and encourage younger MPs. Writing to Harold Nicolson on 9 September 1943 about Peter Thorneycroft, an MP since 1938 and future Chancellor of the Exchequer, 'that nice though Thorneycroft is, neither his voice nor his intellect appeared likely to be an answer to the Central Office's prayer . . . He seemed very ordinary indeed, and this is a quality which only makes for success in broadcasting when it's pushed to the point of genius.'[20]

At the beginning of November 1943, a new name was suggested as a speaker for *The Week in Westminster*. Hector McNeil was a former journalist on the *Daily Express*, elected to parliament in 1941 and a Parliamentary Private Secretary in the Ministry of War Transport. 'This man has never broadcast before, and is a choice of mine', reported Burgess. 'I have, however, consulted the Labour Party who think very highly of him and he is also, if not popular, much respected by the Tories. I have great hopes that he may turn out a real winner, but this opinion as yet is only at the "hunch" stage.'[21]

On 2 November McNeil made his first broadcast. It was a success. Writing four days later to thank him, Burgess noted, 'I think you have it in you to be a very fine broadcaster indeed, and I look forward, both on broadcasting and on personal grounds very much indeed to any future collaboration that we can both manage.'[22] McNeil was to become a regular broadcaster from that point. It was to prove a very shrewd decision.

Burgess ended 1943 with a good report from Barnes, supported by Maconachie:

> Maintains a wide range of contacts and can be relied upon to report new ideas and tendencies, though his judgement in selecting from them what is important is sometimes wild. Aided by a good secretary his office work has improved, but it is still apt to be careless. Complaints have again been received from outside the Dept from announcers of his manners, but such complaints are not from speakers. There is no doubt in my mind of his high value as a Talks producer and his presence is always stimulating . . . Grade increment recommended.[23]

His relationship with authority and expenses continued, however, to be a problem. In January 1943 his December expenses were queried:

> His office hours are very flexible – he is rarely here before 10.45 a.m. since he reads his papers and Hansards at home and spends most of the rest of the day out of the office making contacts . . . Some producers apparently manage their business by taking a bus or tube and seem to be able to allow sufficient margin of time, except in exceptional circumstances, for using this ordinary means of transport. Mr Burgess isn't the most extravagant on taxis, but the taxis on the 15th and 29th appear quite unreasonable, since he lives in Bentinck Street.[24]

As always there was an explanation. 'What, in fact, happened was that in one case I walked some way with Brooks (15/12) and in the other I dropped him at his house (taxis being in short supply) (29/12). In the second case I have only charged a proportion of the taxi fare to the Corporation since I do not normally take taxis to Bentinck Street.'[25]

Concerns that Burgess was exploiting the BBC rumbled on, with further queries from BBC Administration that Burgess was rather too generous in terms of his entertaining of potential speakers at the cost of the taxpayer, and his habit of loaning BBC secretaries to type out MPs' scripts. 'To take the two questions separately, as regards expenses I feel that nearly £11 in a month, the bulk of which is entertaining of one sort or another in connection with the House of Commons is far too high. I realise that a certain amount of drinking at the bar is inevitable, but I cannot believe that it is not possible to do business with responsible MPs except at the bar.'[26]

Burgess's colleague dealing with administration, G.J.B. Allport, noted that many of the same names kept cropping up, such as Quintin Hogg:

> while there is almost continual entertaining to lobby correspondents, and I must say I do not quite see how they fit into the picture as between Burgess and prospective speakers . . . I do not know whether it is my business to say this, but I feel sure someone will be asking before long whether it would not be better to have a rather older producer in charge of this series. I should rather have thought that this was the one series above all others where the art of salesmanship

in the sense of selling the BBC to its prospective speakers was not required.[27]

The disputes over expenses continued throughout the year. In August he was authorised to spend up to £1 a week on entertainment whilst parliament was sitting. When Burgess claimed that some weeks he didn't go to the Commons, other weeks he was there all the time, and wondered if he could carry the allowance forward, the frosty response was that this was 'not in the spirit of the authorisation'.

When, at the end of October, Burgess went to Cambridge to give the tribute at the memorial service for John Hilton, who had died in August, and took taxis to and from Liverpool Street Station and within Cambridge, it did not go down well at the Corporation. Burgess was furious:

> If you will refer to your papers, you will see that in the past I success-fully established the principle of travelling first class when at work, under wartime conditions, on Corporation business. I think you will find this on your predecessor's minutes. I normally travel first class and see no reason why I should alter my practice when on BBC business, particularly when I am in my best clothes to attend a service.[28]

Allport was not convinced, however, stating 'there is no case for Mr Burgess travelling first class on an occasion such as this'. He added, 'Incidentally, could Mr Burgess be requested not to write memoranda on the backs of expenses sheets?'[29]

Even when Barnes warned Burgess that, if he went ahead with an appeal on the rail travel, it 'would probably do me serious harm and end up on my personal file', Burgess refused to budge. 'I hope it's not necessary to put on record that I am not anxious to waste time or cause trouble, and that since the financial sum involved is so small, it is surely obvious that I am arguing on a point of prin-ciple.'[30] It was an indication of how far Burgess would push, when others would have made a strategic retreat.

The episode doesn't appear to have affected Burgess's annual confidential report from Barnes, who approved a grade increment and wrote, 'I have little to add to my report of 27/11/42. He is as full as ever of ideas, he shows signs, faint signs, of a growing sense

of responsibility, though he still writes and speaks before he thinks. A bit of a sea-lawyer on matters of administration, but yet a valuable member of the department.'[31]

By 1944 the government was beginning to think about the post-war world, not least the importance of propaganda. Harold Nicolson, a former diplomat, foreign affairs expert and broadcaster, was consulted, and he recommended Burgess be approached. As a recognised propaganda expert from his days in Section D and the JBC, and with good political connections, it is not surprising that Burgess should be asked. At the beginning of January 1944, he and Barnes met Sir William Ridsdale at the News Department of the Foreign Office to discuss plans to develop post-war propaganda. The discussions continued the following month, when Burgess, Ridsdale and Nicolson dined at the Moulin d'Or restaurant to discuss plans for post-war talks on foreign affairs at the BBC.

In fact these discussions had been going on for much longer. In May 1943 Burgess had approached Ridsdale, with whom he had liaised at the Ministry of Information as well as the BBC, making suggestions on foreign affairs programming, and in particular controversial subjects such as Poland.[32] On 4 March Burgess gave his three months' notice to Barnes, saying he had been offered a job in the News Department of the Foreign Office. This was part of a careful plan. The News Department had been blunting the almost totally pro-Soviet line of the Ministry of Information and the Russians needed someone to address that. Burgess was felt to be just the person.

At the end of March, Sir Alexander Cadogan, the Permanent Under-Secretary at the Foreign Office, wrote directly to Robert Foot, the BBC Director-General, an indication of how important the transfer was believed to be, asking if Burgess could be released early, as the News Department was short-staffed:

> I understand that Mr Burgess of your Talks Department is interested in this vacancy, and from our point of view he would appear to be well qualified to fill it. I fully appreciate that he is doing most valuable work with the British Broadcasting Corporation and I fear that his release may inconvenience you. But as I have said, our own need is great, and we should therefore be most grateful if you could see your way to facilitate his transfer to us.[33]

Though Barnes told Maconachie he couldn't spare Burgess, he agreed to a one-month notice period, adding, 'I agree with you that it would be useless to keep Burgess against his will, but his mind is by no means made up, and I have told him that if he stays he would handle the proposed foreign affairs series. He has promised to let me know by 2.30 tomorrow whether he means to resign.'[34] But Burgess's mind had been made up. At the end of March, he gave formal notice to Barnes asking to be released early and offering to work part-time. 'Personally, it will be a real grief to leave the department and the division. I should like to emphasise this very strongly. Also to say that I should like to give any assistance that may be possible in the future to the department if this should be found useful.'[35]

Reluctantly the BBC agreed, on the understanding he stayed until 4 June, but could work two hours a day at the Foreign Office to learn his work there. In a memo to the Director-General, Maconachie wrote, 'Mr Burgess is a very good producer and, although he has his failings, will be a serious loss to the Talks Department.'[36]

Burgess's career at the BBC was now over. Following in the footsteps of Donald Maclean and Kim Philby, he had manoeuvred himself into the Foreign Office. He knew this was where the real power lay.

19

The News Department

Burgess officially started in the News Department, then based in the Ministry of Information, on a temporary posting as a press officer, at the beginning of June 1944, though he had taken most of May off from the BBC as holiday entitlement and had been working two days a week at the Foreign Office from 1 May.

The Department had been headed since 1941 by William Ridsdale with a staff of ten, who all worked in a large room on three long tables. Alan Maclean, brother of Donald, who worked alongside Burgess, remembered:

> There was also a small room leading out of the arena which boasted of desks and telephones, a Reuters ticker-tape machine which chatted out hot news and round-ups from all over the world, and a safe for the daily batch of incoming telegrams. One of us came in early to read through them and mark up the interesting bits. There was hardly room enough for us all to be in the room at the same time but we had no need of desks of our own and no paperwork. All our work was done on the telephone or face-to-face and we travelled very light.[1]

Ridsdale himself conducted three briefings a day. At 12.30 p.m. the diplomatic correspondents of the *Manchester Guardian*, Reuters, the *Daily Herald*, the BBC and the *News Chronicle* would gather for a briefing on whatever subject they chose. There was a further briefing at 3 p.m. and then one at 4 p.m., when *The Times* diplomatic correspondent had his own private briefing. For the rest of the staff, Alan Maclean later wrote:

> The Twelve Thirty was the central point of our day. A short list of 'topics' was made up first thing in the morning after someone had done an

early trawl through all the morning newspapers. We could make an educated guess at what would be the main stories on which we might be asked for a reaction. If the Department concerned authorised a formal statement which could be attributed to a Foreign Office spokesman, we all had a copy to keep handy. But the Twelve Thirty was a free for all and everything said by the man in the chair was on the record.[2]

Burgess's job was to liaise with foreign editors, diplomatic correspondents and London correspondents of the foreign press, explaining government policy and reacting to events in the news, but sometimes he would have to take the press conferences in the absence of a more senior figure. It meant that everyone on the staff, including Burgess, spent the morning being briefed on the expected news of the day, or reading Foreign Office telegrams. As events unfolded, the News Department would obtain the Foreign Office opinion from the relevant expert, a statement would be agreed and then released to the press. It also meant that Burgess saw almost all material produced by the Foreign Office, including telegraphic communications both decoded and encoded, with keys for decryption, which would have been invaluable for his Soviet handlers.

This was a post for which Burgess was admirably suited, given his wide range of journalistic contacts and interest in politics. As Goronwy Rees later wrote:

> He liked the feeling of having an inside knowledge of British foreign policy and the considerations out of which it emerged. He liked expounding that policy to others, and employing all his ingenuity in showing that British policy was rational and coherent and corresponded to long-term historical interests. He liked and understood journalists, and sympathised with them, because he shared their passion for news, and he enjoyed being on intimate terms with them and exchanging with them that kind of backstage political gossip which was the breath of life to him.[3]

The recollections of most his colleagues are not, however, so flattering. William Hermondhalgh, who on inheriting Burgess's desk found the middle drawer locked and inside a bottle of gin and a book on flagellation, remembered him as always wearing his OE tie. He was 'left-wing, but I didn't realise a communist, pale-faced . . .

145

grubby and slovenly and constantly chewing garlic, which he thought good for his health'. Often, Hermondhalgh noted, Burgess would disappear to the Reform for lunch and return drunk, but even then he had a prodigious memory. He also noticed Burgess would use make-up in the morning if he'd had a particularly bad night. 'Unreliable, often late, louche, but always engaging, Burgess wanted to be the insider and have power over others.'[4]

The cartoonist Osbert Lancaster, who also worked alongside Burgess, thought him, 'Disastrous, unadulterated hell. A fabulous drunk. Very intelligent until six in the evening. He had charm and had been very good-looking, but the booze had done its work. When he was in his cups, he made no bones about working for the Russians.'[5] Another colleague, Richard F. Scott, son of the *Guardian* editor C.P. Scott, recollected, 'He smoked incessantly. He was very dirty. When he wished, he had considerable charm, but he was not an easy colleague . . . He was a Bolshie in both senses of admiring the Russians and being bolshie in everyday life.'[6]

Lord Arran remembered Burgess stopping a cab outside Buckingham Palace to symbolically urinate against a statue and how he took the role of licensed jester, often enlivening boring news briefings by handing around half-naked pictures of his latest male conquest.

Peregrine Fellowes, father of the writer Julian Fellowes, claimed that, 'Some of the stuff he and Burgess had to decode and analyse was top secret and they used to have to do it in a locked room, where no one could interrupt them. There, Burgess used to sit on top of a kind of safe – or security cupboard – and read out the frequently hilarious messages in a variety of comic voices making [Peregrine Fellowes] howl with laughter.'[7] Alan Maclean summed him up. 'Guy knew everybody. He was notorious. He liked trouble. He enjoyed being scandalous . . . Guy tended to cause chaos wherever he went and delighted to do so . . . He was clever enough to realise he couldn't be top, so preferred to be bottom . . . He was very clever. His opinions were always very interesting.'[8]

In a department that was busy and short-staffed, Burgess quickly made himself useful, offering to work Saturday afternoons, when no one else was around, and by August had received permission from Ridsdale to take documents home at night. He made good use of

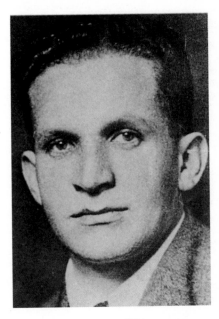

Arnold Deutsch, 'Otto',
recruiter and first handler
of the Cambridge Spy Ring.

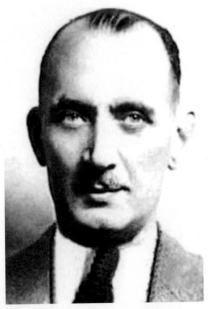

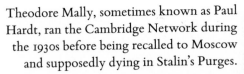

Theodore Mally, sometimes known as Paul
Hardt, ran the Cambridge Network during
the 1930s before being recalled to Moscow
and supposedly dying in Stalin's Purges.

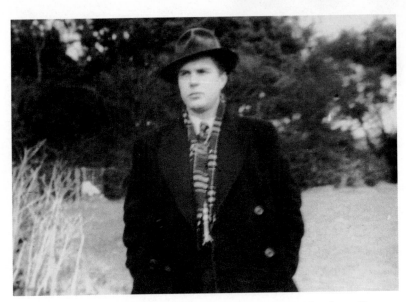

Yuri Modin, Guy Burgess's handler from 1947-1951 with whom Burgess
remained on close terms until his death, pictured in 1950 at Box Hill.

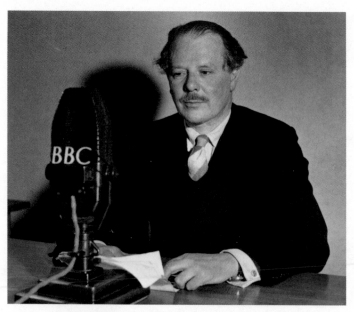

Harold Nicolson, husband of Vita Sackville-West,
lover and mentor of Guy Burgess.

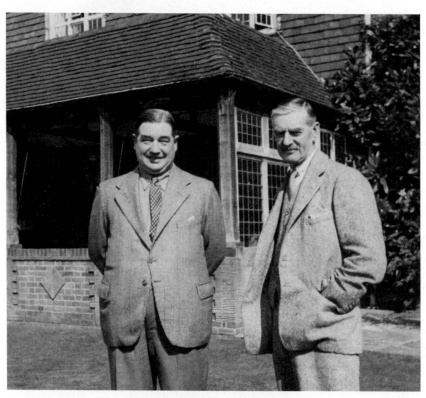

Prime Minister Neville Chamberlain with Joseph Ball, the MI5 officer
who ran Guy Burgess on various secret missions on behalf of the
British Government before and during World War Two.

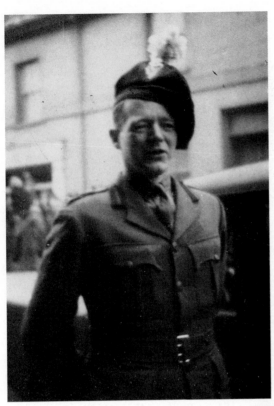

Jack Macnamara, homosexual Conservative MP for whom Burgess worked in 1936 where 'his duties combined those of giving political advice and assisting him to satisfy his emotional needs.'

Edouard Pfeiffer, chef de cabinet to Edouard Daladier, sado-masochist and a leading member of the French scouting movement.

Esther Whitfield, secretary and mistress of Kim Philby and one of Guy Burgess's closest friends, whose life was destroyed by her association with the two men.

Rosamond Lehman, writer and friend of Guy Burgess with whom he often stayed but who refused to let him seduce her gardener.

James Pope-Hennessy, biographer of Queen Mary and lover of Guy Burgess with whom he picked up young men in the pubs of Soho.

Clarissa Churchill, niece of Winston Churchill who married Anthony Eden in 1952. The Russians urged Burgess to seduce her.

Advertisement for The Gargoyle Club, haunt of Guy Burgess.

Eric Kessler, Swiss diplomat journalist and lover of Guy Burgess whom he ran as an agent for MI5 having previously recruited him as a Russian agent.

Andrew Revai, Hungarian journalist and another Guy Burgess lover who was run by him for both MI5 and the Russians. Later a gallery owner and friend of Anthony Blunt.

Guy Liddell, outstanding cello player and long-serving MI5 officer, for whom Anthony Blunt worked, whose career was tarnished by his association with Guy Burgess.

Kemball Johnston, wartime MI5 officer, who ran Guy Burgess as agent Vauxhall. Burgess was god-father to one of his children.

Dick White, the only man to have headed both MI5 (1953-1956) and MI6 (1956-1972), who oversaw the investigations into 'The Climate of Treason'.

Victor Rothschild, MI5 officer during World War Two. Guy Burgess was paid a retainer by the Rothschild family in the 1930s ostensibly for financial advice but more likely for political information. He rented a flat in Bentinck Street from Rothschild 1941-1945.

Ernest Bevin with his Foreign Secretary deputy Hector McNeil (standing to his left), February 1947. McNeil was Guy Burgess's boss and protector.

Guy Burgess cartoon doodled in 1948 when attempts were being made by Hector McNeil to contact Foreign Secretary Ernest Bevin who was holidaying off the South Coast.

the freedom. That month he supplied telegrams from Duff Cooper, then the British representative on the French Committee of National Liberation in Algeria, suggesting the creation of a strong Poland to counter-balance the Soviets, though the Foreign Secretary, Anthony Eden, insisted that British policy must continue to be co-operation with the Soviet Union.

On 1 Sept the *rezidentura* reported that 'MADCHEN has for the first time brought a large number of authentic materials. We have photographed ten rolls of film, six of them decrypted telegrams',[9] and the following month, Boris Merkulov, the Commissar for State Security, authorised a £250 bonus to Burgess as he was so productive. Moscow Centre's suspicion of their Cambridge agents was over. It had been a massive miscalculation, based on ignorance of how British Intelligence worked. By 24 October the Centre was reporting that 'in the course of only several months, MADCHEN has become the most productive source . . . now he gives most valuable documentary material'.[10] Six weeks later, the *rezidentura* was asking of their Cambridge spy, whose codename had been changed, 'whether HICKS uses sources unknown to us, because information received from him is wide in scope and deals with a variety of questions'.[11] According to one of the files examined by Mitrokhin, of the Foreign Office documents provided by Burgess in the first six months of 1945, 389 were classified 'top secret'.[12]

An indication of the quality of intelligence Burgess was now supplying can be seen in Harold Nicolson's diary entries. In February 1945 he wrote, 'I dine with Guy Burgess, who shows me the telegrams exchanged with Moscow. It is clear that the Ambassadors' Commission is not to be a farce in the least.'[13] The Commission, which consisted of the Soviet foreign minister Vyacheslav Molotov and the British and American ambassadors in Moscow, was to settle composition of the new Polish Provisional government. It's clear from the fact that Nicolson saw them that Burgess had access to Foreign Office cables between London and the Moscow embassy, and was able to remove them and pass them to Moscow, allowing Molotov to be well-briefed in negotiations. On 4 March, Burgess's Soviet handler Boris Kreshin, 'Bob', reported he had brought several Foreign Office telegrams and 'had also written an agent's report on the procedural conduct of debates in parliament on the Polish question'.

But Burgess was becoming careless. In March, Kreshin reported 'a rather unpleasant incident' to the Centre:

Recently I have been meeting HICKS in the street. But on 4 March it was raining and HICKS suggested going into a pub for a short while. We went inside where we spent no more than fifteen minutes. Having left the pub, I noticed that HICKS was picking up materials on the floor. Without entering the pub I waited in the street until HICKS came out. He announced that when he had approached the door, the ZAKOULOK [Foreign Office] materials had fallen out of his briefcase onto the floor. The telegrams had fallen face downwards and nobody paid attention, because the door was screened from the pub by a curtain. Only one telegram had become dirty. HICKS claims that he thoroughly inspected the place and not a single document remained on the floor.[14]

Kreshin delivered a lecture on personal security, but when Burgess returned to collect the copied documents with his briefcase tied up with string, he dropped them again. 'It was good that there was no one else in the lavatory and the floor was clean,' Kreshin commented dryly'.[15] Shortly afterwards, at a meeting with 'Bob', Burgess was 'approached by a police patrol, who suspected that the bag contained stolen goods. Once reassured that the two men had no housebreaking equipment and that the holdall contained only papers, the patrol apologised and proceeded on its way.'[16]

The material he was supplying was dynamite. A report of the meeting of 4 March listed amongst much else: a report by Burgess on the debates in parliament on the Polish question, telegrams on the San Francisco Conference the following month that set up the United Nations, and the British position on the division of Germany, which went against what the American delegation had proposed at the Yalta Conference a few months before. A May 1945 Chiefs of Staff report for General Ismay, which set out plans for war between the British Empire and Soviet Union – Operation Unthinkable – was passed to Moscow, probably by Burgess. The report accepted a three-to-one superiority of Soviet land forces in Europe and the Middle East, where the conflict was projected to take place, but did nothing to allay Russian suspicions that the wartime alliance was clearly over.[17]

During the autumn, Burgess accompanied Ridsdale to the Paris

Peace Conference, which prepared the draft peace treaties with Italy, Romania, Hungary, Bulgaria and Finland, staying in the Hotel George V. Ridsdale attended many of the meetings where policy was being formulated. Alongside him was Burgess.[18]

In June, Churchill had forbidden a delegation of eight British scientists from travelling to Moscow for the twentieth anniversary of the Academy of Sciences of USSR, confirming Russian concerns that relations were becoming increasingly hostile and suspicious – information Burgess duly passed to the Russians.[19] The opening shots of the Cold War came with two important defections in September 1945 – defections that revealed the full extent of Soviet espionage against the West while supposedly allies, and threatened the whole Cambridge network.

On 5 September Igor Gouzenko, a twenty-six-year-old cipher clerk at the Soviet embassy in Ottawa, appeared in a Canadian newspaper office with a shirt stuffed with secret documents revealing a major spy network in Canada, and that the highly secret atomic bomb project had been betrayed. Gouzenko worked for Soviet military intelligence, GRU, and therefore knew nothing of the Cambridge Ring. However the other defector did.

On 20 September an agitated Burgess delivered an urgent message for Moscow Centre, which Philby had hand-delivered to him at the Foreign Office, saying that in late August an NKGB officer stationed in Turkey, Konstantin Volkov, had contacted the British vice-consul in Istanbul seeking an appointment. After he had no response, Volkov, deputy chief of Soviet intelligence in Turkey, had presented himself at the embassy on 4 September and in return for political asylum for himself and his wife and £50,000 (almost £2 million today) offered a list of 314 Soviet agents in Turkey and details of a British one, fulfilling 'the duties of the chief of an otdel [department of the English counter-intelligence directorate] in London' – almost certainly Philby.[20]

The revelations were passed to the British head of Soviet counter-espionage, Kim Philby, who immediately saw that Volkov could expose him, Maclean and Burgess. He arranged to go to Istanbul to deal with the walk-in, but he deliberately took his time. By the time he arrived on 26 September, Volkov and his wife had been exfiltrated to the Soviet Union, and executed. It had been a close call.

20

Relationships

Peter Pollock had been taken prisoner of war at Anzio in March 1944. Burgess, deeply concerned, had lobbied hard through Eric Kessler for Red Cross parcels to be sent to him. He had also during this time taken Pollock's two sisters, Gale and Clare, under his wing, at one time even thinking of marrying the latter. Then aged eighteen, Gale Pollock remembers Burgess calling to invite her to the Ritz:

> He was terribly nice and continued to be terribly nice. He was very concerned for me. He took me to the theatre a lot and the Gargoyle and a restaurant, Garibaldis . . . Guy knew everybody. We saw a play, 'Uncle Harry', and met Michael Redgrave afterwards. He was so nice and would include me in everything . . . He had a great capacity for enjoyment. He enjoyed himself and was always welcoming . . . very amusing, concerned, extravagant . . . he wouldn't mind spending other people's money with no intention of ever paying it back . . . he was especially fond of Clarissa (Churchill) and very flirtatious with her.'[1]

In the spring of 1945 Peter Pollock returned to Britain. The prospect of a career in Midlands light engineering with the family company did not appeal, and instead he bought a farm at Flaunden, in Hertfordshire. Sharlowes was a large medieval open-hall house with cross wings dating from 1500, and here he took up pig farming, greyhound breeding and 'in the lazy summer afternoons, idling through the leafy Hertfordshire lanes in his vintage Rolls'. Frustrated by his own lack of creative achievement and with a passion for the arts and the company of artists, on Sundays he provided open house for painters, writers, actors and actresses.[2]

Burgess would come down to Flaunden on alternate weekends and would often drink at the seventeenth-century Green Dragon

pub – a haunt during the 1930s of Joachim von Ribbentrop, who had a weekend home nearby – run by Bob Burgess (no relation), where Mrs Green, Bob's daughter, remembers Burgess as 'an interesting man and very good-looking'.[3]

The actress Fanny Carby, a friend of the Pollock sisters, was one of those who attended these weekend gatherings. 'He loved coming down. He liked to be cosy. Though he led a decadent life, he loved to sit around the fire at the farm. He liked people making cups of tea and pie crusts . . . He was terribly likeable. He had a charisma, a sort of fatal fascination. It wasn't just charm. You were always so glad to see it was Guy. He was never cold or moody, but he was a bit sad and very jealous.' She recollected terrible rows with Pollock over whom he had a hold. In turn, Burgess would tell her that Pollock was the only person with whom he claimed he ever fell in love. 'He was a very corrupt person. Everyone thought he had corrupted Peter.'[4]

That summer Pollock and Burgess had seen much of Brian Howard and his boyfriend, Sam, staying with the couple at their home in Tickerage, East Sussex. On one occasion they had visited the elderly Lord Alfred Douglas in Brighton, as Burgess wanted to show off Pollock and prove he was even more attractive than the famously attractive Douglas in his youth.[5]

On 26 July as the General Election results and a Labour victory were being announced, Burgess and Peter were staying with Barbara Rothschild, but their relationship was faltering.[6] As Pollock later remembered, 'Age differences and sexual incompatibility caused the final breakup. We'd had nearly four years apart. By 1945, given the life I had in those years, I was a completely different person.'[7]

Brian Howard was sad to hear the news, writing to Peter:

> Guy tells me that he and you have parted for good. If, as you may, you feel disinclined to talk about it, we certainly will not. But I admit to an almost selfish distress, because I had somehow convinced myself that nothing would or could go wrong with you both. I had begun to regard it – and in a sense – depend upon it as a supremely satisfactory disproof of the vulgarian theory that 'that sort of thing' never works. This is why I say that my distress is 'almost' selfish.[8]

Reflecting on the difficult love lives of their circle, Brian Howard wrote to Pollock:

> We all of us – all five [Burgess, Blunt, Howard, Pollock and Eric Kessler] – share a certain emotional point of view about life that makes it not twice, but ten times more difficult for us to lead a happy and fruitful existence. We are haunted, day and night, whether we realise it or not, and not only by immaterial fears and enemies. There are certain sensitive, prudent and strong-minded people of this kind – like K[essler] and B[lunt] – who come to find their position finally impossible . . . O what do they do? They take to their careers exactly as fugitives take to the hills, and thence forward they consider themselves on a higher level, that level can be very barren, and very sad . . .[9]

Burgess and Pollock were both members of the Reform Club and the possibility of their running into each other there now became an issue for Burgess. '. . . the Club is a second home to me, a place I go to daily to meet my friends, work, read etc. I know what a sacrifice it has been to you not to come. But it means so much more to me than it can to you that, honestly, I'd rather still say what I've said all along, which is please don't come till we have firmly established in practice that we can meet happily and easily.'[10] Noel Annan often saw Burgess at the Reform. Even then:

> He had the most remarkable way with him . . . In those days he didn't look dirty, but more like those drawings in Billy Bunter – he was full of jokes and ideas, bubbling over with theories . . . he had a magical quality, but could be withering if one did not fall under his spell. He could make a cutting and wounding remark, but would then shrug it off quickly. He wanted to dominate.[11]

Domination, especially intellectual, and manipulation were a strong part of Burgess's character. He was known for 'his seemingly inexhaustible supply of acid metaphors and devastating epigrams [which] could effortlessly reduce his critics to ashes', remembered Hugh Trevor-Roper. His self-confidence enabled him to 'command his little Cambridge world.'[12] Modin had likewise noticed that he was 'an authoritarian young man, perfectly capable of bending others to his will and dominating them, even as he remained tolerant and understanding of their difficulties'.[13]

Through force of personality and sheer stubbornness, Burgess had been used to having his own way since he was a child and that did not change as an adult. Rees thought:

> he was the most persistent person in achieving his own ends that I have ever known. If one went to the cinema with him and wanted to see Greta Garbo, while Guy wanted to see the Marx Brothers (and he invariably did want to see the Marx Brothers), it was always the Marx Brothers whom one saw . . . If one wanted to drink white wine and he wanted to drink red (and he always did want to drink red), it was always red wine that one drank. He was persistent as a child is persistent, who always knows it will have its own way if it is willing to behave badly enough; and Guy always was willing to behave badly enough. And in this persistence there lay a formidable power of the will, which because of the general disorder and absurdity of his personal life, for the most part went unnoticed.[14]

Burgess needed to be the centre of attention and saw himself as the controller of all his networks, whether espionage or homosexual. 'He really did not like to think that anything was ever happening anywhere in which he was not in some way involved', Rees later recalled. 'It was as if, in reality or in his own imagination, he was always searching for the human vices and weaknesses which might explain any public event, and which he might one day have an opportunity to exploit.'[15]

'Surely the thing about Guy is that he has an imperative need to impress,' Peter Watson wrote to Brian Howard. 'I met him at the Reform yesterday, and he told two long and funny stories (political, of course – one about Churchill) and then said he had invented them!'[16]

During 1945 Burgess had moved to 26 Medway Street, a block of interwar red brick flats close to the Houses of Parliament and Whitehall, where he lived until 1947.[17]

Though they had broken up, he and Pollock continued going on holiday together, sometimes with Brian Howard and Sam to north-west Sutherland, in Scotland, or the four of them would see Billy Clonmore, the 8th Earl of Wicklow and part of the Evelyn Waugh and John Betjeman Oxford set, in Dublin.

Writing to Peter in July 1946, just after one of his regular trips to Dublin, Burgess said he was just off to see a Marx Brothers film

with Blunt. 'I seem to have had a very nice week indeed. Either Dublin food has improved my outlook or the weather . . . but somehow I've had 2 good times with Dennis P, 2 good times with David F, including one brilliant music hall. A very nice day with Goronwy, Margie and the Kids (last Sunday) and Philip Hope Wallace. Also nice parties with Blunt & Hunter (who is nice). I wish you'd been here to share some . . .'[18]

The following month, he wrote to Pollock about holiday plans, now that his mother's 'private aeroplane trip to Tangier' was full, suggesting the group travel to the United States separately – Pollock with Lawrence, a friend, and Burgess with Johnny Philipps, a rich gay bachelor who lived in Albany. He claimed he had refused other invitations, so was free for Pollock in October, otherwise he would stay with the Rees's, who had been lent a house in Wales. Another option was going to a hotel on the Swiss part of Lake Maggiore, close to 'a lovely villa inhabited by a rich queer, Norman Douglas Batchelor (who I know)'.[19] 'Now please don't make difficulties. I only have one precious holiday a year. I know that I like travelling with you, as I do with Anthony, and you told me (in the Gargoyle) it was the same with you. This is not a question of love, but of a lovely plan we'd both enjoy for a fortnight or so.'[20]

Burgess and Pollock did go on their American holiday and continued to remain close friends, but with Pollock now happily settled with Paul Danquah, Burgess remained as unsettled and restless as ever but he was about to receive a promotion that would place him at the heart of British foreign policy.

21

Back at the Centre of Power

On 19 December 1946, Harold Nicolson wrote in his diary, 'Dine at Travellers with Preston and Burgess. Burgess been appointed private secretary to McNeil.'[1] Burgess's cultivation of the young Scottish politician Hector McNeil had paid off. The two men had stayed in close touch and Burgess had recently ghosted McNeil's chapter, 'The Labour Party's Foreign Policy Between the Two Wars', in Herbert Tracey's history of the Labour Party. McNeil, from his modest provincial background, though some four years older, rather looked up to the urbane Burgess. The two men, both heavy smokers and drinkers, shared an interest in London's seedier side and it is not fanciful to imagine that Burgess may have exploited McNeil's particular interest in topless night clubs. Certainly he was to become an important protector of Burgess.

When McNeil was appointed a Minister of State in the Foreign Office in October, he quickly sought to appoint Burgess as a super-numerary personal assistant, speech writer and as a general political dogsbody. He was attracted by Burgess's range of contacts, his intel-lectual brilliance, apparent sophistication and his independence of mind. According to Norman Reddaway, private secretary to Christopher Mayhew, who was Parliamentary Private Secretary to Ernest Bevin, McNeil wanted Burgess because he believed he understood left-wingers and Russians.[2] Lord Thurlow thought McNeil felt inferior for not having been at university and was uncertain of himself with Foreign Office people. He wanted a personal assistant who was not a career diplomat and had broad political and journalistic experience. As if confirming such a suspicion, the Foreign Office were opposed to the appointment, but they were the orders of a minister and, sensi-tive to class politics, they had no choice but to agree.[3]

This was a huge opportunity. Reporting his coup to the Russians, Burgess explained that the routine office work would continue to be looked after by the Foreign Office private secretaries, and his role would be the:

> formulation of policy by the study of documents and by personal contacts and conversations with other officials and also with politicians both British and Foreign. There will also be opportunities for direct co-operation with the Secretary of State's Office. He also wishes me to spend a certain amount of time in the House of Commons. It would, I think, be wrong if I did not say that in my opinion great opportunities are opened to us by this transfer. Apart from telegrams which I shall continue to see, I shall hope to be able to see those minutes and private letters (e.g. from and to Ambassadors) which describe the inception and formulation of policy and to be present at, or aware of, conversations in which future decisions are canvassed and discussed before being arrived at . . . As I say, I think this appointment is to one of the most desirable central positions in the Foreign Office and I should welcome any instructions as to how to make the fullest use of it and in what manner it can be turned to our best advantage.[4]

Highly regarded, McNeil often deputised for Bevin but he was also lazy, preferring to go to:

> Restaurants, or films, or plays to working at his desk. Guy immediately grasped this and took advantage of it, doing McNeil's work for him without complaint. When McNeil was asked to draw up a report or analyse a set of classified documents, the job was passed straight to Guy, who was only too happy to oblige. When everything was typed up and ready, all McNeil had to do was sign it and send it on to his colleagues in the government, or to the Prime Minister. In consequence, Burgess was held in deep reverence by his grateful boss, who directed him to keep track of all the reports and telegrams proceeding from the post-war international conferences then under way.[5]

Though Foreign Office officials disapproved of the appointment of someone who wasn't part of the Foreign Office and thought it most irregular, it was an appointment befitting the new Labour government, who wanted to do things differently. Burgess acquitted himself well, arriving punctually at work and seldom missing appointments. The only black mark against him was his untidiness in both dress

and of his desk, with its overflowing ashtrays. 'Confidential papers were strewn over it like confetti, yet he could easily retrieve anything wanted urgently by burrowing like a squirrel beneath the daily newspapers and his drawing pad, on which he would sketch libellous caricatures of any subject that momentarily took his fancy.'[6] Tom Driberg later wrote:

> As an historian [Burgess] had always been fascinated by the idea and character of the eminence grise, the shadowy but influential figure lurking at the elbow of the public man. He liked the company of eminences grises. I have little doubt that, perhaps half-consciously, he saw himself, too, as McNeil's personal assistant in this role. As Minister of State, McNeil held Cabinet rank. In the absences abroad or through illness of his chief, Ernest Bevin, he often had to act as Foreign Secretary. At last, at the age of thirty-six, his steady inner purpose and his calculations, assisted by a series of fortunate chances and coincidences, Guy Burgess was indeed near to the very centre of power.[7]

It had indeed brought him to the heart of the British government at a crucial juncture in twentieth-century history, giving him access to almost all papers that came to the Foreign Office ministers, including the minutes of meetings of the Cabinet, the Defence Committee and the Chiefs of the Imperial General Staff, and the positions of Western countries on the post-war settlement in Europe and Britain's military strategy. He also took advantage of the daily afternoon tea party in the ambassadors' waiting room, fifty yards from McNeil's office, to pick up all the latest gossip and expand his network of contacts.

The Centre was thrilled by Burgess's new access and Kreshin was made personally responsible for translating his communications and, on the order of General Fedotov, the number of people initiated into the HICKS case was limited to no more than five. Security was so tight that even the typists had no access to his material.

Burgess worked alongside Fred Warner, a career diplomat. Seven years younger and six feet five – some six inches taller than Burgess – Warner had also been educated at Dartmouth and had joined the Foreign Office from Oxford and after service in the Royal Navy. A man about town with independent means, he lived in Albany, a fashionable set of apartments off Piccadilly, and he and Burgess

quickly became close friends. The two men shared a small, high-ceilinged room overlooking Downing Street, between the minister and a room with clerks, acting as gate-keepers between the Foreign Office and the minister.

Goronwy Rees remembered the two men 'facing each other across an enormous desk littered with an assortment of official papers and a large selection of the daily press, of which Guy was a devoted and assiduous student. There would also be a few volumes from the London Library, a few sketches and caricatures which Guy had tossed off in the course of the day . . . overflowing ashtrays, burned-out matches and empty cups of tea . . .'[8]

Rees added, 'Messengers entered, looked vainly for in-trays under the deluge of paper, and dropped their files wherever Guy indicated with a negligent gesture of his hand. Some of the files, marked URGENT, one of the two would occasionally pick up and glance at for a moment, with a look of distaste, and as hurriedly restore to its appointed place among the debris.'[9]

The private secretaries had access to almost anything they wanted, including cables from embassies and foreign governments, reports from various sections of the Foreign Office and Cabinet papers. All communications destined for the Minister of State first passed through the hands of Burgess and Warner, who decided if they should be passed on, or if additional information was needed. They might then summarise the document, highlighting the most important parts and perhaps draft a response. They were also in a position to make suggestions and their influence was therefore enormous.

The writer Andrew Boyle claimed that Burgess had access to the office safe and all the secrets of State:

McNeil liked him, humoured and pampered him, accepted his under-graduate wit and flashes of erudition in the mistaken notion that the department, the government, and the public were the beneficiaries of his own astuteness in selecting this exceptional personal assistant. Burgess had the complete run of the inner sanctum. If he needed the minister's keys, he asked for them. If *he* wanted access to classified files, he secured the necessary authorisation without question by saying that *his minister* wanted such-and-such at once.[10]

This was important, as McNeil was the minister liaising with MI6, who sent him their reports in small yellow boxes, but it is not clear if Burgess ever took advantage of this access. It was not until the end of March 1948 that he managed to obtain a duplicate key, either through McNeil or Warner, having smuggled it out to the *rezidentura* through Blunt. Within weeks however, he had returned the duplicate to one of his Russian case officers, explaining that though he was often alone with the boxes, the risk of opening them was too great.[11]

Warner and Burgess were drawn together by similar louche life-styles and lack of respect for authority. When McNeil would ring his bell, 'the peremptory summons would normally be greeted by some such words as:

"Oh Lord, there's Hector again."

"What on earth can HE want?"

The two men would wait to see if the minister would ring again and if he did not they would agree that it couldn't have been important. All this was a reflection of Guy's basic attitude that established institutions were created for his own convenience and use.'[12]

On one occasion, Goronwy Rees remembered, Burgess led his visitor out of McNeil's office and into a large ornately furnished room where the Foreign Secretary presided on formal occasions. At one end of the room stood a bookcase of reference books, among which was one precious volume that Burgess kept there 'out of harm's way' so that nobody – not even Bevin – would borrow it and then 'fail to return it'. It was a copy of the recently published Kinsey Report on the sexual activities of the human male, then unobtainable in Britain, which Burgess had promised to lend him. '"I had to hide it somewhere safe," he said. "Everyone's trying to get hold of it."'[13]

As a result of his new job, Russian contact with Burgess, which ironically had been halted just as he took up his post, resumed at the beginning of 1947, after special permission by the Minister for State Security, Colonel-General Viktor S. Abakumov.[14]

Within days of taking up his post, Burgess had supplied two documents from the Russia Committee, a Foreign Office committee that dealt with all aspects of policy towards Russia. It reported that Bevin and the Cabinet were about to decide 'whether to extend

Great Britain's present hostile relations with the governments of the countries which he calls Soviet satellites (Poland, Bulgaria, Romania), and whether Great Britain should maintain its present policy of support for the opposition, or whether the time has come to recognise Soviet influence and cease the fight against it'.[15] Further documents followed, including various ministerial minutes on German post-war political and economic reconstruction, notably from the Overseas Reconstruction Committee, chaired by Ernest Bevin.

At the beginning of March, Burgess met his Russian handler with details on the four-power conference of foreign ministers in Moscow, which was to take place over the next six weeks. The Council of Foreign Ministers had been created at the Potsdam Conference in 1945 and included representatives from each of the four occupying nations, with meetings rotated among the capital cities of the four powers. The Moscow Conference would deal with issues such as the future government of Austria and Germany, reparations and boundaries, and the negotiating position, and Burgess provided it, helped unwittingly by Edward Playfair, a member of the delegation.[16] It was also an opportunity to meet Kreshin's replacement, Mikhail F. Shishkin (ADAM), operating under press attaché cover at the embassy. So pleased were the Russians by Burgess's documents that Abakumov was authorised to pay a bonus of £500 – almost a year's salary.[17]

Squadron Leader Richard 'Dickie' Leven often encountered Burgess at the Reform. 'He always seemed to make a point of talking to me, although I found his approach was rather oppressive. I never could understand why he always wore the Old Etonian tie, no matter what clothes he was wearing.' One evening they had an argument over rumours Russia intended to invade Yugoslavia. 'Guy Burgess surprised me by declaring, "I am the adviser to the British government on Russian affairs and the government will do as I advise." I replied at once that if this was the case, then he would be mad to let the Russians go into Yugoslavia. Guy laughed, "For once," he replied, "I agree with you. In fact I have just told Bevin what to do about the matter."'[18]

Leven didn't give the impression he believed him. Burgess was furious and stormed off in a taxi to the Foreign Office, returning an hour later. 'I read two memos from Burgess to Bevin, in which he

had asked to be allowed to negotiate direct with the Russians. He hoped to persuade them to let the British government come to financial negotiations with the Yugoslavians and for Russia to refrain from military intervention. I read a handwritten note from Bevin to Burgess telling him to use his own discretion in dealing with the Russians, as he felt it would be in the best interest of our country.'[19]

If Burgess thought a Labour victory might lead to closer relations with the Soviet Union, he was swiftly disabused when the new Prime Minister, Clement Attlee, refused to criticise Churchill's speech at Fulton, Missouri, in February 1946, arguing that an Iron Curtain now divided Europe. He found, too, that Bevin and McNeil were strong anti-communists and would later claim that he 'became increasingly unhappy and ill at ease in the service of a minister and policies that he was convinced were disastrously mistaken'.[20]

With his great sense of Britain's imperial past, Burgess found it dispiriting to see Britain economically and ideologically becoming a satellite of the US. Fred Warner remembered, 'I can't recall that Guy automatically followed the Stalinist line. In fact, I doubt very much whether he cared a rap for the teachings of Marx or Lenin. In those days he sought to convey the impression of being a radical social democrat, who believed firmly in Tawney.'[21]

Added to concerns about his tidiness, there were increasing complaints about Burgess's disregard for regulations. Andrew Boyle wrote:

> McNeil did occasionally try to remonstrate with Burgess, but to little or no effect. Contrition came as readily to the capricious lips of his personal assistant as insouciant devilry. Yet if Hector McNeil felt at times that he was being let down by Guy, his friend, then Burgess could only say how deeply upset he was to hear it; and he would solemnly promise to behave in future like an adult.[22]

In September 1946, George Carey-Foster, a former group captain in Bomber Command, had been appointed as the Foreign Office's first full-time chief of security. Carey-Foster slowly built up a department of seven, recruiting officers from the services to handle security in overseas embassies, and a couple of MI6 officers were loaned on a temporary basis. Security until then had been lax, with offices left

unlocked, files not put away, and everything depending on trust. The Foreign Office felt like a large family – many of the staff had been educated and grown up together – paternalistic and trusting. Because they thought they acted honourably, they assumed everyone else did as well. As a result, Carey-Foster didn't find his colleagues, especially in personnel, were particularly helpful; for example, his recommendation that all Foreign Service officers be vetted was rejected by Harold Caccia, the chief clerk.[23]

Carey-Foster was unimpressed by Burgess's 'dishevelled and unshaven appearance. He also smelt so strongly of drink that I enquired who he was and what his job was.'[24] When he questioned Burgess about taking documents home, Burgess responded he was simply 'a zealous martyr to duty'.[25]

In April 1947, encouraged by McNeil, Burgess applied for the more senior A Branch, going before the Civil Service Commission as an 'over-age' candidate. In his application he gave his address as the Reform Club, and his mother's address as Oakhurst House in Berkshire, a large Victorian house with a lake and park, exaggerating his academic achievements by implying he had taken a First in his finals. His references were Blunt and Maconachie. His medical examination on 26 August showed him fit with good eyesight, though near-sighted, to be 5 feet 11.5 inches and 12 stone, with a small scar over his left eye, where a cyst had recently been removed.[26]

The BBC in response to the question, 'Whilst in your service was he honest, sober, and generally well conducted?' had replied, Yes. 'Are you aware of any circumstances tending to disqualify him for the situation which he now seeks?' No. S.D. Spring at BBC Talks confirmed he was 'honest, sober and generally well-conducted' whilst at the BBC and there was no reason why he was not suitable for a Foreign Office post, with the head of the News Department describing him as 'a keen, able and resourceful officer'.[27]

Burgess appeared to be a good candidate.

22

Russian Controls

In the autumn of 1947, Yuri Modin met Burgess for the first time. Having been involved in translating and analysing the 'product' of the Cambridge Ring at Moscow Centre, he had now been sent on his first overseas posting. 'It was eight in the evening, at dusk,' he later wrote:

> The venue was an outlying part of London, the weather was fine and you could see people clearly a long way off. I waited alone at a crossing: exactly on time, I saw Korovin approaching with my new charge. After the briefest of introductions, Korovin turned on his heel and left us together; no doubt he had left his car nearby, a risky thing to do. Burgess and I walked off side by side. He carried himself well, a handsome man in fine clothes, starched shirt collar, gleaming shoe and well-cut overcoat. He was the image of a smooth British aristocrat, with a free and easy manner and a firm step. In the half-darkness, his face was barely visible.[1]

And so began an important partnership. The two met again at the same spot the following week. 'He was once again right on time for the second rendezvous. I saw him a long way off, wandering tranquilly among the trees, a folded newspaper under his arm.'[2] Burgess was keen, however, to switch their meetings to one of his favourite pubs in Soho, as he explained that he hated leaving the centre of London, but Modin had his way, insisting they always met in streets parks and squares – a favourite was one in Ruislip. If caught together, he suggested he should simply pretend he was asking for directions. Burgess had another suggestion.

'I've a better idea. You're a good-looking boy, and I'm a fiend known all over London for my insatiable appetite for good-looking

boys. All we need to say is we're lovers and looking for a bed.' Modin, newly married, was not amused.[3]

Modin was to be Burgess's Soviet contact for the next three years. He remained impressed by him:

> Guy Burgess was punctual to a fault, took all the customary precautions and again and again gave proof of his excellent memory . . . To my surprise Burgess turned out to be an extremely conscientious worker. He answered my questions as best he could. He took no notes, because his memory was faultless: for example, he could remember word for word something you asked him three months earlier. And from the first he treated me with kindness and consideration. When he passed me documents, he unfailingly told me which should be sent to the Centre without delay, and which could wait till later.[4]

But he was also intrigued by him, not least by his appearance:

> His shoes fascinated me: I never saw such unbelievably shiny ones, before or since. His shirt was always as perfectly white as at our first meeting. But as I got to know him better, I noticed that his jacket and trousers tended to be stained and wrinkled, and he never seemed to have them pressed. His clothes were definitely odd; they caught the attention of people in the street and, on occasion, of the police. I never could fathom why he looked like a tramp at close quarters, even though his clothes came from the best tailor in London.[5]

It became clear to Modin that Burgess was an ideological spy. 'Guy Burgess believed that world revolution was inevitable. Like his Cambridge friends, he saw Russia as the forward base of that revolution. There was no alternative, of course: he might have his reservations about Russia's domestic and foreign politics, and I often heard him berating our leaders, but in the end he saw the Soviet Union as the world's best hope.'[6]

'He was a naturally gifted analyst,' Modin remembered.[7] 'His reports were thoughtful, layered and clear – easy to translate. He was by then a great pro, despite his reputation as a disreputable, drunken, homosexual philanderer.'[8]

Modin realised his job was to encourage and support Burgess. 'I kept reinforcing his importance, the value of his espionage and his

reports. He was very flattered when I told him how good I thought his writing was. I used to say he should write novels. He liked that idea, and I think dreamed of retiring to do so.'[9]

Sometimes, at particular moments of international crisis, the two met on a daily basis. If they needed to meet, Burgess would dial a number that was manned day and night by a Russian agent, to whom Burgess would give a code number before hanging up. The code meant that within an hour either Modin or his colleague Korovin would meet Burgess at a prearranged rendezvous. For example, during the London Conference of November 1947, Burgess was able to supply, at a late night meeting with Korovin, the British and American position on the status of Berlin. The Soviet foreign minister Molotov received the information well before the British delegates, who had to wait until they convened the following day.[10]

At the insistence of the Centre, Burgess was supplied with money to buy a car as it made communication with him easier. He immediately bought a second-hand two-seater gold Rolls-Royce with folding top from a dealer in Acton, and then offered Modin a ride. 'The two minutes that followed were among the worst in my life. Guy gunned the engine and the Rolls leapt forward, reaching a very high speed within seconds. Guy drove like a maniac, looking neither right nor left.' Modin was terrified and asked if Burgess always drove through crossroads without looking if other cars were coming. '"You're quite right. I really don't look at all. And that's one reason I bought this old banger, because even if I write it off, I won't get hurt. Rolls-Royces are very *sturdily built* you know."'[11]

In December 1947, Burgess attended with McNeil the Council of Foreign Ministers meeting in London, with delegates from the United States, Soviet Union and France, where again the future of Germany was discussed. During the period from 6 November to 11 December, he passed across more than three hundred various documents to his Russian contacts, for which he received a £200 bonus.

It was then that he drew the two-headed beast, which was later widely reproduced in the media. 'Guy intended his two-headed beast merely as a savage embodiment of Anglo-American policy,' his authorised biographer later wrote, 'but it may certainly be agreed that his

own condition was at this time painfully schizophrenic – split as his mind was between duty to the nation's service and conviction that the nation was being led towards catastrophe.'[12]

Burgess had found himself increasingly at odds on policy, as much as with colleagues. 'He was shocked to find how far Bevin was now committed to the most reactionary elements in the Foreign Office, and how unprotestingly McNeil allowed himself to be dragged along by his powerful chief . . . but he had no choice but to stay.'[13]

The pressures of his double life were beginning to affect Burgess, who oscillated between hyperactivity and depression. He was drinking whisky throughout the day from a flask kept in his desk, eating cloves of raw garlic as if slices of apple, and passing around pictures of various youthful conquests. Rees noted:

> He was now perpetually taking sedatives to calm his nerves and immediately followed them with stimulants in order to counteract their effect; and since he always did everything to excess, he munched whatever tablets he had on hand, as a child will munch its way through a bag of dolly mixtures, until the supply has given out. Combined with a large and steady intake of alcohol, this consumption of drugs, narcotics, sedatives, stimulants, barbiturates, sleeping pills, or *anything*, it seemed, so long as it would modify whatever he happened to be feeling at any particular moment, produced an extraordinary and incalculable alteration of mood.[14]

Robin Maugham, who had met Burgess through Harold Nicolson, recognised his dual personality. 'In drink, Guy could be unpleasant and malicious, but his nature was essentially generous.' But Maugham was nonetheless shocked to see him drunk at a lecture Maugham gave at the Royal Empire Society in 1948, where Burgess, sitting with a boyfriend in the third row, sought to correct him on a matter of detail:

> Afterwards there was a small party at my sister's house. Guy arrived with a young friend. By then he was very drunk. His blue eyes were a little watery. His curly hair was dank. But with his inquisitive nose and sensual mouth he never lost his alert fox-terrier expression – nor his energy. There he sprawled on the floor in front of the fireplace. He wore a very old tweed jacket with leather patches at the elbows. And very old, very dirty, grey flannel trousers. His shoes were cracked and dusty. His fingernails were uncut and grimed with dirt. His talk

was wild and extremely pro-Russian. Suddenly his conversation switched and he began to quote and re-quote E.M. Forster's dictum to the effect that if he had to choose between betraying his country and his friends, he hoped he would choose to betray his country.

'I believe Guy Burgess is a communist,' my sister Kate said to me later. 'Nonsense,' I answered. 'If he were a communist surely he wouldn't act the part of a parlour communist so obviously – with all that communist talk and those filthy clothes and filthy fingernails.'

'Perhaps it's a double bluff,' my sister Kate suggested.[15]

23

Settling Down

Jack Hewit had spent time in Germany, first with the Army Theatre Club and then as a sergeant in the Counter Intelligence Bureau, before going on to work for the Nizam of Hyderabad in India. At the end of 1947, he returned to London, engaged by a firm of petroleum engineers in Baltic Street called Head Wrightson Processes, as a temporary typist and later as an office manager in the buying department. Burgess had always felt guilty about the way he had treated him. 'I entirely agree with what you say about Jackie,' he had written to Pollock during the war, when he'd had a brief fling with Hewit. 'It is only lately that I have realised how unhappy I make him at times when we're together. It could never have been the thing . . . But he made me realise what life cld be – and now he seems to have performed the same miracle for you where I failed. Please send me his address (which I have lost) I want to write blessing him. He has a horrible life.'[1]

Burgess, often torn between his neediness and desire for sexual freedom, had repaired his relationship with Hewit, who had claimed, 'I've only ever been in love once in my life' – with Burgess.[2] He later remembered how 'Guy did lovely things. When I was in Germany, ankle-deep in mud, hell, suddenly the post arrived and a box from Fortnum and Mason. There was a bottle of Jicky eau de Cologne . . .'[3]

In 1947 Burgess had moved to a new flat, taking over from his colleague in the News Department, Richard Scott, at £150 p.a., and was joined there by Jack Hewit in February 1949.[4] No. 3 Clifford Chambers, 10 Bond Street, just off Piccadilly, was on the third floor of a Victorian building reached by narrow, dark stairs covered with a thin, greasy carpet. It consisted of a small hallway tiled in black

and white, and two bedrooms, a kitchen and lavatory. The main room was decorated like Chester Square in Burgess's favourite colours of red, white and blue. White walls and paintwork, red carpet, blue curtains lined with white, a blue-covered settee, two blue armchairs with red cushions, and a large divan covered in red, with blue cushions.

Jack Hewit remembered that 'in the corner there was a very old harmonium on which Guy would play and sing hymns and bawdy versions of "The Eton Boating Song", and a version of "La donna è mobile", which started off, "Small boys are cheap today, cheaper than yesterday". There was also a record player and several records. His favourite at this time was one I had given him called, "Life gets tedious, don't it".'[5]

However, as Jack Hewit noted:

The loo in Bond Street was the focal room. Situated to the left of the front door, it was painted white and furnished with bookshelves, on which were copies of his favourite books, and a Toulouse La Trec [sic] lithograph of Yvette Gilberte. It was beautifully decorated with pink carpet. Damask wallpaper, pink (what other colour?) blush carpet. No loo seat cover. I wanted to get one, but Guy wouldn't let me. There was a chandelier from a Portobello Road stall. It had drops which fell down. An ashtray, a box of cigarettes, a box of mints. Guy used to go in at 8.15 and come out at 10. He read the newspaper there, and later his books, in the loo.[6]

Just around the corner from the flat was Churchill's, a gentlemen's club providing the rich and famous with nubile young ladies, many of whom went on to marry into the aristocracy. The club had some 27,000 members and, with its ceilings draped in pleated satin, was a favourite of young officers from the Brigade of Guards and film stars such as Errol Flynn and Terry-Thomas. It had close links with the south London gangster Billy Howard and would later be patronised by the notorious Kray twins. It featured a floorshow with singers and dancers, as well as the more immediate attractions of alcohol and hostesses, who collected cocktail sticks to show how much money they were owed and made private arrangements to engage in after-hours assignations. Burgess quickly became a member and would often drop in for a drink and chat. It proved to be a useful venue for entertaining his contacts – and then compromising them.[7]

Micky Burn remembered that at the end of January 1948 Burgess came to dinner at his flat in Connaught Square and 'got almost hysterical because I chanced to put on a recording of Tchaikovsky's Symphonie Pathetique. "Oh God, Micky, not THAT symphony."' In the corridor he tried to kiss Burn, now married, who refused. '"Don't be so pompous." Then he said that if ever I wanted a room in which to be unfaithful, he had one he could lend me. I remember thinking that if I ever did, and I did now and then, it would not be anywhere of his. I had ceased to trust him, though spying had never entered my head.'[8] Shortly afterwards Burn saw him in Piccadilly Circus, 'very conspicuous in his camel-hair coat, obviously looking for a man. It was a notorious place and I thought he was running a big risk. So I tapped him on the shoulder and said, "Don't be such a fool." Guy said, "Are you the police?" Anyhow I got him away and he took me to the Reform Club for a drink instead.'[9]

Burgess was continuing to see his old circle of friends. Every Monday evening he would go to a music hall with the same small group of friends, most notably Guy Liddell and David Footman, and he would often see Dadie Rylands at the Reform Club. 'He was a scallywag but very good company, literary, well-read, clever,' recollected Rylands. 'He was engaging. He always had some scandal to tell – who was having an affair with whom, what parties had been going on' but also 'unscrupulous and keen on the bottle. I don't think he cared about the truth.'[10]

It was an unsettled life and Burgess talked of leading a more conventional life, with marriage and children. He was good with children because, in many ways, he was a child himself. His brother Nigel had two sons – Anthony and Simon, who had been born during the war – and Anthony remembers how his Uncle Guy taught him to draw perspective and stairs.[11] Goronwy's daughter, Jenny Rees, remembered Burgess visiting the family, then living in St John's Wood, next door to Louis MacNeice, just after the war:

Guy was very keen on cooking, and one of his 'signature dishes', as I think they would be called now, was soufflé omelette. When he came to see us, there was always a lot of excitement. My sister, Lucy, and I shared a bedroom on the top floor, but could always hear sounds of clinking glasses, raised voices and merriment coming from

the kitchen, as Guy and my mother, watched by my father, got together to prepare their supper. We would creep down the stairs in our pyjamas and sit, looking through the banisters, to see what was going on. Part of the art of making a good soufflé omelette is to flip it up into the air, making sure that it returns to the pan, which often involved gymnastics. In Guy's case, this often involved accidents, too. And I remember once spotting the remains of an omelette stuck quite high up on the kitchen wall, while I ate my breakfast following one of their livelier evenings together.[12]

'He dropped hints that he was thinking of getting married, and once at least he professed to have decided on the bride,' Goronwy Rees later wrote, 'though I think that the lady in question would have been surprised and perhaps alarmed to know that she had been selected as Guy's intended victim.'[13] His old school-friend Michael Berry later remembered how he 'met Guy and his fiancée as we both stepped off the train at Paddington, and we shared a taxi as far as his flat in Bond Street, where they both got out. I cannot remember the date, but, at a guess, I should say it was 1947 or early 1948, because I remember mentioning to him a book I had written at that time.' Burgess claimed it was an 'experiment' and Berry never saw or heard of the young woman again.[14]

Who was the fiancée? A number of names have been put forward. Burgess was attractive to women, who wanted to mother him and clean him up, and he had several heterosexual affairs. Burgess certainly discussed marriage with Peter Pollock's sister Gale, and Margarita Sagrado, a friend with whom he had a shared love of crosswords, was in love with him. Nigel Burgess, interviewed in 1985, said his brother 'used to say he would marry Clarissa during the war. He told his mother that.'[15] Dadie Rylands remembers Burgess bringing Clarissa Churchill down one weekend to stay with his parents in Devon and introducing her as his fiancée – this may have been the trip where Michael Berry saw them – and the actress Fanny Carby separately claimed Burgess was engaged twice – once to Clarissa Churchill, and once to the daughter of a well-known politician.[16]

Clarissa Churchill's relationship with Burgess was certainly closer than she has remembered – a number of contemporaries recollect

them being very friendly and there are constant references to her in the letters to Peter Pollock – but it is hard to believe that it extended to getting married. Anthony Blunt, when interviewed by MI5 officer Peter Wright, said that 'Burgess was tasked by his Soviet controllers to wed Clarissa Churchill, to ensure him perfect cover for his espionage activities'. Burgess was 'appalled by the task', not least because James Pope-Hennessey 'had become infatuated with her . . . One evening he arrived at Burgess's flat with a revolver, threatening to shoot them both before attempting to commit suicide.' The mystery of the relationship remains.[17]

Burgess, always prone to depression and insecurity, claiming to have lost interest in politics, talked of leaving the Foreign Office and becoming the motoring correspondent of *Country Life*. Rees was surprised by this. 'I had always felt that Guy's political interests, whether misdirected or not, were the most important part of him, and that if they died, the most valuable part of him would die with them; it was as if by abandoning them he was betraying himself.'[18] It was something Micky Burn also noticed. 'Guy Burgess was immensely political. If he was to become martyred or notorious at all, it must be for something not merely personal, involving a fine or a short spell in jail, followed by odd jobs on the BBC, or occasional reviewing for the *New Statesman* for the rest of his life. It must have to do with great historical conflicts and *Weltanschaung*, and be as upsetting to as many people in authority as possible. This, after a fashion, he achieved.'[19]

Rees was intrigued to ask if he had given up his activities as a Russian agent. Burgess at first didn't reply, then refused to discuss the matter and finally relapsed into sullen silence. Rees, keen to 'put an end to the doubts and suspicions' which had troubled him for many years, then provoked his friend, claiming he had kept a written record of their 1939 conversation and deposited a sealed copy with his lawyer. Burgess, becoming agitated, 'asked angrily why on earth I had done anything so foolish, begged me to destroy the document and said that if it were ever made public it would not only put an end to his career at the Foreign Office, but prevent him from following any other'.

Rees, sensing real fear, was perturbed. Rather than putting an end to his suspicions, 'they had been strengthened to a point at which one conclusion seemed to be unavoidable'.[20]

24

The Information Research Department

In April 1946 Christopher Warner, an Assistant Under-Secretary at the Foreign Office, had drafted a memo, 'The Soviet campaign against this country and our response to it', arguing for the need to respond to the Soviet ideological 'offensive', which had taken the form of sponsorship of communist organisations in Western Europe and support for 'nationalist' and 'anti-colonial' movements. The Foreign Secretary, Ernest Bevin, had agreed the need for a department which could seize the propaganda offensive from Russia, a desire strengthened by his experience at the United Nations in October 1947, where he had faced an onslaught of well-researched misinformation and disinformation from the Russians. Christopher Mayhew, the other Minister of State at the Foreign Office, who incidentally had gone to Russia with Anthony Blunt in 1935, was tasked with setting up a department to win the propaganda war against the Soviet Union.

The new organisation was approved at a Cabinet meeting on 8 January 1948, when it was decided 'that a new line of foreign publicity should be adopted, designed to oppose the inroads of Communism by taking the offensive against it'.[1]

Established with £150,000, the new organisation was given the innocuous title of the Information Research Department and came into being at the end of February. Though only in part funded by the Secret Vote – how parliament funds MI5 and MI6 – from September 1948, it enjoyed close links from its inception with MI6. The department didn't just deal in distributing propaganda through British embassies and media, but also supplied the Labour Party's international department, whose secretary was Denis Healey, and trade unions. IRD collated information on the Soviets and communism in the Soviet Union, Europe and the Middle and Far East from

the media and British representatives abroad, and then produced rebuttals, much like a political research department.

Its role was to brief ministers and delegates to international conferences, produce 'Speaker's Notes', and place articles in the widest range of publications. In the first three months of the department's existence, briefs were produced on such subjects as the real conditions in Soviet Russia and in the communist-dominated states of Eastern Europe, labour and trade unions in the Soviet Union, and communists and the freedom of the press.

Given his background in propaganda, it was natural that Burgess should work with the new department. Mayhew had approached Hector McNeil, saying he needed someone who 'knew more about communism than the communists'. McNeil immediately recommended Burgess. 'I think he wanted to get rid of him,' Mayhew later remembered. 'I think Guy Burgess also had a plan in mind. I interviewed Guy Burgess and, of course, on the subject of communist and anti-communist warfare he was brilliant. He knew more about it than I did. He had ideas that had never occurred to me. I immediately employed him.'[2]

The Information Research Department had three sections: Intelligence, Editorial and Reference. The Intelligence Section was responsible for collecting material from Whitehall departments, reports from missions and colonial posts, as well as press and broadcast monitoring. The Editorial Section prepared the output material and the Reference Section indexed and stored it. It was staffed not just by Foreign Office personnel, but also by wartime propagandists and journalists. There were separate desks for geographical areas, such as Eastern Europe, Africa, China, and Latin America, as well as sections on subjects such as economic affairs.

Burgess's role in IRD is unclear. According to the Foreign Office official historian Gill Bennett 'Burgess was never a member of IRD in any established sense . . . Burgess may have been involved in discussions about the creation of the department, and its early work, but I have seen no documentary evidence of any input from him. I have confirmed this with someone who knows a lot about IRD'.[3]

But he certainly played some role. A former member of IRD Hugh Lunghi, remembered how Burgess was always losing things

and he was sacked because he was 'lazy, careless, unpunctual and a slob'.[4] In his memoirs, Mayhew wrote, 'I threw him out. He was dirty, drunk and idle. I couldn't sack him. He was Hector's protege. I just disposed of him. I sent him back to the pool with a very bad report. Hector was a splendid fellow. He was very patriotic. He was a good man. An able man. But he was taken for a ride by Burgess.'[5]

Whatever his role, it is likely Burgess gave the Russians details of what he had learnt about the fledgling organisation. Certainly a Soviet bloc newspaper was carrying details of the new IRD by 4 April 1948.[8] What is not clear is exactly what Burgess was able to reveal as, according to a leading authority on the subject, 'Nothing has been found in the IRD files about Burgess or his position in the Department and other early recruits have no recollection of reading any of Burgess's work . . . specific directives regarding propaganda in different regions were not drafted until the summer of 1948, when Burgess had almost certainly left the IRD.'[6]

Burgess was back working for McNeil by the middle of March 1948. Indeed, so trusted was he that McNeil asked him on 15 March to report on anyone who might be suspicious on the staff. Two days later, he accompanied McNeil to Brussels for the signing of the Treaty of Brussels that set up the Western Union Defence Organisation, which was eventually to evolve into the North Atlantic Treaty Organisation (NATO). There he took the minutes at a secret meeting between McNeil and the Belgian foreign minister, Henri Spaak, with only the British ambassador to Brussels, Sir George Rendell, present. Aware of the heightened security, Burgess was cautious and simply confined himself to passing on the text of the Brussels agreement and the minutes he had so dutifully taken.[7]

One of Burgess's responsibilities was dealing with French claims arising from the war. Ronald Grierson, then in the Paris embassy, remembers liaising with Burgess over the military awards to members of the French Resistance, and thought him 'unstuffy and like an eccentric academic'.[8] Rosemary Say, who had escaped as a young au-pair from German-Occupied France in 1942 and then found herself presented with a bill by the Foreign Office after the war, for

monies she had been advanced by consular officials to live on, remembered, 'I was still bitterly resentful that I had to pay the full cost of my escape and that no recognition had been given of what I had done or had been through. I was by now working as a secretary to Tom Driberg, the Labour MP. In that capacity, I had come into contact on several occasions with a very helpful official at the Foreign Office – a Mr Guy Burgess.' At the end of November 1947, she wrote to Burgess asking if her debt could be cancelled and three weeks later, writing from 8 Carlton House Terrace, he replied that he had made enquiries and it had been agreed.[9]

There were also various odd jobs. McNeil chaired the Refugees Defence Committee, which looked at the question of resettling the millions of people displaced by the war. Michael Alexander, only just released as a POW from Colditz, worked with him on resettlement and was noticeably struck by Burgess's ruthless views on sending refugees back to their home country.[10]

Another role was as McNeil's speech writer. The journalist Henry Brandon, who was a close friend of McNeil's, later claimed, 'McNeil kept him on in spite of his often irascible behaviour and drinking habits because, he said, Burgess had all the important Stalin and Lenin quotes at his fingertips.'[11] The relationship between Brandon and Burgess was less good. 'He considered me too prejudiced against the Soviet Union', Brandon later wrote. 'Once at a small dinner in McNeil's flat in London, Burgess attacked me personally in such an abusive manner that next day the Minister of State sent me a note of apology; none came from Burgess.'[12]

In spite of the difficulties of taking out documents, a Russian assessment of the information Burgess provided for the six months to 15 May 1948 shows that he had taken out over two thousand documents, of which almost seven hundred had been forwarded to Moscow where they were distributed to, amongst others, Stalin, the foreign minister Molotov, the Foreign Ministry, Russian Army intelligence, and various directorates of Soviet intelligence. So pleased were the Russians that Burgess was paid £200.[13] During the summer, he was much involved in the Berlin Crisis, working closely with the German political section in Northern Department and IRD. There are numerous minutes giving background to the crisis and it's clear

Burgess saw reports from the Berlin Intelligence Staff and the Military Government Liaison Section.[14]

A good example of how stolen documents helped the Russians is a memo Burgess wrote on 5 July 1948 to McNeil, on the agreements governing written rights of access to Berlin.[15] Why was this important? The previous month, Britain, France and America had given up their zones to create West Germany, with Berlin remaining a divided city reached through the Russian sector. The Russian response was to cut off all rail and road links, in an attempt to force the city to become part of the Russian sector. The knowledge that the British had looked recently at the agreements about access to the city would have given the Russians a clear idea of the policy and mindset of the British.

The Berlin Blockade, which was to last until the following May and only be broken by an airlift of supplies to the beleaguered city, was the background for one of Burgess's best-known cartoons. Bevin had committed himself to a bilateral Anglo-American trading agreement, which he did not feel the Cabinet would accept. Accordingly he had succumbed to a diplomatic illness and was recuperating on Lord Portal's yacht at Poole. When the Prime Minister heard about the agreement, Bevin was summoned to Downing Street, but the Foreign Secretary had ensured that the yacht should not be in wireless communication with the shore. Fred Warner was therefore sent to sit in the yacht-club in Poole and try to establish contact by semaphore whenever the yacht sailed close to the shore. Meanwhile Burgess, acting as the intermediary between Poole and Downing Street, doodled a drawing of Bevin in a small speedboat exclaiming, 'Ector needs me!' McNeil added an 'H', showed it to Bevin and it was circulated around the Cabinet table as part of a softening ruse to bring the Cabinet on side. The cartoon is now part of the Cabinet papers.[16]

Apart from the Berlin Crisis, Burgess continued to work on a variety of issues for McNeil, particularly Palestine, where the Arabs had risen against the British Mandate. In the autumn he accompanied McNeil to the Third Session of the General Assembly of the UN in Paris, passing on the draft resolutions, including the Universal Declaration on Human Rights, and the Cabinet's instructions for the British delegation, to his Russian controller under the Arc de Triomphe.[17]

It was in Paris that a UN official, Brian Urquhart, came across him:

> An evening meeting of the Balkan Subcommittee, which was trying
> to deal with the violent and chaotic situation on the northern borders
> of Greece, offered an excellent opportunity for Burgess's propensity
> to shock. The group consisted of the foreign ministers of Great Britain,
> Greece, and of Greece's Balkan neighbours, the latter being eminently
> conventional, old-fashioned communists, and Burgess's appearance
> one evening, drunk and heavily painted and powdered for a night
> on the town, caused much outrage. When I mentioned this episode
> to Six Alexander Cadogan, the head of the British Delegation, he
> replied icily that the Foreign Office traditionally tolerated innocent
> eccentricity.[18]

In February 1947 Kim Philby had been posted to Turkey as the
head of the MI6 station, eventually settling in a house at Vanikoy,
up the Asiatic coast from Istanbul. It was an old Turkish structure
standing alone on the shore, looking out to the left to the minarets
of Aya Sophie and to the right to the Anadolu Hisari fortress. A few
hundred yards downstream was the boat station, from which Kim
caught the ferry to his office in the majestic Consulate General
building, which MI6 preferred to the embassy in Ankara. It was here
in August 1948 that Burgess arrived, probably unannounced, on three
weeks' leave, claiming to be on government business. Tim Milne, a
school-friend of Philby and colleague in SIS, who was staying at the
same time, later wrote:

> However professional the visit, Guy was in no way inhibited from
> behaving the way he usually did. He came and went as he pleased.
> He might be out half the night, or hanging around at home all day.
> If he was in, he would probably be lolling in a window seat, dirty,
> unshaven, wearing nothing but an inadequately fastened dressing-
> gown. Often he would sleep there, rather than go to bed.[19]

Sometimes Milne, his wife, Philby and Burgess would go on countryside
drives in the jeep. 'Guy would sit at the back singing endlessly, "Don't
dilly-dally on the way" and a peculiar ditty of his own invention, "I'm
a tired old all-in wrestler, roaming round the old Black Sea".'[20]

Philby and Burgess would spend days out together, sometimes with

Burgess's cartoon with sketches of his Foreign Office
collegues Fred Warner and Hector McNeil.

Philby's secretary Esther Whitfield, with whom Philby was having an affair, leaving Aileen at home with four young children. One evening the two men turned up at the exclusive Moda Yacht Club – Burgess was dressed in an open-necked shirt and sandals and had to borrow shoes and a tie from a waiter to be allowed in – where, with two young women, they proceeded to drink fifty-two brandies.[21] On another occasion, Milne remembered Burgess, proud of his swimming and diving, one day spurred on by drink but by no means drunk, deciding 'to dive into the Bosphorus from the second-floor balcony at Vanikoy. With no room to stand upright on the balcony rail, he fluffed his dive and hurt his back.'[22] Burgess continued to be the house guest from hell and Aileen became increasingly depressed by his behaviour and bad influence over her husband.

One night Burgess had not returned home by about midnight and Philby began to get extremely worried. Had he found himself in a drunken fight, had an assignation with a cadet at the nearby military academy, or was he meeting a Russian contact? After looking for him for almost an hour, Philby gave up. Burgess turned up the next day with no explanation. When a telegram arrived saying that Burgess was not needed back at the office and could stay another week, Philby attempted to suppress the telegram but, in the end, Burgess discovered it and stayed the extra week.

And yet for all his 'awfulness, unreliability, malicious tongue and capacity for self-destruction', Milne found him 'oddly appealing. He let his weaknesses appear, something that Kim seldom did. Indeed he wore almost everything on his sleeve, his celebrity-snobbery and names-dropping, his sentimentality, his homosexuality; he never seemed to bother about covering up.'[23] Milne was particularly struck by Burgess's sentimental side. One evening Guy told the story of how the founder of MI6, Mansfield Smith Cumming, trapped after a road accident, had amputated his own leg in order to get to his dying son. When he finished telling it he 'burst into tears, to our embarrassment more than his . . .'[24]

Burgess would recount stories about the famous and his encounters with them. '"If I'd had a choice", he would say, "of meeting either Churchill or Stalin or Roosevelt, but only one of them, I wonder which it would have been", adding, "As it is, I've met Churchill

. . .'" Milne remembered that 'far from being a mere name-dropper; he could talk interestingly, often brilliantly, about his celebrities, and indeed about many subjects', but he found him to be a tragic figure. 'Unlike Kim, he did not have the nerve for the role he was called to play. I wonder if some hint of this showed itself on his visit to Istanbul . . .'[25]

25

The Far East Department

In April 1948 Burgess had begun to give thought to the next stage of his career, aware that his two-year posting with Hector McNeil would be up by the end of the year and he might have to go abroad. McNeil had recommended him for the senior branch, which required experience in one of the ordinary departments and advised the Far East Department, which promised much scope for an ambitious diplomat.

On 12 October Burgess explained to Moscow Centre that he had failed to get into General, American or Northern Departments, as they had wished, but they shouldn't worry.

> I won't do my duty if I don't tell you that I am going to work to this department with completely different opportunities in comparison with those I had while working with Hector. It is true that I am being transferred there with his support and that he has spoken to Dening and Caccia, chief of the Personnel Department, and given a recommendation and asked to give me important work. Still, we shall see. I suggest: (1) My being cautious and even timid in this respect until the opportunities become clear. (2) Using to the maximum on a personal basis the contacts and friends, Fred, Hector and co. I know that suggestion No. 1 will be approved.[1]

On 1 November 1948 Burgess started in the Far East Department. At thirty-eight, he was one of the oldest third secretaries ever and the most junior member of a small department responsible for China and the Philippines, but was consoled to find that all but one of his colleagues in the department were Old Etonians. The department was run by Peter Scarlett, whom Burgess described to the Centre as 'quite an ordinary man, typical of an English gentleman', but it was his deputy, Frank 'Tommy' Tomlinson, to whom he most warmed

as 'an Etonian among radicals and he likes me as a radical among Etonians'.[2] His other colleagues were Nigel Trench and Patrick Coates, an old China hand who had served in four posts in China between 1937 and 1946, and had spent two years during the war attached to the Chinese (Nationalist) Army.

Margaret Anstee, who worked in the South American Department across the corridor from the Far Eastern Department, often saw Burgess there, or lunching at a pub in Whitehall that was often frequented by Foreign Office staff. 'He was a disagreeable character. With his early good looks consumed by fast living, he presented an unkempt and often distinctly unclean appearance . . . his fingernails were always black with dirt. His conversation was no less grimy, laced with obscene jokes and profane language.'[3]

Burgess's job was to deal with correspondence from British officials in China, to monitor and interpret information from the media and various diplomatic representatives, and from them to produce policy documents and advise ministers. Though much of the work was mundane, it played to his interest in the Chinese Revolution, and gave him an insider's perspective on the final months of the civil war between Mao Tse-tung's communists and General Chiang Kai-shek's Nationalist Army. He had a genuine interest in the Chinese Revolution and for once was completely in agreement with the foreign policy he had to administer.

'Because of his knowledge of communism he became, in effect, the Department's political analyst of the Chinese Revolution. His colleagues knew China: he knew Marxism', wrote his biographer Tom Driberg. 'It was a happy partnership. He took the line that the Chinese communists were neither mere agrarian reformers, nor mere Russian puppets, but genuine Chinese communist revolutionaries: here was another colonial revolution that was, in the old Marxist phrase, "Socialist in content, national in form".'[4]

Drawing fine distinctions between Soviet Leninism and the agrarian populism, which he detected emerging in Red China, played to his own sympathies, not least because it gave some legitimacy to his anti-Americanism. Even before the outbreak of the Korean War, the American government was moving towards the contrary view that the USSR and the People's Republic of China (PRC)

constituted a Marxist–Leninist monolith, an assumption that was to colour US China policy for the next twenty years.

The diplomat and writer Robert Cecil has suggested it's possible 'that Burgess's arguments contributed in some degree to the recommendation made by Ernest Bevin, and accepted by Attlee's Cabinet in December 1948, in favour of de facto relations with the PRC'.[5] This is an exaggeration, as Burgess had only just joined the department as its most junior member a month before, but his position did allow him to keep Moscow informed on the formulation of British policy on the People's Republic of China, founded in October 1949, and towards Korea, right through until the outbreak of the Korean War in the summer of 1950.

Though only a grade-four officer, the post gave Burgess regular access to intelligence assessments from the Joint Intelligence Committee, the War Office, Far Eastern Command and MacArthur's HQ at Supreme Allied Command in Tokyo. He was also working closely with the Information Research Department, suggesting his tenure there cannot have been completely disastrous, the various service departments, and liaising with British diplomatic posts in the region.

As the Chinese Communist Party (CCP) and USSR drew closer together, British and American policies began to diverge. Whilst America initially wished to impose trade sanctions, Britain, who had much larger investments in China to take into account and wanted to safeguard the position of Hong Kong, argued that such sanctions would be counter-productive, driving China out of necessity closer to the USSR. There was also a difference over Formosa, with the British taking the view it was just another Chinese province destined to fall to the communists, whilst the Americans wanted to deny it to the CCP, not least for strategic reasons.

The Far East Department's files are filled with Burgess's assessments of the significance of fast-moving events, showing him to be knowledgeable, shrewd in his analysis and able to place developments into historical context, sure in his judgements, trusted by his superiors – he often drafted responses for Scarlett or prepared answers to parliamentary questions – and not afraid to challenge their own interpretation of the situation. He was now able to supply even more

material to Russia than previously, to the extent that he requested Moscow Centre buy a suitcase to transport the material.

Burgess's role was to interpret events rather than shape policy, but it still gave him enormous power in terms of alerting his Soviet masters to what the British knew and were doing. On 4 April 1949, the day the North Atlantic Pact creating NATO – a mutual defence pact aimed at containing possible Soviet aggression against Western Europe – was signed by twelve nations, Chairman Mao stated he would support Russia. Burgess noted, 'Peking, the seat of the CCP, was immediate in broadcasting the CCP's advance support for the USSR in the event of war with the Atlantic Powers.'[6]

Among the documents he saw in April was a CIA report, 'Prospects for Soviet Control of a Communist China', arguing that any pledge that Chinese communists would like foreigners to continue business as usual was only a feint to secure recognition of the regime change and minimise foreign opposition. Burgess was inclined to agree and duly added the briefing to his suitcase.

On 29 April 1949 he saw the Joint Intelligence Committee's views on the nature of Russian air assistance to China. The secret reports listed 'by name, in some cases, Soviet military personnel drafted into China after the revolution, the weapons they brought with them . . . the airfields they were constructing, and the training they were providing to Mao's forces. Such intimate knowledge of how much Western intelligence knew on the military side would have been prized in Moscow in the months before the outbreak of the Korean War.'[7]

On 6 May 1949 he was liaising with the service attachés on the emergency measures being taken at the embassy in Nanking, which threatened to fall to the communists, to safeguard secret documents. Three weeks later, he conceded the Chinese Revolution had succeeded, on 26 May noting that the Chinese Revolution was irreversible after the communists captured China's largest city and port, Shanghai.[8]

In May the communist leadership had approached the United States, claiming that the leadership of the CCP was divided between a pro-Moscow radical faction under Liu Shao-ch'I and a liberal faction under Chou En-lai, who wanted good relations with Western

powers to help China out of its dire economic straits. Mao Tse-tung, the unchallenged leader, was above this factional struggle, but the direction of party policy would be determined by which faction won. A victory for Chou En-lai would mean the CCP would not always follow Moscow's foreign policy line, but exercise a moderating influence, thus reducing the dangers of war. The Americans took the approach as authentic and were prepared to support Chou.

The British received a similar message in August, though tailored to address British interests. The first Foreign Office reaction was a minute by Burgess, who noted the 'fairly extensive diffusion of this top secret information by Chou, and his choice of journalistic channels, makes the thought of a plant very obvious indeed'. Burgess continued, saying that, 'I and my friends are moderates, let's collaborate to keep the extremists out' was a 'trick . . . much used by the Japanese as well as the Nazis to get concessions, even when a hostile policy had in fact been decided on'.[9] Though Coates and the Assistant Under-Secretary Esler Dening were prepared to believe it as a genuine approach, Bevin, siding with Burgess but using the analogy of the behaviour of Soviet satellites, rejected it.

In August 1949, the Permanent Under-Secretary's Committee produced two long papers assessing the prospects for regional collaboration in the Far East. It concluded that the modest British military resources made direct intervention in an anti-communist struggle impossible and that the defence of Southeast Asia was down to the region itself. The PUSC papers were passed to Burgess to send on to Nanking, but went missing. The admission of British reluctance to intervene must have been valuable to the Russians.[10]

The following month Burgess spoke at a Foreign Office summer school in Oxford, which included a representative from MI5, E.H. Carr, and Malcolm Macdonald. When Arthur Martin had heard him talk to MI5 and MI6 officers in the spring, he had thought Burgess 'clearly a clever boy. But it was more than that. He had a magnetic personality.'[11] Now reports were mixed. 'Guy Burgess was there from the Foreign Office, but was not nearly so good', noted Guy Liddell in his diary, whilst Bill Freedman from SIS remembered him 'sitting on the floor. He looked filthy . . . a dirty little man with what used to be called gravediggers' fingernails. I can see him sitting there,

wearing sort of brogues and a pullover. Mind you, despite his appearance, he was very witty and sagacious.'[12]

On 1 October 1949, the Peoples' Republic of China, with Mao as Chairman of the CPG, the Central People's Government, was created, and the following day the Soviet Union established diplomatic relations. The British deliberated, taking soundings from the Commonwealth and other governments, before following suit in January 1950. When the next month the Soviet and Chinese governments signed a thirty-year Treaty of Friendship, which included an extension of a $300 million Soviet loan to China, Burgess analysed the reaction, arguing that this was part of a discernible pattern in the 'chronological carpet' of relations between the two countries and revealed 'careful, successful and detailed Sino-Soviet planning and co-ordination of several recent moves'. Burgess thought the agreements seemed calculated 'to strengthen (a) Sino-Soviet relations against the West and (b) the position of the Chinese Communists, both in China and as the supporters of Far Eastern "liberation"'.[13]

On 25 June 1950, 175,000 North Korean soldiers crossed the 38th parallel heading for Seoul, thereby launching the Korean War. Burgess, not for the first time, again found himself at the centre of world events.

26

Disciplinary Action

On 14 February 1949, Harold Nicolson wrote to Robin Maugham:

> Everything here is the same except for an event. The event was that
> Guy Burgess, leaving a Night Club at midnight, fell down two flights
> of stone stairs, broke his elbow, slightly cracked his skull and dislocated
> three ribs. He was in the company of Mr Fred Warner at the time
> who pushed him into a taxi, bleeding profusely, and took him back
> to his rooms. Guy was scarcely conscious and Fred (who seems to
> have been in a very night club mood) telephoned without avail, to
> every doctor whom he knew by name or repute. He received no
> reply, and remained there all night with Guy groaning on the bed.
> In the early dawn he got hold of Jackie and in the end they found
> a doctor who took Guy off to the Middlesex Hospital where he is
> now lying in the observation ward, perfectly all right and immensely
> patient and courageous. Now you and I, if a similar event happened
> to either of us, would ring up a hospital and ask for an ambulance.
> This does not seem to have occurred to Fred who has ever since
> been going about clouded by a mist of guilt and incompetence.[1]

The club was the Romilly Club, the renamed Le Boeuf sur le
Toit, and Burgess had fallen after a drunken wrestle with Warner.
Some rest and recuperation was advised and, after ten days in hospital
in London, Burgess went with his mother, with whom he often
holidayed, first to Wicklow in Ireland and then for a few days to
the Shelbourne hotel in Dublin.

It was then that writer Terence de Vere White met Burgess:

> He was travelling with his mother, a quiet lady. He took the centre
> of the stage. He was dark and bright-eyed and was either an old-
> looking young man or a young-looking middle-aged man, I was not

quite certain which . . . He was in the Foreign Office and was taking a rest in Ireland on account of an accident in the Reform Club, where he had fallen and bashed his head on the stairs. As a result of this, he was under doctor's orders to keep off alcohol and if he disobeyed the rule, the result was a complete blackout, lasting for more than a day. I noticed that he drank tomato juice, which seemed out of character.[2]

The two men parted after an hour as Burgess was off to see a play at the Abbey Theatre. Shortly afterwards, on 4 March, de Vere White was rung asking if he would give evidence for Burgess in the Dublin District Court. Burgess had been charged with 'driving a car while drunk, driving without reasonable consideration, and dangerous driving' two days before in Grafton Street. 'Confronted with the most positive medical evidence of a shaky walk and alcoholic breath, Burgess was invited by the Justice . . . to explain how he reconciled this with his story of complete teetotalism.'[3] He responded 'with a most affable air' suggesting his tomato juice might have been doctored and pointed at de Vere White who was forced to give an account of the evening.

Burgess's old school-friend Dermot McGillycuddy had been brought in as his defence solicitor and he seems to have worked his magic. The case was dismissed, with the judge describing Burgess as 'a man of brilliance who appeared overwrought and nervous . . . a man of cultivated tastes' – he had been returning from seeing a play at the Abbey Theatre when the accident took place.[4]

According to the doctor, a friend of McGillycuddy, who examined Burgess at the police station, 'There was no smell of drink which witnesses could detect from his breath. He was smoking continuously, his speech was confused and when witnesses asked him to walk in a line, he was definitely unsteady and limp.' It appeared the head injury was more serious than previously thought.[5]

The fall left Burgess with bad headaches and insomnia that he treated with Nembutal to put him to sleep and Benzedrine to wake him up, obtaining his supplies from Peter's vet sister, Sheila. The dosage was as for a horse and Rees later wrote, 'Drugs, combined with alcohol made him more or less insensible for considerable periods in which, when he was not silent and morose, his speech

was rambling and incoherent' to the extent he 'seemed, hardly capable of taking in whatever it was one was saying to him'.[6]

In November 1949, Burgess went on a fortnight's holiday with his mother to North Africa, staying at the Rock Hotel on Gibraltar en route. Here he ran into Dil Rohan, who was also staying with her lover, Mary Oliver. 'We met in the bar before dinner and a young man bounded effusively up to us', Dil Rohan later wrote. 'It was Guy Burgess, with whom I had worked during the war, now better known as the missing diplomat or what I call the missing dipsomaniac . . . I felt rather sorry for his mother Mrs Basset, who was trying to look after him, she was typically English–County, although Bassett is French for Dachshund.'

After dinner Mrs Bassett went to bed and Dil Rohan, Oliver and Burgess adjourned upstairs. 'Guy liked to drink and to talk, now he did both, he talked and talked, sometimes brilliantly, but often with an indiscretion that angered me . . . The main subject of his conversation concerned the merits or otherwise of the British intelligence service; after that he dealt with the future of China and Russia, and was fiercely critical of our foreign office policy.'

The next morning, as Dil Rohan and Mary Oliver were having breakfast, 'Guy burst in, he and his mother with George Greaves were leaving for Tangiers and in a rush to catch the plane.' Taking one of their cups, he filled it 'to the brim with neat whisky, which he tossed down and rushed out'.[7]

David Herbert, an Eton contemporary, meeting him in a Tangier bar, was shocked by his drunkenness and indiscretion, not least by his open espousal of Marxism. By noon each day, Burgess had ensconced himself at the bar of the Café de Paris where he'd recite, 'Little boys are cheap today, cheaper than yesterday.' The final straw for the local gay community came when Burgess started making approaches to their local Arab boys.

Through Robin Maugham, Burgess had obtained introductions to Kenneth Mills and Teddy Dunlop, the local British intelligence representatives in Gibraltar and Tangier. Whilst drinking on the Rock, the three had got into an argument over Franco, whose regime the two intelligence officers supported. Infuriated by his behaviour, which

included criticising the Americans, expressing admiration for Mao Tse-tung, revealing that the British had used the Swiss diplomatic bag to smuggle information out of Switzerland, and disclosing the identities of intelligence officers, Dunlop had complained to the Foreign Office about Burgess's 'extremely indiscreet' behaviour: 'Burgess appears to be a complete alcoholic and I do not think that even in Gibraltar have I seen anyone put away so much hard liquor in so short a time as he did.'[8]

MI6 had held Burgess in their sights for a while, after he had commandeered a source, Alexander Halpern, who had been with British Security Co-ordination in New York during the war. Tipped off by Goronwy Rees that he was visiting London, Burgess had taken him to lunch, and then circulated a memo throughout the Foreign Office drawing on their discussions and identifying Halpern. Annoyed by the compromise and identification of their man and the Tangier episode, MI6 now saw their opportunity to strike.

On his return, Burgess was called in by the Foreign Office personnel department. Apart from the incidents in Gibraltar and Tangiers, Burgess was also accused of passing sensitive material to an American journalist with close links to Soviet intelligence, Freddie Kuh. The subject of a Special Branch file since 1920, Kuh had been the United Press correspondent in Berlin before coming to London in 1933. He had first met Burgess at the BBC during the war and the two men had traded in their favourite currency – information. In March 1943, for example, Kuh had told Burgess that he had learnt from the Swedish minister in London, Prytz, that a Swede had arrived with details from the Finns of 'conditions under which they were prepared to make a separate peace', information that Burgess duly reported back to Moscow, as well as MI5.[9]

It looked like Burgess might have to resign or be dismissed. In January, Guy Liddell reported in his diary that George Carey-Foster had been to see him, seeking his views about Burgess, and that he was speaking to Ashley Clarke, the head of the personnel department. Advice from Bernard Hill, the MI5 legal adviser, was that prosecution would be unwise, as it would only lead to publicity about SIS. 'My own view', Liddell confided to his diary:

was that GUY BURGESS was not the sort of person who would deliberately pass confidential information to unauthorised parties, he was, however, extremely keen and enthusiastic in matters which interested him and would be easily induced by a man such as Freddie KUH to say more than he ought to. So far as his drinking was concerned, I had gained the impression that owing to a severe warning from a doctor, he had more or less gone on the wagon. I did not think he often got wholly out of control, but there was no doubt that drink loosened his tongue. Personally I should have thought a severe reprimand from somebody he respected might be the answer to the present situation.[10]

That was not the end of the matter. Three weeks later, Liddell saw Kenneth Mills, who recounted how he had met Burgess for a drink in Gibraltar – Mills had a beer, Burgess three double brandies – and how Mills had taken Burgess and his mother to the yacht-club, in order that they might be introduced to various local residents. A day or two later, Burgess had called on Mills and his wife when he had consumed quite a lot of whisky, and then just before leaving for Tangier, Burgess had rung up Mills 'and said he was not really sure about de Rohan or Mrs Oliver and that they might, in fact, be up to anything'.

Ten days later, Mills continued, when he was in Tangier, he met Burgess at a hotel where Mills was having a drink with one of his contacts. Burgess, in a somewhat inebriated state, insisted on joining the party. Eventually Mills had to tell him to go away. The same thing happened when Mills was lunching with the American vice-consul and his wife. 'On this occasion he had to go outside with Burgess, who apparently resented being asked to go away. Burgess was clearly drunk at the time and apologised later for having been a nuisance.'[11]

Liddell continued to try and protect Burgess, suspecting that Mills had a personal animus against him, and was reluctant to pass the complaint to the Foreign Office, but Bernard Hill insisted the complaint should be taken seriously. 'The charges were fully investigated by a disciplinary board, and he was severely reprimanded, informed that he would be transferred and that his prospects of promotion would be diminished.'[12] Burgess's response was to tell Liddell that Mills was running a currency racket.[13]

On 17 May Burgess was officially notified that the enquiry conducted into MI6's complaint had been terminated and he was in the clear. He recognised he had survived 'because my friends proved to be stronger than my enemies', but he knew many were gunning for him, not least Carey-Foster, who had recommended that Burgess be sacked. 'His loyalty was not in question', Carey-Foster later wrote. 'It was his behaviour on holiday. Against my advice it was decided to give him one more chance.'[14]

At the beginning of February 1950 Dr Klaus Fuchs had been arrested at Shell Mex House in the Strand. Burgess learnt of the arrest just over a week later, when he had one of his regular meetings with Modin. He reacted with 'calm and composure' to the news of the nuclear physicist's arrest, but was clearly rattled, failing to turn up at the next scheduled rendezvous on 20 March 1950 – the Centre had suspended contact with both Burgess and Blunt for six weeks as a result of the arrest – nor to the back-up meetings.[15] There was extra reason for his discomfort. The previous September, Philby had actually tipped him off that the Venona decrypts had identified a scientist codenamed CHARLES. Burgess thought he had reported this to Modin, but it became clear he'd forgotten to do so. The warning had never reached Moscow Centre. If he had, CHARLES, who was Fuchs, might have been exfiltrated. Instead he was sentenced to fourteen years imprisonment on 1 March.[16]

Donald Maclean had recently returned to London after suffering a nervous breakdown in Cairo, where he had smashed up the room of a young female embassy secretary. Burgess, too, was beginning to crack up under the strain of the Fuchs trial and the progression of the Venona investigation. Harold Nicolson noted in his diary on 24 January, 'I then go to the Reform to dine with Guy Burgess. He is sitting with Alan Maclean of the FO. He is not in one of his most clear-headed moods. I fear he has ruined his life and his career by this incessant soaking. His mind, once so acute, seems to have lost all cutting edge owing to the demon alcohol.'[17] The following day he recorded a similar entry about Burgess. 'Oh my dear, what a sad, sad thing this constant drinking is!'[18]

On 4 June, Burgess had a six-and-a-half-hour meeting in a

suburban park with one of his Russian handlers, Korovin, discussing his worries that he was about to be blown by Venona, that Rees might betray him, even though the two men remained on friendly terms, and that Blunt, who was no longer making his meetings with the Soviets, might commit suicide if caught.[19]

Burgess also seemed to have run into debt, which was strange given his Foreign Office salary was £700 a year, he had a private income of about £500, and the Russians were paying him generously. He was borrowing money from a friend, probably Peter Pollock, according to another friend, almost certainly Jack Hewit. 'I was surprised, because I could not see any change in his circumstances to account for this, and it marked so great a change from a pattern of behaviour that had persisted for so long that I could not help being puzzled by it.'[20]

One night 'Dickie' Leven was in the Reform discussing with two High Court judges the Russian defector Victor Kravchenko's best-selling exposé of Stalinism, *I Chose Freedom*, which had just been published. 'Burgess stopped at our table on the balcony and noticed the book in my lap. He was clearly drunk and took the book from me and harangued the judges and myself about the iniquity of the Americans and how much he hated their way of life. Burgess told us all the book was false and he threw it down from the balcony.'[21]

Though living with Jack Hewit, Burgess continued to have casual affairs with other men. Fanny Carby remembered a much younger boyfriend he had met at Buxtons, a club behind the Haymarket Theatre, 'ravishing though a bit daft. He was an actor and layabout, a German called George Mikell' and also 'an Irish boy called Michael, with a double-barrelled name, whom he met through the director Brian Desmond Hurst'.[22]

On 9 May, shortly before he was formally cleared by the Foreign Office disciplinary panel, Burgess was told he was being posted to Washington as a second secretary, with the role of co-ordinating the affairs of the Far East Department in anticipation of opening an embassy in Peking, a development that would require the transfer of a diplomat with first-secretary rank from the embassy in Washington.[23] Given Burgess's increasing anti-Americanism, the decision to appoint him to an important embassy such as Washington

may seem strange. Certainly MI5 were against it.' There is certainly more opportunity for drinking and for saying the wrong thing in Washington than almost any other capital in the world!' minuted Guy Liddell on 1st May whilst two days later MI5's legal adviser had noted that rather than be 'transferred to a post where he would have less access to secret information. It seems likely that in the Embassy at Washington he will have access to a large amount of secret information.'

Suggestions that the Foreign Office hoped that Burgess, given his anti-Americanism, might not accept are fanciful. As the government later admitted, simply, 'It was decided to try him in a large post like Washington, because there it would be both easier to control and judge him, and less conspicuous to remove him (if need be) than in a smaller post.'[24]

Burgess had been posted to the United States to give him wider experience, but he was reluctant to go. He didn't want to leave Britain and his friends and tried to get himself back into the News Department instead. He spoke of resigning from the Foreign Office, an indication that he wanted out of his double life, just as Rees had a decade earlier, and Blunt had tried at the end of the Second World War. But with no immediate prospects of another job and short of money, with bad grace, after pressure from McNeil, and presumably the Russians, he gave in. Ominously, he told Hewit he would try to get himself recalled.[25]

Neither was Washington enamoured of the idea of the new second secretary. Sir Frederick Hoyer Millar, the minister, balked at the Foreign Office's proposal, exclaiming, 'We can't have that man. He has filthy fingernails.' The refusal produced a sharp rebuke from London, to the effect that Burgess was now an established member of the Foreign Service and it was not for the embassy to refuse to accept him. Bernard Burrows, a first secretary at the embassy, claims he and the minister, Christopher Steel, tried to prevent Burgess's appointment, 'not because we suspected him as a spy, but simply because his unruly way of life and untidy habits of work seemed likely to be disruptive in the workings of our office . . . I had to exert myself to find work for him to do that would not be upset for his irresponsible attitudes and indiscretion.'[26]

Robert Mackenzie, head of security at the embassy, and who had previously been Carey-Foster's deputy in the security department, was given a briefing on the new appointment:

> George Carey-Foster explained crisply why Burgess was getting this last chance to make good, and the character description that followed was withering. He left out nothing that mattered and listed some of Burgess's more glaring peculiarities, including his homosexual habits. I showed the letter to Philby. We agreed it was unusually explicit, then I remember asking Philby what Carey-Foster could possibly mean by hinting that we'd better take care, as Burgess was capable of worse things: 'Surely he can't mean goats?'[27]

At the end of June, Burgess reported to the Russians:

> As instructed, I have given 'Fred' the most important documents I had before my departure. I am leaving in two days' time and today (midnight from 25th to 26th) was the most convenient time for me to organise this (he was also ready) . . . I have carried out instructions on using secure code in correspondence with Fred, which I have agreed with him. However, I would once again press you in writing on what I asked at our last meeting, namely that in the present situation every possible secure attempt should be made for there to be contact in the USA between me and Kim. Events could develop very rapidly and we need to know a great deal. It would be a pity not to make use of past efforts in the current crisis. We are all, of course, sure that you will do all you can. We will all do the same. Jim.[28]

The next evening he was at one of Moura Budberg's parties at Ennismore Gardens with several other suspected Soviet agents, including the publisher James MacGibbon, who was then being watched. The watcher duly reported he 'was inclined to think that Budberg is not a desirable acquaintance for someone of [Burgess's] character and in his position and you may therefore like to have this note for your information'.[29]

On Friday 21 July – '7.30 for a farewell drink' – Hewit arranged a leaving party at Burgess's second-floor flat in New Bond Street. 'For the party, we decided that we would have only champagne to drink and Brie with country butter and pumpernickel', Hewit later wrote. Among the guests were Hector McNeil, Fred Warner, Anthony

Blunt, Guy Liddell, James Pope-Hennessy, Wolfgang von Putlitz, Dennis Proctor, Tessa Mayor, Pat Llewellyn Davies, Peter Pollock, David Footman, Baroness Moira Budberg and Goronwy Rees.[30]

It was a snapshot of Burgess's circle, from spies and spy hunters to senior politicians, diplomats and Cambridge friends. Goronwy Rees couldn't come, but that didn't prevent him from leaving several different accounts of the evening, suggesting it was a more raucous affair than it actually was. According to Rees, 'There were two very tough working-class young men, who had very obviously been picked up off the streets . . . drink flowed faster, one of the young men hit another over the head with a bottle, another left with the distinguished writer, who woke up in the morning to find his flat stripped of all its valuables.'[31] But Jack Hewit remembered that 'the party was restrained and very respectable. I certainly do not remember two "street boys" being present'.[32]

Hewit later wrote that:

Guy Liddell and Hector McNeil were among the first to leave and I am told that David Footman overheard one of them say to Guy as they were leaving, 'For God's sake, Guy, remember three things when you get to the States. Don't be too aggressively communist. Don't get involved in race relations, and above all make sure there aren't any homosexual incidents which might cause trouble.' 'I understand,' said Guy, looking his most mischievous. 'What you mean is, I mustn't make a pass at Paul Robeson.'[33]

27

Washington

On 28 July Burgess set sail from Southampton on Cunard's *Caronia*, with 499 passengers on board, for the week's crossing to New York. It was not just embassy officials who were not looking forward to Burgess's arrival. Neither was Aileen Philby, who had a history of self-harm and had almost had a nervous breakdown after his visit to Istanbul in 1948, but his old friend Kim had agreed to let him stay for a few days, until he found an apartment for himself. She knew better, writing to friends, 'Who do you think has arrived? Guy Burgess. I know him only too well. He will never leave our house.'[1]

'My heart bled for Guy's host and even more for his host's wife. I thought of the cigarette ends stuffed down the backs of sofas, the scorched eiderdowns, the iron-willed determination to have garlic in every dish, including porridge and Christmas pudding, the endless drinking, the terrible trail of havoc which Guy left behind him everywhere', Rees later recollected. 'Yet I knew his misdemeanours would be readily forgiven, for Guy had a devotion to his friends which inspired an equal and answering devotion, and strangely enough, he never quite strained it beyond breaking point.'[2]

The Philbys lived at 4100 Nebraska Avenue, near American University, in a large five-bedroom, two-storey house with a classical portico. Even so, it was a tight squeeze with Kim, Aileen and baby Harry in the master bedroom, the Scottish nanny in another bedroom, and the other four children sharing two more bedrooms. Esther Whitfield, Philby's secretary and lover from Turkey, was in the attic, reached by a retractable ladder on the landing, whilst Burgess was given a room in the basement opening out on to the back garden, which fell away gradually into woods and rough ground. Writing to Peter Pollock, shortly after arriving, he noted, 'I am living in the Philby

house which is nice – in an expanded room with bath, with a separate entrance. Not that separate entrances do much good. I will not write about "Life in Washington", except to say that even I agree with Eric – it simply is not safe or reasonable to do anything in the city.'[3]

If Aileen was unhappy and Philby nervous about their new lodger, at least the Philby children – Josephine, John, Tommy and Miranda – found him a thrilling companion. He was always buying them presents, including a large wigwam, and took a particular interest in John's electric train set, which took up part of his flat, running trains around obstacles such as a bottle of whisky. John Philby later recollected, 'I remember his dark, nicotine-stained fingers. He bit his nails, and always smelled of garlic. Many years later in Moscow, my father told me Burgess had kept his standard-issue KGB revolver and camera hidden under my bed.'[4]

Burgess was very good with children and had numerous godchildren, including Josephine Philby and the sons of Goronwy Rees and his wartime MI5 colleague, Kemball Johnston. Nancy McDonald Hervey, who lived next door to the Philbys, had fond memories:

> Guy Burgess was very friendly to us and we thought that he was great! We called him 'Uncle Guy', probably because that's what Josephine called him, but also because we called our parents' good friends 'aunt' and 'uncle'. Guy Burgess drove a convertible – I have no idea what make or model. He drove us around in the convertible more than once and he seemed to enjoy it as much as we did. Back then, it was exciting to have a ride in a convertible with the top down and Guy Burgess was fun to be with . . . He was jolly and scruffy.[5]

If Burgess was aware of the reaction of Foreign Office officials to his posting, he certainly made no attempt to win their approval. It was customary for all new arrivals at the embassy to visit Francis Thompson, the embassy's senior security officer, for a briefing on local security matters. Burgess did not bother, but the two were quickly to meet after a member of staff reported Burgess for leaving some classified documents unprotected in his office. Thompson took the security violation form to Burgess in his office. 'One of my men found some papers in your office last night which should have been returned to the registry, and we have a system here which requires

you to write an explanation on this form', Thompson told him. 'He did not apologise, as most people normally did.' Thompson advised him to be more careful in future. 'Burgess looked at me in a rather supercilious way, and I left him. My impression was that he was thoroughly unfriendly, and a little scared.'[6]

Burgess's role in the embassy isn't entirely clear, partly because no one wanted him or knew quite what to do with him, and partly because there are so many conflicting reports about what he did and little official confirmation.[7] The embassy had some nine hundred staff, spread over several sites, but most of the important work was done in the sixty-foot stretch of corridor that constituted the chancery on Massachusetts Avenue. It was here that Burgess's office was located by the front door, looking out on to an internal quadrangle.

Next door was Philby, the head of the MI6 station, and his secretary Esther Whitfield, and on the other side Lord Jellicoe, dealing with Balkan matters. Nearby was Geoffrey Paterson, the MI5 representative, and diagonally opposite, Dr Wilfrid Mann, who worked on atomic energy intelligence. This part of the embassy, with its grilles and locks on all doors, was known as the 'Rogue's Gallery' and it suggests that Burgess's responsibilities had some bearing on intelligence, possibly propaganda, and the need for secure communications. It's also clear from circulation lists that Burgess, even though only a second secretary, received highly sensitive material.

According to Denis Greenhill, it was first intended that Burgess work for Counsellor Hubert Graves, who dealt with Far Eastern matters, but he refused to have anything to do with Burgess. The head of chancery, Bernard Burrows, then tried to foist Burgess onto Greenhill, head of the Middle Eastern section, who also dealt with Korea. He refused, because State Department colleagues do 'not like to be fobbed off with a new, more junior man, who had no knowledge of the Middle Eastern area', but he was overruled. Greenhill later remembered how Burgess 'expressed at once a total disinterest in the Middle East and I soon abandoned any attempt to involve him in my work'.[8] Thereafter Burgess had a roving brief that included picking up information gained through his wide socialising and writing general reports on the American scene.[9]

However, there is no doubt that he worked on Far Eastern matters;

Burgess was, for example, on the distribution list for a secret cable concerning Chinese troop movements that otherwise only went to the ambassador, the military attaché and Greenhill, and amongst the heavily weeded embassy files for the period is a report by Burgess to Greenhill and Graves dated 29 August 1950, passing on information from the Chinese Nationalist military attaché, which he'd heard from an unidentified head of mission.[10]

Documentation shows that from his arrival at the beginning of August until the end of November, as Greenhill's assistant, Burgess was also an alternate member of the UK delegation to the Far Eastern Commission. The commission, consisting of the representatives of eleven countries, including the Soviet Union, had been set up in 1945 by the United Nations to ensure Japan fulfilled the terms of its surrender. However, it was ignored by MacArthur and the Soviets resigned from it in February 1950, because there was no representation of the Chinese Communist Government on the commission. The position certainly gave Burgess access to classified documents, but not anything startling. He was also on the Steering and Reparations committees, and on the sub-committees dealing with Strengthening of Democratic Tendencies, War Criminals, Aliens in Japan, Occupation Costs, Financial and Monetary Problems, but as several of these sub-committees didn't meet while he was in Washington, they cannot have been onerous responsibilities.

The legal representative from the State Department on the Aliens in Japan sub-committee, when later interviewed by the FBI, remembered how 'after Burgess came on the committee, he was much more co-operative with the United States in connection with this proposal than had been the prior British representative. She said that he had a good attitude with respect to the work of the committee, and that he seemed to believe firmly in co-operation between the British and Americans' though she 'noted the odour of liquor on Burgess's breath in the morning, and had concluded that he was a rather heavy drinker'.[11]

One of Burgess's jobs was to monitor American public opinion towards the Far East, so he had wide contacts amongst newspapermen. One journalist, who met him several times between January and March 1951 at the Press Club bar of the Foreign Policy Association in Washington, remembered, 'he was interested in questions concerning the Far East' and that:

He seemed to be in agreement with the official British attitude, which was that the rise of communism in China was a Chinese matter which had been accelerated by the Chiang Kai-shek administration, because of the latter's inefficient and dishonest methods. [*Redaction*] stated that it was of great importance to Burgess as a student of China that the Chinese situation be allowed to follow through in its own right to a natural conclusion, and that it bothered Burgess to think that the United States might try to control the Chinese situation.[12]

William Manchester, in his biography of General MacArthur, stated that Burgess 'sat on the top-secret Inter-Allied Board' responsible for policy decisions about the conduct of the war, and therefore was in a position to pass on sensitive material to the Russians, but he provides no more detail and it seems unlikely.[13]

'He was a most unprepossessing sight, with deep nicotine stains on his fingers and a cigarette drooping from his lips', wrote Dennis Greenhill:

Ash dropped everywhere. I took an instant dislike and made up my mind that he would play no part in my official duties. It took little longer to find out that he was a drunken name-dropper and totally useless to me in my work. But he certainly had an enormous range of acquaintances. He made no secret of being a homosexual, but at that time there was no link in official minds with security. Over months it was difficult for anyone to find anything constructive for him to do. I noticed that from time to time he asked me to show him classified telegrams on matters which were not his concern. I declined to do so, not because I thought he might be a spy, but because I felt sure he would not be able to resist the temptation to show off his knowledge to the friends of whom he boasted. He explained his morning lateness in coming into the embassy by 'sinus' trouble, caused by a blow to his head, when a colleague (Sir) Fred Warner had 'deliberately' pushed him down the stairs of a London night club. One redeeming gift was an ability to caricature.[14]

Greenhill felt Burgess took little interest in his work and that 'he was at his most congenial on someone else's sofa, drinking someone else's whisky, telling tales to discredit the famous. The more luxurious the surroundings and the more distinguished the company, the happier he was. I have never heard a name-dropper in the same class.'[15]

A Burgess drawing done for Dennis Greenhill's son Robin.

According to another embassy colleague, Tim Marten, a first secretary dealing with atomic energy:

> He used to appear about 11 o'clock in a suit with a waistcoat which was covered with droppings of his food. Shortly before one, he left for a diner at Dupont Circle. He had his *Stammtisch* – the table where he always sat – and the waiter came with a gallon jar of Californian red, a stone jar, which he plonked in front of him. Burgess couldn't finish that, so the remains would be kept for the next day. He would have pasta . . . and reel out absolutely drunk and then go back to his room at the embassy where he sat, sprawled and snoring loudly, and that was his day. I don't think he ever had any proper work to do. No one trusted him a yard.[16]

Somehow Burgess survived, in spite of his disdain for American values, his superciliousness and his indiscretions, because there were still flashes of the old brilliance, wit and ability to carry out his work effectively, and because he was protected. Tim Marten remembered how 'Oliver Franks and Frederick Hoyer Millar had fought for a year to stop his being posted to the embassy, but his last job had been speechwriter to Hector McNeil . . . Burgess had been very useful to Hector McNeil and Hector felt sort of indebted to him and through Bevin insisted on Burgess coming to Washington.'[17]

One of the first things Burgess, a motor enthusiast, had done on arrival was to purchase a car – a twelve-cylinder 1941 white Lincoln convertible, to which he had added lots of gadgets. This was to be his pride and joy and a source of much irritation to his colleagues, as he parked it wherever he fancied in the embassy compound.

Kim Philby remembered '. . . the delight the Lincoln gave its new owner and it would be nice to say that it was treated thereafter with loving care. But that would give a wholly wrong impression. Love was indeed lavished on it, but not care. It lay in the garden in all weathers with its hood down, its rear compartment gradually filling up with a distasteful mess of miscellaneous junk, sodden newspapers, empty bottles, beer cans, crushed cigarette packets, spent matches and plain dirt.'[18]

Shortly afterwards Burgess wrote to Peter Pollock, who shared his

love of cars, explaining he had already been on two trips of six hundred and eight hundred miles each, often driving at 85 mph all day. 'I have been extremely unfaithful and bought a car that is more beautiful, more fast, more comfortable, more reliable even than the Railton. And nearly as old (1941). It is true that many think it is the best car ever made in the USA – anyhow it's the best I dreamt of having before I arrived here, if I could find one – a Lincoln Continental.'[19]

A family friend of Colonel Bassett from Egypt was Emily Sinkler Roosevelt and, shortly after Burgess's arrival, she and her husband Nicholas, a retired investment banker and cousin of Franklin Roosevelt, issued an invitation to stay at their eighteenth-century estate, Highlands, in Pennsylvania, a hundred-and-thirty miles north of Washington. The Roosevelts, some thirty years older than Burgess, were to open many doors socially for him, not least to the Alsop brothers, Joseph and Stewart, both famous newspaper columnists. Burgess became a frequent visitor to their various properties, including spending Christmas 1950 with them, where he managed to leave behind a pair of striped seersucker, blue-and-white trousers, white dinner jacket, white hairbrush, and umbrella.

In September travelling with Eric Kessler he had a weekend in Virginia, staying with a friend in Richmond and visiting the University of Virginia and Thomas Jefferson's Monticello, which he found 'the most civilised and beautiful house I had ever seen'. Later in the month he drove with a friend, probably Eric Kessler again, who despite his nervousness about Burgess's driving was a frequent companion, to Maryland, where he'd been with Peter Pollock a few years earlier.

'On this trip to Great Falls, Burgess brought 30 to 40 small drawings and watercolours that he had done, most of which were scenes from the Middle East', one FBI report stated. 'Burgess expressed love of life in that part of the world, especially the Mohammedan countries, where men are dominant and women are in the background. Burgess also expressed the opinion that the Western world was very "muddled" and said he would like to get away from it. He told [deleted] that the things he had hoped for in the way of peace, and generally improved conditions, had not come to pass.'[20]

In October he was back at the Roosevelts, where his hosts noticed he was drinking heavily – whisky – but not intoxicated. They 'stated that Burgess had a brilliant mind, talked knowledgeably on many subjects and impressed them as a keen, young British diplomat who was interesting and stimulating. They advised that Burgess appeared to be emotionally unstable, being gay and exhilarated at times, quarrelsome, worried and distracted at others . . . Burgess was a very nervous individual, who chain-smoked cigarettes almost continuously during his visit . . .'[21]

At the beginning of November, Burgess was assigned to look after his fellow Old Etonian, Anthony Eden, probably at the behest of Robert Mackenzie, another Old Etonian. Eden was in Washington, representing the former War Cabinet, at the unveiling of a statue in Arlington National Cemetery of Sir John Dill, the British head of the Combined Chiefs of Staff during the Second World War. It was to prove a dramatic visit. Just as President Harry Truman was about to meet Eden at the White House to drive to Arlington, Puerto Rican revolutionaries attempted to assassinate the President. They were shot dead and Truman continued to the unveiling. Eden, who was to become Foreign Secretary again in October, held a series of high-level talks with the President, Joint Chiefs of Staff, and Secretary of State, and it's highly possible that Burgess, even as a junior diplomat and chauffeur, would have been present.

Eden's thank-you letter, written from Government House in Ottawa, was to become one of Burgess's most valued possessions. 'Thank you so much for all your kindness. I was so well looked after that I am still in robust health, after quite a stormy flight to New York and many engagements since! Truly I enjoyed every moment of my stay in Washington, and you will know how much you helped to make this possible. Renewed greetings and gratitude.'[22]

China entered the Korean War at the end of November and, after Truman suggested at a press conference that he might use atomic weapons against the Chinese, Prime Minister Clement Attlee flew to Washington to remind the Americans they needed to consult Britain if nuclear weapons were to be used. As the embassy's expert on Chinese communism and its relationship with the Soviet Union, Burgess would have been deeply involved in the crisis and would

have passed on any of the discussions, not least information he picked up from Gladwyn Jebb, the UK's ambassador to the United Nations, and his private secretary Alan Maclean, directly to his Russian masters.

A frequent destination was New York, where Burgess often stayed at the flat of Alan Maclean, his former colleague at the News Department.[23] He was also seeing something of his Eton friend Robert Grant, a stockbroker and champion racquets player, and one of his first trips was to Valentine Lawford, a Cambridge contemporary and former British diplomat, whom he insisted on taking for a spin around Oyster Bay and in whom he confided he was 'thinking of leaving the Foreign Office'.[24] On these New York trips he also took the opportunities provided at the Everard Turkish Baths on 28th Street to pick up young men.

The visits to New York took on a new momentum, several times a month, usually staying at the Sutton Hotel on East 56th Street, a semi-residential hotel between 2nd and 3rd Avenue, with literary connections and a swimming pool. Alan Maclean's flat, which he shared with an artist friend, James Farmer, was just around the corner and Burgess often stayed there, to the extent that Gladwyn Jebb formed the mistaken impression that the two men 'shared a flat'.[25] These trips tended to follow a pattern of arriving on a Friday night and returning on Sunday or Monday to Washington. Though ostensibly social, the weekends actually served another purpose. Burgess acted as a courier for Philby, which was the real reason he was living with him, and these visits were used to meet their controller, Valeri Makayev.[26]

Burgess was also travelling further afield. Martin Young, an Apostle and then a junior diplomat, remembered in late 1950 how he brought the diplomatic bag from Washington to Havana, where he was a twenty-three-year-old third secretary:

> I asked Guy to dinner and he spent the evening at my flat in Vedado, scattering the sofa with cigarette ash and mesmerising me with his conversation. Of this I remember only two items: an account of the delights of sex with boys behind the rolled-up mats of one of the mosques of Constantinople . . . The other was the story of his being hauled before the head of chancery or minister in the Washington embassy after one of his flagrant speeding offences, and

getting out of trouble by managing to let whoever it was catch sight of his copy of Churchill's speeches, with Winston's praise for Guy's 'admirable sentiments' inscribed on the fly-leaf . . .'[267]

Young arranged to meet Burgess first thing next morning at a café-bar by the street entrance to the chancery offices, but he didn't turn up . . . 'the driver of the Legation car which had taken him and our bag to the airport later gave me a scrap of paper on which Guy had scribbled an almost illegible drunken apology'.[28]

According to Stanley Weiss, a twenty-one-year-old American whom Burgess had met and unsuccessfully tried to seduce on the boat from London, he was also travelling frequently to Mexico. In spite of the two-decade age difference and the fact Weiss was hetero-sexual, the two men became friends. Over the next six months they would meet every few weeks, occasionally to go to films, but mainly to simply drive around town and drink. 'He loved Beethoven and we would often talk about music. He never stopped smoking or drinking but I never saw him drunk,' Weiss later remembered. Burgess wrote to him regularly, encouraged Weiss's reading – in particular *The Sheltering Sky* by Paul Bowles – and suggested he apply to Georgetown University's School of Foreign Service. In hindsight, Weiss realised he was being cultivated.[29]

The journalist Henry Brandon ran into Burgess soon after his arrival. '"Guy, who on earth sent you to Washington?" Burgess, not sure whether to be flattered or offended by my incredulity, replied that he had just joined the embassy staff as a second secretary concerned with Far Eastern Affairs'. After Brandon had been in Washington for about three months, he got a letter from Hector McNeil:

> Saying Guy was feeling 'lonely' there and could I ask him to some parties of mine? So, to please Hector, I asked Burgess for drinks to my apartment and to one or two dinner parties. He was always surprisingly civil. Several times on leaving my apartment he said to me in a quasi-confidential tone of voice that he was going to spend the evening with Sumner Welles, a very rich man who used to be Under-Secretary of State . . . with a twinkle he suggested that he was a fine man to have an affair with . . .[30]

Burgess continued to be unhappy – about his job and life in America. In December he took the opportunity of sounding out Michael Berry, when he was in Washington for two days, about a job on the *Daily Telegraph* foreign desk, but with no success. Burgess had invited him to have tea with Sumner Welles, who had been the American Under-Secretary of State from 1937 to 1943 until dismissed in a homosexual scandal. Welles's wife had just died and he and Burgess had struck up a friendship, helped by their shared interest in politics, alcohol, men and their self-destructive character.[31] Berry later remembered, 'We went to his house, which was about an hour out of Washington, in Guy's car, and had a very ordinary tea, talking about foreign affairs. One thing I remember was that Guy had a full bottle of whisky in the glove pocket of his car, and offered me a swig directly after lunch. When I declined, he had some.'[32]

When he heard Joseph Alsop was hosting a party in honour of Berry and his wife Pamela that evening, Burgess tried to get himself invited. Though there was no room at the dinner, Alsop suggested he drop in for coffee afterwards. According to one account, 'Burgess arrived drunk, unshaven, and unkempt, and soon started denouncing America's Korean War policy' and was thrown out.[33] Berry's own recollection was more prosaic. 'He was full of beans, but, according to my wife, was a little drunk when he offered us a lift back to our hotel. Consequently, though I had no licence, I was made to drive his car.'[34]

The following day James Angleton, a senior CIA officer, was lunching in Georgetown when Burgess appeared. 'He wore a peculiar garb, namely a white British naval jacket, which was dirty and stained. He was intoxicated, unshaven and had, from the appearance of his eyes, not washed since he last slept. He stated that he had taken two or three days' leave and had "an interesting binge" the night before at Joe Alsop's house.'[35]

Burgess explained that he intended to make a fortune working with a friend on Long Island, importing thousands of the type of naval jacket he was wearing and selling them in exclusive shops in New York. He also pressed Angleton 'for a date when they might meet in order that he might test the overdrive on the Oldsmobile'. The encounter was duly reported back to Philby.[36]

28

Disgrace

On Friday 19 January 1951, the Philbys held a formal dinner party for twelve, which was to become notorious in Burgess's path of self-destruction. Among the guests were the CIA's head of the Office of Special Operations, which involved international liaison James Angleton and his wife Cicely; William Harvey, a former FBI agent responsible for counter-intelligence at the CIA and his hard-drinking wife Libby; Robert Lamphere, the FBI liaison to the CIA and his wife; Robert Mackenzie, the British embassy's regional security officer for the Americas, with Geraldine Dack, one of Philby's secretaries, and Wilfrid Mann and his wife Miriam.

The couples were enjoying coffee when Burgess returned to the Philby house about 9.30 p.m. He was:

> in his usual aggressive mood and, almost immediately after being introduced, he commented to [Mrs Harvey] that it was strange to see the face he had been doodling all his life suddenly appear before him. She immediately responded by asking him to draw her. She was a pleasant woman, but her jaw was a little prominent; Guy caricatured her face . . . so that it looked like the prow of a dreadnought with its underwater battering ram.[1]

'I've never been so insulted in all my life,' Mrs Harvey shouted and stormed out of the house with her equally angry husband. Philby remonstrated it was just a joke and Burgess had meant no harm, but Harvey was having none of it. 'He saw in Burgess's gratuitous insult an aristocratic contempt for his unadorned Midwestern background and that of his college dropout wife.'[2]

Aileen was shattered. Her important dinner party had been destroyed by a man she despised. Whilst Miriam Mann and Cicely

Caricatures by Guy Burgess on Wilfred Mann's copy of *Atomic Energy* by
George Gamow, 25 November 1950. Elizabeth was a close friend of Burgess.

Angleton comforted her in the kitchen, the unrepentant Burgess helped himself to drinks, to celebrate his coup against Harvey. James Angleton and Wilfrid Mann, escaping from the highly charged atmosphere, went outside. On returning, Mann found Philby, in short-sleeves and bright red braces, in a darkened room with his head in his hands. 'The man who had never been known to lose his self-control, the pride of the British service, was weeping. In between his anguished sobs, he kept saying to himself over and over, "How could you, how could you?" One Soviet spy had, in the home of another Soviet spy, insulted the man whose job it was to flush out Soviet spies. As Talleyrand would have put it, it was worse than a crime, it was a blunder.'[3] Burgess might have enjoyed his momentary triumph over Harvey, but he had made himself a powerful enemy.

Returning the next morning to pick up his car, Mann found Burgess and Philby 'in the double bed that was facing me. They were propped up on pillows, wearing pyjamas; one, or even both of them, may have been wearing a dressing-gown as well. They were drinking champagne together, and asked me to have a glass too as a pick-me-up . . . I got the impression that both Philby and Burgess were enjoying the situation immensely.'[4]

Mann's own loyalty has itself been the subject of much debate. In Andrew Boyle's *The Fourth Man*, which led to the exposure of Anthony Blunt, Mann, under the pseudonym 'Basil', was named as himself having worked for the Russians. Citing confidential information from a CIA source, Boyle claimed the Israelis 'passed on to Angleton the name of the British nuclear scientist whom they had unearthed as an important Soviet agent' just after the Second World War, as 'the price for uninterrupted but informal co-operation with US intelligence'. Angleton decided to 'run the operation out of his hip pocket for at least a couple of years . . . Whether Hoover himself was fully informed is questionable. What can be said is that the FBI did learn eventually that "Basil" was working under CIA control as a double agent. It is impossible to be more precise than this, because no complete chronological record of the operation was kept; next to nothing was committed to paper.'[5]

According to Boyle, quite separately in late 1948, American

cryptoanalysis revealed a Russian source inside the British embassy who had passed classified information during the final stages of the Second World War. 'Basil' was identified and 'broke down quickly and easily, confessing that he had become a covert communist in his student days and a secret agent for the Soviets not long afterwards'. He was given the choice of continuing to work for the Russians under CIA direction, or 'take whatever penalties were visited on him by American law'. In return for protection and the promise of American citizenship, 'Basil' agreed to be played back against the Russians. He also revealed that the Russians had penetrated British intelligence, hence Angleton failing to share his coup with the British. According to Boyle, 'Angleton intended to use "Basil" next to test the slight suspicions he had long nursed about Philby.'[6]

Mann understandably vigorously denied the accusations, publishing a book challenging some of the evidence that Boyle had produced, though some of his defences were themselves found to be false – but he did not sue. Mann's recruitment and turning is backed up by Patrick Reilly, chair of the Joint Intelligence Committee, and then the Foreign Office Under-Secretary in charge of intelligence, who wrote in his unpublished memoirs, 'That "Basil", who can easily be identified, was in fact a Soviet spy is true: and also that he was turned round without difficulty.'[7]

Those who defend Mann say his name does not appear in Guy Liddell's diary, the Venona decrypts nor the Mitrokhin Archive, that he was several times security cleared and his FBI file is not designated R for Russian espionage, and they believe Angleton misled Boyle to protect his own reputation over Philby and Reilly simply wrote down gossip.

However, the fact Mann's name has not cropped up in Liddell, Venona and Mitrokhin does not necessarily mean he did not spy for the Russians but simply there is no record. He could, for example, have been run by Russian military intelligence, the GRU, or outside the rezidentura. The spy writer Nigel West claims that in 2003 documents were retrieved from the KGB archive suggesting 'that Mann may have been a Soviet spy codenamed MALLONE' whilst Jerry Dan's novel, based on interviews with a KGB scientific officer Vladimir Barkovsky, *Ultimate Deception: How Stalin Stole the Bomb*

includes an interview with Mann confessing to his treachery. The jury remains out.[8]

Meanwhile some code-breaking investigations, in which the FBI agents at the dinner party were involved, were proceeding.[9] During the previous eight years, American cryptanalysts had intercepted thousands of Soviet intelligence telegrams written in code, though only managed to partially decrypt about two thousand. In 1946 one of the analysts, Meredith Gardner, had, through a Soviet error, managed to decipher one of the messages between the US and Moscow. The operation codenamed BRIDE and then VENONA revealed that over two hundred Americans had become Soviet agents during the war, with spies in the Treasury, State Department, the nuclear Manhattan project, and the OSS. It had also uncovered an unidentifiable Soviet agent, codenamed HOMER, based in the Washington embassy in 1945, who was passing secrets. The information was immediately passed to the head of the MI6 station in Washington, Kim Philby, who in turn told Burgess.[10]

A few weeks earlier the decoders had decrypted a message from June 1944, narrowing the number of suspects for the spy 'Homer'. Investigations suggested one of two men – Paul Gore-Booth and Donald Maclean. Philby immediately informed his controller Makayev and plans were set afoot to warn Maclean and exfiltrate him.[11]

Though neither Burgess nor Philby had yet come under suspicion of espionage, Burgess's cruising of Washington bars and lavatories had begun to excite the interest of Inspector Roy Blick of the Washington Metropolitan Police Vice Squad, who now put him under surveillance, reporting that he had been seen on two occasions escorting a striking platinum blonde, and in the company of Russians eating at the Old Balalaika Restaurant in downtown Washington. Meanwhile Valentine Vivian, now an SIS security inspector and visiting America, warned Philby that his association with Burgess was unwise.[12]

Burgess's increasing disillusionment with political events continued. Writing to Peter Pollock in mid-January from Nebraska Avenue, with instructions on cashing some cheques he'd sent, he admitted, 'Life is not hell at the moment. But it is so absolutely bloody in its official aspects, I mean American Policy, as to make even you most apoplectic . . . Can one last, or will one go quite mad?'[13]

Interviewed later about his Washington sojourn, Burgess spoke of:

> The appalling experience I'd had at the embassy in Washington – that terrible and ignorant subservience to the State Department that I've told you about – <u>and</u> the realisation you see that this was what my life would be for the next twenty years. I wouldn't have minded nearly so much if I could have sat in the Foreign Office all the time. But I knew I couldn't do that: everybody has to serve in the various missions overseas . . . and Washington is supposed to be one of the top embassies – so what on earth could the others be like?[14]

A journalist who saw him several times that spring remembered that Burgess 'drank heavily but was able to "hold his whiskey", in that he could drink six highballs, "without turning a hair". He stated that although Burgess would drink an unusually large amount of whiskey, he never seemed to even approach becoming intoxicated . . . He found Burgess "restless and agitated" and:

> feeling that the United States was headed for doom because of having gotten confused and bogged down with regard to Oriental affairs . . . Burgess was very free in manner and seemed almost desperate in his seeking friends. He stated Burgess made a very poor personal appearance, pointing out that he never wore a hat, his hair was always tousled, and his fingernails were always very dirty . . . Burgess liked to drive his convertible car with the top down in the wintertime and to make a lot of noise with it. He stated that Burgess would continually pace the floor while talking and was a very unconventional type of individual . . . expressed the opinion that it would be interesting, from a psychological point of view, to determine the reason for Burgess's 'flamboyance' and his apparent revolt from conventions.[15]

He recollected how 'Burgess seemed to consider the fact that investigation of homosexuals was being made by Congress as a personal affront . . . that his meetings with Burgess were getting rather monotonous, because all that Burgess talked about was China, the United States, and his Lincoln Continental automobile', adding that after Burgess took him to lunch 'he had parked between two signs designating a no parking loading zone, telling [redacted] that he didn't have to worry about being illegally parked since he was a diplomat'.[16]

Burgess was approaching forty, still a second secretary, often being

given mundane work and aware his Foreign Office career was going nowhere. He and the ambassador had a mutual-hate relationship and Burgess was gradually being demoted from one job to another, until to his indignation he was left administering the George Marshall scholarships. His diabetes was leading to blackouts and his dependence on drink, always there, was becoming more critical. Senator Joe McCarthy's anti-communist crusade was in full swing and Burgess could be aroused almost to hysteria by McCarthy's identification of communism with homosexuality. He was also becoming increasingly angry about American foreign policy. The security violations continued, with constant complaints to Thompson about carelessness, classified papers not locked away, and so on. It was almost as if Burgess was trying to get himself dismissed, not least by his truculent responses. Philby later wrote:

> For all his apparent waywardness, Guy was dreadfully afflicted by awareness of his failures. Indeed the waywardness and the failure fed each other, causing a vicious spiral, spinning downwards. A lesser character might well have succumbed completely, years earlier. But Guy had a stubborn streak of integrity which no outrage could wholly subdue. Repeatedly he sat in judgement on himself, pronouncing harsh sentences. But he had no means of executing them and the sentences remained in the air. The outcome was galling unhappiness. He stood shame-faced in his own presence. [17]

Most of his colleagues tried to avoid him. Patsy Jellicoe remembers him covered in dandruff and an 'awful show-off. He knew everyone and would tell you . . . no one liked him because he pretended to be so grand. He dropped names to be important . . . He was just irritating', adding that 'he was always propositioning everyone'. [18] One colleague, however, with whom he remained on good terms was Esther Whitfield. After they had met in Istanbul, they had stayed in touch when Esther was posted to London between September 1948 and March 1950. They now saw much of each other and even went away for weekends together. Philby told MI5:

> In the meanwhile, his relations with Miss Whitfield developed. I did not pry into the matter myself, partly because I was afraid of being asked for advice. On the other hand, I thought it possible that marriage

might prevent Guy from going completely to the dogs; on the other hand, I doubted whether Miss Whitfield could take the strain. My information on the progress of the affair is therefore derived from rather shoddy de-tails derived from Guy himself. I gather that he did make a definitive proposal on one occasion, but that her reply was non-committal.[19]

Alan Davidson, private secretary to the ambassador Oliver Franks, had first encountered Burgess when he joined the Foreign Office in 1948 and was serving in the Northern Department. In Washington, Davidson would sometimes meet Burgess for drinks with Pat Grant, the personal assistant to the ambassador. One day in the spring of 1951, Davidson had a telephone call from the security guard at the front door, saying there seemed be a fire in Burgess's office. They couldn't get in, but there was smoke coming from under the door, and there had been no response when he'd knocked. Davidson told him to break down the door. The door was solid, and after they had been battering away for some time, to their astonishment it was opened from the inside. 'At that point Guy appeared at the door looking a bit flustered. "I was burning a few papers." It seemed perfectly natural for someone like him to be burning private corres-pondence. Oh Guy, he was always doing crazy things. It fitted in with the messy side of his behaviour.'[20]

29

Sent Home

In February The Citadel, a military college in Charleston, South Carolina, which was hosting the annual three-day South Eastern Regional International Relations Club meeting, asked the British embassy for a speaker. Burgess, the only spare official with the necessary expertise, was sent after the designated speaker had to drop out. He left by car on the morning of Wednesday 28 February for the journey of just over five hundred miles. Accompanying him was a young black homosexual in his late twenties called James Turck. Having formerly served in the Air Force, Turck was a drifter of no fixed address, who sometimes worked for a used-car dealer in New Jersey and whom Burgess already knew.[1]

Twenty miles out of Washington at Woodbridge, Virginia, Burgess was stopped by the police for driving at 90 mph. Pleading diplomatic immunity, he was let off with a warning. A further sixty miles on and the car was stopped again, just north of Richmond at Ashland, Virginia, for driving at 80 mph whilst trying to pass an entire Army convoy. Again no ticket was issued. After Richmond, where they had stopped for thirty minutes to make minor repairs to the brakes, Turck took over the driving, because Burgess had drunk a few beers at lunch. Burgess told Turck he was authorised by him to drive over the speed limit, as he was late for his engagement in Charleston. Five miles south of Petersburg, the car was stopped a third time for speeding – this time doing 80 mph in a 60 mph zone. As Turck handed across his licence to the traffic officer, Burgess intervened. 'I am a diplomat,' he said, passing his passport and driver's licence through the window, 'and Mr Turck is my chauffeur; we are both protected by diplomatic immunity.'[2]

The patrolman, Sam Mellichamp of the Virginia State Police, was

not persuaded that a diplomat's 'chauffeur' was protected by diplomatic immunity, nor was the local justice of the peace in Petersburg, David Lyon, who set bail of $55. After ninety minutes at the police station, Burgess was forced to find a bank or hotel in St Petersburg that would cash a cheque, the fine was duly paid, and the pair continued their journey, spending the night in a seedy motel outside Charleston before Burgess put the young black man on a bus to Richmond, where he was going to a car auction. Turck recalled how Burgess had brought several cameras – 'one was a camera similar to those used by newspaper photographers and the other was a movie camera' – that Burgess claimed he needed to take some pictures near Charleston, 'where the United States had purchased a tract of land for the purpose of building the H–Bomb'. He noticed, too, that he 'carried a British-made pistol in the glove compartment of his car'.[3]

That should have been the end of the matter but, whilst Burgess had been raising money for the fine, Turck had given an affidavit that this was, in fact, the third speeding offence of the day and Burgess had encouraged him to speed. The affidavit eventually found its way to the Governor of Virginia and subsequently to the British ambassador. Meanwhile, unaware of the train of events that had been set in motion, Burgess checked into the Francis Marion Hotel in Charleston's historic downtown area, and proceeded to make the most of his trip south.

Emily Roosevelt had provided Burgess with various introductions to local worthies, who immediately took him in hand. Benjamin Kittredge, a relative of hers, gave him a personal tour of the hundred-and-sixty-three-acre swamp garden he had spent forty years creating. Burgess responded by passing out drunk on the floor of his boat, and he had still not fully sobered up by the time he arrived for dinner at 5.30 p.m. in the Citadel's mess hall, where he was seated at the head table with a State Department official, professors from Duke and Princeton, and diplomats from other embassies.[4]

In front of over some two hundred listeners, at 7.15 p.m. Burgess then launched into his talk, 'Britain: Partner for Peace', in which he defended Britain's recognition of Communist China. 'We feel that by continuing relations, at least one Western foot can be kept in the Chinese door. We are not sufficiently mobilised to run the risk of

breaking with China and possibly precipitating World War III. We are fighting a delaying action.'[5] Loma Allen, a young cadet, remembered how enthusiastic the cadets had been to hear a British diplomat but how disappointed they had been when he appeared. 'He was totally dishevelled and his suit looked like he had slept in it for several days. His speech was laughable and one of the most inept presentations I have ever heard. His delivery was stammered, there were long pauses between sentences and it was incoherent'.[6]

Allen was part of a group discussion with Burgess after the talk and found the diplomat continued to be 'unresponsive, mumbling and very anti-American'. Though Allen did not see Burgess again, Burgess returned to Charleston several times over the next few months and cadets often saw him in a downtown bar.

Much of the speech was a diatribe on the failures of American foreign policy, and especially its refusal to recognise Red China. 'How Red is the Yellow Peril, tell me that?' he supposedly kept asking. The speech was received with polite applause. As the next speaker began his presentation, Burgess put his head back and went to sleep.[7]

The next day Emily Fishburne Whaley, the niece of Emily Roosevelt, gave him a tour of Charleston, which included a long lunch at one of its finest restaurants. She found him both charming and erudite and couldn't wait to introduce him to her husband, but when she rushed up to him at the cocktail party held in his honour that night by another local dignitary, Burgess looked at her blankly. He couldn't remember who she was. The next day she showed him the one-hundred-and-seventy-acre Cypress Gardens, which included some eighty acres of blackwater swamp, 'paddling him through that black shiny water and explaining to him what had been done in the garden. She noticed his head was sinking and in no time at all he was asleep right under her nose . . . They left him on the island in the bateau sleeping.'[8]

Burgess's path of self-destruction, not helped by his diabetes and inability to hold his drink, continued. Through Philby, Burgess was invited to a cocktail party on 16 March at the home of Kermit Roosevelt, a senior CIA official and grandson of the US President Theodore Roosevelt. Amongst those there were Franklin D. Roosevelt

Jr, son of FDR, the British military attaché, and the wife of Walter Bedell Smith, director of the CIA. Burgess quickly got into an argument with Roosevelt over the Korean War, which became so heated that the two men had to be separated. So enraged was Roosevelt that he recounted the episode to Allen Dulles, deputy director of the CIA, the next morning. Dulles had already heard it from his boss, Bedell Smith.

Meanwhile John Battle, the Governor of Virginia, had written to John Simmons, the State Department's chief of protocol, enclosing Turck's affidavit and complaining about Burgess's 'flagrant violation of our traffic laws, which might very well have resulted in a disastrous accident . . . Mr Burgess claimed diplomatic immunity for himself and his driver, even going so far as to threaten the arresting officers in the event the case was prosecuted.'[9] As Oliver Franks, the ambassador, was in London until 28 March, the State Department did not bother to forward the letter to the embassy until 30 March. Franks immediately consulted with the Foreign Office.

Burgess, in Charleston on a week's holiday with his mother to celebrate his fortieth birthday, was oblivious to the course of events. He was on his best behaviour and 'exceedingly judicious in his drinking', partly through mortification at his behaviour on his previous trip, and partly because of the presence of his mother. Mrs Roosevelt found him 'calm and serene, was cheerful, looked well, and exhibited no signs of tension. He told her that he had applied to the Foreign Office for release from his present assignment.'[10]

On Saturday 14 April, Burgess returned to Washington and was immediately summoned to Oliver Franks's office. On Wednesday 18 April the embassy notified the State Department that Burgess was being recalled. He had been suspended and was due to appear before a disciplinary board with a view to his resignation or dismissal. Franks reported to the Foreign Office that his 'work had been unsatisfactory, that his routine work lacked thoroughness and balance, and that he had had to be reprimanded for carelessness in leaving confidential papers unattended'.[11]

If Burgess had deliberately planned this recall, as many accounts claim, he put up a good front, storming into Greenhill's office 'boiling with rage'. Greenhill wrote, 'Later he tried to make light of it to

me, saying his only regret was that he would find it hard to explain to his friends in London . . . To report failure would, he said, be embarrassing.'[12]

Contrary to the accepted wisdom that Burgess had deliberately engineered his return, it was only the chance remark by Turck, of which Burgess had been unaware, about the previous traffic violations that had been the nail in his coffin. The speeding episode was also the final straw for his colleagues in the embassy. Burgess's poor record had finally caught up with him. As Robert Cecil put it, '. . . although Burgess may have collected more tickets than usual on that particular day, neither his speeding, nor his tendency to pick up stray homosexuals was in any way a novelty; it just happened to be his unlucky day'.[13]

One morning in spring 1951, according to one of the varying accounts of the episode he later gave, Michael Straight was coming out of the embassy in his car, when he saw a man 'waving vainly at the taxis as they rushed past down the hill'. It was Burgess. 'He climbed in beside me. "Can you drop me downtown?" he asked. "I've lost my car, or rather, it's been taken from me."' Straight claimed to be surprised and appalled to learn his Cambridge contemporary had been in Washington since October. '"You told me in 1949 that you were going to leave the Foreign Office. You gave me your word." "Did I say that? Perhaps I did."'[14]

Straight was even more concerned to discover that Burgess was responsible for Far Eastern affairs at the embassy. In October, South Korean and American troops had crossed the 38th parallel and advanced to the Yalu River, where they had been ambushed by a massive Chinese force. He put it to Burgess that he had been aware of the plans to advance into North Korea and would have sent the information to Moscow, who would have passed it to Peking. If so, Burgess had caused the deaths of many American soldiers. Burgess defended himself by saying that everyone knew about the plans, including the Chinese. Straight wasn't convinced:

'"We're at war now. If you aren't out of the government within a month from now, I swear to you, I'll turn you in." Guy looked back, smiling, as he climbed out of the car. "Don't worry," he said.

"I'm about to sail for England and as soon as I return, I'm going to resign."'[15]

Clearly this meeting could only have taken place after Burgess's dismissal in April. Straight claimed that he had been unaware that his fellow Apostle and recruit had even been in Washington until that 'chance' meeting in the spring of 1951. There had, however, been a Straight meeting in March, not with Burgess, but with a boyfriend of Blunt's called John Blamey. He was coming to Washington and Blunt took the opportunity of the visit to pass on to Burgess a copy of his latest book, *The Nation's Pictures*. Burgess claimed to Blamey that he didn't have time to meet him, so Michael Straight had dined with Blamey instead and the book was duly passed across.[16] 'There is little doubt, according to Yuri Modin, that there would have been a message in the book for Burgess – a warning for him to get out of the United States.'[17]

For his last few weeks in the embassy, Burgess was given the most tedious tasks, including having to respond to the flood of outraged letters to the embassy after Truman dismissed General MacArthur on 11 April, supposedly under British influence. 'He sat, brooding amidst overflowing ash trays', wrote Greenhill. 'After many days, he drafted a private letter to Donald Maclean, head of the American Department in the Foreign Office, analysing the correspondence.'[18]

However, much of Burgess's day was spent dropping into the offices of colleagues to pour out his woes or pacing up and down the embassy library. The security officer Francis Thompson 'kept as much casual observation on him as I could, and formed the impression that he was under great mental strain, and possibly a little mad, so eccentric was his behaviour – though at no time had he shown any very normal behavior, for he had always appeared to lack even the most elementary social graces'.[19]

There was a brief trip to New York, the third week of April, where he saw W.H. Auden and then, on Saturday 28 April, Burgess left Washington for good. That night he wrote to Pollock on Mrs Nicholas Roosevelt's Gippy Plantation notepaper:

Whatever may be the reason for yr silence you must have a letter on this notepaper. I am thank God returning to England immediately

and leave on the Queen Mary on May 1st. I don't know when it arrives, but you can look it up. I think it terrifyingly possible that there will be a war and if so very soon. So it's wonderful to be coming back . . . This place stinks.[20]

Over a meal in the noisy Peking Restaurant, the night before, he and Philby went over the escape plan to exfiltrate Maclean. 'Burgess did not look too happy, and I must have had an inkling of what was on his mind.'

'Don't you go, too,' said Philby, as he drove Burgess to Union Station the next morning.[21]

Burgess spent the few days in New York, in a state of semi-permanent intoxication, staying with Alan Maclean. On the night before he sailed, a leaving party was held with some friends including Norman Luker, now working for the BBC in the Rockefeller Center. Luker later remembered:

On that evening, the greater part of which was spent in making music for our guests, present-day politics were not discussed – except that long after midnight, one significant remark was made to me by Burgess. It was that the memory of such an evening of music-making among friends would never be forgotten. He felt that war was imminent and that it probably would take place within ten days. As he was slightly under the influence of drink, his remark made no impression on me – but in view of his disappearance, he obviously felt that there was significance in the remark, which he repeated in the sober light of the following morning.[22]

Burgess was drunk, but also in reflective mood, and asked Luker if he could borrow his 'sound mirror', as tape recorders were known at the time, as he wanted to record his impressions of Churchill for posterity. David Brynley, a friend of Burgess, later recalled, 'He began telling us about an interview he said he had with Churchill. He imitated Churchill's voice, and it was screamingly funny . . . He went on for more than half an hour. Then he began singing. He was mellow, but not drunk – oh dear, no.'[23]

Luker was surprised when Burgess, who had only left the party at 2.30 a.m., appeared just before lunch the next day, as the *Queen Mary* was due to sail at just before 3 p.m., asking to listen again to

the tape, which had taken three takes to record, 'in case there is anything incriminating in it'. When it was finished, Burgess said, 'That's okay. It's an interesting story and a jolly good recording. I wish you'd send me a copy of it,' and caught his waiting taxi.

Was this a treasured memory of an important moment in his life or did the tape have greater significance – a discreet reminder, should it surface, of Burgess's high-level connections?[24]

30

Back in Britain

Burgess spent most of the five-day Atlantic crossing drunk, the trip only enlivened by a stocky companion in his mid-twenties named Bernard Miller, whom Burgess later claimed ran a progressive theatre off-Broadway, and who disembarked at Cherbourg.[1]

Burgess arrived at Southampton on 7 May and was met by Anthony Blunt. The two returned to Blunt's flat at the Courtauld Institute, where Burgess passed on what Philby had learnt of the investigations into 'Homer' and they discussed plans for Maclean's exfiltration. The next day, Tuesday 8 May, Blunt met with Modin to pass on the news that Maclean was close to being exposed. 'The Centre reacted very quickly. Its message was clear and unambiguous: "We agree to your organising Maclean's defection. We will receive him here and provide him with whatever he needs, if he wishes to go through with it." '[2]

Burgess, meanwhile, went down to see Goronwy Rees in Sonning, in Berkshire, bringing with him various presents including two cowboy outfits, with hats and pistols, denim jeans, and a plastic washing-up bowl that Burgess insisted Mrs Rees test for toughness by driving the car over it – it sprang back into shape. He was also reunited with the Rees's tabby cat, Burgess.[3]

Rees thought Burgess in better physical shape than when he had left. 'His suit was freshly pressed, his handkerchief was clean, even his fingernails were almost clean . . . He was gay and charming and delightful, as I had not remembered him for many years . . . But it was also evident that he was labouring under a tremendous sense of excitement, as if he was under intense internal pressures.'[4]

Burgess spoke of his worries about American foreign policy, the threat of McCarthyism, and war, and the fact that the Foreign Office couldn't see that threat. He produced an analysis of the American

political position he had written that the ambassador, Oliver Franks, had forbidden him from forwarding to London, which he told Rees he now intended to show to the head of the Far Eastern Department and the ex-Minister of State for Foreign Affairs, Kenneth Younger:

> I suddenly had the slightly queasy feeling that I was talking to a lunatic. I had never had quite the same feeling about Guy before, in spite of all the monstrosities of his behaviour. He had always had an extremely sharp insight into the workings of the English social and bureaucratic system. Now he seemed to be throwing all this away, for some purpose which I found myself totally incapable of understanding.[5]

But the real purpose of Burgess's visit became clear. He was there to ensure that Rees would hold his tongue and he did so by appealing to the Apostolic virtues of loyalty, to friends above country. That evening the two friends walked down to the river and had a few beers in a local pub, where Burgess explained to Rees that he had been suspended and would probably be dismissed from the service.[6]

The next morning he duly reported to the Foreign Office personnel department, where it was suggested that he should consider resigning. Burgess was given a week or two to think this over, as a briefing note to Herbert Morrison, the Foreign Secretary, confirmed. 'The possibility of his dismissal was not raised with you at this time, as it was hoped that he would voluntarily submit his resignation. If he had refused to do so, the next step would probably have been the holding of a Disciplinary Board, whose findings would have been subject to your approval.'[7]

That evening Burgess returned to New Bond Street and a reunion with Jack Hewit, after almost ten months apart:

> When I got home, Guy was there. He looked younger and much fitter than he had looked before he left for America. He gave me a lightweight summer suit he had bought for me at Saks in New York. He was in great form and was delightful and charming, and obviously very excited at being back in London. I made a meal for us. He asked me to make a kedgeree and we ate and talked. At least, he talked mostly and I listened . . .
> While unpacking, I found a thick packet of bank-notes in his luggage.

'What on earth is this?' I asked him. 'Oh, I brought it from America for a friend.' 'Pity,' I said, 'we could do with it. The telephone bill has to be paid and the electricity bill is due soon.' 'Well, it's not mine,' he said. And that was the end of that conversation. I thought then of the other times I had found large sums of money lying around . . . He never explained why he had these mysterious sums of money at odd intervals.[8]

All those who came across him over the next few days were struck by his forebodings about the possibility of war and his anti-Americanism. Cyril Connolly ran into him in the street, where, 'He came up with his usual snarling-playful manner . . . He seemed very well and almost jaunty, obviously pleased to be back. He went around saying he was convinced that America had gone mad and was determined on war.'[9]

Quentin Bell, having a lunchtime drink at the Reform with him, noticed he had seven gin and gingers. 'I was amazed that he remained standing and coherent, or at least fairly coherent. He had just returned from Washington DC. He expressed his hatred for the Americans with great vigour and although I, too, disapproved of their policies, I was astonished by his violence and his bitterness. He ceased to convince or to amuse me and I escaped as soon as I could.'[10]

Dickie Leven often saw him that month:

He would often arrive at the Reform Club in the morning without having shaved and dressed like a tramp, although, of course, he always wore his Old Etonian tie. One evening I was sitting with Burgess and Anthony Blunt when Burgess said to Blunt, 'You have got to help me sell some pictures.' Blunt looked at Guy as if he was mad and said, 'Bring them round to the Club and I will see what I can do.' Then he suddenly added, 'For God's sake, stop talking about your problems, I am getting everything organised for you.' . . . Guy became quite pathetic, and begged me to go back to his flat with him.

Seeing how upset he was, Leven agreed. Once there, 'suddenly Guy put his hands on my legs and tried to clutch hold of my penis'. Leven, appalled, made to leave. Burgess apologised immediately, but by way of explanation continued, 'I can seduce any man or woman I want to. I have always been able to have an affair with anyone I

want to.' He then proceeded to show him a file of handwritten –
though whose is not clear – letters from his 'friends'. According to
Leven's account, Anthony Eden had written, 'Dear Guy, I am sorry
you have not been well. Do let me know when you recover and I
should enjoy another dinner together'. There was one from Churchill,
'Dear Guy, I am sorry to hear of your illness. Please communicate
with me when you are better', and another from Louis Mountbatten,
'Dear Guy, Brian and I miss your company. It will be a happy day
when we meet again. God bless you, and may you soon recover.'

Leven had agreed to buy two pictures for £52 and the next morning
Burgess dutifully delivered the pictures to the Reform Club. Leven
thought no more about the episode until a Mrs Rimington from MI5
came to interview him in 1972 about his links with Burgess.[11]

Saturday 12th May was the Apostles annual dinner, held in
Cambridge that year. En route Burgess paid a visit to his old wartime
friend from MI5 Kemball Johnston, whom he had seen much of
since the War, first at his home at Woodstock, near Oxford, and now
at Henhan in Suffolk. Johnston's ten year old son Timothy remem-
bered Burgess as 'a fat, smelly, untidy man, with a red face and slob-
bery lips, who peed behind a bush in the garden instead of going
to the lavatory like normal grown-ups.'[12]

Burgess doodled cartoons for the Johnston boys including one
enigmatic one of Stalin peering over a wall captioned 'I wonder
what Kemball is thinking?'

Burgess was one of the speakers at the dinner that year. The subject
for his speech was to be Truth. Hewit remembered how 'He asked me
if I would make some notes for him while he tried out some thoughts
he had on the subject. He walked up and down and talked. He likened
truth to beauty and how beauty was indeed in the eye of the beholder
and how different people saw beauty in different things and that one
object or person could be looked at in many different ways and that
some people would call what they saw beautiful while others would
call what they saw ugly. Truth he said was like beauty.'[13]

Peter Marris, the youngest member at the dinner, remembered an
encounter with Burgess that evening 'As the party broke up, I was
offered a lift home by Guy Burgess, who was, as I understood,
something connected to the Foreign Office. Something about him,

at once aggressive and insinuating, made me uneasy. When we reached the horse pond at the top of Hampstead Hill, I asked him to let me out, pretending that I was only a few steps from my house.'[14]

Realising he had no future in the Foreign Office, Burgess was attempting to find a job. He invited Michael Berry to lunch at the Reform Club, explained that his Foreign Office future looked uncertain and asked if there might be any work at the *Daily Telegraph*, perhaps as a diplomatic or motoring correspondent. Berry remembered that, 'Guy gave me a document to read, marked Top Secret. That was typical Guy. It was a report he had drafted for the ambassador at the embassy in Washington on the state of American opinion on something or other, but it never got passed on. I was appalled when I read it. His writing had certainly gone to seed. He wasn't seedy, but his writing was.' Feeling sorry for him, Berry suggested Burgess come to dinner on 29 May to discuss his prospects further.[15]

Burgess's priority was to make contact with Maclean and he arranged to meet him at the Foreign Office, only natural given Maclean's job as head of the American Department. They sat talking on a sofa outside Maclean's room, afraid that his room was 'miked'. Maclean then suggested they should lunch together at the Reform Club, but the dining-room was full, so they walked a few doors down and lunched at Burgess's other club, the RAC.

> As soon as we met, Donald said, 'I'm in frightful trouble. I'm being followed by the dicks.' Maclean pointed at two men following him. Sure enough, there they were, jingling their coins in a policeman-like manner and looking embarrassed at having to follow a member of the officer classes. '*Idiots* they are,' he went on, with a sort of savage contempt. 'They're so clumsy that their car even bumped into the back of my taxi the other day . . . That's when I first saw their faces. After that, they put two different chaps on.[16]

Supposedly at Dick White's suggestion, the watchers from A4, the MI5 surveillance section, had deliberately made themselves known, as part of the psychological pressure on Maclean. Certainly Patrick Reilly, meeting Maclean in St James's Park, noticed, 'The man following him could be fairly easily identified.'[17] Whether this was a deliberate policy or simply poor surveillance is not clear.

Carey-Foster had spotted from the intercepts of Maclean's tele-phone conversations that Burgess had contacted him as soon as he had returned from Washington, and that subsequently the two men were frequently seen together. He suggested to MI5 that Burgess should be watched too.[18]

The Centre gave instructions for Maclean to defect, but he was reluctant, not least because his wife Melinda was expecting their third child. He then claimed he couldn't make the journey alone, so Burgess, at a meeting with Modin, was instructed by the Centre to accompany him for part of the way. That decision – one that hadn't been thought through by Moscow Centre – was to have momentous consequences, not just for Burgess but also for Philby.[19]

The Cambridge Spies knew they had to act swiftly. Philby had seen a telegram sent to the MI5 representative in the embassy, Geoffrey Paterson, seeking to clarify 'a technical point about the original "Homer" telegram by interviewing a cipher officer, who in 1944 had been on duty in the embassy and was once more serving there. It was stated that an answer was required by 23 May for a meeting to be held on the following day.'[20]

Exfiltration by train or plane was impossible, given Maclean was on watch lists, and false papers could not be produced sufficiently quickly. Modin, who had been tasked with the escape, looked at 'sending a submarine closer to London and putting him on the submarine to take him away to the Soviet Union. However, it was hardly practicable. A motor ship would deliver the two from English territory to the French border, but what would be in France? We didn't know.'[21]

It was supposedly either Modin or Blunt who then noticed that there were ships – favoured by officials and businessmen for entertaining their mistresses – that sailed without passport checks from the southern English ports and cruised along the French coast, putting in, though not strictly allowed, to French ports such as St Malo for a bit of shopping. This seemed the perfect solution.

Maclean was tailed to and from Victoria and Charing Cross each day – though he had taken to varying the route to his home in Tatsfield, in Kent – but Modin knew MI5 could not mount a major surveillance operation at Maclean's house, 'Beaconshaw', without it

being noticed. 'On the train, too, Donald would know the other passengers by sight, all of them being people who had taken the same train for years, to and from their offices. A follower would stick out like a sore thumb at the little station at Tatsfield, especially since Donald always went home from the station by car, never on foot. MI5 might manage the thing successfully once or twice, but certainly not on a daily basis.'[22] A counter-surveillance operation confirmed Modin's instincts and a plan was formulated. On 17 May, instructions detailing how Maclean would make his escape were sent to London.[23]

MI5 surveillance and telephone tapping of Maclean – the telephone at Beaconshaw had a microphone that relayed conversation to MI5's headquarters at Leconfield House in real time – had picked up Burgess and he was now being followed. According to an A4 surveillance report:

> Guy Burgess appears to have something on his mind and is, in fact, obviously deeply worried. He will order a large gin (his favourite tipple) and will then pace the bar for a few seconds, pour the neat spirit down his throat and walk out, or order another and repeat the performance. In the open he frequently shows indecision with, apparently, his mind in turmoil. With CURZON [Maclean] there is an air almost of conspiracy between the two. It is quite impossible even in a bar to hear a word of what they are saying. It would seem likely that Burgess has unburdened himself to CURZON, as the latter does not display any normal emotion when they are together.[24]

On Tuesday 15 May, final plans were drawn up in the office of Sir William Strang, the Permanent Under-Secretary, to bring Maclean in.[25] Later that week, Guy Liddell confided in his diary:

> I had a meeting on the MACLEAN case with Dick, James Robertson and Martin, when they outlined to me the position which had been reached and the future programme culminating in the interrogation of Maclean. The only interesting development has been a visit by Maclean to the V&A Museum where he met Peter Flood, who is a known member of the underground Berger Group. Whether he was seeing FLOOD about something in his own particular field at the museum is not known, but apparently Maclean knew him very well. Maclean is evidently drinking very heavily.[26]

The following Monday, 21 May, a group from MI5 met in Strang's office again. The head of MI5, Sir Percy Sillitoe, was anxious to maintain good relations with the FBI, especially after the damage inflicted by the Fuchs case, and wanted the head of the FBI, J. Edgar Hoover, kept fully informed about MI5's plans. Dick White, head of the counter-intelligence B Division, argued they should wait a bit longer, in case Maclean cracked and incriminated himself. What they did not know was that Maclean had told the Russians that if interrogated, he would confess.

On Wednesday 23 May, Robert Mackenzie, the regional security officer at the British embassy in Washington, who was in London en route to an intelligence conference in Paris, called on Liddell and White to complain that the procedures for Maclean's interrogation were taking too long. 'From all I hear, Maclean is on the point of cracking up. You ought to pull him in at once and get the truth out of him without all this nonsensical kid-glove treatment.'[27]

Finally, on Thursday 24 May, full details of the plan were telegraphed to Kim Philby in Washington. 'I seem to remember that some hitch with the FBI caused a last minute delay,' wrote Patrick Reilly. 'A meeting chaired by Strang fixed the final instructions for the interrogation to be held in the week of 28 May, probably on that day, the Monday.'[28]

But the timetable remained flexible. British intelligence had no wish to reveal their hand in court with the Venona decrypts, so the case had to be built either by Maclean being caught red-handed with his Soviet controllers, or from a confession. Indeed, Sillitoe was hoping to personally brief Hoover on the investigations when he was in Washington in early June.

Melinda Maclean was due to give birth in hospital by Caesarean section in the second week of June, and it was thought this would provide an opportunity to search the Maclean's home, whilst Donald was at work. What MI5 did not realise was that Maclean's escape plan was ready to spring into action.

31

The Final Week

Burgess spent the weekend of Friday 18th to Monday 21st May with Peter Pollock in Hertfordshire. Pollock remembered Burgess 'whilst there behaved very oddly indeed. He was taking codeine tablets, he drank a lot though not excessively and was extremely sleepless, wandering about the house at night. He was obviously very unwell.'[1]

At the same time Esther Whitfield had written to Burgess c/o Reform Club asking what she should do about the Lincoln adding a postscript which she asked him to destroy 'when you go to Michael Berry do be clean (nails, hands, face etc), clothes' signing off 'Dear sweet, bless you. Lots of love, Esther.'

She then continued clearly responding to his marriage proposal:

> Nothing in our relationship has been exactly traditional . . . It's not so much the actual bed but everything – the attention, care and interest – that it engenders that I myself wd want and that I don't think you wd give. Being a woman I cd give all that without the bed, but for a man I suppose it is different – all those things only come as a result of the bed. How mis and badly circumstanced everything is. But I suppose nothing wd be more mis than being unhappily married. I wd far rather keep you always as a good and loving friend. Guy there is one thing I wd like to know about this bed. Has it always been like that with you or is recent or is it just me? I hope this is not a very impertinent question.[2]

On Monday 21 May Bernard Miller arrived in London, staying first at the Russell and then Green Park hotel, and was entertained several times by Burgess at the Reform Club and Gargoyle and introduced to various of his friends, including Jack Hewit, who was told the two men would be going away for a weekend together.

234

That week Hewit noticed that Burgess was in a strange mood. 'He was smoking a great deal and he was back on Nembutal. I had a day off on the Tuesday and during the morning he made a telephone call to Lady Maclean, Donald Maclean's mother, and he asked her for Donald's home telephone number. He said he had a message for Donald from his brother Alan, whom he had met before he sailed from America.'[3]

On Tuesday he visited Tomas and Hilda Harris. Burgess had previously been barred from their house, largely owing to Hilda's intense dislike of him, but he had been allowed 'to work his passage back'. When asked about Kim Philby, he had put his hands to his head and said, 'Don't speak to me of Kim – nobody could have been more wonderful to me', and then burst into tears.[4]

'He was still in an odd mood on Wednesday, fluctuating between bouts of good humour and moments of sentimentality', remembered Hewit:

> I put it down to the fact that he had decided to resign from the Foreign Office. That evening we dined at home. We had smoked eel, which he bought at Fortnum & Mason, and a shepherd's pie which I had made, and a great deal of red wine . . . Then, quite suddenly, he said, 'I'm not going away with Bernard this weekend.' 'Why ever not?' I asked. I thought for one happy moment that he was going to ask me to go with him instead. 'I have to do something else. There is an old friend of mine at the FO in serious trouble and I'm going to use the other ticket to help him get away from it for a while.' We were both a bit tight by this time, as we had consumed quite a lot of red wine. We talked about it. 'Why you?' I asked him. 'Because I'm the only one he will trust,' was the answer. 'How long will you be away?' I asked. 'If all goes well, I should be back on Monday, but if I decide to go on to Paris from St Malo, I will let you know.' The *Falaise* was due to sail on Friday at midnight from Southampton to St Malo and return via Jersey. Then quite suddenly and for no reason that I can give I said, 'It's Donald Maclean, isn't it?' He never answered.[5]

On Thursday 24th, after lunch with Donald Maclean at the Reform Club, he went down to see his old history teacher, Robert Birley, now headmaster of Eton, to ask his advice. He claimed the Salisbury family had asked him to complete the life of the Victorian prime

minister Lord Salisbury, which Salisbury's daughter had left unfinished, but he was hesitating. '"Well, you see, Salisbury was a convinced Christian and I am a complete agnostic. I think that matters. What do you advise?" Birley replied, "The only thing I can suggest you can do is talk to the present Lord Salisbury and put that to him." He thanked me. We discussed other subjects . . . then Guy left.'[6]

He then paid a nostalgic visit to his childhood home in Ascot, asking if he could look around, the first time he'd visited the house since his mother had moved out over ten years before. Little had changed, with the bell pulls for Mr Nigel and Mr Guy's rooms still prominent at the entrance. He looked around the house, signed the visitors' book and returned to London.[7] He then saw Peter Pollock, who had left his Rolls-Royce parked behind Burgess's flat, and put a call into Stephen Spender asking if he could speak 'very urgently' to W.H. Auden, who was staying with him. Natasha Spender explained he was not there and Burgess said he would ring back.

That night he met Fanny Carby for a drink at the Players Theatre, telling her he had been learning Russian, which he thought might lead to a job on the *Daily Telegraph*'s diplomatic staff before going on to have dinner with Peter Pollock, Andrew Revai and Bernard Miller.[8] Hewit was out to dinner that night, but returned at 10 p.m. to find Burgess having an argument. 'I listened outside Guy's door and heard Guy speaking his brand of French to someone who answered in French, but was obviously neither French nor English. The argument was really quite fierce and I thought that Guy had brought back someone who was spoiling for a fight, so I knocked at the door and asked Guy if he needed anything. He said he didn't . . . I didn't hear anything else, nor did I hear his visitor leave.'[9]

Hewit later wrote of how, on Friday 25th, 'I made tea as usual about 8 a.m. and took it in to him. He was alone in bed reading. The curtains were closed and the bedside lamp was on. The ashtray was overflowing. I realised that he had had one of his very frequent sleepless nights. I opened the curtains, emptied the ashtray, plumped up his pillows, planted a kiss on his forehead and said, "I'll see you later." He didn't say anything.'[10]

Burgess spent the morning telephoning old friends. He tried Wystan Auden again, in the hope of arranging to stay with him on

Ischia, where he now lived, and this time Stephen Spender took the call. Burgess told him, at length, how much he had enjoyed Spender's recently published autobiography, *World Within World*, which discussed his disenchantment with the Communist Party during the late 1930s. Spender found the praise 'strange', as it was the first conversation he could recall having with Burgess in five years. When Auden came home late that night, Spender told him that Burgess wanted him to call back. 'Do I have to?' Auden drawled. 'He's always drunk.' He did not call back.[11]

Burgess then talked to Margie Rees on the telephone for about twenty minutes, which was so incoherent and made such little sense that she assumed he was either drunk or under the influence of drugs, and did not really pay much attention to what he was saying. 'Among other things, he had said that he was about to do something which would surprise and shock many people, but he was sure it was the right thing to do.' He had gone on to say that he would not see them for some time and that this was really for the best, because they no longer saw eye to eye politically, but that Goronwy would understand what he was going to do, and indeed was the only one of his friends who would.[12]

At about the same time on the morning of 25 May, the Foreign Secretary, Herbert Morrison, approved a timetable for suggesting to the US security authorities that Maclean be interrogated the following month, when his wife was in hospital having her baby.[13]

Later that morning Burgess went to the Continental Booking Office at Victoria and booked a two-berth cabin for a weekend cruise to St Malo for him and Bernard Miller, but Miller knew nothing of this. He had only just come from France and had no wish to go back. Nor was he a homosexual, nor the owner of an off-Broadway theatre. He was, in fact, a medical student spending a semester at the University of Geneva and, according to his later FBI interview, he had come to London simply because Burgess had promised to introduce him to a friend, who was a doctor at London's Middlesex Hospital.[14]

He hired a cream Austin A-40 saloon from Welbeck Motors in Crawford Street and saw Blunt at the Courtauld in Portman Square. He then went on to the Reform Club, where he had lunch then

saw Bernard Miller. As part of his deliberate laying of a false trail, Burgess ostentatiously looked at road maps of the north of England, discussing the merits of various routes with one of the club servants, and letting it be known he was planning on going to the Lake District or Scotland.

Later that afternoon with Miller he bought a suitcase, shirt, socks, a black soft hat and umbrella at Gieves in Old Bond Street.

Returning to New Bond Street, he packed a tweed suit, some nylon shirts, shoes, socks, dinner jacket, shaving kit, £300, some savings certificates and the collected novels of Jane Austen, as 'I never travel without it', and just before 6 p.m., he set off on what would be the first stage in his journey into exile.[15]

Meanwhile Maclean had been celebrating his thirty-eighth birthday with friends at two restaurants in Central London, before returning to the Foreign Office. As he crossed the Foreign Office courtyard about 6 p.m. he unexpectedly ran into the Deputy Under-Secretary of State, Roger Makins, who was also leaving, and they exchanged a few casual remarks during which Maclean mentioned he wouldn't be in the next day. Makins, who was aware of the investigations, had no wish to give Maclean any grounds for suspicion and assumed that the surveillance stretched to Tatsfield. Nevertheless, he returned to the Foreign Office to check with Carey-Foster, or his secretary, that Maclean had indeed taken the day off, but both had already gone home. Maclean, followed by the watchers, caught his usual train home from Charing Cross.

Shortly after Maclean arrived home, Burgess drove through the gates of Beaconshaw, the four-bedroomed house that the Macleans had bought on their return from Cairo, and was introduced as Roger Styles – the name was taken from two Agatha Christie books, *The Mysterious Affair at Styles* and *The Murder of Roger Ackroyd*. The two men had a quick supper and then told Melinda they had to meet a man in Andover. Whilst Burgess waited in the hall, Maclean said goodbye to his two young sons, before leaving about 9 p.m. Taking turns driving, the two men sped the ninety miles along the back roads to Southampton. Just before midnight, the car screeched to a halt on Southampton dock. Abandoning it, they ran up the gangplank as it was being raised. 'Back Monday,' shouted Burgess.

In fact, the two men had not gone unnoticed. Maclean, whose name was on a watch list, had been clocked by an immigration official, and he immediately rang MI5's operational headquarters in London, Leconfield House, where a number of officers were still planning the Monday interview. Alerts were put out to British intelligence officers on the Continent, but the French police, for fear of a leak, were not informed. Without a warrant to arrest the two men, there was little the British authorities could do.[16]

The *Falaise* reached St Malo at 9 a.m. on the Saturday morning. It was raining, so only a few of the two hundred passengers aboard alighted. Burgess and Maclean remained lingering over a breakfast of eggs and bacon and then went ashore, leaving in their cabins the luggage they had brought with them. As they had missed the 11.20 a.m. boat-train to Paris, a taxi-driver called Albert Gilbert drove them to Rennes, where he dropped them off in the main square, and they caught up with the train. That was the last anyone from the West was to see of them for five years.[17]

32

The Bird Has Flown

On the Saturday, Jane Portal, one of Winston Churchill's secretaries, was on weekend duty manning the switchboard at Chartwell, a few miles from Tatsfield. At 7 p.m. she took a call from the resident clerk at the Foreign Office. 'So I put the call through and listened in as it was our duty to make a note. I remember the resident saying, "Your neighbour has flown." Churchill replied, "Thank you for letting me know. Do keep me in touch."'[1]

Alerts had already gone out across the Continent, but only to British intelligence. Anthony Cavendish, at the MI6 station in Berlin, was summoned to the office in the Olympic Stadium, where he was handed photographs of the two men, and together with some fifty other colleagues, he manned the crossing points into the Soviet sector until Monday, when the alert was called off.[2]

William Manser, then at the British legation in Berne, was given the task of finding the missing diplomats. 'Intelligence had come through that the two were in Switzerland, it was thought at Ascona on Lake Maggiore. I was to go there at once, find them and stop them.' Deciding the most likely place to find Burgess was a bar, he began to search for them on bicycle, not just in Ascona, but from Brissago to Locarno. He decided if he came across Burgess, 'I would invite him to share a bottle of champagne with me – something that he was very much odds-on to accept – and into his successive glasses I would tip gross quantities of Kruschen salts, indistinguishable in taste, colour and sparkle. That would certainly immobilise him. Failing this, I would "do anything".' After four days of searching with no success, Manser returned to Berne.[3]

Jack Hewit had spent Saturday 'doing household chores and shopping' for 'a sort of belated birthday party' that evening, before having

Burgess's cartoon of Jack Hewit in the flat they shared in New Bond Street.

a drink at the Bunch of Grapes with some of the working girls he knew in Shepherd Market, in Mayfair. That night he rang Blunt to report that Guy had not returned from his overnight trip and Blunt, in turn, rang Ellis Waterhouse to check if he was there.[4]

On Sunday evening, 27 May, Goronwy Rees returned from All Souls and learnt of Burgess's call. His sister-in-law, Mary Hardy, who lived with the family, remembered the reaction. '"For God's sake. Guy's gone to Moscow. We must tell someone." They were like people possessed.'[5] He immediately telephoned David Footman, with whom he had worked at MI6, to say Guy had 'apparently vanished into the blue' and that MI5 should be told.[6] Footman immediately informed Guy Liddell. Rees then called Blunt, asking for advice.

Realising that there was a danger of Rees going to the authorities, Blunt rushed to Sonning, where Rees told him that he thought Burgess was a Soviet agent. Blunt tried to persuade him there was no firm evidence, Burgess was a fantasist, and Rees's 'belief that he might be a Soviet agent rested simply on one single remark made by him years ago'.[7] He pointed out that Burgess was one of his oldest friends and that making the kind of allegation he proposed was not the act of a friend. Rees, however, remained adamant that the authorities must be told.

On Monday 27 May, Melinda made two calls to the Foreign Office. The first to the American desk to ask if her husband was there. The second, in the afternoon, to Carey-Foster, whom she had met in Washington a few years earlier and knew was head of security, reporting that Donald had left on Friday night with a Foreign Office colleague, 'Roger Styles', and wondering where he might be.[8]

Writers have argued that this is a sign of Melinda's innocence. The popular perception is she had no knowledge of her husband's espionage activities and was an innocent victim of the Cold War. Burgess's visit was a complete surprise and she had no idea her husband would be off that night, or when he would return. Even when interviewed by the FBI in September 1981, Melinda insisted, 'At no time during this period did Mrs Maclean suspect her husband was a Soviet Agent or even that he was a Marxist . . . Mrs Maclean first met Guy Burgess on the day her husband fled from Britain,

25 May 1951. Mrs Maclean could not recall her husband ever speaking of Guy Burgess before that time.'[9]

The truth is very different. The calls had been made safe in the knowledge the two men were safely away. Melinda had known throughout the marriage that her husband was a Soviet agent and in 1943 had actually agreed, if required, to act as a go-between for him and the Russians.[10] It was she who had insisted Maclean go, rather than brazen it out, saying she could always join him later. Even Modin admitted she 'knew Burgess perfectly well'.[11] When Melinda's sister-in-law and her husband, Nancy and Robert Oetking, were interviewed by the FBI in 1954, they said it was obvious Maclean wasn't expected back, as no place had ever been set for him at the table.[12]

According to Patrick Reilly's unpublished memoir, there was little concern at the Foreign Office, because Roger Makins had thought it possible that he had agreed to Maclean taking the Monday off as well as Saturday,[13] but the reality was different. On Monday, George Carey-Foster and Patrick Reilly immediately arranged to see the head of the Foreign Office, William Strang, and were later joined by Percy Sillitoe and Dick White from MI5. Told they needed the Home Secretary's approval for the men's passports to be seized, Carey-Foster, Sillitoe and White then walked over to the Home Office, where they waited for ages in the private secretary's office, whilst the Home Secretary in conference decided whether or not to reprieve a murderess.[14]

Carey-Foster then rang Robert Mackenzie, who was at the Paris embassy for a security meeting, to enlist the help of the French police and the French counter-espionage service, the Deuxieme Bureau. By the time Mackenzie rang back it was very late. Assisting Carey-Foster in his investigations was his new deputy in the security department – Milo Talbot, Burgess's former Cambridge pupil, whom he had himself brought into British intelligence.[15]

That evening Hewit returned from work, claiming that he expected to see Burgess. 'I knew from the state of the flat that he hadn't been back, as it was still clean and tidy.' At 9 p.m. he rang Rees and spoke to Margie, who said she'd last spoken to him on Friday morning. He then rang Blunt 'and asked him if he had any idea whether Guy was

going to Paris, or whether he had mentioned going somewhere other than Paris'. He told Blunt he was going to telephone the Green Park Hotel to see whether or not Bernard Miller was there. '"I shouldn't do that," he said. "Why not?" I asked. "It doesn't seem right to upset a comparative stranger, who has no doubt been disappointed at not going on the trip," he replied.' When Hewit insisted he should phone Miller, Blunt was 'quiet for some time, then he said, "I don't want you to speak to Bernard. If Guy comes in, ask him to ring me. If I don't hear from him, I will ring you at your office tomorrow. Don't worry and please do as I say."'[16]

The next morning, Tuesday, Blunt rang Hewit, saying they needed to meet as soon as possible. He picked him up from his office and asked for the key to the flat. Telling Hewit to lie low and stay with friends, he took his key and cleared the flat of any incriminating evidence and then passed the keys to MI5, to save them the trouble of applying for a search warrant. Blunt then accompanied MI5's Ronnie Reed in a second search. A guitar case in a cupboard was found to hold bundles of love letters going back over twenty years, held as much for blackmail as sentimental reasons.[17] Blunt later claimed that he'd had an accomplice, telling Rosamond Lehmann, just before his death, that Rees had helped him search the flat.[18]

Even with the clearance, Special Branch found a twenty-five-page bundle of internal Treasury appreciations going back to 1940 in the flat, identified by a sharp-eyed MI5 officer, Evelyn McBarnet, to have been written by John Cairncross. Cairncross was immediately put under surveillance and a telephone tap revealed a request to meet a Soviet embassy official in a wood in Surrey, to discuss the Burgess and Maclean case. The search also found pen-portraits of various officials, some giving details of alleged character weaknesses and other features that might be exploited. Blunt had stayed with Special Branch as the flat in New Bond Street was officially searched, and, by chance, himself found a letter to Burgess from Philby, saying that if he ever needed help he should contact Flora Solomon, as she knew all about his secret life. Blunt pocketed the letter.[19]

Born in 1895, Solomon was the daughter of a banker in Czarist Russia, who had been one of the backers of the deposed Russian prime minister, Alexander Kerensky. In 1917 she had fled to Britain,

where she had married a Colonel Harold Solomon and during the 1930s had been an active Zionist. She had known Philby since he was a boy and had subsequently introduced him to his second wife Aileen – both worked for Marks & Spencer – and was one of two witnesses at their marriage. Through Philby and W.H. Auden, who tutored her son Peter, she had also met Burgess.[20]

Philby had confessed to Solomon, just before he set out for Spain in the spring of 1937, that he was secretly working for the Comintern, and had tried to recruit her himself during one of his trips back from Spain. MI5's Peter Wright, who interviewed her in 1962, found her 'a strange, rather untrustworthy woman, who never told the truth about her relations with people like Philby in the 1930s. I guessed from listening to her that she and Philby must have been lovers in the 1930s.' Wright concluded, 'She had obviously been in the thick of things in the mid-1930s, part inspiration, part fellow accomplice, and part courier . . .'[21]

On Tuesday, Blunt also saw Peter Pollock at Flaunden, supposedly on behalf of MI5, telling him to say nothing. 'You keep me out of it,' he said, 'and I'll keep you out of it.'[22] Tuesday was also the day the recriminations began. Carey-Foster had recommended Burgess be dismissed for indiscretions and lack of security before his posting to Washington and reluctantly had 'agreed to the views of the other members of the Board which Ashley set up – 4-1 against. What was B anyway at the time? An unpleasant junior officer – a headache to Security Department – not a matter to worry you with.'[23]

News of the Burgess and Maclean flight reached the Washington embassy in an overnight coded 'Most Immediate' telegram to Geoffrey Paterson, the MI5 liaison officer. As his secretary was on leave, Esther Whitfield was woken in the middle of the night to help decode the message. Philby guessed what it might be but he could do nothing. The next morning he casually dropped in on Paterson, who looked grey. 'Kim,' he said in a half-whisper, 'the bird has flown.' Philby feigned horror at news that Maclean had escaped. 'But there's worse than that . . . Guy Burgess has gone with him.' As Philby recollected, 'At that my consternation was no pretence.' Given that few knew of the 'Homer' investigation, and his close association with Burgess,

he realised it would be only a matter of time before he, too, would come under suspicion.[24]

The Burgess and Maclean case was the third body-blow that American security had suffered as a result of the British, after the atom spies Alan Nunn May and Klaus Fuchs, and they were beginning to feel their whole atomic programme was being betrayed by foreigners. Paterson and Philby quickly arranged to see Mickey Ladd at the FBI and presented him with the telegram. 'Ladd read it, without hurrying, his cigar clamped in his mouth, and then inhaled and regarded his visitors with a smile. "Well, you've made a mess, boys."'[25]

Ladd's own quirky friendship with Burgess – they loved to exchange insults, not least about car rallying – meant he took the news calmly, but Robert Lamphere was more suspicious. 'Paterson and Philby came in. I'm not saying much. They're not saying much. I know one thing for sure: I've been lied to for a long time by MI5. I'm doing a lot of thinking; they're doing a lot of thinking. I'm thinking, Maclean has fled. Burgess, who had been in Philby's house, has fled with him. Surely Philby tipped off Maclean.'[26]

Returning home, Philby placed a suitcase containing his copying camera and accessories in his car, drove to Great Falls, some woodland outside Washington, buried his equipment and returned. The whole trip had taken less than two hours.

Bill Freedman, an MI6 officer at the time, denies that the Americans were kept in the dark. 'It is nonsense to claim that the Americans were not told of the B&M defections. I was ordered by Jack Easton to stay in my office and I had a camp-bed installed and stayed sending telegrams around the world. We opened up immediately, because we wanted them arrested. We sent out photographs of the two, and the Americans would have known straight away.'[27]

There were concerns from Geoffrey Paterson that the FBI would pass the news to the State Department and it was stressed that the security angle must be kept quiet. Preparations were made for a response should the escape be leaked to the press.

That night a group of guests gathered at the home of Michael and Pamela Berry, an elegant Georgian townhouse in Lord North Street, near the Houses of Parliament. They included the writer and

then editor of the *Times Literary Supplement*, Alan Pryce Jones and his wife, the novelist Ian and Ann Fleming, Isaiah Berlin, Anthony Blunt, the poet John Betjeman, and the sister of the Duke of Devonshire, Lady Elizabeth Cavendish.

'We waited some forty minutes for an absent male guest, until Mrs Fleming asked Pam Hartwell for whom we were waiting. "Guy Burgess", said she . . . The talk was cut short by Blunt saying that Burgess either came on time or not at all: we had no reason to wait any longer. And, grumbling, Lady H led us in to dinner.'[28]

On Wednesday 30 May, the opportunity was taken to interview Melinda, when she was in London for a medical examination. She met MI5's chief interrogator Jim Skardon and George Carey-Foster at Lady Maclean's flat, 87 Iverna Court in Kensington, but claimed to know little about the disappearance.

The British authorities were keeping the whole situation tightly under wraps, not quite sure what to do, or exactly where the two men might be. Only now, over four days since the two men had fled, was the Foreign Secretary, Morrison, informed of the disappearance. He immediately 'directed that vigorous action should be taken to trace and recover the missing men, if necessary by arrest in friendly countries'.[29] MI5 reported that ships manifests were being checked, especially on the basis of a tip-off in Marseilles, and the movements of Soviet and Satellite ships being watched. The security authorities had been alerted abroad, including Tangier, and as Guy Liddell noted in his diary, 'These countries were to be asked to arrest and deport, as undesirable aliens, both Maclean and Burgess if found.'[30] Mrs Bassett, who had expected to see her son on the Sunday, wanted to go to the police, but was mollified by MI5 telling her that her son had been traced abroad.[31]

On the Wednesday, Anthony Blunt and Tomas Harris came to see Liddell to discuss the disappearance. Blunt now told Liddell that he had known Burgess had been a communist at Cambridge, but had believed he had left the party in 1935. Liddell wrote, '. . . they both felt it was unlikely that Burgess would have sold himself to the Russians, but they felt he was such an unstable character that almost anything was possible'.[32] Liddell, who trusted his former assistant, Blunt, was increasingly enlisting his help in the search for the missing

diplomats – for example, calling him in on Saturday for tips of any Burgess contacts in Paris.

On Tuesday 5 June, Alan Maclean, who had been recalled from America, was interviewed by Skardon, and the next day Goronwy Rees was interviewed formally by Dick White and Liddell at Leconfield House, in Curzon Street, though he had had an informal chat with Liddell the previous Friday. He repeated his claims that Burgess had confessed to him of having been a Comintern agent and had asked Rees to join them and named as other members of the ring Robin Zaehner, Edward Playfair, Andrew Revai and John Caincross.[33] White was deeply suspicious of Rees. 'If he had really known all these things, why hadn't he come forward? . . . He was as slippery as an eel and had a violent antipathy to Blunt. He said, "Why don't you ask Blunt about these things." But he did not say that Blunt was our man.'[34]

That night Robert Mackenzie, the Foreign Office's regional security officer, called White from Paris. An indiscreet official at the Sûreté had revealed the hunt for the two men to a French journalist and the story was about to break publicly.

33

The Story Breaks

On Thursday 7 June, almost two weeks after the flight, the story broke in the *Daily Express*. 'Yard Hunts Two Britons' screamed the headline. Larry Solon, chief correspondent of the Paris bureau, had been tipped off by George Gherra, the crime reporter of *France-Soir*, that two Foreign Office employees had disappeared and the French police had been asked to check their movements, though initially the two men were not named.[1]

The Foreign Office was forced to put out a bland statement. 'Two members of the Foreign Service have been missing from their homes since May 25. One is Mr D.D. Maclean, the other Mr G.F. de M. Burgess. All possible enquiries are being made. It is known that they went to France a few days ago. Mr Maclean had a breakdown a year ago owing to overstrain, but was believed to fully have recovered. Owing to their being absent without leave, both have been suspended with effect from June 1.'

Burgess was described as: '5 ft 8 in. Thickset. Slightly bald. Grey at temples. Walks with toes turned in. He is invariably untidily dressed. Talks a great deal and is fond of discussing politics, philosophy and the arts. Fluent in French.' Whilst Maclean was: 'Height 6 ft 2 in. Hair brushed back and parted on left. Incipient baldness. Slightly round-shouldered. Long thin legs. Tight-lipped mouth, good features. Carelessly but well dressed. Speaks French but not perfectly.'[2]

The two families were besieged by the press – the Bassetts in Arlington Street and Melinda in Tatsfield – to the extent that the drive gates at Beaconshaw had to be padlocked and blinds pulled down on all the windows. Maclean's son Fergus, then aged six, was followed back from school, had stones thrown at him, and was told his father was in prison. A girl who looked after the children was offered £100

for any documents or photograph she could smuggle out of the house. Blunt's friendship with Burgess also led him to be swamped by press. His appointments were postponed and for days he hid in his flat. Harold Nicolson wrote glumly in his diary:

> I am horrified to read headlines in the evening papers that Donald Maclean and Guy Burgess have absconded. I thought Guy was a brave man, I should imagine that he had gone to join the communists. As I know him to be a coward, I suppose that he was suspected of passing things on to the Bolshies, and realising the guilt, did a bunk . . . I fear this all means a witch hunt. James is in a hysterical state and wishes to do something about it. I must say it is rather alarming.[3]

All Alan Maclean and Colonel Bassett – 'dressed for war, impeccably pin-striped, complete with bowler and rolled umbrella and just a whiff of expensive aftershave' – could do was stoically collect the clothes left behind on the *Falaise* from Waterloo station. After they had identified the obvious clothing for each man – Maclean was some five inches taller than Burgess – only two items were left. 'The first was a pair of really dirty, torn black pyjamas and the other a revolting pair of socks, which were quite stiff with dried sweat and had holes in heels and toes. I was sure that they were both Guy's and said so. The Colonel was equally sure that they were both "your chap's".' Maclean said his brother never wore pyjamas, so they agreed they belonged to Burgess, and in turn Maclean accepted the socks – both were dropped into the nearest bin.[4]

The press descended on Rees in Sonning. Burgess hadn't paid for his call to Margie and a notice to that effect had been posted on the Reform Club noticeboard together with Rees's number. 'Their cars packed my drive; the doorbell and telephone rang incessantly; they took photographs of my wife, myself, and my children from every conceivable angle', Rees later wrote. Enquiries were made in the local shops and pubs, and journalists pressed chocolates and half-crowns on Rees's children, who were only too happy to exercise their imagination on satisfying the curiosity of the journalists. One reporter attempting to interview Margie Rees introduced himself with the words, 'It's all right to talk to me, Mrs Rees. I'm bisexual myself.'[5]

The furore was further fanned when on 8 June Mrs Bassett received a cryptic telegram postmarked Rome: 'Terribly sorry for my silence. Am embarking on long Mediterranean Holiday. Do forgive. Guy.' Melinda and Lady Maclean also received a reassuring telegram signed 'Teeno', Donald's nickname as a child.

On 7 June the American embassy in London asked the Foreign Office for more information on the pair and were disingenuously told they had disappeared on a trip to France, 'but there was no reason to believe they had carried any secret papers with them'.[6] The Foreign Office may have been noncommittal in public, but privately they were closely monitoring press reaction around the world and especially in the US.[7]

'Would the Foreign Secretary,' George Wigg asked on 11 June, 'institute inquiries into the suggestion made in a Sunday newspaper that there is widespread sexual perversion in the Foreign Office . . .?' 'I can only say that perhaps I have not been long enough at the Foreign Office to express an opinion,' was Herbert Morrison's response.

Whilst Morrison was making his short and noncommittal state-ment to the House of Commons, Percy Sillitoe, the head of MI5, flew to Washington with his colleague Arthur Martin, 'who had been selected to accompany Sillitoe to brief Hoover, because he was regarded as the most plausible liar in the office'.[8] It was a damage limitation exercise to reassure the Americans, who were furious that they had not been fully briefed on the investigations and escape, a matter of particular concern, because Maclean had been granted unescorted access to the US Atomic Energy Commission's head-quarters and attended key secret meetings on the Korean War. Martin explained apologetically to Robert Lamphere that Maclean's high position in the Foreign Office had made the investigation very sensi-tive and the Foreign Office had forbidden MI5 from informing the FBI of their suspicions against Maclean. To make matters worse, Martin also admitted there were now grave suspicions that Philby was also a Soviet agent.

The pattern for the cover-up was becoming established. The British were withholding information from the Americans, hoping they could contain the situation themselves. The CIA was withholding

information from the FBI, who in turn were withholding it from the State Department. Each organisation was determined to protect itself and avoid too much publicity.

The same day, the disappearance was discussed at Cabinet, and it was decided to set up an enquiry to look at Foreign Office security by those 'who, in virtue of their past or present experience, have been indoctrinated in the top secret security matters affecting this case'. It was to be chaired by Sir Alexander Cadogan, a former Permanent Under-Secretary of State for Foreign Affairs. He was to be assisted by Sir Nevile Bland, who had been asked the previous year to look at the intelligence services, and Sir Norman Brook, Secretary of the Cabinet. Its remit was 'primarily one of Service administration and ethics. In such matters, the solution is usually best sought from within the ranks of the Service itself.' There was great concern that they should not create, 'A system of spying which would be both repugnant to our traditions and destructive of morale.'[9]

The government was playing its cards close to its chest, with Morrison telling the Commons that afternoon, 'The security aspects of the case are under investigation and it is not in the public interest to disclose them.' Percy Sillitoe had also produced a brief for the Prime Minister about the two men, though it's difficult to ascertain from the surviving document if Burgess's role in JBC, with MI5 and in IRD, has since been removed or simply was never revealed.[10]

Harold Nicolson disclosed his anguish about the disappearance in his diary on 11 June:

> No news or ideas about Guy Burgess . . . It means that the old easy-going confidence of the FO, which was like the non-red-tapiness of the National Trust, will be destroyed and henceforth everybody will begin to distrust everybody else. I do hate that. It is the loss of one more element of civilisation. We used to trust our colleagues absolutely. Now we cannot any more. I feel so angry with Guy in some ways – feel that he has behaved so much like a cad – but in others deeply sorry for him.[11]

Meanwhile Philby had been recalled to London and was interrogated by MI5 between 12 and 16 June.[12] They were particularly interested in how Burgess might have learnt about the identification of Homer.

Liddell, who dared not believe his intelligence colleague could be implicated, tried to rationalise in his own mind the possible scenarios:

> Personally I think it not unlikely that the papers relating to Maclean might have been on Kim's desk and that Burgess strolled into the room while Kim was not there. Alternatively, of course, Burgess may have learned something from the general administrative enquiries which were being conducted within the Embassy under the direction of Bobby Mackenzie, although it is alleged every possible precaution was taken.

But looking back at the Konstantin Volkov case, even Liddell realised it wasn't looking good for his friend. 'One of the British intelligence agents was said by WOLKOF to be head of the CE department. Kim was in fact head of R.5 at the time.'[13] Whilst in the USA, Sillitoe had interviewed Esther Whitfield who told him:

> Guy Burgess was an extremely erratic and irresponsible person, given to boasting, but with a very lively mind and an attractive personality. He was very well read, had a good memory and his knowledge ranged over a wide field. He liked conversation and to impress his audience with his friendship with the great. In most ways he was unreserved but he enjoyed a mystery and a feeling of 'being in the know'. He was very loyal to his friends and very dependent on them. Politics were his chief interest, especially the Far Eastern aspect. His other great interest was in motor cars. He once said that the things he would like to do were to write either a history of the Far East, or of motor cars – or both. [14]

MI5 began to follow leads on all of Burgess's Cambridge communist contemporaries and his close associates and began to interview them. Jack Hewit was summoned to an interview with Jim Skardon in Carlton House Terrace. 'It was quite a small room painted in the usual office cream and brown colours', he remembered. 'It contained a table and three chairs. There was a telephone on the table and the window in the room overlooked the Mall.' Lighting his pipe, Skardon began his questioning. 'There was an air of quiet authority about him. He had a soft well-modulated voice and a very deceptive manner. I answered as best I could, but I did not tell him everything I knew or thought I knew.'[15]

Rosamond Lehmann later claimed she had approached Stewart Menzies, the head of MI6, on the Friday and the following week she was interviewed by MI5 'in a Mayfair mews house', where she told them of her suspicions about Burgess, Blunt and Rees. However, a contemporary MI5 file concluded she 'had little of value to impart'.[16] Pollock was interviewed by MI5 on 12 June and suggested Burgess's closest friends after Blunt were W.H. Auden, Christopher Isherwood, Tom Wylie, Goronwy Rees, Ellis Waterhouse, Victor Rothschild and Isaiah Berlin.[17]

Christopher Isherwood, interviewed on 18 June, described Burgess as 'a "pusher" and an intensely ambitious person and one who took great satisfaction in being close to the great and near-great in the British Foreign Service'.[18] Moura Budberg, herself already the subject of investigations, was being used to draw material from Burgess's circle, including from James Klugmann, who was thought to have been involved in the escape, Peter Pollock, Gerald Hamilton, Philip Toynbee, Andrew Revai and James MacGibbon, who were all put on the watch list at the ports and many had their phones bugged, including the Bassetts.[19]

To John Lehmann, the defection 'acted like a small but violent earthquake in the fairly closely knit intellectual world of our generation' as more and more of Burgess's circle were called in for questioning and began to name each other. He was to suffer himself personally after a private letter about the missing diplomats sent to Stephen Spender was passed to a journalist. The result was to create a rift between old literary friends, who themselves felt betrayed by each other.[20]

Tess and Victor Rothschild 'felt there were a certain number of people whom they knew who had had a considerable Left Wing past at the University and who should in present circumstances come forward and assist the authorities', wrote Liddell in his diary. 'They were considering the desirability of going to those people and urging them to do their duty; failing which they would have to take the matter into their own hands.'[21]

The one person who appeared not to have fallen under suspicion, at least by Guy Liddell, though the press had been besieging him and in spite of Rees's statement, was Blunt. Liddell wrote in his diary

on 12 June, 'I feel certain that Anthony was never a conscious collaborator with Burgess in any activities that he may have conducted on behalf of the Comintern.'[22]

With suspicions of a cover-up, fresh questions in the House of Commons were being asked and statements prepared by the Foreign Office. Were the authorities aware of Burgess's communist sympathies? Why had he not been properly vetted? MI5's response was disingenuous. As Liddell wrote in his diary, 'Our answer is that Burgess was never employed by MI5, but that during the war we were in contact with him in connection with information which he brought from a friend, Eric Kessler, relating to German activities. The Foreign Office asked us to vet Burgess in January 1950, and we replied that although we had no security information against him, we regarded him as both untrustworthy and unreliable.'[23]

Six days later, Liddell confided to his diary, 'The DG returned about midday. He seems to have been successful in keeping Hoover quiet. The only grievance seems to be we didn't tell the FBI about our short list.'[24] That was not entirely true. The Americans were calling for answers and the importance of a joint line, but this found no favour in London.

The FBI had begun their own investigations and interviews, including a search of Burgess's abandoned car, which yielded a hotchpotch of material, ranging from *The Complete Short Stories of Jane Austen* and *Up at the Villa* by Somerset Maugham, maps for the Carolinas and Virginias, Delaware and Maryland, a photograph of a boy and girl aged about six, to hundreds of copies of two graphs – 'Defense Expenditure as Percentage of National Income', comparing the US and UK 1943-1950, and 'Defense Manpower – Men in Armed Forces as a Percentage of all Men Aged 18-44.'[25]

Bernard Miller told the FBI he had arrived in London on 21 May and seen Burgess at his flat for cocktails and dinner two days later. He 'recalled that at various times Burgess mentioned a desire to go to the Continent, particularly to Paris. He recalled further Burgess mentioning a friend who had settled in a beautiful place in Locarno in Switzerland . . .'[26]

Shortly before the flight, the Americans had been moving towards closer co-operation on intelligence and atomic matters, in spite of

the cases of Fuchs and Bruno Pontecorvo, an Italian nuclear physicist who had defected to the Soviet Union in 1950. They now broke off all atomic energy intelligence liaison, in the words of the CIA Director Walter Bedell Smith, 'for the time being'.

Tim Marten set out the situation for Roger Makins on 20 June, saying that while the Atomic Energy Commission and State Department were still open to co-operation, the CIA and Defence were not. 'The one gleam of hope is that Bedell Smith and the Department of Defence may be prepared to reverse their present attitude of opposition, if some solution of the Maclean-Burgess affair is found which is not damaging to the reputation of British security.'[27]

In fact, as a senior MI6 officer at the time, with close ties to the Americans, later admitted, 'The B&M defection caused a terrible rift between us and American intelligence, and at the time they simply clamped down and stopped giving us anything.'[28]

The Americans now had their suspicions of Philby. On 13 June, Bill Harvey submitted a five-page memo to the Director of the CIA, laying out why he believed Philby was a Soviet agent. Walter Bedell Smith then sent it to Sir Stewart Menzies, the chief of MI6. It was clear that if the 'special relationship' was to survive, Philby must go.[29] Ramifications over Philby continued through the summer. Menzies' deputy, Jack Easton, was dispatched to Washington on 13 July to tell Hoover and Smith that Philby had certainly been indiscreet and an inquiry was being set up, but there was no firm evidence against him. The Americans were unconvinced, but the problem was that without a confession and only circumstantial evidence, Philby knew he was in the clear.

Many in the intelligence community found it difficult to believe that Philby and Burgess had been spies. MI6 officer Nigel Clive would often see Burgess after work at Brooks's club, with their mutual friends Goronwy Rees and David Footman. He had first met Burgess in 1946, introduced by Dick Brooman-White, having heard he was a 'clever, amusing, stimulating character'. They lunched at Pruniers, one of Burgess's favourite restaurants, where Clive had noticed his immorality. After they had been served, Burgess clapped his hands and asked for the head waiter, claiming there were worms in his prawns and hinting that it would make an item in a newspaper

diary. The two men were immediately, amidst profuse apologies, given complimentary champagne. Clive was shocked but Burgess delighted. 'I thought it would be fun so just tried it on.'[30]

The disappearance was a godsend to the press and no paper seized the opportunity more enthusiastically than the *Daily Express*, which had broken the news of the disappearance. On 30 June they offered £1,000 reward for information that established the whereabouts of the diplomats and shortly afterwards the *Daily Mail* raised the reward to £10,000. By 1962 the *Express* had spent nearly £100,000 on the story.[31] Nigel Burgess was offered £500 to collaborate with a water diviner to find his missing brother, whilst Jack Hewit was sent by the *Express* to Paris to go round old haunts – the Left Bank, a hotel near the Bourse, the Ritz hotel bar – in the hope of finding his former boyfriend.

Some 15,000 policemen in West Germany, Austria, Italy and the Scandinavian countries peered into cafés, bordellos, hotels and airports. The search spread to Cyprus and Malta; Egypt's police were watching the entire western desert coastline, and the French Foreign Legion were brought in.[32] Auden's home in Ischia was watched constantly by press and intelligence services alike and Peter Rogers, a friend on the way to stay with Auden on Ischia, was arrested on the quayside at Naples on suspicion he was Burgess.[33]

The photographer Humphrey Spender, the younger brother of Stephen, and the writer Geoffrey Grigson, touring Wiltshire for a photo-article for *Picture Post*, found themselves arrested whilst trying to develop some film at a chemist in Warminster. 'We have reason to believe that you and your friend in the car outside are Mr Burgess and Mr Maclean,' intoned the policeman. The two, wondering 'which of us was Burgess, which Maclean', duly trooped down to the police station, where their identity was only confirmed when a call was put into the editor, Tom Hopkinson.[34]

Stanley Karnow, the *Time* correspondent in Paris, was asked to check out a rumour that Burgess and Maclean were hiding in a chateau near Paris. Presenting himself with a colleague at the heavy oak door, he asked, 'Je m'excuse de vous deranger, monsieur mais Burgess et Maclean vous savez les diplomats anglais, est-ce qu'ils sont

ici, par hazard?' 'No, I'm afraid you're terribly mistaken,' came the reply. Relieved, he could only manage, 'Oh well, I just happened to be in the neighbourhood, and I thought I'd ask.'[35]

There was a frenzy of sightings throughout the summer in Brittany, Monte Carlo, Berlin, fishing villages near Naples, in Rome, in Andorra and the Soviet district of Vienna. The police in British Guiana were put on alert, and men called Burgess on motoring holidays on the Continent were routinely stopped. A swoop on one hotel for two 'Englishmen' turned out to be two Irish priests spending a holiday there.[36]

One paper said they had registered at a hotel in Barcelona as Marshall McLean and Willis John Burgess, another that they had been exfiltrated by ship from Antwerp, while there were rumours Burgess had gone to see Truman Capote in Sicily.[37] FBI reports are filled with suspicions the men had fled to Buenos Aires disguised as women, or been seen at a Greyhound Bus Station in New York waiting for a bus to Florida – Maclean described as having 'very black hair and protruding teeth'.

In January 1952 the Associated Press was quoting diplomats in Berlin that the two men were in the Lubyanka prison, having been held for months in Prague.[38] *People* reported that Burgess had attended a conference in the Chinese province of Kwei-Chow, whilst the *Graphic* in June claimed he was staying with Freya Stark in Italy.[39] 'Evidence that the missing British diplomats Guy Burgess and Donald Maclean may have travelled to Poland in a Polish ship from Dunkirk a few days after they were last seen in Brittany in May of last year has been obtained by German intelligence agents from a communist agent arrested in Bremen', wrote the *Washington Post* confidently in July.[40]

The truth was no one had a clue.

34

Repercussions

The escape had a number of consequences, forcing governments to reassess their security and liaison procedures, and also individuals to reconsider their friends.

Guy Liddell had some soul-searching about his own friendship with Burgess. 'I find it difficult, too, to imagine Burgess as a Comintern agent or as an espionage agent in the ordinary accepted interpretation of these terms,' he wrote in his diary a month after the disappearance. 'He had certainly been Marxian and, up to a point, an apologist for the Russian regime, and would have been capable of discussing in a highly indiscreet manner with anybody almost anything that he got from official sources. He would have done this out of sheer political enthusiasm without any regard for security.'[1]

Blunt too was in the frame. Liddell noted in his diary on 7 July that a former ambassador, Owen O'Malley, had come to him 'to say that he had positive evidence that Anthony Blunt had been a friend of Guy Burgess and that while at Cambridge he had been a Communist'. Dick White suggested Blunt should see the two MI5 investigating officers, James Robertson and Arthur Martin, 'on certain points which have cropped up in the Guy Burgess correspondence taken from his flat in Bond Street'.[2]

But Blunt, when confronted, according to another Liddell diary entry, 'was quite emphatic that when Burgess approached him, I think in 1937, to assist him in obtaining political information of an anti-fascist kind, he was firmly under the impression that Burgess was working for the government. Burgess had never said anything to him which would imply that he was working for the Comintern.'[3]

The following week Liddell recorded that minds had been set at rest at Buckingham Palace, especially Sir Alan 'Tommy' Lascelles,

the King's private secretary, about Blunt's communism, there already being concerns about his views after 'Blunt had intimated to the Queen that he was an atheist – Tommy thinks he may well have said an agnostic – and the Queen had been a little shaken by his remarks. He was certain that if he now went up and told her that Anthony was a communist, her immediate reaction would be, "I always told you so!"'.[4]

On 11 July, Philby was again interrogated by MI5 and officially dismissed with a golden handshake of £4,000 instead of his pension – half immediately and the remaining £2,000 in four payments over the next two years. It was paid partly because it was regarded as bad security to have a former member of MI6 destitute with a family to support, and partly because many of his MI6 colleagues felt there was still scope for doubt. After all, hadn't he helped identify Maclean, and there had been no betrayal of the Nunn May and Fuchs cases.

At the beginning of October, Liddell noted in his diary:

> Since I have been away the case against Philby seems to be somewhat blacker, although we are still working on what may be pure coincidences. While all the points against him are capable of another explanation, their cumulative effect is certainly impressive. It now seems that his first wife made a number of journeys to the Continent at the time when Kim was living with her in London. The inference is she was then acting as a courier. The facts were never revealed by Kim, although they must have been within his knowledge. His association with her only ended in 1940.[5]

Interrogation of Philby continued through 1951, and though MI5 were convinced he was a Russian agent, Liddell noted, 'the chances of prosecution were extremely remote, since all the evidence amounted to was a chain of circumstances which pointed to PHILBY's guilt, and that all these circumstances were well-known to PHILBY himself on account of the appointment he had formerly held in SIS. The odds, therefore, were strongly against any satisfactory conclusion of the case.'[6]

The British continued to not fully brief the Americans, not least about the Venona decrypts. Liddell confided to his diary on 9 August:

I saw Patrick Reilly and cleared with him, and subsequently with SIS, a letter which the DG is sending to Hoover, suggesting the indoctrination of Bedell Smith into basic material connected with the Maclean case. In spite of the fact that Bedell Smith is chairman of USICB, the equivalent of Sigint, he is unaware of the source of our information. This causes his subordinates to worry both SIS and ourselves with wild theories about the disappearance of Burgess and Maclean.[7]

Even Liddell remained unsure about the reasons for the flight:

It seems to me quite possible that Burgess had discussed with Maclean on his return the two memoranda which he had put up to the Foreign Office on our policy in regard to China . . . Such a conversation, over a great deal of drink, might well have led both to express their innermost feelings about Russia. To vent their dislike of US policy, and to come to the conclusion that they must do something to prevent a third world war. At that stage Maclean might well have talked about his past and his apprehension that it might one day catch up with him. They might then have decided to leave the country – Burgess taking the initiative. If this was true, it might account for Burgess's remark that he was going to help a friend who was in difficulties.[8]

Blunt, himself now under suspicion, tried to keep as close to the investigation as he could and to appear as helpful as possible. He confided to Liddell that Burgess had left personal papers with him, also he now remembered that he had probably become a communist in the autumn of 1933 and had then broken with the party in the spring of 1935, but felt his Marxist views had not changed.[9]

Tomas Harris's phone had been tapped, as Philby had briefly stayed with him, and MI5 had now been alerted to possible suspicions of Harris after Philby's wife, Aileen, had spoken to an MI6 officer, Nicholas Elliott. Suspicions were now also being directed at Burgess's mentor in intelligence, David Footman. Robert Cecil, a contemporary and biographer of Donald Maclean with intelligence links, remembered saying to Dick White, 'What about David Footman? He is not necessarily in the clear,' to which White replied, 'You can say that again.'[10]

On 3 November 1951 the Cadogan Committee, set up on 7 July, reported. It had met five times and six witnesses had attended – three

from the Foreign Office and one each from the Cabinet Office, MI5 and Scotland Yard. The problem was that it was very much a Foreign Office committee with no outsiders involved. It had not spoken to the Civil Service Commission, which did the recruitment, nor any psychologists, nor anyone connected with personnel in industry or the armed forces.

It further strengthened positive vetting, which had begun already in early 1951. Previously, candidates had been checked to establish if there was anything negative against them in the files. Now it required all civil servants who had 'regular and constant access to the most highly classified defence information' and those who had 'access to the more highly classified categories of atomic energy information' to submit to positive vetting. About one hundred and twenty-five Foreign Office posts were so designated and had been checked by November. The loophole was that it didn't cover people who didn't have 'regular and constant' access. It was an improvement and required all the relevant departments to set up their own security departments to carry out the vetting – though the Admiralty didn't do so until 1961 – but there were still no background checks.[11]

It suggested that if a person brought discredit on the Foreign Office, whether homosexual or heterosexual, then they would have to resign. Even if there was no scandal, the person should be watched and any appointments taken into account, because of the risk of blackmail. The system of confidential reporting by heads of mission on their staff was improved, though the committee understood the reluctance of colleagues to 'blab' about each other. It was a start, but it required huge resources to administer. Liddell noted in December, 'We are now vetting something like 5,000 cases a week.'[12]

In April 1952 John Cairncross was interviewed about the papers found in Burgess's flat. Liddell wrote in his diary, 'His statement is somewhat contradictory; on the one hand he says that he gave BURGESS the information because he thought that he was working for some government organisation and it would be in his, CAIRNCROSS's, interests to keep in with him. On the other hand, he says he was extremely nervous when he tried to get his notes back and was told by BURGESS that he had either lost or destroyed them.'[13]

Jack Hewit was proving to be a headache to both Blunt and Rees.

Several times he had threatened suicide and had even been hospitalised in St Mary's Hospital. He was asking Peter Pollock for money, which Pollock eventually gave him. Blunt also reported to Liddell that Hewit seemed to have passed a diary and address book to a man called Jenkins, who had attempted to blackmail the Bassetts.[14]

In April 1952, Blunt, borrowing money off Tomas Harris, had paid off a man called Woods, who seemed to be in league with the *Daily Mail*, who had 'a sad story about how he had been duped by HEWIT and was involved in malversation of funds belonging to Head Wrightson. If this money could not be repaid the firm would prosecute. BLUNT knowing the state of mind in which HEWIT was in at that time agreed to pay.'[15]

Concerns about Hewit's behaviour continued. Short of money, he was making various allegations including that he had been shared as a lover between Burgess, Blunt and Fred Warner, and had tried to implicate Warner in a forged letter published by the *Daily Express*.[16] In November, MI5 called him in for further questioning. Kenneth de Courcy, a maverick figure who operated on the fringes of the intelligence world, had also written to Anthony Eden naming other spies, including Warner.

Liddell was still in denial about Blunt, even after another informant came forward about him. In July 1952 he wrote in his diary:

> While I believe BLUNT dabbled in Communism, I still think it unlikely he ever became a member. He has nearly all his life been so absorbed in artistic matters that it seems unlikely that he has ever been really interested in politics. I think however it likely that, in view of his close association with BURGESS, he may well have been indiscreet in discussing matters going on in this office.[17]

The government found itself in a difficult position. It clearly needed to be seen to be doing something to reassure the Americans and satisfy public interest, but there was a reluctance to simply pander to sensationalism, appear McCarthyite, and to reveal its hand too openly in terms of intelligence investigations. The Foreign Office and MI5 dreaded the two defectors would be paraded at a press conference, causing further embarrassment with the British public and American authorities.

The government managed to control what was in the serious press, notably *The Times*, whose line often seemed to come straight from the Foreign Office that this was simply a drunken spree by two low-level diplomats, but they could do little about the *Express* and the *Mail*, whose proprietors saw the disappearance of the two diplomats as a useful tool to beat the government, whilst also increasing circulation. The authorities' poor handling of the crisis only deepened distrust of the competence of the government and its moral authority. In contrast to the secretiveness of the British authorities keen on damage containment, the Americans seemed more open and to be telling a very different story.

Whilst Herbert Morrison had claimed Maclean had not had access to secret information, Dean Acheson, the US Secretary of State, exclaimed, 'My God, he [Maclean] knew everything! If Burgess and Maclean have gone to Moscow it will have very serious consequences. There go the minutes of the Deputy Foreign Ministers' meeting.'[18] The Deputy Foreign Ministers' meetings were nothing compared to what the two diplomats knew about the creation of NATO, the Korean War, the Japanese Peace Treaty, and the development of the atomic bomb.

Whilst the Americans and British squabbled in public, the Russians watched quietly and said nothing. There was only a passing reference to the disappearance from the Soviet news agency Tass. British diplomats were surprised they did nothing to take advantage of the situation, uncertain whether the Russians were playing a very deep game indeed, or simply didn't know how best to exploit the disappearance.

The media, however, saw it as a wonderful story and brought in a succession of writers to attempt to do it full justice. In August 1952 Roald Dahl was asked to write an article on the disappearance for the *Women's Home Companion* called 'The Great Vanishing Trick', though it was never published. Five months later, Eric Ambler was commissioned to write two articles, 'Trail of the Disappearing Diplomats', where he offered 'several clues to one of the most baffling mysteries of modern times . . . Their disappearance has provided the police forces of Free Europe and the rest of the Western World with the greatest mystery they have encountered since the death or disappearance of Adolf Hitler.'[19]

It was inevitable, given the newspaper interest, that the Burgess and Maclean story would also generate books. The first to appear, in 1952, was by Cyril Connolly, who had known both men. Entitled *The Missing Diplomats*, the fifty-page essay, based on a collection of articles in *The Sunday Times* that September, contained shrewd pen-portraits of both men, but added little to the story.[20]

In March 1953 Joseph Stalin died, followed shortly afterwards by his deputy and spy chief, Lavrentiy Beria. The Soviet Union became a more open society and in September, with the aid of Soviet intelligence, Melinda Maclean slipped away quietly through Switzerland to join her husband in Russia.

Throughout 1953, as the 'sightings' became less frequent, the British press changed tack and began to speculate on the hidden hand of the pair in Soviet diplomacy, crediting them with all sorts of new initiatives. There were suggestions that Soviet statements now had a touch of Foreign Office polish. Roger Makins, now the British ambassador in Washington, wrote jokingly to Sir William Strang, 'The latest mot here is that the uncertainties of current Soviet policy are due to a struggle for power which is going on in the Kremlin between Burgess and Maclean.'[21]

Though publicly nothing had been heard of the men, they were known to be alive. And this was confirmed when just before Christmas 1953, Eve received a long letter from her son, which gives some idea of the Oedipal relationship they had. Dated November and posted in South London, it read:

Darling Mum,
I find it so hard to decide whether I <u>should</u> write to you or not – that is if I cause you more misery by doing so than if I were silent.

But I go on thinking you would like to know how well your eldest son is and how unchanged in everything his love for you which grows.

Therefore this letter is meant to arrive somewhere between your dear birthday, which I did not forget, and in time to wish you a happy Christmas and a <u>happier</u> New Year. I shall join in spirit to the toast Jack always drinks 'to your beautiful eyes'. Will you ask him to drink it once more this year coming from me?

I wish I could say something definite to cheer you up about the

possibility of meeting, but, <u>as yet</u>, I can't. As David F would say 'the situation is still too untidy'. Incidentally I wish you would send my love as coming from 'his rather <u>controversial</u> Guy' (his phrase always) and say how sorry I was to have to miss my first meeting with his new wife. Perhaps you have met her. David's first divorce was one of the happiest I have known so his second marriage should be wonderful.

I don't like to send specific messages to many friends who I must have wounded too deeply for them to wish to have them – but you know who my close friends were – I still think of all of them in the same way and often – so please distribute my love to anyone who <u>you</u> think would still like it.

But don't distribute <u>too much</u> of it for it's all yours, my precious.

As I said in my last letter I have to stop myself thinking of you too much or too often and it must be worse for you. I'll do every-thing I can to make next year a happier one for you.

Always darling as ever your only loving,

Duy Boy.[22]

Journalists continued to look for the exclusive scoop. One was the crime correspondent Duncan Webb, who was tipped off through underworld contacts that a meeting with Burgess could be arranged for £10,000 through the Italian Mafia. Meetings were arranged in various Soho clubs and restaurants with the nephew of Lucky Luciano, the five-foot duffel-coated Luigi Rocco, who proved his credentials, as an authorised intermediary, by producing a letter from Burgess to James Pope-Hennessy referring to their collaboration on the biography of Lord Salisbury. Pope-Hennessy was convinced it was genuine, saying 'my belief is that no living person other than Guy could have written it'. Rocco explained that if sufficient bounty was paid, Burgess could be smuggled from behind the Iron Curtain, with the help of his two bodyguards, as he was fed up with his role of going around Iron Curtain countries 'giving pep talks and propaganda lectures to institutions and factories'.[23]

At the end of November 1954 the plan swung into action and Webb was told to book into the Hotel Miramare on the Lido in Venice, ready for Burgess to be brought across from Yugoslavia. The journalist was to bring £10,000, partly for bribes and partly for Burgess, who had plans to settle in Spain. Burgess had been taken

to a house just outside Pula, on the southernmost tip of the Istrian Peninsula, where he would be collected by motor launch. The exchange was to take place at dead of night, but when Webb turned up with some of the money, he found Rocco and his gang had disappeared.[24]

Whilst the press retained their interest, MI5 decided in 1954 to cease their investigations. For them the case was closed. It was the disclosures of a Soviet defector in Australia that was to ignite the story all over again.

35

Petrov

In April 1954, Vladimir Petrov, a lieutenant colonel in Soviet intelligence, had defected in Australia along with his wife, also a KGB intelligence officer. For the British, they were the most important defections since Gouzenko in 1945, showing the full extent of Soviet espionage in Australia, but also revealing that Maclean and Burgess had been Soviet agents. Part of Petrov's material came from an NKVD colleague in Australia, Filip Kislytsin, who had been a cipher clerk in the Soviet embassy in London from 1945-8, and who had then been put in charge of a new one-man section at Moscow Centre that housed files of documents supplied by Burgess and Maclean – so many that most remained untranslated or were not distributed to the ministries concerned. It was Kislytsin's information that confirmed to the intelligence community that Burgess and Maclean had been recruited as Soviet agents at Cambridge, that Soviet intelligence had exfiltrated them, and that they were alive and living in Kuybyshev.

A Royal Commission was set up, producing a final report in August 1955. That and the publication and newspaper serialisation of Petrov's memoir *Empire of Fear* in *People* magazine between 18 and 25 September 1954 raised the question of the Missing Diplomats again. In his book, Petrov claimed Burgess had handed over 'briefcases full of Foreign Office documents, which were photographed in the Soviet embassy and quickly returned to him. Kislytsin used to encipher the more urgent information and send it to Moscow by cable; the rest he prepared for dispatch by courier in the diplomatic bag.'[1]

The government's hand had been forced. On 19 September, the Foreign Office reluctantly announced a White Paper on Burgess and Maclean, which had been held ready 'against the contingency

that the Petrov disclosures would make it necessary for us to say something'.[2]

On 21 September the Cabinet discussed the White Paper 'Report Concerning the Disappearance of Two Former Foreign Office Officials' in a two-and-a-half-hour meeting, which was published two days later. It suggested Maclean had only come under suspicion shortly before the flight, when in fact he had been on the shortlist for weeks, his flight had been triggered not by a tip-off but because he had detected the surveillance, and that the authorities had acted immediately, rather than the several days it took them in reality to swing into action. It understated the traitors' access to important secrets, notably Maclean's special access to atomic affairs and Burgess's role as an agent runner in MI5, and pretended that the authorities had no legal power to prevent the men from absconding. It even got the name of Maclean's college at Cambridge wrong.[3]

It had been carefully crafted by Graham Mitchell, an MI5 officer then in charge of counter-espionage, himself later to come under suspicion of being a Russian agent, with instructions to limit the damage to the reputations of MI5, the Foreign Office and the British and American governments. It simply fanned the flames and it was quickly christened the 'Whitewash Paper'.

A *Times* editorial entitled 'Too Late and Too Little' concluded, 'The White Paper does little to remove doubts about the security authorities' handling of the matter',[4] whilst an article in the *Spectator* by Henry Fairlie coined the phrase 'The Establishment'. Fairlie noted:

> What I call the 'Establishment' in this country is today more powerful than ever before. By the 'Establishment' I do not mean only the centres of official power – though they are certainly part of it – but rather the whole matrix of official and social relations within which power is exercised . . . No one whose job it was to be interested in the Burgess-Maclean affair from the very beginning will forget the subtle but powerful pressures which were brought to bear by those who belonged to the same stratum as the two missing men.

In short, how Britain's elite were still interconnected and protecting their own.[5]

On 12 October a Conservative MP and former MI6 officer, Henry

Kirby, called for a public inquiry, because 'Maclean and Burgess were known as drunks and sex perverts for years'. It was clear something needed to be done. A week later, Harold Macmillan, the Foreign Secretary, sent a memo to the Cabinet concerning the forthcoming debate on the disappearance of Burgess and Maclean, making clear that the terms of reference would be prescribed. He proposed that any inquiry be limited to what could be done in the future, rather than what had happened in the past.

The advantages he saw in holding such an inquiry were that the public would feel that something was being done and 'that the public will be brought up against the dilemma of security in a free society. Almost all of the accusations of the press against the laxity of the authorities are really demands for changing the English common law.'[6]

On 25 October a Labour MP, Marcus Lipton, used a parliamentary question to name Philby as a Soviet agent. Hoover, the head of the FBI, had already tipped off a few American journalists and Philby had been named openly two days before in the *New York Daily News*. Repeating the claim under parliamentary privilege allowed the British press to report the allegation and a parliamentary debate was called, but there was still insufficient proof for a court of law. Macmillan was forced to admit at the close of the debate, 'I have no reason to conclude that Mr Philby has at any time betrayed the interests of his country or to identify him with the so-called third man, if indeed there was one.'

The next day Philby called a press conference at his mother's flat in Drayton Gardens, parried questions by hiding behind the Official Secrets Act and then served beer and sherry to the assembled press corps, amongst whom was a young Alan Whicker. Instead of smoking him out, Hoover's actions had cleared his name.

Writing in the *Express* a few days later, Osbert Lancaster, with whom Burgess had served in the News Department, put the likely damage of Burgess's treachery in context:

With the inside knowledge of one who worked for more than a year with Burgess in the same department, I do not hesitate to maintain that if the Russians have taken him on their payroll, they're going to

have their biggest headache since the Berlin air lift. For among his many exceptional qualities was an ability developed to a degree which I have never encountered elsewhere, to answer at length any and every question except that one put to him.[7]

The Burgess and Maclean story was not going away. On 5 November a *Times* leader thundered, 'Successive governments added greatly to the public anxiety by declining for so long to give reasonable information to parliament and the people . . . Even the shamefully belated White Paper, touched off by the results of the Petrov inquiry, does not do a great deal more than confirm reports that have appeared in the press either here or abroad.'[8]

The government's next initiative was a committee chaired by the Lord Chancellor, Lord Kilmuir, with Herbert Morrison, Edward Bridges, and Earl Jowitt among its seven members. It met eight times, starting at the beginning of December 1955, to look at practical problems of vetting, given the large numbers of people involved and that they were continually changing jobs, and took evidence from the Foreign Office, Admiralty, Treasury and Ministry of Supply.[9]

On 7 November, the White Paper was debated in the House of Commons. Macmillan claimed that nine hundred Foreign Office officials had now been checked since 1951, with four asked to leave and six moved or resigned. He explained why a watch had not been put on Maclean beyond London, and discussed the security and vetting arrangements that had been made since the two diplomats disappeared, memorably concluding that Burgess 'had been indiscreet, but then, indiscretion is not generally the characteristic of a secret agent'.[10]

At the end of December it was the turn of the House of Lords to debate the scandal. Some of the attitudes of the time can be seen in the speech by Lord Astor, later to figure as a central character in the Profumo scandal. 'I am one of the few people who never knew Guy Burgess, and apparently I missed a lot. By all accounts, he was one of the most amusing and clever conversationalists there was, who charmed a great many people.' He continued:

> But he was a drunk, dirty, and a sexual pervert. He had been ever since his school days. He made no pretence about it, either in his

conversation or his conduct. Now the question I ask is: Did the Foreign Office know about his peculiarities and tolerate them, or were they the only people who did not know about them? . . . I am not one of those who takes the view that the homosexual is a criminal. Those of us who are lucky enough to be normal should, I think, have nothing but pity for people in that situation. But when it is a crime, and when it brings a country into disrepute or lays a person open to blackmail, surely it should be laid down quite clearly that people of those characteristics should not be used in the Foreign Service . . ."

The publication in December 1955 of yet another book on the case, *The Great Spy Scandal*, added little not already revealed in the press or in previous published accounts. Published by the *Daily Express*, it was simply a compilation of reports by the various *Express* reporters who had been covering the case, including the chief European correspondent, Sefton Delmer. What few readers knew was that Delmer had a particular knowledge of Burgess. He had worked with him in black propaganda during the war and he now volunteered to pass on to MI5 everything he found during his journalistic investigation.

Claims about the whereabouts of the spies continued to appear throughout 1955, with a security officer at the American embassy in London reporting in July that an informant had told him that Burgess had committed suicide in or near Moscow. The world was shortly to discover exactly what had happened to them.

36

The Missing Diplomats Reappear

In February 1956 Richard Hughes, a *Sunday Times* correspondent with links to MI6 – he is Old Craw in Le Carré's *The Honourable Schoolboy* – was staying at the National Hotel in Moscow to interview Molotov, the Soviet foreign minister. He left with him a memorandum, stating that Soviet reluctance to explain the fate of Maclean and Burgess was preventing better Anglo-Soviet relations, and gave him a deadline of 5 p.m. on Saturday 11 February to reveal the whereabouts of the missing diplomats. The deadline passed and Hughes, resigned to the fact his request had failed, booked a Sunday afternoon plane to Stockholm.

At 7.30 p.m. the phone rang, asking him to come to Room 101.[1] Assuming it was the manager suggesting a farewell drink, he ignored it and carried on packing. The phone rang again. '"Mr Hoojus" – a touch of impatience – "please come now. Urgent."' Hughes abandoned his packing and walked down the corridor to Room 101. Entering it, he found 'five men sitting at a white-clothed table, surrounded by late Victorian bric-à-brac, a marble clock above the fireplace, and antimacassars. Drifting snow partly obscured the view of the lights in the Kremlin and Red Square. A tall man in a blue suit and red bow tie stood up and extended his hand. "I am Donald Maclean," he said with a wooden smile. "I am Guy Burgess," said the shorter man in a blue suit and an Old Etonian tie, with a bubbling smile . . .'[2]

Already there were Sidney Weiland, the Reuter correspondent, and the Russian representatives of Tass and *Pravda*. From a leather valise Burgess produced, with a flourish, four copies of a signed, typewritten, three-page, thousand-word 'Statement by G. Burgess and D. Maclean' and handed a copy to each man, giving the last

273

one to Hughes with a swift wink and a slightly stressed, 'And this one for *The Sunday Times*.'[3]

Part of the statement read, 'We both of us came to the Soviet Union to work for the aim of better understanding between the Soviet Union and the West, having both of us become convinced from official knowledge in our possession that neither the British nor, still more, the American government was at that time seriously working for this aim . . . We neither of us have ever been communist agents . . . As the result of living in the USSR we both of us are convinced that we were right in doing what we did.'[4]

Weiland wanted to ask questions, but laughing, Burgess stood up jauntily, followed by Maclean. 'I have given out too many statements to the world press in my time not to know what a story I am giving you fellows tonight.' The interview had lasted five minutes.[5]

Weiland remembered how both men 'were very nervous. They had been instructed to keep it as short as possible' and he thought they might only have just been brought to Moscow. As he left to file his story at the Central Telegraph Office, Burgess followed him and asked him to send a message to his mother.[6]

A few days after the press conference, Burgess called Peter Pollock, the first of what would become weekly Thursday-morning calls, much to Pollock's discomfort, with Burgess asking for the latest gossip about their friends and requesting books to be sent out. Burgess also wrote an upbeat letter to Peter's sister Sheila from his two-acre dacha, an hour from the centre of Moscow. He explained he was commuting to Moscow daily, though he actually had a flat in the city, was drinking less but was partial to Russian champagne, and hadn't got much to write about 'unless I were to write a book'. His only regret was too little Bach and Mozart. 'I really am in good form – whether you think I deserve it or not.'[7]

Following their appearance, the two men were allowed to take a more public profile. In mid-February, Burgess wrote an eight-hundred-word article for the *Sunday Express*, saying nothing about himself, but denouncing American foreign policy and offering his fee to the Royal National Lifeboat Institution, who refused it.[8] The following week Maclean penned a similar piece for the *Daily Herald*.

Though the embassy staff in Moscow were told to avoid any

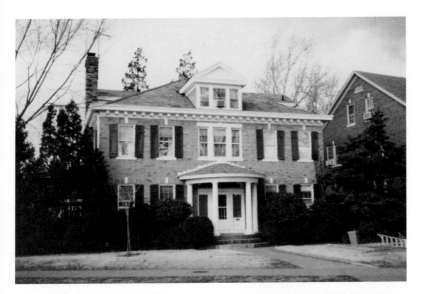

Kim Philby's home in Washington, 4100 Nebraska Avenue, where Guy Burgess lived in the basement 1950-1951.

Guy Burgess owned a Lincoln convertible in which he was caught speeding three times in one day in February 1951, leading to his recall from America shortly afterwards.

Wilfrid Basil Mann, the atomic energy intelligence expert and colleague of Donald Maclean, Kim Philby and Guy Burgess in the Washington Embassy who was recruited by the Russians but 'turned' and 'played back' against them.

Donald Maclean's house, Beaconshaw, at Tatsfield in Kent where Guy Burgess, under the name Roger Styles, went for a last supper on British soil before fleeing to Russia on Friday 25th May 1951.

The furniture at Guy Burgess's flat at 10 New Bond Street included this table lamp with a straw hat as a shade.

Guy Burgess's boyfriend from 1936 to 1951, Jack Hewit, in the New Bond Street flat they shared, shortly after Burgess's disappearance in 1951.

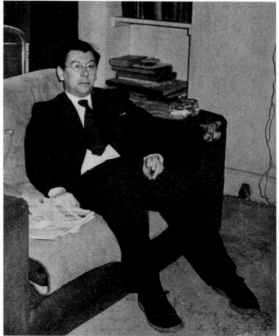

Percy Silitoe, head of MI5, arrives in America, 11th June 1951 to brief FBI chief J. Edgar Hoover.

On the 'wanted' posters which were put up all over Europe Burgess was described as: '5 ft 8 in. Thickset. Slightly bald. Grey at temples. Walks with toes turned in.'

A French diviner, Jules Calte, brought in to help locate the 'Missing Diplomats' in June 1953, claimed they were south east of Paris.

Tom Driberg's biography published in November 1956, was used as a disinformation exercise by Soviet Intelligence and as an attempt to trap Burgess by British Intelligence.

Tom Driberg visiting Burgess in Moscow.

Burgess outside his dacha near Moscow in 1956, where all the rooms were bugged except, as a friendly guard confided, the study.

Always a keen musician, Burgess spent many hours playing the piano in his Russian exile.

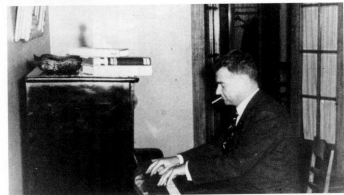

Burgess sitting in front of his apartment block, as ever with a cigarette, on 19th April 1962 as rumours circulated that he might be flying to Britain, much to the dismay of the British authorities.

Burgess with his mother in Sochi in 1956, the first time he had seen her in more than five years.

Flat 68, 53/55 Bolshaya Perogovskaya Street, Moscow, where Burgess lived from 1956 until his death.

A picnic on the Moscow River in the summer of 1960, Guy Burgess is on the right in a white shirt, when the artists Mary Fedden and Julian Trevelyan visited him.

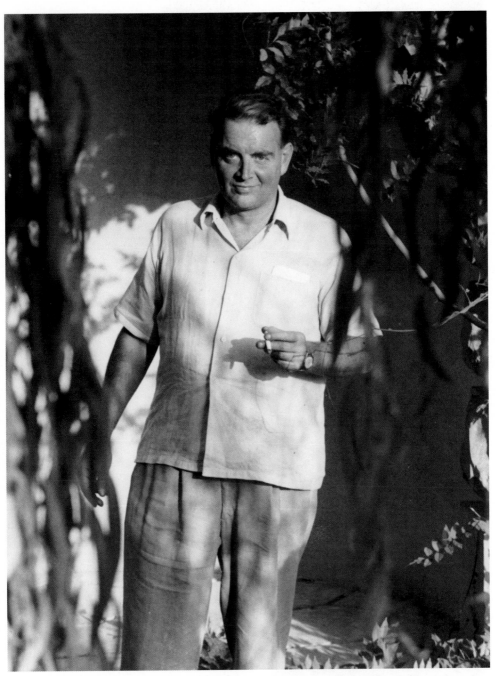

Guy Burgess in Sochi in summer 1962 and the last picture taken of him.

Nigel Burgess in the centre, carrying the coffin at his brother's funeral in Moscow, on 4th September 1963.

Nigel Burgess, Melinda and Donald Maclean with Burgess's faithful, weeping housekeeper Nadezhda Petrovna. Maclean was said to have stood by the door like a country vicar, shaking hands and thanking each mourner for coming.

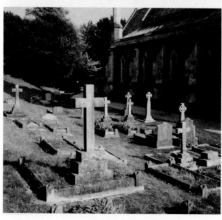

The family grave in West Meon, Hampshire where Guy Burgess's ashes were buried on 5th October, 1963.

social contact with the two men and to leave any function they attended immediately, and that their passports were not to be renewed nor any travel facilities offered to them, the British authorities monitored the situation closely. Sir William Hayter, the ambassador in Moscow, produced a briefing paper for the Foreign Secretary, Selwyn Lloyd, 'The Effect of the Reappearance of Burgess and Maclean on Anglo-Soviet Relations', surmising that the timing was partly to cause fresh discord in Anglo-American relations after the Prime Minister's recent visit to Washington, but also to clear the air ahead of the visit by the Soviet prime minister Nikolai Bulganin and the First Secretary of the Soviet Communist Party, Nikita Khrushchev, to the UK in April. He called their statement 'unconvincing and ill-drafted' and felt with its odd phrasing that it was probably not written by the two men. He concluded the two men were likely 'attached to some kind of research unit, where they prepare long memoranda on Western policy to which little attention is probably paid'.[9]

On 11 March *The People*, a mass-circulation Sunday newspaper, began a five-part series sensationally headlined, 'Guy Burgess Stripped Bare: His Closest Friend Speaks at Last'. Described as disclosures 'from the one man in a position to know the complete story', it promised to 'reveal the full depth of corruption that lay behind Guy Burgess's treachery'. This was the fullest portrait yet of Burgess and covered in graphic detail his dissolute private life and his admission to having been a Comintern agent. It revealed how he kept every letter he received in case they could be used for blackmail, named many in Burgess's circle, and made oblique references to Anthony Blunt. It even revealed that a drunken Donald Maclean had confronted the author in the Gargoyle Club saying, 'I know all about you. You used to be one of us, but you ratted.'

It concluded by warning the public that there had been a cover-up. 'I believe that Burgess and Maclean staged their recent public appearance in Moscow as a warning to those remaining traitors – a warning that they can be exposed if they do not continue in the service of Russia. The traitors must be rooted out before the long-range blackmail begins to work. Only then will Britain be saved from another Burgess and Maclean scandal.' Though anonymous, it

was apparent that the author was Goronwy Rees and he was quickly named in a *Daily Telegraph* gossip column.[10]

What had possessed Rees to write the articles? Partly the £2,700 he was paid, which came in useful to pay off some debts, but money was only part of it. Rees was later to claim that Burgess's reappearance had forced him to reassess his relationship and the articles, which had been rewritten by staff writers, were a half-confession, an attempt to explain why he had befriended and not betrayed Burgess.

According to Isaiah Berlin, 'It was a kind of insurance policy. I think it was because he was afraid of Burgess spreading disinformation and telling terrible stories about him and everyone else and he had to get in first . . . I think Goronwy was frightened. I think he thought that anything could happen and he panicked.'[11] Perhaps, too, it was another warning shot across the bows of Anthony Blunt.

The consequences for Rees were catastrophic, costing him his recent job as the principal of the University College of Wales at Aberystwyth and ostracising him from his friends. A letter from Roy Harrod was typical. 'Guy was such a charming, cultivated, civilised and loveable person. I cannot bear to think of that memory of him being sullied. Your account presents him as half drunk, half sex debauchee. Could anything be further from the truth? It is really too bad of you.'[12]

What had upset people was it had been done anonymously, the choice of paper, the hypocrisy of claiming there were more traitors but doing nothing about them, and the smearing of easily identifiable people in public life. Burgess, himself, was unperturbed – 'poor chap . . . he probably needed the money badly'. What offended him most was the suggestion he and Maclean had been lovers. 'It would have been like going to bed with a great white *woman*!' he exclaimed.[13]

But Joseph Ball, who was named in the articles, successfully issued a writ against Rees and *The People* seeking an apology and damages, saying that he had 'never met Guy Burgess in his life and had never heard of him until he fled the country'.[14] MI5, who hitherto had not taken Rees entirely seriously, immediately now sent two officers to interview him in Aberystwyth and read the original version of the manuscript.

A few days after the first of *The People* articles appeared, Burgess wrote to Tom Driberg, who had written a sympathetic article in the left-wing *Reynold's News*, agreeing to meet. 'I don't want to go here into a long screed about not having been an agent. There is no evidence that I was: in fact I wasn't and that's that.'[15] The two men had known each other during the war when Driberg was a contributor to *The Week in Westminster.* Driberg had felt that Burgess had not been dealt with fairly and had written shortly after the Moscow appearance, asking if he could come and see him.

Burgess, annoyed at the way he had been depicted in the media – particularly the suggestion he had been expelled from Dartmouth for theft – may have felt the need to set the record straight, and invited him to visit. The two men shared an appetite for alcohol, 'rough trade' – Francis Wheen suggests Driberg saw much of himself in Burgess and hoped to understand himself better by talking to Burgess[16] – and had both worked for British Intelligence. Driberg had been an MI5 informant since entering parliament in 1942 and now became part of an unwitting sting operation on behalf of MI5, who were interested to see what Burgess would confess to in a memoir.[17]

Another visitor was also on her way. In March, Eve Bassett had written to Sir William Hayter at the embassy in Moscow, seeking permission to see her son after Burgess had requested a visit. 'Would it be troublesome if I came? And could I be prevented from returning for propaganda purposes?' she wrote. 'And could my presence be used in any way by the Russian authorities to put pressure on Guy? I do not want to be the cause of any fresh trouble to the British authorities, but naturally I long to see my son again. I am not very well and getting old.'[18]

At the beginning of July she came out for a month and the two holidayed at a government sanatorium in Sochi with a private beach, 'mixing freely with other holidaymakers, sunbathing, riding in speed-boats, and walking through the palm-lined streets. People who have been at the sanatorium said Mrs Bassett had taught the cooks to make her son's favourite English dishes.'[19]

A few days after she left, Driberg arrived in Moscow for a two-week stay and installed himself at the National Hotel to await his instructions. The next day Burgess called him, asking him to go to

the Moskva Hotel some fifty yards away, where Burgess claimed he had a suite. 'Guy Burgess was standing outside the hotel entrance. He was instantly recognisable despite a slight greying of his dark hair. His bird-bright, ragamuffin face was tanned by the Caucasian sun', Driberg later wrote. 'He came forward to meet me and we shook hands. I felt a little like Stanley discovering Livingstone.'[20]

Over the next two weeks Driberg took down the details of Guy Burgess's life as Burgess chose to remember them – not always accurately. In turn, Burgess introduced him to his new social circle, which was rather less glittering than the one he had frequented in London. They spent 'a pleasant evening of serious talk' with two British communists, and another with Ralph Parker, who had been the Moscow correspondent of *The Times* and *Daily Worker* and whom Burgess distrusted. 'We all think he's an agent, but we can't make out whose side he's on.'[21]

Driberg also spent a weekend at Burgess's dacha, driven there in an official pool car. The dacha was the largest in the village and was guarded constantly by four secret policemen, who lived in a cottage in a corner of the extensive grounds, and reported on his conduct, movements and visitors. All the rooms were 'miked' except, as a friendly guard confided, the study.

'The village of Guy's dacha was a small and pretty one, with an English-looking duck pond and a typical onion-domed Orthodox church. Walking round it on the Saturday afternoon, I asked if there wasn't a bar we could go to in the evening, as one would go to a pub in England. Guy looked worried. "There is one," he said, "but I can't go there now. Donald was staying here, and he had one of his drunken fits and wrecked the bar. There was a hell of a row about it. That was before he had his last cure."'[22]

Driberg noticed that whilst in Moscow Burgess was generally drunk on vodka by evening, he was much more abstemious at the dacha, where he only kept wine – usually a Georgian white wine. His days were quite solitary, with only the company of a guard or his elderly housekeeper Dusa, and he spent most of his time reading English literature, biography and current affairs. Driberg had brought him a copy of the English Hymnal and sometimes Burgess would pick out tunes with two fingers on a decrepit upright piano.

There were two immediate consequences of the visit. Driberg, a compulsive 'cottager' in public lavatories, introduced Burgess to the large underground urinal behind the Hotel Metropol, tended by an elderly female cleaner who seemed oblivious to the mating signals of the hundreds of homosexuals standing in rigid line. There Burgess met Tolya Chishekov, then in his late twenties, an attractive young electrician in a state factory with a keen interest in music, who supposedly came from Tolstoy's estate and whose grandmother had been one of Tolstoy's lovers – Burgess liked to claim he was Tolstoy's illegitimate grandson. John Miller remembered him as 'short, cheerful and broad-shouldered'.[23] He was to become Guy Burgess's lover, amanuensis, servant – and inform on him – until Burgess's death.

Whether Burgess had lovers in Russia before Tolya is unclear. According to Modin, when Burgess arrived:

> as a homosexual he needed a companion. Eventually he found one and the counter-intelligence people called him in to see the bosses. They said, 'We don't care what you got up to in London, but with us this kind of thing is punishable by law. We will punish you if you continue.' So he stopped. But you can imagine the feelings of some-one deprived of the possibility of fulfilling his physical needs. He was angry.[24]

Driberg's good turn did not go unpunished after he was caught in a KGB sting operation at the urinal. Confronted with photographs of his sexual encounter, he agreed to work as a Soviet agent and was given the codename Lepage. For the next twelve years Driberg was used as a source within the Labour National Executive, reporting back on the evolution of Labour policy and the rivalries within the party leadership.[25]

In the autumn he returned, to go through the proofs, bringing with him some items that Eve had asked if he would take to Burgess, including some prints, a pair of shoes, some new socks and a leather bottle case, which 'he took everywhere with him as he had a great affection for it'.[26]

Driberg's publisher had asked him to supply some pictures for the book, so Burgess arranged the photographer and said he would bring him to Driberg's hotel that afternoon. When he did so, arriving late,

Driberg realised he was drunk, 'reeling and chortling idiotically and then, when the photographer tried to do his job, making silly faces at the camera'.[27]

The shoot had to be rearranged for the following morning. 'At eight next morning he rang me, sounding his usual bright and brisk self. "I'm afraid I shall be late again this morning," he said. "I've been 'sent for' . . . about yesterday afternoon." He explained he had been given a talking-to by Russian minders. He had been "extremely nice" about it, said Guy, "which of course made one feel all the more of a shit." In short, he summed it up, his chief had behaved "exactly like the best type of English public school housemaster".'[28] When Driberg recounted the episode to Eve, whom he occasionally visited on behalf of Burgess, her response was, 'You know . . . I think that Soviet discipline is *good* for Guy.'[29]

Burgess was happy with Driberg's account and used his influence, which appeared considerable, to secure an introduction to Khrushchev that led to an interview appearing in *Reynold's News*.

Driberg's book, bought by Weidenfeld & Nicolson and published on 30 November 1956, was a huge publishing event, with the *Daily Mail* buying the serial rights for £5,000 and ITV's *This Week* producing a story with footage of Driberg and Burgess visiting various public monuments in Moscow.[30]

Days before the serial was due to run, the D-notice committee had requested the deletion of a paragraph about a post-war operation against Albania, on the grounds of security – though as it had come from Burgess, the Russians clearly already knew about it. This provided an opportunity for MI5 to fire a warning shot across Burgess's bows. Using the journalist Chapman Pincher, a story was planted that Burgess had breached the Official Secrets Act and would be arrested if he ever returned to Britain.[31] Then Joseph Ball, again through solicitors, insisted any references to him be deleted.[32]

The serial ran over seven days the following week, with the *Mail* taking one of their customary positions. 'His Burgess story is a frankly partisan work. With many of his opinions the *Daily Mail* disagrees . . . but prints it none-the-less uncensored. Differing opinions cannot obscure the fact that it is the major news scoop of the decade.'[33]

They were right. Driberg had simply not bothered to challenge

Burgess's accounts of events, which claimed he had never been a spy, had stopped drinking, and loved being in Russia. Though panned by the critics, it made Driberg a huge amount of money. This was an authorised version of equal delight to Burgess, the KGB and MI5.

Reviews were mixed. In *Tribune*, Claud Cockburn, who had been part of Otto Katz's circle, described it as 'one of the major political and journalistic events of the decade',[34] whilst Alan Moorehead in the *New Statesman* thought it 'a credible picture of Burgess . . . even though it leaves us in the end with a sense of the futility and the littleness of this life . . . One looks back through these brief pages thinking that somewhere something must have been left out. After all, Burgess was an interesting man, and one feels that he can scarcely have been as trivial as all this.'[35]

John Connell in *Time & Tide* began, 'This is a bad, unpleasant book about a bad, unpleasant man . . . What kind of people does Mr Driberg, who continues to live and work in our midst, think we are, to be deceived by this packet of glibness and plausible triviality?' adding it was 'thoroughly badly written, ill-constructed and repetitive . . .'[36] Whilst in the *Spectator*, John Davenport, who had known Burgess since Cambridge, called it 'this brilliantly boring pamphlet seems to me altogether too much of a whitewash of its subject . . . We cannot make a hero of our time out of such an ass.'[37]

According to Driberg's book, there had been no escape plan beyond catching the boat. 'Donald had suggested that we ought to make for Prague, because there was a trade fair on, which would make it easy to get visas.'[38] They had caught the Paris express from Rennes and taken an overnight train to Berne, where they collected visas at the Czech embassy. 'We knew that nobody would start doing anything about it till some time on Monday' but had a shock to discover there wasn't a flight from Zurich to Prague until Tuesday, so Burgess 'went and looked at motor-cars', whilst Maclean 'lay on his bed reading Jane Austen. We were both rather in a Jane Austen mood.' Turning up at the Soviet embassy in Prague, the reaction was 'deadpan. You know the sort of thing: "Very interesting, but we must get instructions."' The two men waited a week, expecting news of their disappearance any day on the wireless, 'looked at various palaces and read Jane Austen'.[39]

It was the news breaking on 7 June whilst they were still in Prague, according to Burgess, that 'decided me to go to Moscow with Donald at once. Up to that moment I'd still got a faint idea that I might first go on to Italy for a holiday. After all, I'd done my part for Donald – I'd delivered him safely, as it were, behind the "Iron Curtain".'[40]

Arriving in Moscow they 'were taken to a hotel for a day or two' then lent a flat, where three days later they were interviewed and then sent to 'a dreary provincial town' for 'about six months. We had beautiful flats, looking out over the river, but I was very unhappy there; it was permanently like Glasgow on a Saturday night in the nineteenth century.'[41]

Burgess took a job in the Foreign Languages Publishing House, 'making suggestions and trying to get them to translate and publish more good English books of all kinds', worked for 'the Anti-Fascist Committee', which collected 'information on post-war fascist trends in various parts of the world', and the World Peace Movement, sometimes consulting on 'anything from Somerset Maugham to British policy in Trinidad. You might call me an expert Englishman with a roving commission.'[42]

He confessed to missing London, New York and friends. 'But I have become used to the ways of solitude, and on the whole I like it. I read an enormous lot – I've read most of the Everyman library. I lead a very quiet life.' In London his 'main expenditure was on drink and cigarettes' and both were cheap in the USSR. 'I only drink wine – this Caucasian white wine, whenever I can get it. Hardly ever vodka, unless I'm sick. It's the best cure for an upset stomach.'[43]

And he maintained that he still admired Russia. 'Sometimes, yes I am lonely. I'd like to have a good gossip with some old friends. But here I'm lonely for the unimportant things. In London I was lonely for the important things – I was lonely for Socialism.'[44]

His published account was, however, only part of the story.

37

First Steps

Mystery still surrounds the exact escape route the two men took. Writers have suggested all sorts of routes, one – *Deceiving the Deceivers* – even speculating they were picked up by submarine in Nantes. Robert Cecil, quoting private information, argues they used the same route as Melinda a few years later, through the Soviet zone of Austria, which Burgess's KGB minder Sergei Humaryan confirmed.[1]

Christopher Andrew, in his official history of MI5, and Modin, give more-or-less the same route to the one Burgess gave Driberg. The two men caught a train from Paris to Geneva and then an overnight one to Berne, arriving at 6 a.m. on Sunday 27th. They presented themselves at the Soviet embassy, where they were given two false passports, and flew out on the first suitable flight two days later to Stockholm, alighting in transit in Prague, where they were 'processed' and at the beginning of June flown to Moscow.[2]

Guy Liddell revealed in his diary that 'GCHQ reported an increase in volume of traffic between London and Moscow as from 25th May, the day Burgess and Maclean left. Two or three days later there was an increase in the traffic from Berne, and about the 4th or 5th June an increase in traffic from Prague', suggesting that maybe Burgess's account was broadly accurate.[3]

Once in Russia, no one quite knew what to do with the agents until Stalin and Beria had decided. Nigel Burgess recalled how, when he was in Moscow in 1963:

> Donald showed me a great hotel balcony on the first floor overlooking the Kremlin. He told me that when they arrived, they all had dinner on that balcony. They had got drunker and drunker on vodka until three in the morning. People were running about all over the place looking for them and there they were on the balcony boozing. The

next day, Donald was in bed with a hangover and Guy told him that he was going out. He had to find a bar, he said. Donald said that they were in Moscow now . . . Guy said he could find a bar anywhere in the world. And after a long bar crawl, he was hauled back to the hotel that night.[4]

Modin gave a similar version, saying the pair 'arrived in Moscow, the authorities met with them, shook their hands, drank cordials of good brandy, and sent them to Kuybyshev'.[5] A city on the Volga, and formerly known as Samara, Kuybyshev had been where the Soviet government had been evacuated in 1941 when Moscow was threatened by the Germans, and was closed to foreigners. Burgess told foreign correspondent John Miller they were 'put in a small house guarded night and day by KGB troops. To all intents and purposes, they were under house arrest. The debriefing became an interrogation. This went on for several months and it quickly dawned on the two runaway diplomats that their hosts suspected they were in fact double agents. So they had to be broken . . .'[6]

It's a view confirmed by Sergei Humaryan, then in his early twenties, who guarded them and was later director of the KGB museum in Samara, who said the men first shared a flat, and when Maclean's family arrived they were housed on the same floor in the same apartment building.[7] There the two men were fully debriefed on the issues, personalities and material they'd supplied. Burgess 'had to recall a lot, add new information, make comments on different documents, expound on the information the Cambridge Five had given to the Soviet Union. Many KGB agents from Moscow were coming to Samara to work with them . . . He got drunk a lot. Also, he could walk alone for hours. Samara at that time wasn't especially fancy or attractive. Surely not the best city in which to spend time.'[8]

The men took on new identities: Maclean was Mark Petrovitch Frazer (in homage to the Scottish anthropologist James Frazer) and Burgess was Jim (after his Cambridge friend Jim Lees) Andreyevich (after a character in *War and Peace*) Eliot (after his beloved George Eliot).[9] Whilst Maclean learnt the language and took a job in a linguistic institute, Burgess, who never progressed beyond kitchen Russian, spent his time reading and drinking cheap liquor.

Quite how long they stayed there is unclear. Many writers have

taken Burgess's claim to Driberg of six months at face value, but it's clear the two men were there at least until after Stalin's death in March 1953, and probably longer. Petrov claimed that Burgess and Maclean were still living in Kuybyshev in 1954, Burgess told Miller they were there until 1955, and it is likely they had only just come to Moscow when they appeared at their press conference in February 1956. A Russian internet project says they were in Kuybyshev until 1954.[10]

Burgess later told Stephen Spender how Kuybyshev 'was a horrible place and things were made worse by the fact that Beria, in an effort to gain popularity after the death of Stalin, released 80 per cent of the criminals in Russia. Kuybyshev was invaded by gangsters and scoundrels. That's how I lost the tooth on one side of my face. I was walking along a street when a thug saw my watch and knocked me down.' The tooth was replaced by a stainless steel one, which proved disconcerting to those meeting him for the first time.[11]

When Modin saw Burgess, after his tour of duty in the summer of 1953, he claimed Burgess was living in a small village on the outskirts of Moscow on the road to Sheremetyevo airport – a description that matches the dacha Driberg stayed at during the summer of 1956.

> The Burgess abode was small and attractive, a wooden, typically Russian structure. He had put in a special request to be lodged in old buildings dating from before the Revolution, and this was easily granted. A woman was employed to do the housework, and otherwise Burgess was assigned a KGB bodyguard to help him in his day-to-day existence. He seemed to like his lodging, which had five well-furnished rooms and a fully equipped kitchen. It seemed to suit him, a real intellectual's retreat, with a large tidy garden planted with fruit trees.[12]

Burgess made clear to Modin that he resented the way he had been treated since coming to Russia and couldn't understand why he simply couldn't return to Britain, adamant he could withstand any MI5 interrogation. When questioned on why he had carried on beyond Prague, Modin 'concluded that he came along for the fun of it, expecting some kind of party at the Kremlin in his honour,

and he was genuinely stunned when they forbade his return to England. He bitterly resented this treatment at the hands of the KGB.'[13]

In 1956 Burgess moved to a sixth-floor flat in a new block, filled with senior army officers and party officials, Flat 68, 53/55 Bolshaya Pirogovskaya Street. The flat consisted of a long sitting-room, small bedroom, bathroom, kitchen and balcony, and was located in one of the oldest parts of Moscow, and one rich in historical monuments. It looked out on to the crenellated walls and dozen watch towers of the Novodevichy Convent, where amongst others were the graves of Chekhov, Gogol, Khrushchev, Prokofiev and Stalin's wife, Nadezhda Alliluyeva, who had committed suicide in 1937. Burgess was to become a regular attender of services in the convent.

He confided to Driberg that he would have preferred a couple of rooms in one of Moscow's old, yellowing houses and told John Miller he wanted to take over an outhouse in Novodevichy but buggers couldn't be choosers.[14] In this Stalinist skyscraper he largely recreated the rooms he had lived in at Cambridge and in London, insisting he couldn't work without his porcelain desk lamp with its huge shade, clavichord, old regency sofa-table and Tsarist writing-set, which were duly shipped across at KGB expense.

'My flat in its new form is a continuous joy and the admiration of all who see it. I do hope you will be included in the number some time. It really makes a great difference to life in Moscow to have one's eyes soothed instead of affronted by one's surroundings', he wrote to Driberg, who had organised the shipping out of much of the furniture from London. 'The curtains are particularly successful, also the lamps. As you know, the best in the way of Soviet lampshades you can get have apparently come straight out of Lily Langtry's boudoir and are tiring to the eyes, as well as hideous to the sight.'[15]

Social realist posters from Collet's left-wing bookshop in Charing Cross Road hung beside framed reproductions of English hunting scenes and a Chagall reproduction. On his desk were pictures of his mother and himself at Eton. Bookshelves lined the walls with hundreds of books on everything from racing cars to a yearbook of English roses. With little else to do apart from listen to music, especially Mozart and Haydn, Burgess read voraciously and widely,

as he had most of his life – often about politics and history. Two of his favourite books were David Benedictus's satirical novel about Eton, *The Fourth of June*, and a limited edition of the homosexual Irish Nationalist Roger Casement's *The Black Diaries*, which he took great pleasure in lending to various visitors in the hope they might be shocked.[16]

Burgess had told Driberg that he was working at the Foreign Languages Publishing House, recommending Western authors, such as E.M. Forster and Graham Greene, for Russian translation. He did not mention he was also working at the Information Committee of the USSR Foreign Ministry, subsequently described by Boris Piadyshev, who worked there from 1956, as 'a powerful structure, created at the junction of the intelligence and foreign policy service. It was a clearing house for information coming in from the foreign intelligence service, the Foreign Ministry, and diplomatic missions abroad. This information was analysed and used as a basis for situation assessment and proposals and recommendations concerning global and regional actions that were sent to the country's top leadership . . .'[17]

Piadyshev remembered how:

Guy Burgess's office was on the second floor, next to our room . . . His table was piled high with newspapers, books, pipes and other knick-knacks without which a British gentleman is not a gentleman. We received the European edition of the *New York Herald Tribune* and a couple of other newspapers from Paris two or three days late. Guy was the first to read them. Then he took great pleasure in informing the public about what he thought were the most interesting reports . . . Unfortunately, he was never able to fit into a new environment. He did not have a family. He had very few friends . . . Later, Burgess left the Information Committee English-style – that is, without saying good-bye. We were told that he had been offered a new job.[18]

38

'I'm Very Glad I Came'

Having described himself as 'an old-fashioned, nineteenth-century, dogmatic atheist, *not* an agnostic',[1] Burgess grew to respect those who were religious. Driberg remembered on one of his visits accompanying Burgess to Novodevichy:

> A choir was singing in the distance beyond the screen – one of those poignantly resonant Orthodox choirs, its cadences liquid yet lingering like honey, its harmonies almost unbelievably profound and rich . . . It was at this moment that, glancing at Guy to see if he were bored and wanting to move on, I noticed to my astonishment that his eyes were glistening with tears, and that he was standing rigidly still, as though riveted by the music. When we came out of the church, he was still too much moved to talk; he muttered an excuse, and went and sat by himself for some minutes on a gravestone.[2]

In London, Burgess's main expenditure had been on drink and cigarettes and, as he had told Driberg, one of the pluses of Russia was they were so cheap. Modin admired Burgess for his intellect but worried about the constant drinking. 'When I told him it was against the unwritten laws of England to drink before noon, he just laughed at me. I'm not in England, comrade.'[3] He kept in touch through numerous British newspapers and magazines, which reached him a few days after publication. He ate little – preferring to smoke, drink and talk – though his housekeeper insisted he always had a large breakfast of eggs and would sometimes produce partridge, pheasant, wild duck and other game from the black market.

His mother sent him a hamper from Fortnum's several times a year. 'Burgess attacked these hampers like a Billy Bunter, first gobbling

up everything that took his fancy, such as the pâté and the chocolate biscuits, and finishing up with items he didn't particularly care for, such as the dried prunes and tinned fruit. Everything was washed down with slugs of cognac and squeaks of "goody-goody gum drops! What's next?"'[4]

His life was circumscribed. He had a series of guards – whom he sent on errands to buy food – his flat was bugged, he wasn't allowed to go out until he had received a phone call each day about 4 p.m., and when he ventured outside he was followed.

Whereas Philby and Maclean were under the control of the First Chief Directorate, because of his homosexuality, Burgess for security reasons came under the auspices of the Second Chief Directorate. A promiscuous homosexual in Britain, now he was in Moscow he carried on exactly as he had before, in spite of homosexuality being a criminal offence and the fact he had a live-in lover, casually picking up men on the street. The KGB watchers responsible for following him, astonished at how easily he seemed able to pick men up, quickly learnt to turn a blind eye. He received a small income from the KGB and they would lend him a car with a driver when he needed it. 'He was at ease in Moscow because his needs were being met,' claimed Sergei Kondrashev, a KGB officer who supervised him.[5]

Burgess delighted in wearing an Old Etonian bow tie, often at the same time as the Order of the Red Banner, which he claimed to have been awarded by the Russian Foreign Ministry. 'It helps in the restaurants,' he used to say, without specifying which of these distinctions he meant.[6]

He had a regular group of correspondents, such as Roy Harrod, Wolfgang von Putlitz and Harold Nicolson, who then shared his letters with other mutual friends such as Robin Maugham and Peter Pollock. Harrod, who described Burgess as 'a very dear friend of mine, one of the persons whom I have loved most', sent him several of his books including *Foundations of Inductive Logic*, remembering Burgess had 'made very intelligent comments on it. Indeed, I think that his were the best comments I had on that book.'[7]

A flavour of his life can be found in this extract from a long and chatty letter to Pollock, by now happily settled with Paul Danquah:

I am writing this late at night, exhausted, & with my Paul buzzing about, putting the 9th Symphony on, dancing & asking questions on every subject from Stravinsky to Irving Berlin with Rimbaud thrown in and quotations from Maupassant's Bel-Ami which every Russian seems to know better than you or I, just as they do Mark Twain, Galsworthy & sometimes Shakespeare and always Dickens. I told Tom Driberg that I would pay for the HI-FI radio-gram system he is organising for me and that he should get the money off you. I thought this would save you trouble and Tom has contacts. So give him any money he asks. If it is more than you have out of the 150 I sent you I will send more.

I despair of receiving BOOKS from you. Have you sent any? I have opened an account at COLLETS, Charing Cross Road, so please hand the lists I sent to you to them. (Wait a week after you receive this or account may not be yet open.)

I don't know quite yet whether my Paul will be a Paul or only a Michael. I think a Paul. A great relief, as you know as well as I – or better. At the moment he is singing the 'Drinking Song' from Traviata and complaining sharply that I am writing – Paul or Michael? We go to the Bolshoi theatre Figaro tomorrow & I shall think of you. Do you remember the many occasions on which we played or saw it together. On one occasion interrupted by Tom Wylie's snores.

Now Peter I shall consult Leonard Cassino tomorrow a.m. at dawn or thereabouts & send you a list of records I would like you to buy for me. Please do this & give them to Tom Driberg to send with my furniture. I think his telephone number is LEE GREEN 8035. But I will ask him to ring you also . . .

What a bad letter. I really am very well & things are going much better for me here than I ever expected or asked – and as you know I expect & ask a lot. A visit from you would be lovely but for the reasons you wrote & I wrote had better be left in cold storage as regards actual arrangement 'for' as A. Marshall wld say, 'the nonce'. What about you & Paul coming together I think I could bear it. (Jealousy wld be no obstacle of course – but discretion of behaviour by Paul would be v important – on the other hand anyone of his race is v popular here . . .

What Jane Austen calls 'my instrument' (i.e. piano) is now being played on con brio. At the moment, Verdi, but I am promised 'One of Beethoven's latest quartets' at any moment . . .

Life as you see is full of incident & curiosity & I'm very glad I came.[8]

It was a lonely existence and Burgess took every opportunity to mix with Western visitors, lingering in haunts where they might be found such as hotel lobbies or the Bolshoi, though he was often annoyed at how few visitors noticed him. In July 1957 an American lawyer from Memphis, William Goodman, found himself sitting beside Burgess at a performance of *La Traviata*. Burgess, who was with a woman and young boy, explained he was in Russia 'preventing World War III', though refrained from going into exact detail how he was doing so. Wearing a dark pinstripe suit and his Old Etonian tie – to which he immediately drew attention – Burgess introduced himself as 'one of the two missing British diplomats' and reminisced about his time in the USA during the three twenty-minute intervals. When Goodman asked Burgess what job he had, Burgess only smiled mysteriously, showing a stainless steel front tooth, and evaded the question with a hint that he was doing 'rather important work for the Soviet government'.[9]

Burgess was not just working for peace and at the Foreign Language Publishing House, but he also appears to have written a training manual for KGB recruits about the British way of life. Modin claimed, perhaps mistaking the analysis Burgess had written some twenty-five years before at Cambridge, 'Towards the end of the 1950s, he embarked on some research for the Centre, notably a study of British students in the 1930s, with a discussion of their behaviour and their political and social aspirations. This work included a brilliant analysis of the methods used by the Soviets to recruit young Britons at the time, in which Burgess showed quite clearly how and why the NKVD had succeeded in creating a network of absolutely crucial importance.'[10]

Interviewed for this book, Modin claimed that in the late 1950s:

Burgess was writing a book, a book about spies. You cannot find it; it's in a secret library . . . I gave him the idea to do that. The authorities were nagging me to come up with how to better use him. The book produced great commotion. He greatly criticised us in the book, how we behave ourselves, where we are right, where we are wrong, and where is our weakness, why we fail more often than win. So it means that he gave a deep analysis. When the head of the intelligence agency found out about it, it appeared that he was shaken for a long time . . .[11]

Anatoly Golitsyn claimed in his unpublished memoirs that Burgess had also been used in recruitment operations from 1953, and in 1954 was sent to Peking as part of a homosexual blackmail operation against a friend serving in the British mission there.[12]

From 1962 Burgess also worked closely with Sergei Kondrashev, a former *rezident* in London and Berlin, where he had run George Blake, and according to the CIA officer Pete Bagley, Burgess:

> bubbled with suggestions for active measures. Kondrashev would bring him plans that were being worked out in the Service, and Burgess would make constructive and thoughtful comments. He took drafts of articles the Service were preparing to float in the English-language press abroad and edited them into native English. He helped them to counterfeit British or American official documents. And he helped forge letters ostensibly from private citizens to British MPs and to British and American newspapers, and hate letters to be sent to religious organisations, with the aim of stirring discord.[13]

His training in the Joint Broadcasting Committee and Information Research Department was being put to good use.

Kondrashev enjoyed his contact with Burgess and was impressed by his grasp of foreign and domestic affairs, his lively imagination, and his intuition about people, but he was not an easy man to work with. He could be moody, wilful and petulant, and would keep Kondrashev, a dozen years younger than him, waiting whilst he finished playing his clavichord before settling down to work, or insist they have a few drinks first. Once Kondrashev was forced to stand in the corridor outside his flat whilst a young man, still half-dressed, was hastily ushered out. But Kondrashev valued Burgess as a unique asset. 'He was far more useful than the other defectors from the British establishment who were then living in Moscow.'[14]

This is a view confirmed by Modin. 'They used him, and he made a very large positive contribution . . . he predicted a lot of things correctly in foreign policy and also in intelligence.'[15]

In September 1957 Burgess wrote to Peter Thorneycroft, who was now Chancellor of the Exchequer, asking for monies from his bank account to be paid to him in Russia, so he could settle bills with

the grocer Fortnum & Mason, his shirtmaker New & Lingwood, his tailor Tom Brown and the bookseller Collet's. He reminded Thorneycroft, whom he addressed as Peter, much to the disgust of civil servants, that he had invited him on to *The Week in Westminster* more often than the Conservative leadership might have liked, complaining his income from a trust fund paid into the St James's Street branch of Lloyds was being monitored by the Treasury. It worked and Burgess was allowed access to his bank balance of just over £1,000. His furniture was also shipped to the USSR.[16]

Two months later, Burgess was designated as a non-resident British subject, which meant money could be sent to him and he wouldn't be in breach of foreign exchange control regulations. When this became public, there was an outcry in the press and parliament, with suspicions that he had been given special treatment because of friends in high places, and that other fugitives were not treated as well.[17]

One of Burgess's closest confidants was his old mentor Harold Nicolson, to whom he felt he could write openly about both politics and his private life:

Your letter, the second letter, from the 'shameless port' of Famagusta reached me here in one of my favourite places – Tiflis – to you and me and many Russians, but now officially what it always was to the Georgians, Tbilisi. I think the Georgian word just more expressive of this lovely, romantic, gay, open-hearted, sly, secret-living, friendly (to foreigners, less so to Russians) place, with I should think the highest standard of living and eating, of clean, thick cream daily, silk tunics, belted round waists which seem immune to the expansive effect of litres of wine, anywhere in the Soviet Union – higher indeed than many West European towns we both know. I won't go into the reasons for this.

I am writing this in the late morning. The early morning was spent lying in hot mineral water (natural hot) in a Georgian bath in what has been both a Christian and Mohammedan place of worship, being scrubbed, washed in a way only Orientals wash (but I refused depilation) by a youth whose nationality I don't know, tho' not a Russian or Georgian? A Circassian? with apparently waterproof Mascara round his eyes, an individual of great experience and technique and judging by the jealous grunts of a vast Armenian, obviously a regular visitor, who had unfortunately for him arrived 5 minutes after me and missed that bus this morning, of great popularity. I went

to the bath early because last night I was 'with Georgians at a party' (see drawing by Sir Harry Luke in, I think, his 'Cities and Men').

My dear Harold, what a nice letter yours was, and so full of information. I was very touched and grateful. Gossip is apart from the Reform Club, the streets of London and occasionally the English countryside the only thing I really miss.[18]

Now that Modin was back in Moscow, he often met Burgess and he saw the two sides of Burgess's character. When Modin ran into trouble with his superiors, after writing a critical report on his London colleague Nikolai Rodin, Burgess intervened with a forthright letter to Ivan Serov, president of the KGB, which saved his former handler from being sent to Siberia.[19]

But he was never popular with those entrusted to guard him. 'Those detailed to look after Guy Burgess suffered acutely, for he was unpredictable, aggressive and provocative to them by turns. I remember one counter-espionage agent who had been with Burgess in a KGB holiday camp in the south, who told me how odious he had been. For example, he derived a warped satisfaction from dragging an inflatable bed along the beach, brushing past the people sunbathing and spraying them with sand. He was roundly abused, of course, but didn't give a damn.'[20]

Terence Lancaster, whilst he was in Moscow for the *Express* in November and December 1957, saw Burgess most days, usually about 9 a.m. before he left for his job at the Foreign Languages Publishing House. He had been told Burgess was vain and lonely and only too happy to talk. 'He had a dissolute look about him, but always clean shaven and in an OE tie,' he remembered. Lancaster enjoyed their encounters, finding Burgess had great charm, was a good conversationalist and listener and could be funny, even about leading Soviet figures. They dined several times, including at a Chinese restaurant, and Lancaster noticed him keen to shock, but also fascinated to hear political news and social gossip. 'He was very funny at imitating people, particularly Churchill and Macmillan, but not so good on Gaitskell.'

Burgess told Lancaster that he had not intended to go to Russia, but 'one thing led to another' and 'always his feeling for England cropped up. His conversation, his friends, his talk, even his appearance

dated Burgess as a man of the thirties.' Lancaster felt Burgess never forgave Britain for Munich and he still firmly believed in the communist system, even with its faults, whilst having no illusions about the Soviet system. 'You are operating in the Soviet Union and the principles of free speech do not apply here.'[21]

When Lancaster left Moscow, Burgess asked him to post some Christmas cards to his old school-friend, the diplomat Con O'Neil ('Hope I didn't cause him any problems') and Hector McNeil's widow, and requesting Tom Driberg to send him some indigestion mixture. He also gave him £1 to repay Thomas, a waiter at the Reform Club, and asked Lancaster, the product of Salisbury Modern School, to buy half a dozen OE ties. Entering the shop, embarrassed by the bizarre request, the newspaperman, not a frequenter of such outfitters, explained, 'They're for a friend.'

'That's what they all say,' the assistant replied acidly.[22]

39

An Englishman Abroad

In December 1958 the Shakespeare Memorial Theatre Company toured Russia in the first major visit of a British theatrical company since the Second World War.[1] It was seen as a significant cultural exchange in forging good relations between Britain and the Soviet Union and a major operation, with 28 tonnes of scenery and 350 costumes. Several performances were filmed and watched by some five million viewers across Russia. The seventy-strong company, which included Michael Redgrave, Coral Browne, Angela Baddeley and her husband Glen Byam Shaw, gave fifteen performances of various Shakespeare plays, including *Hamlet* and *Romeo and Juliet* directed by Byam Shaw and *Twelfth Night* directed by Peter Hall.

After two weeks in Leningrad, the company flew to Moscow, where a journalist took Michael Redgrave aside at the airport and gave him a message: 'Guy Burgess wants to know if you would agree to meet him.' Redgrave had not seen Burgess since Cambridge, but readily agreed. 'I had a general recollection that he was amusing. He had a very lively mind.' The opportunity would present itself immediately. On the first night of *Hamlet*, a group of British newspapermen had gathered outside Redgrave's dressing-room when he heard a familiar voice. According to Redgrave's own account, in swept Burgess extending both arms in greeting, 'Oh, Michael! Those words, those words! You can imagine how they carry me back. Magic!'[2] He then carried on past the startled actor and was sick in his basin. In truth, realising he was drunk, Redgrave had refused to let him in and Burgess stumbled and was sick in the next-door dressing-room belonging to Coral Browne. It was an encounter that was to inspire one of the most memorable dramas about Burgess – Alan Bennett's drama *An Englishman Abroad*.

Redgrave and Burgess arranged to meet for lunch at the latter's flat the next day, where after pâté de foie gras, the housekeeper served hare or suckling pig – accounts vary – which proved to be inedible because the gall-bladder hadn't been removed. Then, after lunch, they went for a walk around the Novodevichy monastery, where Burgess volunteered to Redgrave that he had not intended to go on to Russia, once he had delivered Maclean to 'a certain place', but in spite of his wishes, he had been forced to continue his journey and ended up in Russia.[3]

Coral Browne separately accepted an invitation to lunch, which she enjoyed: '. . . he was not really just a bungling drunk. He had style. And apart from that incident, wonderful old-world manners' though the food 'was pretty foul . . . we ate small withered oranges which cost a pound a time. Guy did eat whole cloves, though.' Burgess complained about his Russian false teeth and clothes and desperately asked her about people in London she didn't know. At one point he played a record of Jack Buchanan's 'Who Stole My Heart Away', whilst he waited for his late-afternoon call from his minders to allow him to leave the flat and escort Browne back to the Hotel Metropol, where she was staying.[4]

Before she left, Burgess asked if she would buy him some new clothes, including a single-breasted, grey chalk-stripe suit, a summer suit, and another in dark-blue flannel for his live-in companion Tolya, plus two Homburg hats – one green and one blue – with turned-up brims, from either Lock's in St James's Street or Scott's in Piccadilly. Subsequently he sent his measurements together with a cheque for £6 for her to treat herself to lunch and 100 roubles, asking for a pound each of white and green wool, together with a note, 'It was a great pleasure to gossip with you all. The Comrades, tho' splendid in every way of course, don't gossip in quite the same way about quite the same people and subjects.'[5]

Browne duly paid a visit to Turnbull & Asser in Jermyn Street and arranged the purchases, which were paid for through Burgess's London account. He was delighted, writing to thank her for 'all your trouble (which must have been great) and even more for your wise and happy choices. Everything fits.' Browne volunteered to buy anything further he needed. Burgess was thrilled:

What I really need, the only thing more, is pyjamas. Russian ones can't be slept in – are not in fact made for that purpose. What I would like if you can find them is 4 pairs (2 of each) of white (or off-white, not grey) and Navy blue Silk or Nylon or Terrylene [*sic*] – but heavy, not crêpe de chine or whatever is light pyjama. Quite plain and only those two colours . . . Don't worry about price . . . Gieves of Bond Street used always to keep plain Navy blue silk. Navy and white are my only colours, and no stripes please.[6]

The visit had been a poignant reminder of what he had left behind almost eight years earlier. Redgrave's wife Rachel Kempson remembered how, 'He would ring me in the hotel bedroom every morning and talk for about a quarter of an hour, saying how wonderful it was to hear an English voice.'[7] He had become quite friendly with the cast, whom he saw perform several times and had met at a party given by Ralph Parker. In particular, he had taken a shine to Mark Dignam who played Claudius and was a communist, whom he described as 'an angel' and whom he had instructed to tell the British embassy that if they needed any introductions to Russians, Burgess was happy to oblige.[8] On the day the company left, Burgess came to see them off. As they drove away from the Hotel Metropol, where they had been staying, Redgrave noticed he was almost in tears. 'Write to me,' he said, 'it's bloody lonely here, you know.'[9]

When Harold Macmillan, now the Prime Minister, visited the Soviet leader Nikita Khrushchev in February 1959, Burgess told Harold Nicolson that he was 'able to give advice at a suitable level' and remembered how he had once spent an evening with him at the Reform, where Macmillan 'had listened – as who could not as it was my club – to my rantings'. And to Stephen Spender, he confided, 'I was able to be a good deal of help to Macmillan during his visit. I wrote a report that he was in favour of friendship and should be trusted, whereas all the others wrote that he was a dangerous reactionary.'[10]

Burgess used the opportunity of the visit to reiterate his desire for safe passage to see his sick mother, enlisting a host of former contacts to make his case, including Sir Patrick Dean, now Deputy Under-Secretary of State at the Foreign Office, who had accompanied Macmillan, telling him, 'I will not make embarrassments for

Her Majesty's Government if they don't make them for me. I will give no interviews without permission. I was grateful in the early days that Her Majesty's Government said nothing hostile to me. I, for my part, have never said a lot of things that I could have said.'[11] The implicit threat was there.

He also rang Randolph Churchill, who was on the delegation as a journalist, and asked to see him. Randolph Churchill later wrote that Burgess appeared in his room in Moscow's National Hotel, introducing himself, 'I am still a communist and a homosexual.' To which Randolph replied, 'So I had always supposed.'[12]

The government now began to look seriously at whether anything could be done if Burgess, whose passport had expired in 1958, chose to travel to Britain. The Attorney General Sir Reginald Manningham-Buller, reviewing the evidence against Burgess, concluded there was not enough evidence to prosecute him for spying under section one of the Official Secrets Act and only technical offences under section two had been committed. On 17 February the Cabinet discussed Burgess and thought it might 'be advisable to require him, if he presented himself at a British port, to establish his identity and to prove that he had not become an alien by acquiring Soviet nationality'.[13]

David Ormsby-Gore, who now had Hector McNeil's job as Minister of State at the Foreign Office, reported to the Cabinet on 25 February, 'We cannot hope to obtain legal proof that Burgess has committed any treasonable act while in the Soviet Union or any seditious act . . . Indeed if he knew how little evidence we had, he would be more likely to be encouraged than deterred.'[14]

The following day the Foreign Office informed the Moscow embassy they were not to extend any travel facilities to Burgess and hoped he didn't put the issue to the test. 'The Cabinet considered the question of Burgess this morning. They were advised by the Attorney General that there are no (repeat no) grounds on which Burgess could be prosecuted by the Crown if he returns to this country. Nor are there any means of preventing him from returning if he is determined to do so.'[15]

Burgess seemed to be aware of the weakness of the case against him, writing to Harold Nicolson:

I won't go into long details about the so-called 'evidence' of which you write except to say (what I know is the case) that so nervous are the authorities of what might happen if I come back that they drop deep hints to selected persons known to be in touch with me that there is evidence for a case. In private, I know that the authorities say to each other (as a senior British ambassador said to a friend of mine, not knowing he was a friend), 'The trouble is we don't know what we could do if he came back. There is no evidence.'[16]

But Burgess was pragmatic. 'I am bound to take into account that a case might be drawn up by the authorities I mention and to fight it would incur publicity and calling as witnesses all sorts of good friends to whom I have done enough harm already.'[17]

It remained a lonely life, only enlivened by 'chance' meetings with foreign visitors. Patrick Reilly, who served in the embassy until August 1960, recalled, 'Once he accosted a newly arrived American admiral, who was wearing a brand new Old Etonian tie, saying how interested he was to see that they had been at the same school. The admiral, much embarrassed, explained that he had just bought the tie in the Burlington Arcade, because he thought it pretty.'[18]

Revealingly, when Paul Robeson, a former lover of Coral Browne and hero of Burgess, was taken ill in Moscow in the spring of 1959 and had to spend a month at a sanatorium, Burgess confessed to Browne he was 'too shy to call on him . . . I always am with great men and artists. Not so much shy as frightened . . . tho' I know that he is as nice as can be . . .'[19]

Burgess was now in regular touch with various journalists and enjoying the mischief he could make. Robert Elphick, Reuters correspondent in Moscow from 1958–62, remembered 'Burgess at various parties in a grey suit, rather stained and baggy, and wearing an Old Etonian tie. He had usually had too much to drink but was lucid.' Elphick once asked him if it had all been worth it. '"Well, we all make mistakes," he replied.'[20] The *Observer* journalist, Edward Crankshaw, saw Burgess several times on a visit in January 1959 and reported to the Foreign Office:

I had better say at once that I had not been with him long before I understood what I had failed to see before. B's brilliance and charm. . .I have never known anyone who flaunted his homosexuality

so openly: whether he did this in England others will know. But he neither bullied one nor bored one with it. And once I got accustomed to this stage atmosphere I liked him much and finished up by being deeply sorry for him, although at no time did he exhibit self-pity or ask for sympathy. Only for the opportunity to talk and talk and talk . . .'[21]

Crankshaw told them that Burgess had 500 roubles a month, a 'Boy Friend' who was 'a priest at the Novedevich Monastery who was 6 foot, youngish and wholly repellent – v handsome in a horrible way – and corrupt to the core. B is quite obviously head over heels in love with this monster though he did not say so. I went to an evening service and watched B when he was looking at this priest. B's face was radiant and he was clearly transported with delight.'[22]

He remembered Burgess's 'normal drink is 200 grams of vodka with 200 grams of tomato juice in a large glass. At our first lunch we drank five of these shockers as well as a good deal of chianti . . . Burgess said Maclean liked laughing at himself but could not bear it when others laughed at him. Burgess always did laugh at him. He, Burgess, on the contrary found it almost impossible to laugh at himself, though he tried very earnestly, but did not mind being laughed at by others.'[23]

Crankshaw continued that though still anti-American 'Burgess's politics are not his best point' and noted his 'endlessly pacing up and down the room when he talks' and 'he boasts of blackmailing virtually Peter Thorneycroft into having his furniture sent out from England . . . The man is half dotty, not actively vicious . . . The whole situation is the sort of personal tragedy that can only be ended by death.'[24]

At the beginning of 1959, the Canadian freelance journalist and film maker Erik Durschmied, then in his late twenties, obtained Burgess's number from a junior diplomat at the British Embassy and rang Burgess, who invited him over as long as he brought some whisky. Armed with two bottles and some car magazines, Durschmied went to Burgess's flat. 'A tired-looking man, run down like the building he lived in. He was not what I had imagined a super-spy to look like. On hunched shoulders he carried a worn-out tweed jacket over a good-quality white shirt, which had endured too many washings

with Russian detergent. A bow tie, baggy pants and a pair of Church's brogues, worn down on the heels, completed his outfit. But his eyes were something else: there was such deep sadness in them. Pools of despair. A man who had given up hope.'

Burgess agreed to be interviewed for the Canadian Broadcasting Corporation's programme *Close-Up* and a suitable location was found – the snow-covered graveyard of an abandoned monastery near his flat. The nine-minute interview, which was only broadcast in Canada and rediscovered in 2011, revealed very little. Burgess, clearly half-drunk, continued to maintain he was not a spy, he had come to Russia as a 'tourist' and that as 'an extreme socialist' and Marxist he was delighted to be living in the Union of Soviet Socialist Republics. 'What is life like?' Durschmied asked off-camera.

'"Life?" There was a long silence. He stared through the window and focused on a point in time and space, some three thousand miles from Moscow and several years ago. "My life ended when I left London."'[25]

40

Visitors

Burgess's health was now beginning to give him trouble, as he explained to Tom Driberg:

> I can't quite get it clear about my heart. It's certainly what we call Angina Pectoris with which you can live till 90. It's equally certainly a worrying nuisance. Amongst other things it interferes with work – and if one goes out without ones Nitroglycerine tablets – which remove the symptoms in a few minutes <u>unfailingly</u> but which are no cure – one may be caught. My attacks for some reason are normally first thing in the morning, either when I wake up (sometimes they wake me up) or, if not then, after breakfast. It interferes with work by having one v tired – and indeed even if no attack one seems to feel tired always. Exercise also brings it on, particularly walking upstairs. Pain oddly not in heart but in chest – <u>particularly</u> in <u>arms</u> (not much in chest). According to electrocardiograms, one of which was rather bad, they say, I have had it for a long time . . . I beg you to say <u>nothing at all</u> to my mother.

Shortly afterwards, dining with Yuri Modin in a Moscow restaurant, he collapsed with what seemed to be a heart attack, though it turned out to be too much drink. When he recovered, he was 'very emotional', saying 'he did not want to die in Russia'.[1]

In August Jack Hewit had written to Driberg asking for Burgess's address. In 1956 he had written a rather bitter letter, which he now regretted – 'it's all rather "old hat" now, and I really would like to hear from him again'.[2] James Pope-Hennessy had also tried to make contact through Harold Nicolson, sending a copy of his biography of Queen Mary that Burgess had not acknowledged.

At the beginning of February 1960, hearing Stephen Spender

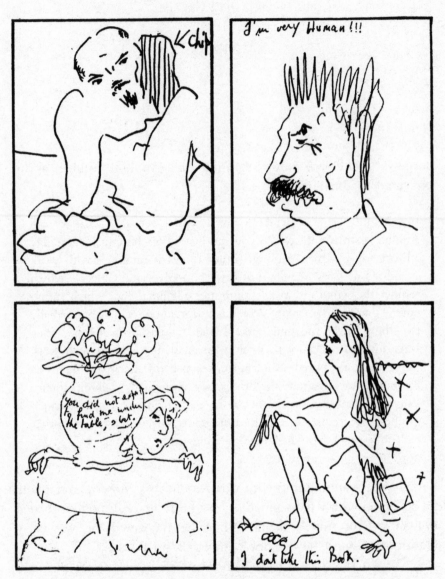

According to psychologist Mayo Wingate these Burgess doodles reveal 'A strong resentment to feminine domination from which the artist was trying to break away . . . a lightly neurotic type . . . it is highly probable that the man who drew these is suffering from a split personality. He has strong leanings towards escapism and there is a rebellious streak in his nature, an eccentric and a fighter but at the same time a shrewd negotiator.'

would be in Moscow, Burgess rang him – at 1.15 a.m. – and they arranged to meet the next morning. Spender was struck by how he had changed:

> ... looked at full-face he was quite like he was before – somewhat florid, the same bright eyes and full mouth. Side-face, he seemed very altered indeed – almost unrecognisable: thickset, chin receding, eyebrows with tufts that shoot out and overhang ... He had a seedy, slightly shame-faced air and a shambling walk, like some ex-consular official you meet in a bar at Singapore and who puzzles you by his references to the days when he knew the great, and helped determine policy.[3]

Burgess was still working for the Foreign Language Publishing House, where he was championing Jane Austen and Anthony Trollope, and the two men discussed books that might be translated. Burgess invited Spender back for lunch, telephoning his cook with gusto, 'We shall lunch off grouse!' As they waited for a taxi, he asked a policeman how to get one that was not pre-empted by Intourist, adding, 'Moscow policemen are sweeties.'[4]

Before lunch the two men walked around the Novodevichy monastery and discussed religion, Burgess claiming to be a non-believer. 'It's the intellectual betrayal involved. Last time I met Christopher [Isherwood] I made him cry by attacking him for his religion.'[5] Then they moved on to treachery. 'Everyone gives away information,' argued Guy. 'When Churchill was in opposition he used to give away confidential information about what the government was thinking to Maisky, then Russian ambassador ... during the war, there were frequent exchanges of information between the British and the Russians, in which the rules of secrecy were more or less ignored, or considered to be suspended.'[6]

Spender was struck by the extent to which Burgess had reinvented the past in his mind. He asked him whether he had made friends in Moscow and Burgess replied in the affirmative. 'Are they like your friends in England?' 'No one has friends anywhere like they have in England. That's the thing about England.'[7]

Graham Greene also saw him and later remembered, 'I don't know why he particularly wished to see me as I didn't like him, I was

leaving early the next morning, and I had begun a serious attack of pneumonia. However, curiosity won, and I asked him for a drink. He drove away my very nice translator, saying that he wished to be alone with me, but the only thing that he asked of me was to thank Harold Nicolson for a letter and on my return to give Baroness Budberg a bottle of gin!'[8] Burgess later admitted to Harold Nicolson, 'I fear I behaved inconsiderately and tried him and exhausted him by keeping him up – the temptations of parish-pump gossip were too great.'[9]

The theatre director Joan Littlewood was another visitor, bringing some requested curry powder when Theatre Workshop went to Moscow. She remembered how 'Guy Burgess was always phoning my home at Blackheath, because my friend Tom Driberg was staying with me and Guy adored gossip about politicians. He missed London terribly . . . Tom told me how Guy's eyes filled with tears as he talked about home. He asked Tom to help him get back, apart from anything else he wanted to see his mother, who was old and not well. Tom tried but didn't succeed. Guy was no spy . . . He didn't know the final destination when he set out.'[10]

When in August 1960 the journalist James, later Jan, Morris came to report the trial of the American pilot, Gary Powers, whose spy plane had been shot down over the Ukraine, Burgess contacted him and the two had champagne and caviar in Morris's room at the Hotel Metropol. Morris felt 'sorry for the poor wretch, whose Foreign Office elegance was by then running to fat, whose manners had become a little gross, but whose humour was still entertaining'.[11]

Morris wrote later, 'He was sent the *Guardian* by mail from England, and was chiefly anxious to talk about everyday affairs at home – new books, teddy boys, changing tastes, and politics . . . He gave me the impression that, for all his almost hearty air of assurance, his whole life had collapsed around him, and that nobody really much wanted him, either there or here. I couldn't help feeling sorry for him, for he seemed almost a parody of a broken man.'[12]

When Morris said he had to go as he had a ticket for the Bolshoi, Burgess said he'd come along as well. He knew the management well and there was bound to be a spare ticket. 'We walked through the snow to the theatre, and in the lobby I left him to deposit my

coat and galoshes in the cloakroom – "quite all right, old boy," he said (for he spoke in a dated vernacular), "I'll just fix it up with the manager and meet you here."' When Morris returned Burgess had disappeared. 'Had some secret policeman spotted him and warned him off? Had he decided that I was not the kind to be photographed in compromising positions at orgies? Was he simply not so well in at the Bolshoi as he had implied? I don't know. I never saw him again.'[13]

Burgess had known the painter Derek Hill through the Reform Club and Anthony Blunt, and had gone on holiday with him, Andrew Revai and Peter Pollock to Ascona in 1947. Hill had become one of Burgess's correspondents. Hill now paid Burgess an unexpected visit in the summer of 1960, bringing some 'He-Tan' for Tolya and pyjamas for Burgess, which he passed on to Tolya. 'The pyjamas you brought for me fitted him perfectly and were the centre of attention on the rather grand beach of the sanatorium of the Council of Ministers at Sochi where I stayed. He in town lodgings and commuting in salmon-coloured Van Heusen pyjamas with a beige face on a bus to the beach.'[14]

Another visitor, with his wife, the painter Mary Fedden, was the artist Julian Trevelyan, who had been a contemporary at Trinity. As they arrived by boat in Leningrad, a man handed them a small piece of folded paper that read: 'Come and see me the moment you reach Moscow. Guy Burgess'. 'And every day we were in Moscow, we saw him, because he was so eager to talk to English people, and people from home, and he was very homesick, longed to come home, but knew that he would go to prison if he did,' remembered Fedden. They, too, went with him to the Novodevichy monastery, where it was clear he knew the clergy well, and on a picnic with him and several Russian artists, bathing in the Moscow River.[15]

Frederick Ashton, on the Royal Ballet's first visit to Russia in June 1961, was keen to meet his old wartime friend from the Café Royal – 'I liked him very much . . . He was fun and lively' – and Burgess 'sent a message to me somehow to come and see him', but the British embassy refused to let them meet.[16]

Also in Moscow in the summer of 1961 was 'Brian', a recent Cambridge graduate and gifted linguist working for the Foreign

Office, who had obtained an introduction to Burgess from Tom Driberg. He recalled that Burgess's 'cut-glass accent is blunted; the midriff and jaw-line not what they were; no hand tremor though; a slightly lumbering gait; an ill-fitting suit that speaks more of Red Square than Savile Row (whence he had, at some point, ordered several suits). The charm and wit are still very much there along, rather flatteringly, with a distinctly proactive interest in me and my doings, and an almost childlike hunger for first-hand news of London and, indeed, of *anything* British', but what most struck Brian was Burgess's emotional intelligence. 'After several meetings,' he said, 'Burgess struck me as lonesome, emotional and with a dispropor- tionately strong urge to help me.'

Soon after visiting him, Brian found himself in need of such help, after being caught in a homosexual honeytrap whilst on holiday in Sochi. He was threatened with prison or becoming an informer. Knowing no one he could turn to and terrified by the implications for his career, he approached Burgess, who immediately swung into action with calls to various Soviet officials.

'Indeed, Guy must have moved heaven and earth to help me as he had finally prevailed on a top Soviet mandarin to abandon his holiday, return to Moscow and meet me in his dustsheet-covered apartment.' Brian heard no more from anyone and went on to have a distinguished career as a journalist.

'I think Guy Burgess was very conflicted. He certainly saved me from a show trial. In saving me I wondered if he was making amends for his treachery. I gave him a cause and arguably he saw me as an act of redemption.'[17]

Burgess's sympathies may have been triggered by his own experi- ence early on in Russia. Modin recounts that when Burgess was 'vacationing on the Black Sea in Sochi, he had an incident when he was propositioning a man and he was placed under arrest by the militia . . . It was very hard for him.'[18]

That Christmas 1960, Burgess asked Driberg whether he should offer himself as the Moscow correspondent of *Reynold's News*:

I am not a journalist but I do know more than many other journal- ists do and certainly more than Embassy . . . Tolya has got a good new job – organising and playing in concerts in a big factory. He's

very happy 'living among real workers'. And I continue to be v. happy with him. I don't know what saint in yr calendar to thank. Perhaps only Greek Church, or Armenian, has such a saint. I do wish you were similarly suited. It's the best thing. Politically, I congratulate you on being both brave, truthful and prudent. I am only the first two.[19]

May Harper, whose husband Stephen had come out as Moscow correspondent of the *Daily Express* in 1961, remembers meeting Burgess at her engagement party given by the Burchetts. She felt sorry for Burgess. 'He was pathetic, a maudlin drunk with food spilt down his suit and tie. He looked ill – flabby and pasty. What I remember most vividly is his slack mouth and the weaselly-looking Russian who came with him. Victor must have been twenty years younger and looked evil.'[20]

In the last six months of Harper's posting, Burgess regularly rang him when he knew his Russian lesson finished. 'For some reason, probably because he was homesick, he used to ring me almost every morning precisely at 10 o'clock for a long chat, mainly about the dirt he knew about Lord Beaverbrook.'[21]

A new confidant was Jeremy Wolfenden, who had been sent to Moscow by the *Telegraph* in April 1961. Wolfenden, whose father chaired the commission which legalised homosexuality in 1967, was some twenty years younger than Burgess, but they immediately became close friends. Wolfenden had been the top scholar at Eton and gained a history scholarship to Oxford, where he had taken a First in PPE and been a Fellow of All Souls. He shared Burgess's Eton schooling, homosexuality, love of conversation, talent as a mimic, preference for alcohol over food, left-wing politics, intellectual arrogance, and desire to *épater le bourgeois*.

What Burgess didn't know was that they had more than that in common. Wolfenden was a double agent, an MI6 informant who had been photographed in a homosexual honeytrap – Wolfenden professed to be so delighted with the pictures that he requested enlargements – and was being blackmailed by the Russians. When Burgess decided to give an interview, it was to Wolfenden. 'In his own disreputable way, Guy Burgess is very amusing,' Wolfenden wrote, 'but he has to be taken in small quantities . . . apart from anything else, to spend 48 hours with him would involve being

drunk for at least 47. He has a totally bizarre, and often completely perverse [idea] of the way in which the outside world works; but he makes up for this with a whole range of very funny, though libellous and patently untrue, stories about Isaiah Berlin, Maurice Bowra and Wystan Auden.'[22]

Journalist Ian McDougall saw this odd behaviour when he and the *Observer* correspondent Nora Beloff entertained Burgess at a private room in the National Hotel. Burgess arrived drunk and during the course of the meal became steadily drunker, until half-way through dinner he:

> unceremoniously removed his shirt, complaining of the heat – it was a Moscow July at its sultriest – and revealed a very hairy chest. My guess is that he would have done the same even if we had been eating in the public dining-room. We had a long argument about, of all things, religion. He knew a great deal about the history of the Papacy, and I formed the strong impression that his communism, as is often the case with a certain type of intellectual, was one facet of a deep religious instinct . . . I also formed the impression that, if he had not consistently drunk so much, Guy Burgess would have been an outstandingly intelligent man, and that the early image he was given in the press – that of a sidekick to Maclean – was probably the reverse of the actual relationship between them.

To the two journalists, he claimed he was working for Russian radio and television studios monitoring British broadcasts.[23]

Nora Beloff had first met Burgess through a letter of introduction from the Soviet commentator Edward Crankshaw. Burgess had promptly rung her and invited her to his flat. 'Burgess was a flabby, shabby man with badly broken teeth . . . He met me with an endearing smile and disarming candour. "You will have heard that I normally prefer boys," he said, "but I will make an exception in your case."' They met 'fairly frequently' and Beloff joined him for a holiday in Sochi, where she even danced with him. 'He gave me a few basic tips about how to treat the bureaucracy – for instance, to bang your fist on the table and outshout them. Later, when he used to come to visit me, and we ordered meals in my Intourist suite at the National Hotel, he would storm at the servants until we got adequate service.'[24]

Norman Dombey, an exchange graduate student at Moscow State University in the autumn of 1962, was introduced to Burgess through Jeremy Wolfenden, with whom he had been at Magdalen College. He visited Burgess at his flat, which he thought large by Soviet standards, noting that with the exception of the guards at the entrance, 'The flat could have been in Chelsea. There was a pile of *New Statesman*. He had subscriptions to various British papers. Burgess looked to me like a Western intellectual.' He found him well-informed on British politics and the two men talked about the failures of Soviet communism and how the Chinese model was better, and Burgess lent him Joseph Needham's *Science and Civilisation in China*. He also remembered how Burgess spoke a lot about his mother, but an attempt to meet again had to be cancelled because Burgess was ill.[25]

A regime of little food and excessive alcohol had taken its toll on Burgess's health. In the spring of 1960 he had spent time in a sanatorium in the park of Prince Youssopoff's Archangelsk Palace just outside Moscow, being treated for arteriosclerosis, ulcers and arthritis.[26] He wrote to Nicolson, 'The house itself which resembles Chiswick and Osterley and might have been built by the brothers Adams . . . is a museum full of Herbert Roberts but one good Titian, one very good Tintoretto.'[27]

During the summer of 1961 he had two operations for his ulcer and in October he was hospitalised for hardening of the arteries, quipping, 'I think it was Churchill who said nobody does any good work who has not had hardening of the arteries at 40 or 50.'[28] The next month he almost died.

41

'I'm a communist, of course, but I'm a British communist, and I *hate* Russia!'

In November 1961 Burgess's stepfather John Bassett died. It had never been a good relationship – the two men were too different and Burgess was jealous of another man in his mother's life – but it created more worries about his mother, herself not in good health. Many of his friends, such as Anthony Blunt, Harold Nicolson and Tom Driberg, took the trouble to visit her and pass on news of her son and she sought out the company of many in his circle.[1]

Rosamond Lehmann recorded in a notebook, 'Mrs Bassett, Guy Burgess's mother came at her own request to see me. Although perfectly "real", she looked and spoke so like a stock uninhibited character-Mum that I had constantly to remind myself that I was not watching her and listening to her speaking her lines in one of those typical West End comedies, sealed off from life. Garrulous, staunch, naïve-shrewd, scatty, naval and military wife and widow . . . Smartly dressed. Brisk and bright.'[2]

Eve told Rosamond how she thought 'Soviet discipline was good for Guy . . . he had drunk too much in the old days' and was drinking less now but that he 'must miss his friends so, and although of course he'd made a lot of new ones they were such a very different type – not what one was accustomed to . . .' Was there any secret behind her round bright light-coloured eyes? Only a child-like sadness, it seemed.[3]

Peter Keen, a freelance magazine photographer, first met Burgess at a party given by Jeremy Wolfenden at the beginning of 1962 and thereafter often saw him at parties 'glass of vodka in one hand and cardboard-filtered cigarette in the other . . . Apart from his "official"

occupation advising the Kremlin on which English literature should be published (Dickens was high on the list), it was also rumoured that he had the responsibility of vetting those visiting correspondents applying for entry visas. If his view was that for political reasons they were undesirable, no permits or visa were issued, so in some respects his contact with the British press was double-edged.'[4]

When Keen mentioned he was just off to a photo-assignment showing Muscovites on vacation at the Black Sea resorts in April, Burgess – off to Sochi himself for a month's holiday – offered to show Keen the sights.

> He would be staying at the sanatorium of the Council of Ministers as an official guest, though his engineer friend would be ensconced in one of the resort's many hotels. We met at my hotel, minus the engineer, where I ordered coffee and he vodka, even though it was only mid-morning . . . We sat for a while on the main promenade just managing to talk above the blaring martial music, interspersed with propaganda messages which came from loudspeakers on poles placed every hundred metres along the sea front.[5]

Keen remembered how 'Burgess smoked continuously without even stopping to eat. He walked energetically, talked enthusiastically' and he talked fondly of his mother, who was too ill to make her yearly visit to him. He asked Keen, whom he hardly knew, if he would 'take photographs of him sitting in a quiet corner in the grounds of the sanatorium, where in the past he would sit with his mother, and send them to her on my return to London' on the understanding that Keen would only release them to the press on Burgess's death.[6]

Burgess's request had been precipitated by rumours that he and Maclean might be passing through Britain or flying to attend a communist conference in Havana. Other newspaper rumours suggested they were heading for the United Arab Republic or Guinea. The authorities were immediately put on alert. Special Branch searched the 7,490 ton Soviet liner *Baltika* as it docked at Tilbury, and Shannon airport was watched. The authorities were in a quandary, as they still did not have sufficient evidence to convict Burgess. Word was put out that should they step on British soil, they would be arrested.

The police picked a day when there was a case with keen press

interest at Bow Street to apply for arrest warrants under Section One of the Official Secrets Act 'on grounds for supposing that Donald Maclean and Guy Burgess may be contemplating leaving or may have left the USSR for some other territory'.[7] To make doubly sure, they then issued a press release. The press were only too happy to oblige with suitably lurid headlines.[8] Independent Television News had a hundred and twenty people working on the story and according to journalist John Miller 'were planning for the first time in British television history, to interrupt broadcasts with live inserts from Amsterdam and Holland'.[9]

In fact, the intelligence leak applied only to Maclean, who was believed to be in Cuba and it was thought might transit in Britain on his flight back to Prague. Burgess's whereabouts were a mystery, the *Daily Express* claiming he had 'been at a convalescent home near Leningrad for the past fortnight. He is under medical supervision because of heart trouble, ulcers and his heavy drinking.'[10]

Stephen Harper called round at Burgess's flat. The black leather upholstered door was answered by Tolya, still in pyjamas, who told him Burgess was at the Black Sea and uncontactable, but he had telephoned the night before 'with instructions to tell callers that he had gone to Cuba or somewhere'.[11]

In fact Burgess had been in Sochi, and rushed back to Moscow, claiming he wanted to set the record straight and not alarm his mother, but he was only too happy with the attention paid him by journalists. Discovering he was at Wolfenden's room in the Ukraine Hotel, Harper sped across town, meeting John Mossman, the *Daily Mail* correspondent, in the lift on the way. Harper would later recall:

> We burst into room 2702 and found Burgess, then aged fifty, sitting on the edge of the bed in stockinged feet, a tumbler of Canadian Club whisky in his hand, and his flies undone. Wolfenden looked surprised and hastily put typewritten sheets into a desk drawer. The jacket of Burgess's Bond Street-tailored suit hung over the back of a chair, with the white ribbon of the Order of the Red Banner in the lapel. It was awarded for services to the Soviet Union, but Burgess joked, 'It shows I support Dynamo football club.'[12]

John Mossman, seeking a fuller interview, was quickly invited to lunch. He found Burgess 'ailing and overweight, tortured by ulcers

and drinking heavily' but 'still in full control of a brilliant mind. He still has a great sense of humour, daringly enough used as frequently against the Russian political bosses as Western politicians.'[13]

Lunch, Mossman remembered, comprised of roast suckling pig served by his elderly housekeeper and was accompanied by so much vodka, whisky and Georgian wine that Burgess 'broke off once or twice to rush to the bathroom to be violently ill. He explained that it was the tension of his life in Moscow that affected his stomach so badly.' Dressed in a shabby and food-stained maroon smoking jacket, Burgess paced up and down the room talking about 'my friend Harold Macmillan' and reminisced about his London clubs – now he 'had to content himself with the Workers Club attached to the Foreign Languages Publishing House' – whilst Tolya (who Mossman remembered as being called Jan) strummed a guitar nearby.

'"Look," said Burgess. "I'm a firm believer in communism, of course, but I don't like the Russian communists. Oh, what a difference it would make if I was living among British communists. They are much nicer, more friendly, people, you know. I'm a foreigner here. They don't understand me on so many matters."' He gave a deep sigh and suddenly changed the subject. He finished the meal 'in ruminative silence, pencilling a brilliant drawing of Stalin on the tablecloth'.[14]

The two men met occasionally, often for lunch in the Moscow hotel where Mossman lived, 'during which he became progressively more drunk'. After one such lunch, Burgess impishly suggested he should crash a French reception at one of Moscow's smartest hotels. Mossman tried to dissuade him, to find on his arrival Burgess in the line-up 'waiting to be introduced to the hostess. When it was his turn, he introduced himself as Lewis Carroll. "You're Guy Burgess," exclaimed the alarmed woman, who was the wife of the Agence France-Presse correspondent. Burgess staggered drunkenly into the room and pretended to urinate in the fireplace.'[15]

Mark Frankland, then the *Observer* correspondent in Moscow, remembered a visit from Burgess in 1962. His 'expression was defiantly louche, challenging me to show alarm, and ready to jeer if I did. The eyes were large and watery, the lips full and moist. A trilby hat and a camel-hair overcoat patterned with stains and cigarette

burns completed the impression of someone got up as Laurence Olivier playing Archie Rice . . .'[16]

Both had been members of the Apostles and they talked about Cambridge and the society. 'It was clear after only a few minutes of our first meeting that he still lived in London in his mind. The airmail edition of *The Times*, which he read each day, and the London political weeklies and BBC broadcasts that supplemented it, were his parish magazines, for he knew most of the British public figures they reported on and many of them had been his friends.'[17] Having given his flurry of interviews, Burgess set off on 24 April for 'Bokhara and Samarkand in the footsteps of Tamerlane (sic) and Genghis Khan'.[18]

On his return, he wrote to Harold Nicolson dismissing the suggestion he had planned to return. 'I had no such intention or plans. Chiefly because any return and any trial which they might have to bring, presumably would cause pain and troubles to dear friends . . . HMG has been <u>as badly advised</u> by the people who once nearly arrested Hilda Matheson as a German spy.' He was saddened that friends, such as James Pope-Hennessy, were no longer writing to him and ended wistfully, 'I should love to see you and them in Albany.'[19]

What the press hadn't realised was how ill Burgess was. On Easter Monday 23 April he wrote a letter with his last wishes to Esther Whitfield:

Anything may happen at any operation. If anything happens to me – it's 99% against – I've sent this plan since everyone makes muddles and puts things off. There should be a balance to my account at Lloyds Bank, St James's Street, and Montreal Trust Company, St James's Square, but owing to me. It won't be much. But as a souvenir want to send a quarter each of total to these four – a quarter each to:

1. Sir Anthony Blunt
2. Miss Esther Whitfield
3. Tollya [*sic*] Borisovich Chishekov – Russian name and address is below
4. Kim Philby

If 1, 2 or 4 don't want this, send his/her share to Tollya [*sic*] . . . Mummy I'm sure would like her sofa table as a family thing to go to Nigel, which I have arranged. Other furniture, books, clothes here

also disposed here – some books to nephews. Russian dining set to a Russian is arranged. Not family & it should stay here. Aunt Peggie's White Russian loot. Sorry brother. Guy not a worry really.[20]

His old friend from West Meon and Eton, William Seymour, on a visit to Moscow as part of a United Nations delegation in 1962, 'saw quite a bit of him in the three weeks I was there, and he was most helpful. I remember his mother had given me some socks to take to him.' They talked about British politics, Burgess offered to fix him up with some good fishing and before he left 'instructed his housekeeper to buy me two kilos of the best caviar not then on sale to tourists . . . There was much to like about Guy, and I enjoyed his company when I was in Russia.' The two continued to correspond afterwards.[21]

The art historian Francis Haskell, in Moscow to bring back to London his future wife Larissa, a curator at the Hermitage, was invited by a friend to a party to celebrate Burgess's birthday. He remembered an evening talking about the past – Haskell was also an Apostle – and books. To Haskell, seventeen years younger than Burgess, he appeared 'like a figure from P.G. Wodehouse' but also 'cultivated and intelligent'. He took up an invitation to lunch at Burgess's flat – guinea fowl cooked by the housekeeper – where he told Haskell he wished to be buried in the Novodevichy cemetery.[22]

Increasingly, however, Burgess became more and more drunk, until he suddenly said "'Of course we're bugged in here. I know where it is," shouted Burgess, and he pointed, "It's up in that corner," and shook his fist at the invisible bug. "I *hate Russia*. I simply *loathe* Russia. I'm a communist, of course, but I'm a British communist, and I *hate* Russia!"'[23]

Burgess was not welcome at the British embassy and the embassy staff were told to avoid him, so he tended to socialise with a mixed bag of expatriates, many of whom were keen on 'baking cakes, making jams and cordials and selling old English memorabilia'. The sports writer and novelist Jim Riordan, studying in Moscow that year, remembered Burgess would often pop in to the *Daily Worker* bazaars to raise money for its 'Fighting Fund' held in the flat of the

translator Hilda Perham, 'hoping for a jar of home-made marmalade or his favourite seed cake'.[24]

Riordan met Burgess several times either at funeral wakes for British communists or in his flat, where he 'delighted in showing off a whole drawer full of Old Etonian bow ties and the tailor's tag on his bespoke suits from Eton High Street'. Discovering Riordan came from Portsmouth, Burgess 'reminisced about the "sailorboys" he'd known, the nights he'd spent with them at the Keppel's Head Hotel down by the Hard, and his sexual activities in the Queen Street red-light district'. Riordan's abiding memory, however, was of the smell of 'alcohol and tobacco intermingled with garlic and cloves, which he would pop into his mouth from a side pocket as if he were chewing gum'.[25]

What must be one of the strangest sporting events to have been held in Moscow took place that summer – a cricket match organised by Donald Maclean, who captained an eight-man Gentleman's team against a seven-man Player's, team, captained by the *Daily Worker* correspondent Dennis Ogden, with Burgess as umpire. Melinda Maclean and the other wives prepared a cricket tea of cucumber and caviar sandwiches.

A reasonably flat grassy area, though with the added hazard of cowpats, was found near the dacha of another member of the expatriate community, the translator and former British diplomat Robert Dagleish. Although a man short, the Players won with fifty-four runs and one wicket to spare, helped by the 'runs scored by a former American spy who adopted a baseball stance' – much to Maclean's chagrin.[26]

That summer the journalist Erik da Mauny visited Burgess to discover if he knew the whereabouts of Kim Philby, who hadn't been seen since his disappearance from Beirut in January. Let in to the book-cluttered flat by Burgess's grey-haired and rather motherly housekeeper, Nadezhda, Mauny found Burgess lying on a Victorian chaise-longue, wearing pyjamas and a stained, dark-blue silk dressing-gown:

His face was puffy, with a greyish tinge like liver paste, but he had managed to preserve a sort of ravaged jauntiness; there was even a

weary seigneurial quality in the gesture with which he invited me to pull up a chair. We might have been meeting for sherry in the rooms of an Oxford college, except for the hash reek of Russian tobacco, under which lay a mustier, sickroom smell, accentuated somehow by the bright sunshine beyond the closed windows. It was Burgess's conversation, however, that produced the strange effect of a complete throwback to an earlier period before his dramatic disappearance with Maclean. All those years in Moscow seemed to have washed over him without a trace; I had the impression that he had remained totally unassimilated into Russian life.[27]

Burgess claimed to have no knowledge of Philby's whereabouts. The two men shared a bottle of Hungarian brandy and reminisced about mutual friends in London, Burgess twice letting a bowl of chicken broth brought by his housekeeper go cold, preferring instead to chain-smoke.

During the summer of 1963 Burgess stayed in his flat, lying on a chaise-longue in pyjamas and dressing-gown, smoking up to sixty cigarettes a day – and drinking Armenian brandy or Scotch, which he ordered by the case. A nurse visited him several times a day to give him injections in his backside. Once, when she failed to turn up, Burgess asked John Miller: "'I say, old boy, would you give me an injection?" "Where?" I asked, suspecting trouble. "In the bum, of course, where I am badly pricked."'[28]

On 20 August he was admitted to a special third-floor general ward for heart cases at the Botkin hospital with an advanced case of arteriosclerosis – the disease that had killed his father some forty years earlier. It was there he died in his sleep at 6 a.m. on Friday 30 August of acute liver failure. He was fifty-two.

The only coverage in Russia was a seventy-eight-word obituary on page four of *Izvestia*, but his death created headlines around the world, including a television interview with Tom Driberg that had been made the previous year. Blunt was staying with John Golding in the south of Italy when he received news of the death and Golding remembered how he 'was transparently moved and distressed by it'.[29]

According to the Russian authors Yuri Modin and Genrikh Borovik, Burgess had not seen Kim Philby in Moscow – either they had been kept apart by the Russian authorities or Philby had refused

to see him. According to Modin, 'He could never forgive Burgess for defecting with Maclean. He regarded him as an out-and-out traitor, who had broken his word in the full knowledge that by doing so he was leaving a friend in desperate danger.'[30]

But Philby's third wife, Eleanor, says they did meet 'briefly as he lay dying in hospital', as does his biographer Patrick Seale. The KGB general Sergei Kondrashev confirms it, but in a final irony, the two men, whose lives had been so entangled and who had given up everything to go into exile, found they had 'grown apart'. According to Kondrashev, Burgess 'was conscious of the fact he had put suspicion on Philby'.[31]

Eve, now in her late seventies, was too ill to attend the funeral, so Nigel went alone. When Nigel was buying his ticket to Moscow at Thomas Cook's, the clerk paused for a moment after he gave his name. 'Will that be a single or a return?'

Burgess's funeral was held on a warm September morning – Wednesday 4 September – at the Donskoi Crematorium, a ghoulish 1930s hall notable for the number of urns and plaques around the walls dedicated to former members of the Soviet Secret police who had died on duty. It was attended by just over a dozen people including Donald and Melinda Maclean, the ever-faithful housekeeper Nadezhda Petrovna, journalists such as John Miller and Richard Hughes, colleagues from the Foreign Languages Publishing House, and some Soviet intelligence officers, including Modin. Philby was told not to attend because of the presence of journalists. There were also a few members of the expatriate community such as Archie Johnstone, a former editor of *British Ally*, the British propaganda newspaper in Russia, Ralph Parker, a former Moscow correspondent of *The Times*, and Len Wincott, who had been involved in the 1931 Invergordon Mutiny in the Royal Navy.[32]

Burgess's body in a black coffin draped in red crepe, and with an artificial orchid atop, was brought to the crematorium in a blue van and then carried into the building by six pallbearers, including Donald Maclean, Nigel Burgess and Jeremy Wolfenden, to the accompaniment of Bach's 'Air on a G String'. Three six-foot-high wreaths of irises, roses and chrysanthemums were then placed by the coffin. One was labelled, 'To Guy from his British friends', and another in

Russian was from the Foreign Languages Publishing House. Georgy Stritsenko from the Publishing House gave a short speech about his former colleague Jim Andreyevitch, followed by one from Maclean, describing Guy Burgess as 'a gifted and courageous man who devoted his life to the cause of making a better world'. Then, after a two-minute silence, broken only by the weeping of Nadezhda, as the one body with two names disappeared through the crematorium doors, the whole of the Moscow Silver Band emerged from behind pillars where they had been lurking and started playing 'The Internationale'. The whole service had lasted seventeen minutes. Maclean then stood by the door like a country vicar, shaking hands and thanking each mourner for coming.[33]

After Burgess's death, the KGB cleared his flat of all his papers, including a manuscript memoir, letting the family take only a few sentimental effects.[34] Tolya disappeared, never to be heard of again. Nigel remembered how 'I brought back one or two books – that table, that funny inkstand and that's really all – his pianola I gave to his daily – an absolutely terrifying lady of enormous size who promoted herself into a wailer – they have wailers at funerals. She made a noise like a steam engine. She had the pianola.'

Burgess had left no will, but the instructions in his letter of intent sent to Esther Whitfield at Easter 1962 were followed. The £6,222 in his British account was left to Nigel,[35] but Philby's £2,000 proved to be a financial headache, as it had been gifted when Philby was in Beirut and not Russia. The Treasury looked at whether 'The Third Man' might at least be in breach of the Exchange Control Act if the monies were transferred to his account in Russia, as technically he was still a UK resident for exchange control purposes.[36]

Burgess also left him a dressing table, portable organ, plum-coloured wing armchair, carved bedhead, his clothes – he was about the same size – and many of his books. Eleanor Philby took a fancy to a Paul Klee print that had hung in the bathroom.[37] Though Maclean had helped Nigel deal with Muscovite bureaucracy after the death, Burgess and Maclean had never been close in life and had seen little of each other since coming to Moscow. To the man with whose name he has indubitably become linked, but whose association was only fleeting, Burgess left nothing.[38]

42

Summing Up

I find it hard to drum up any patriotic indignation over Burgess or Blunt, or even Philby. No one has ever shown that Burgess did much harm, except to make fools of people in high places. Because he made jokes, scenes and most of all, passes, the general consensus is that he was rather silly.[1]

Alan Bennett, introduction, *Single Spies and Talking Heads.*

In October 1955, a damage assessment memorandum for the Joint Chiefs of Staff concluded that:

(a) Burgess and Maclean were Soviet agents for many years prior to their defection. They were apparently protected from exposure and dismissal for a long time by other highly placed officials of the British government, particularly the Foreign Office.

(b) Maclean had access to practically all high-level plans and policy information that were Joint US/UK/Canada projects. As Code Room Supervisor, he naturally had access to all the UK diplomatic codes and ciphers as well as the opportunity to scan all incoming and outgoing communications.

(c) In the fields of US/UK/Canada planning on Atomic Energy, US/UK postwar planning and policy in Europe and all by-product information up to the date of defection undoubtedly reached Soviet hands. Probably via the Soviet embassy in London.

d) All UK and possibly some US diplomatic codes and ciphers in existence prior to 25 May 1951 are in possession of the Soviets and of no further use.

Insofar as US security implications are concerned it would appear that very nearly all US/UK high level planning information prior to 25 May 1951 must be considered compromised . . . It may be more appropriate to assume total compromise as of the defection date.[2]

Maclean's devastating impact is clear but Burgess's treachery is less apparent. The following year the Senate sub-committee on Internal Security looked again at the Burgess and Maclean case. They interviewed many of the key participants, including Maclean's sister Harriet Sheers, looking, in particular, at whether either diplomat had affected the war in Korea through their revelations.

A note from the State Department, as part of the evidence, concluded, 'The Department has also failed to bring to light any information which would justify it in stating that developments affecting the security of the United States could be traced to Burgess during the period of approximately nine months when he served as second secretary of the British Embassy in Washington' and 'There is no information in the Department's records which would indicate that Burgess, in his position in the Far Eastern Department of the British Foreign Office in 1948, furnished information valuable to the Chinese communists and injurious to the United States.'[3]

We know some of the material that Burgess passed to the Russians, and that it was so extensive that much of it was never even translated – the Russian agent Kislytsin talked about Burgess bringing out suitcases of documents and at one point Burgess requested he be supplied with a suitcase. But we know only what the Russians have chosen to share in authorised books such as *Deadly Illusions* and *The Crown Jewels*, fascinating accounts but which have to be treated carefully as the Russian authorities often had another agenda. There are certainly still shelves of material on the Cambridge Spy Ring that have not been released. What we do know, according to *The Crown Jewels*, is that from 1941 to 1945 Burgess passed 4,604 documents to Moscow Centre.[4] These documents included, amongst much else, telegraphic communications between the Foreign Office and its posts abroad, position papers and minutes of the Cabinet and Chiefs of the Imperial General Staff.

However, even when we know what documentation was taken, we don't know who saw it, when, and what they did with the material. The irony is that the more explosive the material, the less likely it was to be trusted, as Stalin and his cohorts couldn't believe that it wasn't a plant. Also if it didn't fit in with Soviet assumptions,

then it was ignored. Much of the material Burgess supplied, out of practical necessity for security reasons, was oral briefing, which could easily be misinterpreted as it was passed on.

What could Burgess have passed to the Russians? Clearly anything he drafted himself, but also anything that came across his desk or he asked to see. In particular, as Hector McNeil's private secretary and as a Far East expert, he would have seen very important and secret documents, especially crucial during the Four Powers conferences, when the British negotiating position would have been known to the Soviets during the conferences themselves. He was known to work late and at weekends and had access to secret safes, but even plain texts of enciphered cables were useful for code-breaking efforts. We can certainly surmise that he passed across information about the post-war peace conferences and founding meetings of the United Nations, NATO and OECD, plans for the reconstruction of post-war Germany and the immediate negotiating positions at conferences such as that creating the Brussels Treaty.

Guy Burgess was also a magnificent manipulator of people and trader in gossip. He was highly social and almost always out at dinners and night clubs – usually paid for on expenses or by others. In the Foreign Office, he is remembered for always attending the group tea at 4 p.m. and popping in and out of other people's offices. He knew how to extract material through charm, provocation, his own powers of argument and knowledge and, when required, blackmail. Here was a man who supposedly kept every love letter in case it could be useful and who was happy to lend his flat for assignations. People liked him and confided in him and Burgess took every advantage.

As Goronwy Rees noted, 'Guy possessed an appalling fund of information to the discredit of numerous persons in this country. Collecting it was one of his private hobbies; it was a native instinct in him and it was done primarily, I think, for purposes of gossip and private amusement; but I believe . . . it constitutes a formidable weapon of pressure and blackmail.'[5]

Tom Wylie, Dennis Proctor and Fred Warner may not have been Soviet agents, but they might as well have been as they showed Burgess the interesting papers that crossed their desk. One can only

speculate at the information he may have gleaned from his friends in intelligence, Guy Liddell and David Footman, on their weekly visits to the music hall. And there was always the excuse at various moments that Burgess was working in the cause of anti-fascism, that Russia were our allies, or it was for some hush-hush British organisation.

Apart from actual documents, he could provide lists of agents when he worked for MI6 and MI5, he could interpret policy and human nature, and he could provide insights into character that might allow others to exert pressure on a particular individual.

Rees later wrote:

> The very existence of a secret service was for Guy a challenge to curiosity and certainly he showed a persistent determination to penetrate its secrets which had nothing to do with his official duties. It is quite certain that during the period after the war, both in London and in Washington, he acquired a remarkable knowledge for one in his position, both of the personalities and of the working of the security services . . . What is difficult to exaggerate is the amount of information which he had acquired about the machinery and methods of our security services, their organisation, and the names and positions of those who worked in them.[6]

Indeed the very word 'secret' was like a call to battle for Burgess, a challenge that he never failed to accept; he hunted out secrets like a hound after truffles.

He was also an agent of influence, most notably in the BBC and during his time on Far East affairs, where he helped shape British policy to recognise Communist China when America refused to, but also later in Moscow working on Soviet disinformation. Then there were all the agents he was responsible for recruiting – Anthony Blunt, John Cairncross, Michael Straight – and the agents they in turn had recruited and all the information they supplied to the Russians. And these are just the agents we know about.

One of the most damaging legacies was the defection itself, which undermined Anglo-American intelligence co-operation at least until 1955, and public respect for the institutions of government, including

Parliament and the Foreign Office. It also bequeathed a culture of suspicion and mistrust within the Security Services that was still being played out half a century after the 1951 flight.

Guy Liddell retired from MI5 in 1953, aged sixty-one, having never made Director General. Though guilty only of a friendship with Burgess, he continues to be accused of being a Russian agent. David Footman moved in the same year to a fellowship at St Antony's College, Oxford. Esther Whitfield's service was terminated in 1951, though MI5 accepted she was not responsible for the leak. She had a series of jobs emigrating first to Rhodesia, where she worked for Rio Tinto, and then Spain, and never married. Alan Maclean was forced to resign from the Foreign Office and became a publisher. Fred Warner's career stalled for a time, though he eventually became ambassador to Japan.

Milo Talbot became the temporary head of the Foreign Office Security Department in July 1953, but six months later abruptly resigned. He served briefly as consul-general and then ambassador in Laos, until taking early retirement in May 1956. He died in mysterious circumstances, aged sixty, and his papers were destroyed. Many of Burgess's circle, such as Victor Rothschild and Dennis Proctor, remained under suspicion. Anthony Blunt, in return for immunity, only confessed in 1964, but was not publicly revealed until 1979. John Cairncross was also exposed that year, having been allowed by MI5 to move abroad in 1952.

Burgess was the first of the Cambridge Spies to die and history has not been kind to him, with a succession of books depicting him as some sort of tragic-comic figure, who achieved very little, but to the intelligence professionals he is seen as the major figure in the group. Yuri Modin was later to write '. . . the real leader was Burgess. He held the group together, infused it with his energy and led it into battle, so to speak. In the 1930s, at the very start, it was he who took the initiatives and the risks, dragging the others along in his wake. He was the moral leader of the group', adding, 'He was the most outstanding and educated among all the five.'[7]

Sergei Kondrashev, a KGB general who worked with Burgess on disinformation measures, agreed. Asked who was the most important

of the Cambridge Spies, he immediately replied, 'Burgess. Definitely.'[8] It's been assumed that Burgess's most damaging period was the four years he spent in the inner sanctum of the Foreign Office, as private secretary to the deputy Foreign Secretary, but Kondrashev revealed that in Russian eyes, 'One of the most important periods of his service was just before the German War', when Burgess was acting as middleman between the British and French in the crucial days immediately preceding the Second World War.[9]

It's a view shared by the doyen of spy writers, Nigel West. 'Anthony told me that Guy Burgess was the genius in the network, the key man. He was the person everybody had to go to for instruction, help and advice. Guy was always in touch with the Russians and could make decisions and could counsel other people.'[10]

The question that continues to baffle writers and intelligence professionals alike is why did Burgess do it? Why did he agree to work for a foreign power, of which he knew little, as a student, and continue to serve it until his death some thirty years later? Why did this apparently most British of figures leave behind all the things he most cherished, such as the Reform Club, gossip, his circle of lovers and friends, and his mother, to whom he was devoted, for a lonely exile in Stalinist Russia?

Burgess was a product of his generation. Born a few years earlier or later, his life would have taken a very different course, but he came from a generation politicised during the early 1930s that felt it needed to stop theorising and do something, even if this call to action took many forms and led few to beat a path to Moscow. David Haden Guest went to work with the young Communist League in Battersea, and John Cornford to serve the party among the Birmingham working-class, before both died in the Spanish Civil War. Maurice Cornforth gave up philosophy to become an agricultural organiser in East Anglia, whilst many, such as Eric Hobsbawm, became communist intellectuals.

For Burgess, serving the Communist Party in Battersea or Birmingham was less attractive than trying to shape political events at the highest level. It played back to his school-day fascination with Alfred Mahan theories of great power blocs and Marxist teachings. Burgess needed a moral purpose, to do something positive in the

struggle against fascism, and at a vulnerable point in his life, the Russians provided the opportunity.

Writing to Harold Nicolson in 1962, he quoted Stendhal's 'The Pistol Shot in the Theatre' on the importance of timing in shaping political and personal decisions:

> You were born too early to be hit by this at the age at which one acts, & the intelligentsia of the 40s and 50s were both too late. I was of the generation of the pistol shot in the 30s. I notice the intellectuals of the 60s, the young at Aldermaston, have again been hit by the continuing fusillade. I notice this with pleasure, one greets others getting into the same boat; and with sorrow that they don't know how rough the crossing is.[11]

He refused to believe that his God had failed him, as it had Koestler, Spender and the other fellow travellers. Like Catholics in the reign of Elizabeth working for the victory of Spain, or indeed the sleepers of Islam now, there was a certainty in the correctness of the choice. It was, as Graham Greene would write of Philby, 'the logical fanaticism of a man who, having once found a faith, is not going to lose it because of the injustices or cruelties inflicted by erring human instruments'.[12]

Burgess was guided by a strong sense of history, which he then misread. Goronwy Rees would write, 'The truth is that Guy, in his sober moments, had a power of historical generalisation which is one of the rarest intellectual faculties, and which gave conversation with him on political subjects a unique charm and fascination. It was a power which was, I think, completely native and instinctive to him. It might have made him a great historian; instead it made him a communist.'[13]

Just as the nineteenth century had belonged to the British Empire, Burgess felt the twentieth century would belong to Russia. George Weidenfeld, at one of Baroness Budberg's drinks parties, remembered how Burgess accused him of 'sitting on the fence' by supporting a pro-European policy for Britain. 'There is no such thing as a European policy,' he pontificated. 'You've either got to choose America or Russia. People may have their own view which to choose, but Europe is something wishy-washy that simply does not exist.'[14]

In Graham Greene's *The Confidential Agent* a character says, 'You choose your side once and for all – of course, it may be the wrong side. Only history can tell that.'[15] The same can be said of Burgess.

No account of Burgess's life can be written without an understanding of the intellectual maelstrom of the 1930s, especially amongst the young and impressionable. In *An Englishman Abroad*, Burgess is asked why he became a spy. 'At the time it seemed the right thing to do,' he replied. For Burgess and others, their conversion had strong political roots, but most fellow members of the Cambridge cells did not spy for the Russians and indeed lost their communist fervour in 1939 with the Nazi-Soviet Pact, in 1956 with the invasion of Hungary, or simply because they had to get on with the business of earning a living.

So why did Burgess stay the course? Partly because, having picked his football team, he loyally stuck with them through thick and thin, capable of all sorts of intellectual somersaults to keep in step with the changing situation. He stayed because he was flattered to feel he did have a real chance to affect events and from a perverted form of imperialism, that having witnessed the death of one empire, he decided to attach himself to another which he felt less materialistic. He also stayed because the Russians wouldn't let him stop and because he actually enjoyed his clandestine role, hunting with both the hare and the hounds.

Burgess was a spoilt child, indulged by his mother and with an absent father – a characteristic of several of the Cambridge Ring – and he had never been given boundaries. His mother, who refused to set them, seemed to be grateful to first Dartmouth and eventually the Soviet Union for so doing. Without a strong moral compass, he was vulnerable to the blandishments of the highly sophisticated Soviet recruitment techniques, which offered excitement and a sense of worth. The Soviets recognised his desire for clandestine danger in his private life, but also his guilt and desire for some sort of redemption, and simply utilised it for their own ends.

The Apostles proved to be fertile recruitment ground, because the society drew men attracted by secrecy, by apparent higher loyalties, and a feeling of superiority. Burgess was perhaps a classic

example of his acquaintance Cyril Connolly's theory of arrested development, a Peter Pan figure who never grew up. Cyril Connolly noted that 'the child whose craving for love is unsatisfied, whose desire for power is thwarted or whose innate sense of justice is warped . . . eventually may try to become a revolutionary or a dictator'.[16] Service to the Soviet Union gave Burgess a cause after he had failed with many of his other ambitions. A sense of purpose, a new beginning after rejection, the opportunity to create a heroic role for himself.

Guy Burgess wanted to be someone and shape events. Knowing he would not make it as a Cambridge don or high-flying mandarin, the role offered by the Russians seemed attractive. Malcom Muggeridge, a shrewd judge of character, reviewing the Tom Driberg biography noted 'the vanity, snobbishness, romanticism, weakness masquerading as defiance, retreat from reality somehow made to seem an advance upon it, which constitute him. One senses the influences which played upon him, the perky, half-baked longing somehow to be someone.'

Part of the fascination with Burgess is his complexity and paradoxes. No figure could have been more British and Establishment with his Eton and Cambridge education, membership of London clubs, expensive clothes, love of British literature, hunting scenes on the walls of his flat, and final wish to be buried in Britain. But this was only one part of him and any analysis of his character and motivation needs to be aware of his second world – with the romance of Russian music and literature and his respect for the ruthlessness of its history and political system.

Spies live double lives, sometimes out of necessity, but generally from choice. Burgess wasn't torn between his various lives; they existed in parallel and even together. Marching with the hunger marchers he wore his Pitt Club scarf and Old Etonian tie, just in case such protective clothing was required. The order of Britain and the wild danger of Russia were simply the yin and yang of his personality.

Burgess was not unaware of the purges in the 1930s, the failure of Collectivisation, the labour camps, and so on. After all, he lectured on the evils of communism at the Foreign Office summer schools

and made his reputation as a British propagandist against the Soviet Union, notably in the Information Research Department. But though an intelligent man, he was also politically naïve – a not uncommon combination – and he simply chose to ignore what did not suit him. Any change, such as the Nazi–Soviet Pact, could instantly be explained away in view of the bigger picture.

He had learnt to compartmentalise his life and feelings as a child and he carried this through into adulthood. Like an actor, he played each part as required, but he was a Janus. To his close friends, and in particular women, he was kind, loyal, stimulating company, a good conversationalist, thoughtful and charming. Miriam Rothschild remembered, 'He had slightly protruding top teeth (like a baby thumb-sucker) which made him youthful-looking and appealing. And he was always in sort of high spirits – like a school girl.'[17] Whilst Rosamond Lehmann felt he 'was not only brilliant, but very affectionate and warm-hearted . . . I was very fond of him.'[18]

Yet from Stanley Christopherson at Lockers Park – 'He wasn't the kind of boy I wanted as a friend. He wasn't quite right' – to over thirty years later, there were those who were repelled by him. Margaret Anstee, a young female colleague in the Foreign Office, thought him 'extremely repulsive. He was rather greasy and dirty. He was always telling awful dirty jokes.'[19]

Brian Sewell, who was eighteen when he met Burgess, remembered 'he had egg on his tie, tobacco of his breath, and wandering hands; I might have been glad of such hands of a boy of my own age, but not his and the accompanying odours – not even the strawberry milk shakes that he was inclined to buy me could compensate for those.'[20] John Waterlow put it simply, 'I don't think Burgess had any real warmth of character.'[21]

Harold Nicolson could see both sides of Burgess's character and his conflicted personality. 'He publicly announced his sympathies with communism and yet he heartily disliked the Russians . . . When Burgess was sober he was charming, jolly, and a magnificent talker. When he was drunk, he drooled foolish nonsense. He was a kind man, and despite his weaknesses, I don't think he could do anything dishonourable or mean. But he was so terribly impetuous.'[22]

You don't want to betray if you belong. It is all relative, but Burgess never felt he belonged. He was the outsider. At Lockers Park the fathers seemed more distinguished, at Eton he resented his failure to make Pop, at Cambridge the Etonians didn't want anything to do with him, in the Foreign Office he wasn't taken as seriously as he would have liked. Small slights grew into larger resentments and betrayal was an easy revenge. Espionage was simply another instrument in his social revolt, another gesture of self-assertion.

His homosexuality could have been a factor in feeling an outsider, but it strangely wasn't, because on that score he felt no sense of shame. Robert Cecil, who knew him, noticed, 'He had no particular wish to change the law on homosexuality; so long as he succeeded in defying it, the risk involved gave an added frisson to his exploits.'[23] And frisson was part of the attraction of first communism and then his spying, which, as one newspaper put it, provided 'a gesture of rebellion, an intellectual excitement; an outlet for his sense of adventure and love of mischief'.[24]

Spies have to be good liars and even fantasists, not least for self-protection, but for Burgess deceit was integral to his life, from his sexual activities to his political allegiances. As Andrew Boyle noted, 'Truth for Guy would always be a moving target, but the ability to dazzle friends and casual acquaintances with the lurid glare of his fantasies consistently prevented them from finding him out.'[25]

Guy Burgess sought power and realising he was unable to achieve that overtly, he chose to do so covertly. He enjoyed intrigue and secrets for they were his currency in exerting power and controlling people. Goronwy Rees recalled, 'He liked to know, or pretend to know, what no one else knew, he liked to surprise one with information about matters that were no concern of his, derived from sources which he could not, or would not, reveal; the trouble was that one could never be sure whether the ultimate source was not his own imagination.'[26]

There was, too, a moral vacuum. His BBC colleague John Green remembered, 'He had literally no principles at all. None at all . . .'[27] For Steven Runciman, 'It was a wasted life. There was a solid core missing . . . épater le bourgeois. That's what really started him off.'[28]

Burgess would, of course, not have seen his life as one of failure,

hypocrisy and deceit. Just as his Huguenot ancestors had chosen to start a new life abroad, he too had put his political principles ahead of his personal wishes. He did not see himself as having betrayed his country, but as a Soviet agent who had nobly served his adopted country.

And yet, at the final reckoning, it was to his childhood home that Stalin's Englishman wanted to be taken.

Guy Burgess in Literature

The Burgess and Maclean story, from the very start, inspired novelists and dramatists. In 1954 Adam de Hegedus, a friend of Burgess writing under the pseudonym Rodney Garland, published *The Troubled Midnight* with the central character Eric Fontanet, who had been at Eton, the BBC and the Washington Embassy, a thinly disguised Burgess. The book is about the mysterious disappearance of two diplomats, narrated by a writer who had known them and was 'able to investigate and interpret their political and emotional pasts from his own special knowledge'. It is full of the sort of insights into Burgess and his circle – Arthur Beaufort is Harold Nicolson, E.M. Forster is C.C. Gallen – which could only come from a close friend. 'Fontanet seemed the type of youth who got away with things because of his personality, charm, good looks . . .' and concludes with the confession that he, Eric, and his fellow spy Alan Lockheed 'are far more valuable than an atomic scientist. We know all the methods of the Foreign Office and the State Department. All the joint plans of England and America. How their policy operates, what are the main points of friction between them. How to drive a wedge between them. Don't you see, our worth is enormous. Science changes, strategy can be altered, but the methods of the Foreign Office must go on for ever.'[1]

Other novels about the pair have included Godfrey Smith's *The Flaw in the Crystal*, Richard Llewellyn's *Mr Hamish Gleave*, *Smith and Jones* by Burgess's Trinity contemporary Nicholas Monsarrat, better known for *The Cruel Sea*, and Michael Dobbs's *Winston's War*, which takes as its starting point the encounter between Churchill and Burgess at Chartwell during the Munich Crisis.[2] David Mure, who had known most of the members of the Cambridge Ring, wrote

The Last Temptation, subtitled 'a novel of treason', which reworks *Alice in Wonderland* suggesting Guy Liddell was a spy, with Burgess as Duchess, Blunt as Red Queen and Philby as Red Knight.

In 1997 two novels appeared centring around Blunt, but in which Burgess made a strong appearance – John Banville's *The Untouchable* and Rufus Gunn's *A Friendship of Convenience*.[3] Burgess has also figured in almost a hundred novels with a walk-on part ranging from Nancy Mitford's *Don't Tell Alfred*, in which a character Hector Dexter meets Burgess and Maclean in Russia – 'When Guy Burgess and Donald Maclean first arrived we all shared a dacha. I cannot say it was a very happy association' – to Terrance Dicks's Doctor Who novel *Endgame*, which has the Doctor sharing a few drinks with Burgess at his Dacha in Moscow.[4]

In the 1970s Goronwy Rees, who had originally been commissioned by Chatto in 1959 to write a novel about Burgess, wrote a screenplay, *Influence*, which was never developed and intercuts events just before and after the flight in 1951, including Rees's interrogations by MI5. The play begins in Dexter Linden's flat in Bond Street, which he shares with an ex-dancer, Derek Morris. The walls are white, the paintwork blue, and the curtain and carpets red, and the bedroom 'peopled with eighteenth-century dolls, battered most of them, and ragged'. He has just returned from America and visits Richard Owens (Rees) and tells him that he had nearly got married. 'There was a nice girl I met. I say girl, she was forty. She was ready to marry me, then Phillips told her I was queer.' Other scenes follow, with him meeting David Rooks (Maclean) at the Foreign Office with Mrs Denning (Mrs Bassett), where they discuss the girl Dexter almost married fifteen years earlier, culminating with Linden and Rooks looking back at Southampton from the decks of their boat bound for France, and a short epilogue that concludes, 'Richard Owens, who lives in London, has received a visit from Her Majesty's Secret Service every week for the past eighteen years. They are still not entirely satisfied with his story.'[5]

The visits to Rees by Burgess after his return from America, and then Blunt following the escape, is the subject of Robin Chapman's play *One of Us*, first staged in February 1986 with Ian Ogilvy as Burgess and Anthony Andrews as Rees. Julian Mitchell's play *Another*

Country, staged in 1982 and filmed two years later, argues that the homosexual Guy Bennett's sense of betrayal and rejection at school fuelled the resentment of authority which led to his recruitment.

Granada's drama *Philby, Burgess and Maclean* (1977) with Derek Jacobi as Burgess, the BBC's 1986 quasi-documentary drama *Blunt* with Ian Richardson as Blunt and Anthony Hopkins as Burgess, and the BBC television mini-series *The Cambridge Spies* (2003) with Tom Hollander as Burgess, maintained the interest. There was even a musical comedy, the Natural Theatre Company's *Spy Society or Burgess, Philby and Maclean (The Musical)*, in which 'Bing Philby, Frank Burgess and Grace (or is it Shirley?) Maclean sing their greatest hits and give away all their secrets (and everyone else's)', and a play taking the form of the 1933 Cambridge Footlights revue *The Iron Curtain Call*.

Snoo Wilson's 2004 Radio 3 play *Hippomania*, about John Betjeman in wartime Dublin, also features Guy Burgess, whilst Ernest Caballero's radio play *On the Rock*, first produced in December 2009, is set at the Rock Hotel, Gibraltar, when Burgess brings Philby a new code. Burgess's role as an intermediary for Joseph Ball and Neville Chamberlain is the subject of John Fletcher's radio play *Sea Change*, first broadcast on Radio 3 at the beginning of 2012, and Michael Dobbs made the encounter with Churchill at Chartwell during the Munich Crisis a central part of his television play *The Turning Point* (2009), starring Benedict Cumberbatch. John Morrison's play *A Morning with Guy Burgess*, first produced in January 2011, is set in 1963 and looks at the nature of belief, loyalty and betrayal after Burgess receives an unexpected visit.

The dramatist Alan Bennett heard the story of Burgess's encounter with Coral Browne and felt it would make a television drama. *An Englishman Abroad* (1989), which is now paired with his 1988 play on Blunt, *A Question of Attribution*, as *Single Spies*, is perhaps the best-known depiction of Burgess.[6]

Notes on Sources

Preface

1. *Spectator*, 4 March 1972.
2. Goronwy Rees Inquiry Papers, GB 0210 GOREEES, UCW Aberystwyth, *A Chapter of Accidents*, original typescript, p. 76.

Prologue: Full Circle: Saturday, 5 October 1963

1. *Daily Express*, 10 October 1963.
2. Rev. John Hurst to the author, 17 September 1996.

1. Beginnings

1. Tom Driberg, *Guy Burgess: A Portrait with Background*, Weidenfeld & Nicolson, 1956, p. 13.
2. Edward Tangye Lean, *The Napoleonists: A Study in Political Disaffection, 1760-1960*, Oxford University Press, 1970, p. 345. They had the right to issue their own banknotes until the family bank was taken over in 1844.
3. He served with the expedition from Aden against the Foodlee Arab Tribe in 1866, took part in the destruction of Shugra in South Yemen in 1867-8, and as a lieutenant colonel led the Burmese Field Force in an expedition against the Dacoyts of Bubnesh in 1887. Retiring as a colonel in 1891, he died in Wales in 1908.
4. ADM 196/46/196. An account of contemporary life on *Britannia* can be found at http://www.pbenyon.plus.com/Commander_RN/Chap_01.html.
5. Malcolm's naval record can be found at ADM 196/46/196 and ADM 196/126/73.

6. ADM/196/46.

7. *Portsmouth Evening News*, 15 March 1904.

8. Navy List, Oct. 1915, p. 394.

9. ADM/196/126.

10. Driberg, p. 83.

11. ADM 196/126/73. In April 1921, Malcolm transferred to HMS *Emperor of India* based in Malta, where he sailed to Constantinople during the Chanak Crisis in September 1921. Again his record was exemplary: 'Capable, keen and zealous officer with good administrative ability.'

12. Nigel Burgess interview, 3 September 1996.

13. His contemporaries included: Lord Elcho, grandson of the Earl of Wemyss; Tom Mitford, brother of the Mitford sisters; Basil Ava, later the 4th Marquess of Dufferin & Ava; Hon. Martin Charteris, later private secretary to the Queen; the future philosopher, Stewart Hampshire; Bob Laycock, later Chief of Combined Operations during the Second World War; the writer, James Lees-Milne; and the future patrons of the arts and letters, Edward James and Peter Watson.

14. Peter Coats, *Of Generals and Gardens*, Weidenfeld & Nicolson, 1976, p. 14.

15. Cherry Hughes Papers, Interview with Nigel Burgess, 21 January 1986.

16. David Leitch, *Guy Burgess*, unpublished manuscript p. 56.

2. Schooldays

1. Cyril Connolly, *Enemies of Promise*, Chapter 20. Connolly's Eton contemporaries included Eric Blair (George Orwell), Steven Runciman, and Dadie Rylands.

2. William O'Brien to the author, 12 March 1999.

3. A contemporary account by another member of the St Vincent term can be found in Ambrose Lampen's *The Gilded Image*, privately published, 1978, and slightly later in C.C. Anderson, *Seagulls in my Belfry*, Pentland Press, 1997.

4. Charles Owen, *Plain Yarns from the Fleet*, Sutton, 1997, p. 34.

5. William O'Brien to the author, 9 March 1999.

6. Owen, p. 34.

7. Ambrose Lampen, *The Gilded Image*, privately published, 1978, p. 49.

8. Arthur Hazlett to the author, undated letter, 1999.

9. Driberg, p. 13.

10. Creagh-Osborne to the author, 24 March 1999.

11. Lampen, p. 52.

12. A picture of Dartmouth at the time – he joined in January 1927 – can be found in John Hayes, *Face the Music*, Pentland Press, 1991, pp. 27-39.
13. Leitch, p. 69.
14. Interview with Bernard Ward, 21 March 1999.
15 Nigel Tangye, *Facing the Sea*, William Kimber, 1974, p.101
16 ibid pp101-102
17. Robin Tonks to Andrew Boyle, 10 October 1978, Boyle Papers.
18. Captain John Gower, letter to the author, 12 March 1999.
19. Captain M.C. Creagh-Osborne, letter to the author, 24 March 1999.
20. Sir David Tibbits phone call, 12 March 1999, and Tibbitts letter to the author, 10 March 1999.
21. Captain St John phone call, 16 March 1999.
22. John Carmalt-Jones phone call, 16 March 1999.
23. Sir David Tibbitts letter to the author, 10 March 1999. David Buchanan-Dunlop, who had the next bed to Burgess, 'did not like him, he had beautiful blue eyes and used to hypnotise younger naval cadets!', Sir John Leslie to Celia Lee, 21 December 2005. A contemporary in the St Vincent term, a doctor at a famous London hospital, later claimed Burgess was expelled: 'I remember him as a clever chap and very artistic. He was also very good at sport. But it sticks in my memory that he was very shifty-eyed. We were in our fifth term, late in 1925, when the theft came. I had missed drawing instruments. One day I was passing Burgess's locker. It was half open and inside I saw my belongings. I reported the matter to a petty officer and I was interviewed by a Lt. Cavendish who was in charge. He told me to keep quiet about it. Burgess's locker was emptied. He was sacked, and within a few hours he had left the college . . . We never saw Burgess again at Dartmouth, but the story went around that he had left because of poor eyesight. I said nothing, though I knew differently.' *Daily Mail*, 25 October 1955. Burgess left in July 1927, which makes one question the authority of this account.
24. Burgess's medical exam in December 1940 graded him 'One', subject 'to further eyesight test which was not first class'.
25. Yuri Modin, *My Five Cambridge Friends*, Headline, 1994, p. 65.

3. Eton Again

1. Driberg, p. 10.
2. Arthur Hearnden, *Red Robert*, Hamish Hamilton, 1984, p. 64.

3. Burgess would later claim he went rock climbing with Powell in Wales and was invited in the summer of 1933 to go climbing in the Alps, but he had already accepted another invitation to go with Cambridge friends to the South of France. Powell was killed with three other Eton masters on that trip. Driberg, p. 14.

4. Astor and Berry interviews with Andrew Boyle, both 26 April 1977, Boyle Papers 9429/1G/143, Cambridge University Library; *A Mixed Grill*, 4 June 1930; *Motley*, 10 July 1931; and *The Phoenix*, 30 November 1931.

5. Pym to the author, 5 February 2003, and interview, 9 February 2003.

6. The future writer and diplomat Fitzroy Maclean was first, A.J. Ayer was second and David Hedley fourth. Hedley was best man at Ayer's 1932 wedding.

7. One excitement that summer was the American actress Tallulah Bankhead's seduction of several Eton schoolboys, including Peter Wilson, a future head of Sotheby's.

8. He was ill the following year and it was won by Con O'Neil, later a distinguished diplomat, with the future Liberal leader Jo Grimond fifth.

9. Robert Birley to Frank Dobbs, 14 December 1928, quoted Driberg, p. 11. Dobbs stayed in touch with his former pupil. They went on holiday together to France and Burgess stayed with his former house-master at Virginia Water in December 1949 when Burgess visited the Cecil family hoping to be allowed to add a final volume to Lady Gwendoline's life of her father Lord Salisbury. TNA, FCO 158/9

10. Passenger lists, Ancestry.

11. Leitch, p. 65.

12. Michael Berry to Boyle, 26 April 1977, Boyle Papers 9429/1G/143.

13. Evan James to Boyle, 4 July 1977, Boyle Papers 9429/1G/143.

14. Lord Cawley to the author, 12 October 1998.

15. Lord Hastings to the author, 10 January 1999.

16. Lord Hastings to the author, 9 February 1999.

17. Michael Legge letter to the author, 17 August 2000.

18. David Philips telephone conversation with the author, 28 October 1998.

19. William Seymour to the author, 25 August 2000.

20. Mark Johnson to the author, 11 August 2000.

21. Tony Burgess to the author.

22. *Eton College Chronicle*, 10 October 1929.

23. Driberg, p. 12.

24. Gore-Booth later served with Burgess in Washington, but suspicions he may have been a Russian agent did not prevent him becoming Permanent Under-Secretary of State for Foreign Affairs, 1965-9.

25. Eton Archives, SCH/SOC/Pol/1.
26. Interview with Dick Beddington, 27 November 1998.
27. Driberg, p. 15.
28. Christopher Huntly interview, 24 August 2000.
29. Grant went on to Harvard and won the US amateur racquets championship in 1937; Baerlein became a *Daily Express* journalist and novelist and was killed in 1941 as a bomber pilot.
30. Peter Calvocoressi to the author, 4 December 1998.
31. Leitch, p. 80.
32. *Eton College Chronicle*, 6 June 1930.
33. Robert Birley interview with Andrew Boyle, 18 April 1977, CUP 3841.
34. Interview with Sir Steven Runciman, 2 August 1998.
35. Driberg, p. 14.

4. Cambridge Undergraduate

1. Driberg, p. 17.
2. Letter from Michael Vesey to the author, 25 August 2000.
3. Letter from Michael Grant to the author, 21 April 1999.
4. Runciman interview, 2 August 1998.
5. Driberg, p. 18.
6. Perhaps best defined as having characteristics of both sexes and concerned with or dedicated to enjoyment.
7. Letter from Gervase Markham to the author, 2 October 1998.
8. Hunter became a screenwriter after going down with a Third and is perhaps best known for his script for *Carrington VC*, 1954, starring David Niven. He briefly married dying in 1984. 'Guy always said that he had been his greatest friend at Cambridge. A sweet man.' Peter Pollock to author, 17 November 1998.
9. Michael Redgrave, *In My Mind's Eye*, Coronet edition, 1984, p. 90.
10. Jack Hewit claims Burgess first met Blunt when he sat the scholarship exam and the sketch of Anthony in his sketch book was done then, but this seems unlikely. Hewit interview, 5 March 1984.
11. British Library, Blunt Manuscript, ADD Ms 88902/1 handwritten addition, p. 14.
12. ADD MS 88902/1, p. 15.
13. Christopher Mayhew, *A War of Words*, Tauris, 1988, p. 6, and 'Blunt "was Burgess's lover"', *Observer*, 13 January 1980.
14. Interview with Geoffrey Wright, 9 February 2003.

15. Guy was rumoured in Trinity to possess a collection of whips and use them in sado-masochistic orgies, Leitch, p. 93.

16. Early members included Richard Clarke, later a Whitehall mandarin and father of the politician Charles Clarke. According to Charles Clarke, his father used to go to football matches with Burgess and Maclean. Interview with Charles Clarke, 27 February 2015.

17. According to H.S. Ferns, *Reading from Left to Right*, University of Toronto Press, 1983, p. 222, Pascal was asked by Soviet Intelligence to be a talent spotter but refused.

18. Driberg, p. 18.

19. Obituary, *The Times*, 2 November 2000.

20. Runciman engagement diaries, kindly supplied by Minoo Dinshaw.

21. Steven Runciman interview, 2 August 1998.

22. Desmond Seward email to author, 23 August 2013.

23. Steven Runciman interview, 2 August 1998.

24. Interview with Geoffrey Wright, 9 February 2003. A member of Footlights, Wright later wrote musical plays and took part in the musical *Burgess, Maclean and Philby* at the Kings Head.

25. The subject was 'Should Blunt turn Reptile?' The majority, including Burgess, decided not.

26. Keynes papers, King's, undated, but from context January 1934. The first Marxian generation of Apostles are regarded as Dennis Proctor, Alister Watson, Hugh Sykes-Davie and Richard Llewellyn-Davies.

27. The picture was sold for £192,500 in 1983.

28. Some writers have suggested this scandal, which was covered up, made him vulnerable to blackmail.

29. *Spectator*, 3 March 1933.

30. Ibid., 5 May 1933.

31. Ferns quoted John Costello, *Mask of Treachery*, Collins, 1988, p. 249.

32. Driberg, pp. 15–16.

33. Carter, pp. 102–3.

34. Lord Thurlow interview, 21 January 1999, p. 87. Writing in 1942, Burgess would confess: 'All the same I do understand examination terrors. Normally I used to have a nervous breakdown before them. Normally. Occasionally it was much worse. You shld ask A who used to nurse me through them.' Guy Burgess to Peter Pollock, postmarked London, 20 June 1942, Pollock Letters.

35. Michael Burn, *Turned Towards the Sun: An Autobiography*, Michael Russell, 2003, p. 55.

36. Ibid., p. 59.

37. Ibid., p. 65.
38. Anne Barnes, unhappily married, was in love with Dadie Rylands, The Rylands and Barnes collection of letters at King's College, Cambridge give vivid accounts of the South of France holidays and Anne Barnes's friendship with Burgess with accounts of visits to seedy nightclubs and 'alarming drives with Guy constantly getting excited about old houses and young men and taking both hands off the wheel to admire them'. Anne Barnes to Dadie Rylands 20 July 1933, King's College Archives, GHWR 3/23/1.
39. Modin, pp. 70-1 for more on Burgess's arguments to Blunt.

5. Cambridge Postgraduate

1. Driberg, p. 16.
2. Anthony Blunt, *From Bloomsbury to Marxism*, Studio International, November 1973, p. 167.
3. John Humphrey, quoted Penrose, p. 129.
4. Driberg, p. 22. The CUSS minute book 1928-1935 shows the most active members in the period were John Cornford Chairman in 1934, Donald Maclean first elected to the committee in autumn 1931, Kim Philby elected Junior Treasurer in June 1932, David Haden Guest, John Midgley, Fred Pateman, Julian Bell and the two Cumming Bruce brothers. TNA, KV3/442
5. Guy Liddell Diary, 14 November 1951
6. It peaked at six hundred in 1936. Neal Wood, *Communism and British Intellectuals*, Gollancz, 1959, p. 52.
7. Interview with Lord Thurlow, 21 January 1999.
8. Cherry Hughes Papers, Nigel Burgess interview, 16 October 1985.
9. *Granta*, November 1933.
10. See account *Cambridge Daily News*, 14 November 1933.
11. Cherry Hughes papers, Michael Straight to John Costello, 24 November.
12. Carter, p. 110; For accounts see *Cambridge Daily News*, 14 November 1933; Peter Stansky and William Abrahams, *Journey to the Frontier*, Constable, 1966, pp. 106-8; Penrose, pp. 94-7; Andrew Boyle, *The Climate of Treason*, Hutchinson, 1979, pp. 107-8; Costello, p. 225.
13. *New Statesman*, 9 December 1933.
14. Kenneth Sinclair-Loutit, unpublished memoirs, *Very Little Luggage*. Claud Phillimore was a good-looking Trinity architect with whom Blunt had an affair.

15. Penrose, p. 98.

16. Alan Hodgkin, *Chance and Design*, Cambridge University Press, 1992, p. 86. See also Margot Heinemann interview, Imperial War Museum, 9239/5/1-2, 1986. Hedley, who had been converted to communism by Burgess, took up graduate studies at Yale in 1934 and continued his communist activities in America supposedly dying of a heart attack in Los Angeles in 1948 though both Christopher Harmer and A.J. Ayer have suggested he committed suicide. The FBI opened an extensive file on him in 1940.

17. Penrose, p. 108. According to Modin, Burgess was the best read of all the spies on Marxist theory. Roland Perry, *The Fifth Man*, Sidgwick & Jackson, 1994, p. 436.

18. Victor Kiernan, LRB, Vol. 9, No. 12, 25 June 1987, pp. 3-5.

19. The review can be found in the *Spectator*, 23 March 1934.

20. Penrose, p. 133.

21. Runciman interview, 2 August 1998.

22. GBR/0272/PP/GHWR/3/73, Rylands Papers, Kings College, Cambridge Archives.

23. The date is incorrectly given as summer 1932 in Goronwy Rees, *A Chapter of Accidents*, Chatto & Windus, 1972, p. 110, while Costello, p. 222, says summer 1933. More details in Jenny Rees, *Looking for Mr Nobody*, Weidenfeld & Nicolson, 1994, pp. 69-71.

24. Rees, *Chapter of Accidents*, pp. 110-11.

25. Ibid., p. 112, but this is denied by Driberg, p. 24.

26. Driberg, p. 26.

27. Ibid., p. 28.

28. Ibid., p. 25.

29. Rees, *Chapter of Accidents*, p. 112.

30. Driberg, p. 27.

31. Rees, *Chapter of Accidents*, p. 112.

6. The Third Man

1. GHWR 3/73 Rylands Papers, King's College, Cambridge Archives.

2. Interview with Nigel Burgess, 21 January 1986.

3. Kenneth Sinclair-Loutit, *Very Little Luggage*.

4. Interviews with Nigel Burgess, 21 January 1986 and 1 September 1996.

5. In March 1934 Guy had been one of two CUSS militants put in charge

of managing a collection to help Austrian workers, after an appeal from Philby. Christopher Andrew, *The Defence of the Realm: The Authorized History of MI5*, Allen Lane, 2009, p. 172.

6. Anthony Cave Brown, *Treason in the Blood*, Houghton Mifflin, 1994, p. 168, suggests a factor in the recruitment was the erroneous belief that his father St John Philby was in British intelligence.

7. From November 1935 Deutsch lived in Hampstead's famous modernist Lawn Road Flats, whose occupants at various times included Agatha Christie. See David Burke, *The Lawn Street Flats: Spies, Writers and Artists*, The Boydell Press, 2014.

8. Christopher Andrew and Vasili Mitrokhin, *The Mitrokhin Archive: The KGB in Europe and the West*, Penguin, 1999, p. 74. John Costello and Oleg Tsarev, *Deadly Illusion*, Century, 1993, p. 138, says seventeen. Deutsch's recruits included the son of a 'former minister' and, through him, the son of an MI6 employee. The Mitrokhin Archive, MITN 1/7 quoted Jonathan Haslam, *Near and Distant Neighbours*, OUP, 2015 p.297. We know the codenames but not the Identities of 'Attila' and his son 'Otets' (1936), 'Ber' (October 1934), 'Helper', 'Saul' (1936), 'James', 'Socrates', 'Poet', 'Chauffeur' (1936) 'Molly' (possibly Jenifer Hart) and 'Om'. Oleg Tsarev, KGB v Anglii, TSentrpoligraf, 1999, p. 50 quoted Haslam p.297

9. Kim Philby, *My Silent War*, MacGibbon and Kee, 1968, introduction. Originally Philby's cover name had been SYNOK in Russian, but the London 'illegals' preferred to use German rather than Russian as the language they shared and it helped disguise the Soviet link, so he was given the German diminutive, which translated in English means 'Little Son'.

10. Rufina Philby, *The Private Life of Kim Philby*, Fromm International, 2000, p. 251. His Oxford contacts remain unknown.

11. Cryptogram to Centre No. 55/4037 from NKVD *rezident* in Copenhagen, 26 August 1934, quoted *Deadly Illusions*, p. 187.

12. *Deadly Illusions*, p. 456.

13. Philby's KGB memoir, p. 29, quoted *Deadly Illusions*, p. 220.

14. *Deadly Illusions*, p. 462.

15. Rufina Philby *The Private Life of Kim Philby*, p. 230. Theo was another Soviet agent, Theodore Mally. See also Boris Volodarsky, *Stalin's Agent*, OUP, 2015, p. 89, and Anthony Cave Brown, *Treason in the Blood*, Houghton Mifflin, 1994, p. 171.

16. Deutsch to Moscow Centre, undated Burgess file No. 83792, Vol. 1, p. 10, quoted *Deadly Illusions*, p. 225.

17. Orlov to Centre, 12 July 1935, Orlov file No. 32476, Vol. 3, pp. 120-1, quoted *Deadly Illusions*, p. 226. For a slightly different translation, see Voladarsky, pp. 106-7.

18. Psychological assessment of Burgess in the 'History of The London Rezidentura', File No. 89113, Vol. 1, pp. 350-1. Quoted *Deadly Illusions*, p. 226.

19. The list is in Burgess file 83792, pp. 28-31, quoted *Deadly Illusions*, p. 227.

20. Rufina Philby with Hayden Peake and Mikhail Lyubimov, *The Private Life of Kim Philby*, St Ermin's Press, 1999, p. 235.

21. DEUTSCH File No. 89113, Vol. 1, pp. 250-1, quoted *Deadly Illusions*, pp. 228-9.

7. London

1. Eric Hobsbawm, *Interesting Times: A Twentieth Century Life*, Allen Lane, 2002, p. 101. Goronwy Rees later wrote: 'Some said that Guy's sexual life had become so promiscuous especially with Party members, as to become a scandal to the Communist Party and that therefore he had to be expelled.' National Library of Wales, *A Chapter of Accidents*, original manuscript, p. 5.

2. 'William Anthony Camps (afterwards Master) was elected to a Junior Research Fellowship on 23 November 1933. 'This is the only JRF election from this period, and I am afraid there are no papers surviving relating to this appointment, or any other competitions of any kind relating to Fellowships.' Miss J.S. Ringrose, Honorary Archivist, Pembroke College to the author, 26 January 2015.

3. Eton have no record of the approach, but it is mentioned in Tim Card, *Eton Renewed*, John Murray, 1994, p. 187 and Boyle, p. 116, based on private information from Nicholas Elliot, son of the headmaster; Nicholas Elliot, *Never Judge a Man by his Umbrella*, Michael Russell, 1991, p. 46.

4. *Deadly Illusions*, p. 153.

5. Rees, *Chapter of Accidents*, p. 127, Hewit quoted Leitch, p. 154.

6. Frith Banbury to the author, 3 February 2003.

7. Tim Milne, *Kim Philby: The Unknown Story of the KGB Master Spy*, Biteback, 2014, p. 44.

8. Kings Mis 37/1/7 47, 7 May 1936. The two would continue to meet, sharing a Chinese meal in London in July and Burgess is one of the

beneficiaries of MacNeice and Auden's poem 'Last Will and Testament', 'I leave a keg of whiskey, the sweet deceiver.'

9. Rees, *Mr Nobody*, p. 86.

10. Volodarsky, p. 107.

11. Driberg, p. 31. Burgess later pretended to Claud Cockburn that he was Ruzsika's illegitimate son.

12. Miriam Rothschild to the author, 4 February 1999. Miriam Rothschild to Andrew Boyle, 15 September 1977, CUL 3841. See also her comments, Boyle, p. 118.

13. Michael Straight to John Costello, 25 Oct 1988. The book was *Spycatcher* by Peter Wright. MI5 files reveal Rothschild set up a meeting with Chaim Weizmann and Burgess at Claridges about this time, a passage removed from Driberg's biography. Blunt later wrote to Mrs Bassett 'do you remember the occasion . . . when WEITZMAN (sic) was trying to turn VICTOR into a Zionist . . . and Guy argued with VICTOR very strongly against It . . . so to speak WEITZMAN and GUY wrestling for VICTOR'S soul?' TNA, KV2/4117. According to Miriam Rothschild, 'Neither my mother nor I ever, ever mentioned Germany or the Nazi regime to Guy. At my age (90) one's memory is not as good as it was, but of that I am absolutely certain', Miriam Rothschild to the author, 6 January 1999.

14. Norman Rose, *Harold Nicolson*, Jonathan Cape, 2005, p. 223, says they were not lovers, as Nicolson would have recognised Burgess as an 'unpredictable, potentially ruinous partner', whilst Miranda Carter thinks on probability they were, p. 234. Burgess's boyfriend Jack Hewit described Nicolson as 'a pink and white candy floss of a man who, when he did speak to me, always brought the subject round to masturbation. He wanted breathlessly to know how many times a week I did it and how I did it. A patronizing bore.' Hewit, unpublished memoir.

15. Ben Nicolson diary, 25 March 1936.

16. Rees, *Chapter of Accidents*, p. 122.

17. A copy of the January 1936 Anglo-German Fellowship membership list can be found in the London Metropolitan Archives ACC/3121/C/15/003/001 and TNA KV5/3. It doesn't list Macnamara, Burgess or Philby.

18. Burgess supposedly also wrote a pamphlet for the Fellowship. William Duff, *A Time for Spies: Theodore Stephanovich Mally and the Era of the Great Illegals*, Vanderbilt University Press, 1999, p. 117.

19. Cyril Connolly, *The Missing Diplomats*, Queen Anne Press, 1952, p. 23.

20. Pfeiffer was also supposedly an agent of the French Deuxieme Bureau and MI6. Modin, pp. 77-8.

21. Katz's MI5 files TNA, KV2/2178. Interviewed in July 1951 Katz claimed he had met Burgess in 1936 through Victor Rothschild and stated 'that Burgess told him he was helping a group of individuals who were acting as consultants to Winston Churchill and that Burgess's field was Russia and India.' TNA, KV2/4105.

22. National Library of Wales, *A Chapter of Accidents*, original manuscript, p. 12. The manuscript is also available at TNA, FCO 158/184.

23. See, for example, TNA, KV2/1382.

24. TNA, KV2/2587.

25. 'Guy Burgess As I Knew Him' by Gerald Hamilton, *Spectator*, 4 September 1955, p. 578. He gives a similar account in Gerald Hamilton, *The Way It Was With Me*, Leslie Frewin, 1969, pp. 40-4.

26. *Missing Diplomats*, p. 20.

27. Playfair papers, Kings's College, Cambridge, Misc 82/5 & EWP/1935/17-18. See also 26 November 1935, Eddie Playfair to Julian Bell, King's, EWP/1935/17-18. The Comite des Forges were an influential group in France involved in the steel industry and especially armaments, ship-building and heavy industry.

28. Rees, *Chapter of Accidents*, pp. 119-21. Burgess had been a member of the London Library since 24 December 1932. Charles Spencer who is writing a study of the Anglo-German Fellowship believes they were not members but somehow involved.

29. Blunt, MS 88902/1, pp. 24-5.

30. Bruce Page, David Leitch and Phillip Knightley, *Philby: The Spy Who Betrayed a Generation*, Andre Deutsch, 1968, p. 72.

31. Isaiah Berlin recalled that Burgess in 1937 had joined an organisation called Britannia Youth, which took English schoolboys to the Nuremberg rallies and brought members of Hitler Youth on holidays with British scouts. Michael Ignatieff, *Isaiah Berlin*, Chatto & Windus, 1998, p. 95. He also claims there were several trips to Germany, including one to the Olympics, p. 93, a claim also made by Page, p. 92.

32. *Deadly Illusions*, p. 229.

8. The BBC

1. BBC Written Archives Centre, L1/68/1, O.V. Guy to B.E. Nicolls, Controller Administration, 15 November 1935.

2. Harding, later a famous BBC journalist best-known for his appearance on *What's My Line*, was dismissed as 'an odd sort of person . . . am very doubtful about its being worth seeing him . . .' whilst Milner-Barry, who had won the British Boys chess championship in 1923, taken Firsts in Classics and Moral Sciences at Trinity, and would later have a distinguished career at Bletchley and in the Treasury, was passed over as 'He does not really sound as if he had much imagination, and I hardly think it worthwhile putting him on our list.' BBC Written Archives, L1/68/1, 19 November 1935.

3. Ibid., Cecil Graves to B.E. Nicolls, 5 December 1935.

4. Ibid., 'Report on Interview with Mr Burgess', 18 January 1936. Interestingly Burgess, quite independently, had already been asked to take part in a programme on Russia with Gearmen Sverdloff, a press attaché at the Soviet Embassy, to be broadcast on 28th December 1935. The programme was cancelled because of disagreements over the script but was announced in the *Radio Times* where it was seen by Derek Blaikie who wrote a furious letter to the *Daily Worker* denouncing Burgess as 'a renegade from the CP of which he was a member at Cambridge'. TNA, KV2/4106. It was an association MI5 missed until the 1951 Investigations.

5. Ibid., 30 July 1936. Burgess admitted in his application to 'having gone through rather a communist stage'.

6. Ibid., 10 August 1936.

7. Ibid., P.D. Proctor to B.E. Nicolls, 18 August 1936.

8. Paul Bloomfield, *BBC*, Eyre & Spottiswode, 1941, p. 45; *Spectator*, 19 September 1963.

9. BBC Written Archives, L1/68/1, Staff Training Course, 1 October to 31 December 1936.

10. W.J. West, *Truth Betrayed: Radio and Politics Between the Wars*, Duckworth, 1987, claims Burgess lived with Barnes, *Truth Betrayed*, p. 47, but I've found no evidence to support this, though Burgess knew George's wife Anne through Dadie Rylands and Steven Runciman.

11. Gorley Putt, *Wings of a Man's Life*, Claridge Press, 1990, p. 115.

12. Penrose, p. 194.

13. BBC Written Archives, L1/68/1, 24 March 1937.

14. Ibid., 22 June 1937.

15. Ibid.

16. Ibid., 25 June 1937.

17. Ibid., 'Staff Photographs', D.H. Clarke to G. Burgess, 12 July 1937.

18. BBC Written Archives, RCont1, Roger Fulford, Talks 1937-62.

19. Undated letter from 38 Chester Square, TNA, KV2/2587.
20. Katz's MI5 file is TNA, KV2/2587.

9. Russian Recruiter

1. Volodarsky, p. 113, claims that according to KGB files 103 agents were recruited between Burgess and Blunt, but this has been disputed by Nigel West, amongst others.
2. E.M. Forster, 'What I Believe', *The Nation*, 16 July 1938.
3. George Steiner, 'The Cleric of Treason', *New Yorker*, 8 December 1980. Jonathan Haslam drawing on an authorised Russian biography of Blunt by a former ambassador to London, Viktor Popov, claims Rothschild 'effectively provided cover for the Cambridge Five'. Haslam. p.82.
4. Carter, p. 165. Hampshire, who was later, almost certainly unfairly, denounced as a spy by Goronwy Rees, remembered Burgess had tried to recruit him just before the outbreak of the Second World War. *The Observer*, 29 July 1984.
5. Anthony Blunt interview, *The Times*, 2 November 1979.
6. Andrew, *Defence of the Realm*, p. 272.
7. Burgess file in Moscow, quoted Allen Weinstein and Alexander Vassiliev, *The Haunted Wood*, Random House, 1999, p. 73.
8. Michael Straight, *After Long Silence*, Collins, 1983, p. 71.
9. Madchen's report to Moscow Centre, 16 February 1937, quoted John Earl Haynes, Harvey Klehr and Alexander Vassiliev, *Spies: The Rise and Fall of the KGB in America*, Yale, 2009, p. 246.
10. A fuller account of Straight's recruitment can be found in Roland Perry, *The Last of the Cold War Spies*, Da Capo, 2005, pp. 64-73. Perry now believes 'Burgess had sex with Straight and this allowed GB to blackmail MS'. Straight had originally told Perry he had been raped by Burgess, but Perry never published it. 'Now a close friend of MS's has written to me backing up the sexual blackmail angle and supporting MS's "confession" to me.' Roland Perry to the author, 9 February 2006.
11. John Carncross, *The Enigma Spy*, Century, 1997, p. 58. Burgess met Putlitz in 1932 and the two men remained friendly until Burgess's death. Putlitz was recruited by MI5 in the 1930s to inform on his colleagues and later worked during the Second World War on propaganda against Germany. He may have also worked for Soviet Intelligence after 1943 but this remains unproven.

12. LIST file No. 83896, Vol. 1, pp. 1a-4, quoted Nigel West and Oleg Tsarev, *The Crown Jewels: The British Secrets at the Heart of the KGB Archives*, HarperCollins, 1998, p. 206.

13. *Enigma Spy*, p. 59.

14. Rees, *Chapter of Accidents*, p. 135.

15. Ibid., pp. 135-6. More details, Rees, *Mr Nobody*, pp. 88-9.

16. Ibid., pp. 136-7. According to the original typescript of *A Chapter of Accidents*, p. 22, Rees did once raise it with Blunt whilst walking in St James's Park. '"I gather you know what Guy is really up to?" Blunt replied curtly, "Yes", but it was clear he did not wish to discuss the matter any further.'

17. Ibid., p. 138.

18. Ibid. Burgess often came to stay with Rosamond for weekends in the country and they would discuss Victorian novels or swim. 'One time, however, he overstepped the mark, and expressed his hopes of seducing the gardener's handsome son. I forbade it. "Oh, Rosie, Rosie," he cried, "can't I?" "No," I said.' Selina Hastings, *Rosamond Lehmann*, Chatto, 2002, p. 190.

19. Jenny Rees, *Mr Nobody*, p. 274.

20. *Deadly Illusions*, p. 245.

21. Background information on Flit, Modrinskaya. The redacted name is Sheila Grant Duff.

22. *Mr Nobody*, p. 275.

23. Interview with Oleg Tsarev, 3 November 1993, 2/2, Goronwy Rees Papers, National Library of Wales.

10. Jack and Peter

1. Hewit, unpublished manuscript. Holzman has suggested the lover was the actor Douglas Seale (1913-99).

2. Penrose, p. 202; see also Penrose, pp. 202-3, where Hewit gives a slightly different account, and Leitch, pp. 153-4.

3. Hewit manuscript. A similar account is given in Penrose, p. 202.

4. Hewit interview, quoted Leitch, pp. 154-5.

5. Leitch, pp. 154-5. Rees describes a similar diet, *Chapter of Accidents*, p. 127.

6. Leitch, p. 155.

7. Penrose, p. 203.

8. Rees, *Chapter of Accidents*, pp. 113-14. One of his lovers was Donald Maclean. *A Chapter of Accidents*, original typescript, p. 2. Stephen

Runciman interviewed in January 1958 told MI5 the two had 'a roaring affair' in Burgess's fourth year. TNA, KV2/4123.

9. James Lees-Milne diary, 7 Feb 1980. James Lees-Milne, *Deep Romantic Chasm: Diaries 1979-81*, John Murray, 2000, p. 73. Stuart Preston (1915-2005) , known as 'the Sergeant', was the original of 'The Loot' in Evelyn Waugh's *Sword of Honour* trilogy, and friends with amongst others Nancy Mitford, Harold Acton, Anthony Powell, James Lees-Milne and Osbert Sitwell. He had first met Burgess through Harold Nicolson in 1943 and was 'impressed by his self-confidence and brashness. It would be hard not to have been.' Interview with Stuart Preston, 1 March 1998.

10. Harold Acton, *Memoirs of an Aesthete*, Methuen, 1970, p. 87.

11. Modin, p. 68.

12. Peter Pollock to author, letter postmarked 17 November 1998.

13. Marie-Jacqueline Lancaster, *Brian Howard: Portrait of a Failure*, Anthony Blond, 1968 and Timewell, 2005, p. 23, Timewell edition.

14. *Deadly Illusion*, p. 213. Burgess's BBC file shows he was sick 14-18 January 1937.

15. BBC Written Archives, L1/68/1, 15 March 1938.

16. Leitch, p. 151.

17. On 25 April 1938 Maclean wrote to Moscow Centre, 'I heard yesterday that the 3rd Musketeer [Burgess] has had a breakdown of some kind and has had to go away for two months. I have not seen him myself for many months, so do not know if this is likely to be true, but I shall be sorry if it is . . .' *Deadly Illusion*, p. 212.

18. Penrose, p. 204.

19. Pollock interview, quoted Carter, p. 229, Leitch, p. 152; interview with Gale Pollock, 8 August 1996.

20. Carter, p. 230.

21. BBC Written Archives, L1/68/1, Lansel to Maconachie, 8 April 1938.

22. King's, Cambridge, RNL/2/85, Guy Burgess to Rosamond Lehmann, 9 April 1938.

11. British Agent

1. BBC Written Archives. Contributors: David Footman, Talks 1937-49.

2. Undated BURGESS file, No. 83792, Vol. 1, pp. 100-3, quoted *Deadly Illusions*, p. 233.

3. Igor Damaskin and Geoffrey Elliott, *Kitty Harris: The Spy with Seventeen Names*, St Ermin's Press, 2001, p. 151, pb edition. MI5 files which are

not always accurate, however, suggest Burgess's career in British Intelligence may have begun earlier – 'from about 1936 onwards (i.e. before the time of the GRAND organisation) Footman and Burgess were collaborating in the running of an Agent network for MI6'. TNA, KV2/4103.

4. Driberg, p. 40.

5. Jack Hewit memoir. Hewit gave an identical account to Penrose, p. 209. Rather than coincidence, it seems more likely that Hewit was tasked with obtaining a job at the Goring.

6. Rose, p. 215, for full account of his attempt to dupe the British.

7. *Deadly Illusions*, p. 235, details in Burgess file 83792, Vol. 1, pp. 114-34. It has been suggested that Burgess was also used as a courier delivering Chamberlain's letters, without the Foreign Office's knowledge, to Count Ciano. Boris Piadyshev, 'Burgess: In the Service of a Foreign Power', *International Affairs: A Russian Journal of World Politics, Diplomacy and International Relations*, 30 April 2005, No. 2, Vol. 51, p. 188. Though Ball's liaison with the Italians was a Gray's Inn lawyer called Adrian Dingli, this mission suggests Burgess did have contact with Grandi. Certainly when Ball tried to sue Hugh Trevor-Roper for revealing in a letter to the *New Statesman* Ball's links with Grandi – details of which were in the original version of Count Ciano's diaries published in 1948 until Ball forced their removal – Burgess 'offered to give evidence for him if the matter came to court, saying that he had actually carried the messages for Ball', p. 99. See also Ball's papers, Bodleian Library, MS, c.6656, folios 40-9.

8. Burgess file 83792, Vol. 1, pp. 114-34 in *Deadly Illusions*, p. 236.

9. Ibid., p. 237. Also Volodarsky, p. 56.

10. Ibid., p. 237.

11. Ibid., p. 238.

12. Burgess file 83792, Vol. 1, pp. 138-9 in *Deadly Illusions*, p. 238.

13. The American friend may have been David Hedley, now living in the United States. Burgess profile in 'History of London Rezidentura' file 89113, Vol. 1, pp. 350-1, quoted *Deadly Illusions*, p. 239.

12. Meeting Churchill

1. BBC Written Archives, L1/68/1 ,12 January 1938.

2. CUL, Boyle Papers 9429/1G/278(i), David Graham to Boyle, 6 January 1979.

3. A fuller account is given in W.J. West, pp. 138-9.
4. Nigel Nicolson letters and diaries 1930-9, Collins, 1966, pp. 354-5.
5. Nigel West, *Crown Jewels*, p. 209.
6. W.J. West, p. 54.
7. According to Burgess, 'Pfeiffer telephoned to him at the BBC in great agitation, asking him to give an immediate message to his contact. The message was to the effect that he should be told that such a show of force might be fatal to certain plans which Daladier and Chamberlain had in mind, and that he should at once see Chamberlain and urge him to secure the cancellation of the order mobilising the Fleet. Pfeiffer further asked Guy to come to Paris at once to collect a letter amplifying this message. He went to Paris and collected the letter. For once, however he did not deliver it.' Driberg, p. 41.
8. Ibid., p. 43.
9. According to a BBC colleague, 'Burgess rang up the Soviet Ambassador Maisky and asked what he could do to help. Maisky answered: "Go and see Churchill and call on him, in the name of the youth of Great Britain, to intervene." Burgess did not record this in any memo to the BBC but (presumably first) mentioned it at a dinner in honour of the retired Head of BBC Talks, Sir Richard Maconachie, attended by all the Talks Assistants who had worked in his department. The place was in the Langham . . . autumn 1945.' CUL, 9429/ 1G/278(i), Graham to Boyle, 6 January 1979.
10. Burgess's recording recreating the visit can be heard at http://www.city.ac.uk/cambridge-spies-the-guy-burgess-tape.
11. Driberg, p. 46.
12. The book was one of Burgess's most prized possessions and was sent to him in Moscow. On Burgess's death it was left to Philby, but eventually found itself as part of a £55 job lot at a suburban auction house. It was subsequently bought by the billionaire Malcolm Forbes for £2,000 at Christie's. *Daily Telegraph*, 26 April 1997 who sold it for £12,000 thirteen years later. The *Western Morning News* 4th June 2010.
13. Churchill Archives, Char 2/350. John Green told Andrew Boyle the Churchill meeting was 'during the war and not the Munich period. I am confident about this because Sir Richard Maconachie first asked me to go to Chartwell (on a Saturday or Sunday morning I believe) and I remember the prior appointment that prevented me. Burgess went to get some amendments in a script, stayed to lunch, played tennis with the young Mary Soames (in a pair of Winston's flannel trousers!), had drinks (and I believe stayed to supper, the BBC chauffeur waiting

the while)', but admits that may have been a second meeting. CUL 9429/1G/283, Green to Boyle, 31 July 1980.

14. BBC Written Archives, Talks: RCont 1, Winston Churchill 1926-39. 'Part of Conversation with Mr Churchill on Saturday 1 October', 4 October.

15. Nicolson Diaries, Vol. 1, UK ed., pp. 354-5

16. BBC Written Archives, L1/68/1, Maconachie to DSA, 13 December 1938.

17. Ibid., 1 January 1939.

13. Section D

1. Internal history, Section D, p. 6, TNA, HS 7/3.

2. TNA, HS7/5.

3. Driberg, p. 56. MI5 files suggest Burgess may have served in the Spanish section alongside Philby whom he had brought in. TNA, KV2/4106, Interview with Isa Benzie, 6th November 1951.

4. See Paper 82, Joint Broadcasting Committee, TNA, T 162/858.

5. See Wellesley's 3 October 1938 memo 'Special Broadcasting Arrangements, 27-30 September 1938', Chamberlain papers, Add. 14, Birmingham University Library.

6. Driberg, p. 56. In July 1939 JBC moved to offices at 71 Chester Square, TNA, FO395/666.

7. Benes is now revealed to have been a Soviet agent.

8. Christine Nichols, *Elspeth Huxley*, Collins, 2002, p. 150. Another colleague was Blythe Portillo, mother of the British politician and television presenter Michael Portillo.

9. For more details see Budberg's MI5 files, TNA, KV 2/979-981 and Deborah McDonald and Jeremy Dronfield, *A Very Dangerous Woman: The Lives, Loves and Lies of Russia's Most Seductive Spy*, Oneworld, 2015.

10. Nicolson, *Diary*, Balliol. A former MI6 officer, Peter Hofmann, told MI5 'I was with our friends in 1938 and was directed to meet Burgess in a hotel in Geneva. To my surprise he received me, a stranger, in his bedroom in his underclothes (tho the day was hot!) and we got thro' our business' which is either a misremembered date or confirms that Burgess was working for MI6 and maybe JBC earlier than officially claimed. TNA, FCO 158/8.

11. See Burgess report to K3 in KV6/127, TNA.

12. 24 August 1939, TNA, T162/858.

13. *Enigma Spy*, p. 75.
14. *Deadly Illusions*, p. 240.
15. Driberg, p. 52. Burgess reported to Gorski a conversation with Grand's deputy Monty Chidson that 'our aim is not to resist German expansion to the east'. Quoted Haslam p. 103.
16. Burgess letter, 28 August, Burgess file 83792, Vol. 1, p. 302, quoted *Deadly Illusions*, p. 240. See also Piadyshev, p. 189.
17. Blunt, ADD, Ms 88902/1, pp. 37-40.
18. Ibid.
19. Modin, p. 82.
20. Rees, *Chapter of Accidents*, p. 149.
21. Ibid., p. 150.

14. 'Rather Confidential Work'

1. Memo, Burgess & Smollett to Carr, TNA, INF1/27 ff8014/38.
2. West, *Crown Jewels*, p. 157. Smollett was a regular BBC broadcaster on Russian subjects from April 1936, but not produced by Burgess.
3. Eckesley, p. 422. Wellesley had left her husband Gerald Wellesley in 1922 for Vita Sackville-West, before becoming Matheson's partner.
4. Guy Burgess file, SOE files.
5. Report, Sir Campbell Stuart, 18 February 1940, TNA, FO1093/149.
6. *Deadly Illusions*, p. 241.
7. TNA, INF1/4.
8. Selina Hastings, *Rosamond Lehmann*, Chatto, 2002, p. 207 and Costello, p. 376.
9. Leigh Ashton, SOE files, 10 & 14 May, 7 June. TNA, INF1/27, dates his transfer to War Office 'D' as 12 June 1940.
10. *Deadly Illusions*, p. 241.
11. Genrikh Borovik and Phillip Knightley (eds.), *The Philby Files*, Little Brown, 1994, pp. 157-64, claim Philby joined Section D at the suggestion of a *Daily Express* journalist Esther Marsden-Smedley with links to Section D and that may be true as well.
12. See Krivitsky files, TNA, KV2/804 and KV2/805. In January 1941 Blunt gave the Russians the full MI5 debriefing of Krivitsky.
13. Modin, pp. 83-4. According to MI5 files Burgess was sent to Moscow by Grand 'to get in touch with the Comintern and influence them against the Germans' TNA, KV2/4105, Memo 19th July 1951.
14. Holzman, p. 135.

15. Straight, pp. 142-3 and Perry, *The Last of the Cold War Spies*, p. 121. TNA, KV2/4139 FBI interview Michael Straight 1963.

16. Isaiah Berlin, *Flourishing: Letters 1928-1946*, edited Henry Hardy, Chatto & Windus, 2004, pp. 318-19.

17. Miriam Rothschild to the author, 4 February 1999. See TNA, FO371/24847 for the exchange of telegrams showing that the Foreign Office had no idea of the purpose of the trip and were opposed to it.

18. Nicolson, *Diary*, 18 August 1940. Burgess's scheme had proved premature, but just after the German invasion in June 1941, a British combined services military mission was sent to Moscow.

19. TNA, KV2/774.

20. A list of propaganda results for Section D which may have involved Burgess can be found in Appendix 2, TNA, HS 7/5.

21. Philby, *My Secret War*, p. 14.

22. Bickham Sweet-Escott, *Baker Street Irregular*, Methuen, 1965, p. 36.

23. History of the Training Section of SOE, 1940-45, TNA, HS7/51.

24. Philby, *My Silent War*, p. 15. Peters won the VC two years later during Operation Torch, but was killed in an air crash shortly afterwards.

25. For more on Paterson, see Cyril Cuningham, *Beaulieu: The Finishing School for Secret Agents*, Leo Cooper, 1998, p. 53.

26. Costello, pp. 383-5, argues that Harris was also a Soviet penetration agent. Enriqueta Frankfort wrote to the author about Burgess, 29 December 1998, 'I trust you will understand when I say I have no wish to remember him.'

27. Driberg, p. 58.

28. Philby, *My Secret War*, p. 17.

29. Cowan, unpublished memoir, p. 13, Imperial War Museum, 07/25/1, catalogue number 15684.

30. Philby, *My Secret War*, p. 13. D/U was the training sub-section of Section D. Peters was D/US, Barcroft D/US.1 and Philby in fact D/UD. Information kindly supplied by Mark Seaman from a note dated 28 July 1940. The Dud appears to have been Burgess. Philby later wrote 'there was a sad discrepancy between the size of his ideas and his efforts towards implementing them.' TNA, KV2/4102, Philby unpublished memoir.

31. Driberg, p. 58.

32. George Hill, *Reminiscences of Four Years with the NKVD*, private publication, 1968, Hoover Institution Archives, p. 2.

33. TNA, HS7/3, pp. 21-2.

34. Philby, *My Secret War*, pp. 18–19.
35. IWM 14093, unpublished memoir, *No Pipes or Drums*, p. 53.
36. John Mather and Donald Seaman, 'The Great Spy Scandal', *Daily Express*, 1955, pp. 27–8.
37. *Nottingham Evening Post*, 10 September 1940.
38. Rees, *Chapter of Accidents*, p. 154.
39 TNA, FCO 158/9 Note from Selborne 12th April 1956.

15. Bentinck Street

1. 'Flat – I'm still between Chester & Bentinck & unsettled'. 29 April 1941, Pollock letters. There's no evidence he had been living in the interim in Eaton Square, as claimed by Leitch, p. 174.
2. Penrose, p. 255.
3. Gale Pollock interview, 8 August 1998; Peter Pollock to the author, 3 July 1998.
4. Guy Burgess to Peter Pollock, postmarked London, 1 September 1941, Pollock letters.
5. Clarissa Churchill's presence according to Peter Pollock tape, by kind permission of Miranda Carter. Muggeridge gives a vivid description of Burgess and Bentinck Street in his memoirs, written in the 1970s, but judging from his own diary entry for 7 February 1948, he only met Burgess after the war. 'Present: character called Burgess (Foreign Office). Burgess lamentable character, very left-wing, obviously seeking to climb on the Socialist bandwagon. Long, tedious, rather acrimonious argument.' Malcolm Muggeridge, *Like it Was: The Diaries of Malcolm Muggeridge*, Collins, 1981.
6. Hugh Thomas, *John Strachey*, Eyre Methuen, 1973, p. 202.
7. Holzman, p. 142.
8. Penrose, p. 256.
9. Ibid., p. 258.
10. Ibid., p. 257.
11. In his 5 March 1984 interview Hewit claimed it was Blunt who had slept with both Pat and her future husband Llewellyn Davies. Hewit manuscript.
12. Pollock letters, Burgess to Pollock, undated.
13. Ibid., Burgess to Pollock, postmarked 23 December 1940.
14. Ibid., undated. Aileen Furse would give birth to Philby's first child Josephine in 1941. Burgess was one of the godfathers.
15. Ibid., Burgess to Pollock, undated.
16. Hewit interviews, quoted Costello, p. 391.

17. Pollock Letters, Burgess to Pollock, undated.
18. Clarissa Churchill interview, 28 January 2015.
19. Robin Bryans, *Let the Petals Fall*, Honeyford Press, 1993, p. 22.
20. Rees, *Chapter of Accidents*, p. 155.
21. Mary Hardy, email to author, 25 May 2015.
22. Interviews with Mary Hardy, 13 May and 23 May 2015. Elaine may have been Elaine Finlay, previously a saleswoman for a clothing firm but in 1951 working for the Board of Trade, whom Burgess had met through David Footman and the subject of an MI5 investigation. She later married a barrister Cecil Binney.
23. Pollock letters. Burgess to Pollock, 17 April 1941. The following week he confessed to Pollock, writing on the notepaper of the Union Club in Carlton House Terrace but from 5 Bentinck Street, to having stolen 'a Rolls-Royce out of a shop during the last blitz. There's looting.' Pollock letters, Burgess to Pollock, postmarked 24 April 1941.
24. Ibid., undated 1941.
25. Ibid., postmarked 29 April 1941.
26. Ibid., postmarked London, 4 June 1941.
27. Pollock to the author, undated 1998.
28. Pollock letters, Burgess to Pollock, postmarked London, 19 July 1941.
29. Ibid., postmarked London, 1 September 1941. Burgess's wide circle of acquaintances can also be glimpsed through Nicolson's diaries, such as an evening with Augustus John in July 1942 and dinner at the Reform Club with William Beveridge, whose report on post-war welfare was published the following month.
30. Ibid., postmarked 1 December 1941. Pollock's useful work for MI5 is outlined in a future chapter.
31. Harold Nicolson, *Diary*, Balliol, 21 July 1941.
32. Harold Nicolson, *Vita & Harold*, Weidenfeld, 1992, p. 340.
33. Pollock letters, Tom Wylie to Pollock, 8 July, 1941; ibid., Burgess to Pollock, postmarked 20 September 1942.
34. Kenneth Sinclair-Loutit, *Very Little Luggage*.
35. Private collection. Philip Jacobson to Phillip Knightley, 16 November 1968.
36. Interview with Virginia Bath, 22 August 1998.
37. Private information and Michael Luke, *David Tennant and the Gargoyle Years*, Weidenfeld & Nicolson, 1991, p. 177. The building is now the Comedy Club.

16. Back at the BBC

1. BBC Written Archives, L1/8/1, Barnes memo, 20 January 1941.
2. Ibid., Baker to Charles, 15 January 1941.
3. Ibid.
4. Ibid., General Establishment Officer to Burgess, 20 January 1941.
5. Aileen Furse had first broadcast in August 1938 on 'Welfare Work in a London Store'.
6. BBC Written Archives, R51/63/3, Talks: Can I Help You? File 1C 1941. According to Modin, p. 86 he requested an interview with Churchill, the Prime Minister called him in and they discussed it at length, but it never happened for technical reasons. This however may be the wartime meeting to which Green refers.
7. CUL, Add 9429/1G/283. John Green to Andrew Boyle, 31 July 1980.
8. Philip Hunt, who interviewed Eric Fenn in 1994, to author, 23 July 1998. The story also appears in Kenneth Wolfe, *The Churches and the British Broadcasting Corporation 1922-1956* , SCM Press, 1984, p. 585.
9. Eric Fenn, unpublished memoir, chapter VIII, 'The BBC in Wartime', p. 123, by kind permission of Sir Nicholas Fenn.
10. Philip Hunt to the author, 23 July 1998.
11. BBC Written Archives, L1/68/1, 30 May 1941.
12. Ibid., H.A. Pattinson to R.S. Stafford, 29 May 1941.
13. Ibid., 31 May 1941.
14. Ibid., 4 June 1941.
15. Ibid., 9 June 1941.
16. Ibid., Projection of Europe to the Home Country, 7 June 1941.
17. BBC Written Archives Centre, R51/520/1, Draft Suggestions for Talks on Russia, 15 July 1941.
18. Ibid. He later confessed to the writer Anthony Glees that he had been a Soviet agent.
19. See TNA, KV2/2156.

17. MI5 Agent Handler

1. Proctor invited Blunt and Burgess to dinner shortly after Blunt joined Military Intelligence. The writer Anthony Powell was another guest, but was distinctly unimpressed by Burgess, who arrived late, confiding to

his diary on 4 October 1939, 'A BBC fairy of the fat go-getting sort. Absolutely nauseating.' Anthony Powell, *To Keep the Ball Rolling*, Penguin edition, 1983, p. 168.

2. Christopher Andrew, *Defence of the Realm*, p. 272.

3. Burgess was an MI5 agent until 1946 but failed to secure a job with the organisation at the end of the war. TNA, KV2/4103. Donald Maclean's sister Nancy also worked for MI5. According to the Mitrokhin Archive, now in Churchill College, Cambridge, Burgess tried to recruit a counter-intelligence officer, who refused but through friendship did not report the approach.

4. Andrew, *Defence of Realm*, p. 270. Nigel, later the regional security liaison officer for East Anglia, remained in MI5 until 1947, until forced out by cuts, but maintained his links with MI5.

5. Interview with Kemball Johnston, 8 July 1984.

6. Hewit interview, August 1985.

7. Mitrokhin, p. 110.

8. Ibid. Revai after the war set up the Pallas Gallery, which specialised in reproductions by well-known artists.

9. Ibid., p. 120.

10. John Costello, *Deadly Illusions*, p. 242.

11. Nigel West, *Crown Jewels*, p. 163.

12. TNA, HO334/138/6048.

13. Peter Pollock, letter to the author, 17 November 1998.

14. Modin, p. 87. Proctor's wife Barbara has rebutted many of the accusations made against her husband in a letter to Phillip Knightley, 17 February 1983, National Library of Australia, Richard Hall Papers, series 32, folder 45.

15. Chapman Pincher, *Too Secret Too Long*, Sidgwick & Jackson, 1984, p. 386.

16. Nigel West, *Crown Jewels*, p. 160.

17. Ibid., p. 161.

18. Christopher Andrew, *Defence of the Realm*, p. 837.

19. Nigel West, *Crown Jewels*, p. 163.

18. Propagandist

1. BBC Written Archives, R51/115/1, Week in Westminster, 14 September 1941. See W.J. West, *The Truth About Hollis*, Duckworth, 1989, p. 77.

2. *Sunday Graphic*, 17 June 1951.

3. Interview with Leonard Miall, 17 February 1999.

4. BBC Written Archives, L1/68/1, Barnes to Burgess, 13 December 1941.

5. Ibid., Barnes to Burgess, 2 September 1942. Blunt had been instrumental in keeping Burgess at the BBC partly because it saved him from being called up and partly because it suited MI5's purposes. He told Guy Liddell 'the reason for wanting to see Macconochie at this particular stage was that a re-arrangement of duties was contemplated in the BBC, which might have deprived Burgess of the direction of a particular series of talks which put him in a very useful position from our point of view.' 30th April 1943, TNA, KV2/4101.

6. Ibid., Week in Westminster, 1 February 1942.

7. Nicolson Diaries, 3 June 1942. Burgess and Blair sometimes worked together. See W.J. West, *Orwell: The War Broadcasts*, BBC Books, 1985, p. 34.

8. Nicolson, *Diary*, 9 September 1942 and Holzman, p. 190.

9. TNA, INF1/147, Smollett to Atkins, 2 August 1942.

10. Christopher Andrew and Oleg Gordievsky, *KGB: The Inside Story*, Hodder & Stoughton, 1990, p. 269.

11. There is, however, no reliable evidence Henri 'helped to recruit Burgess in 1933' and 'had talent-spotted for the KGB at Cambridge in the 1930s, as Christopher Andrew claims, *KGB*, p. 154.

12. BBC Written Archives, R Cont, Harold Nicolson, Nicolson to Maconachie, 5 June 1942.

13. Donald Gillies, *Radical Diplomat: The life of Archibald Clark Kerr, Lord Inverchapel, 1882-1951*, I.B. Tauris, 1999, p. 140.

14. Jack Hewit interview, 1984.

15. Burgess's use of the programme on behalf of his Soviet masters is covered in more detail in W.J. West, *The Truth about Hollis*, chapter 8.

16. BBC Written Archives, RCont 1, John Hilton, 20 August 1942.

17. BBC Written Archives, RS1/401, RCont, Talks Policy: John Hilton's successor 1943-4, 31 August 1942. According to Micky Burn, Burgess pimped boys for Sparrow, a Fellow of All Souls. Burgess was still putting Pollock forward the following September.

18. Ibid.

19. CUL 3841, Maurice Webb interview. In 1955 Webb claimed that he had been responsible for Burgess's removal from the BBC in 1944 but, if so, there is no evidence in the BBC archives and it seems unlikely Burgess would have then been taken on by the Foreign Office even as a temporary employee. However W.J. West, *The Truth about Hollis*, pp. 111-12, argues that there is truth in Webb's claims.

20. BBC Written Archives, RS1/115/3, Talks: Current Affairs: Week in Westminster, File 2a, 1943-4.

21. Ibid., 4 November 1943.

22. Ibid., Week in Westminster, 6 November 1943.

23. BBC Written Archives, L1/68/1, George Barnes, 27 December 1942.

24. Ibid., O. Thompson, AA Talks to A(H), 2 January 1943. The distance from Bentinck Street to the BBC was half a mile.

25. Ibid., 11 January 1943. The man Burgess had been meeting was Collin Brooks, the editor of *Truth*, a paper that specialised in exposing political and social scandals and had been controlled by Joseph Ball since 1936. Brooks, who had worked for the press baron Lord Rothermere throughout the 1930s, was an important Burgess target – the Russians were interested in Rothermere and his links with the Germans – they often dined together throughout the war and Burgess had taken Brooks to see the occultist Aleister Crowley.

26. Ibid., Guy Burgess and the Week in Westminster, 20 April, 1943. Many of Burgess's contacts came through membership of the Shanghai Club, an informal dining club, which met every Tuesday to discuss politics and was composed of young, left-wing journalists as well as David Astor, George Orwell, John Strachey and Peter Smollett. Along with David Footman, he was also a member of the Thursday Dining Club which included representatives of émigré governments in London and of the Allied governments including members of the Soviet Embassy. TNA , KV2/4105.

27. Ibid., Guy Burgess and the Week in Westminster, 20 April 1943.

28. Ibid., 4 November 1943.

29. Ibid., Mr Burgess First Class Travel, 4 November 1943.

30. Ibid., Burgess to Director of Talks, 3 December 1943.

31. Ibid., 3 December 1943.

32. W.J. West, *The Truth About Hollis*, p. 112.

33. BBC Written Archives, L1/68/1, Foot to Cadogan, 27 March 1944.

34. Ibid., 29 March 1944.

35. Ibid., Burgess to Barnes, 31 March 1944.

36. Ibid., Maconachie to Foot, 1 April 1944.

19. The News Department

1. Alan Maclean, *No I Tell a Lie, It was the Tuesday . . . A Trudge Through His Life and Times*, Kyle Cathie, 1998, pp. 68-9.

2. Ibid., p. 69.

3. Rees, *Chapter of Accidents*, p. 160.

4. Interview with W.B. Hermondhalgh, 19 February 1998.

5. Richard Boston, *Osbert: Portrait of Osbert Lancaster*, HarperCollins, 1989, p. 119.

6. *Guardian* Archives, OHP/79/1. Interview with Richard Scott.

7. Quoted Holzman, pp. 198-9. It's a good story, but Alan Maclean claimed the department saw confidential but not top secret telegrams.

8. Interview with Alan Maclean, 22 October 1998.

9. Nigel West, *Crown Jewels*, p. 172.

10. Ibid.

11. Ibid.

12. Mitrokhin, p. 167.

13. 26 February 1945, Nigel Nicolson (ed.), *Diaries and Letters 1939-1945*, Collins, 1966, p. 434.

14. Nigel West, *Crown Jewels*, pp. 172-3.

15. Ibid., p. 173.

16. Mitrokhin, p. 167.

17. 11 August 1945, TNA, CAB120/691/109040 /002. Authentification of the document was confirmed by Oleg Tsarev in a lecture in Moscow on 26 May 2003, which the author attended.

18. TNA, FO366/1739. Interviewed by MI5 in December 1952, Ridsdale claimed 'Burgess was not a particularly good member of his Department. He was slovenly and irresponsible, and it was never possible to assign to him any task of importance. He had to rebuke Burgess on more than one occasion for his appearance and manners and it was curious that Burgess's reaction was to cringe and be most apologetic afterwards'. Meeting Ridsdale at the Reform in May 1951, Burgess had asked if he could come back to the News Department. Ridsdale told him not to be a fool. TNA, KV2/4149.

19. Allen Weinstein and Alexander Vassiliev, *The Haunted Wood*, Random House, 1999, p. 210.

20. Christopher Andrew, *Defence of Realm*, p. 344, says Volkov claimed there were two Soviet agents in the British Foreign Office and seven 'inside the British intelligence system' including one 'fulfilling the function of head of a section of British counter-espionage in London'. I am grateful to Nigel West for providing the original Volkov list which reads: 'List of employees of military and civilian intelligence services of Great Britain known to NKGB. List includes about 250 official and

secret employees of mentioned service of whom there are descriptions.'
As part of their damage control, the Soviets decided to concentrate
on their two most important British agents Philby and Burgess. Burgess's
cover name in the VENONA traffic was Khiks. Herbert Romerstein
and Eric Brandel, *The Venona Secrets*, Regnery, 2000, p. 14. More details
of Volkov's interrogations can be found in TNA, FCO 158/193.

20. Relationships

1. Interview with Gale Pollock, 8 August 1996. Burgess to Pollock in
 Stalag VII, postmarked 24 May 1944. *Uncle Harry*, with Redgrave playing
 alongside his wife Rachel Kempson, was at the Garrick Theatre.
2. Pollock obituary, *The Independent*, 12 September 2001.
3. Interview with Mrs Green, 11 May 2009.
4. Interview with Fanny Carby, 17 October 1998.
5. Pollock taped interview, by kind permission of Miranda Carter.
6. Leitch, p. 183.
7. Interview with Peter Pollock, April 1998.
8. Pollock Letters, Brian Howard to Pollock, c/o Kessler at Dorchester
 Hotel, postmarked 4 October 1945.
9. Ibid., 21 October 1945.
10. Ibid., Burgess to Pollock, postmarked London, 15 December 1945.
11. Interview with Noel Annan, 10 April 1987.
12. Hugh Trevor-Roper, *New York Review of Books*, 31 March 1983.
13. Modin, p. 68.
14. Rees, *Chapter of Accidents*, pp. 133-4.
15. Ibid., pp. 140-1.
16. Lancaster, p. 490.
17. Electoral Roll 1945. He was introduced to the landlord through David
 Footman. In December 1945 and after Medway Street, he briefly stayed
 with Blunt and Philby. Burgess to Pollock, postmarked 17 December
 1945.
18. Pollock letters, Burgess to Pollock, postmarked 11 July 1946. Hope
 Wallace was a gay, hard-drinking music and theatre critic who claimed,
 for which there is no evidence, to have been on holiday in Italy with
 Burgess just before he fled. *Guardian* archives, OHP/69/1.
19. Ibid., 30 August 1946. Sir John Philipps (1915-48) divided his time
 between Picton Castle in Wales and a flat in Albany – Burgess was a

regular visitor at both. A friend of Brian Howard from Oxford, Philipps was known for his parties and collections of pornography. He accidentally drowned in his bath.

20. Ibid.

21. Back at the Centre of Power

1. Harold Nicolson, *Diary*, Balliol, 19 December 1946.
2. Interview with Norman Reddaway, 23 January 1999.
3. Interview with Lord Thurlow, 21 January 1999.
4. Russian archives, Burgess's handwritten report.
5. Modin, pp. 130-1.
6. Boyle, p. 280.
7. Driberg, p. 62.
8. Rees, *Chapter of Accidents*, pp. 168-9.
9. *Chapter of Accidents*, original typescript, p. 40.
10. Boyle, p. 282.
11. Nigel West, *Crown Jewels*, p. 177.
12. Rees, *Chapter of Accidents*, p. 170.
13. Boyle, p. 282. See also *Chapter of Accidents*, pp. 170-1.
14. During previous occasions when the Russians had had to suspend operations with the Cambridge Ring, Blunt had acted as go-between for Burgess and Philby and he continued in such a role between June and October 1947 and February and March 1948, when contact was broken again. His role involved photocopying Foreign Office documents from Burgess, where he became adept with a second-hand Leica in his room at the Courtauld.
15. See 'The Russia Committee of the British Foreign Office and the Cold War, 1946-7', Ray Merrick, *Journal of Contemporary History*, Vol. 20, No. 3, July 1985, pp. 453-68.
16. Playfair often met Burgess at the Reform Club. He later claimed, 'I never sought his company because I rather disliked him for all the usual reasons and did not share his politics, but above all because I thought him a frightful bore . . . I am surprised that you find the material for a serious book centering on the life of anyone so evidently frivolous.' Letter, Edward Playfair to the author, 22 September 1998. Playfair, later the Permanent Under-Secretary at the Ministry of Defence, was interviewed by MI5 in the 1970s but cleared.
17. Nigel West, *Crown Jewels*, p. 175.

18. Leven, IWM 05/59/1.
19. Ibid.
20. Driberg, p. 71.
21. Fred Warner interview, quoted Boyle, p. 283.
22. Boyle, p. 283.
23. Patrick Reilly, Bodleian Library MS, England 6920.
24. Mitrokhin, p. 186.
25. Boyle, p. 284.
26. TNA, CSC 11/38 Z172650.
27. TNA, PREM 8/1524.

22. Russian Controls

1. Modin, pp. 150-1.
2. Ibid., p. 151.
3. Ibid., p. 152.
4. Ibid., pp. 152-3.
5. Ibid., p. 152.
6. Ibid., p. 153.
7. Ibid., p. 154.
8. Perry, *Fifth Man*, p. 62.
9. Ibid., p. 169.
10. Modin, p. 155.
11. Ibid., p. 156.
12. Driberg, p. 80.
13. Ibid., p. 71.
14. Rees, *Chapter of Accidents*, p. 164.
15. Robin Maugham, *Escape From the Shadows*, Hodder & Stoughton, 1972, p. 173; *Sunday People*, 15 March 1970. Burgess introduced Maugham to one of his lovers, 'Kurt', actually Jorgen Klixbull, a former member of the Danish Underground who later served with the British army, and allowed them to use his New Bond Street flat for assignations, which gave him a hold over Maugham.

23. Settling Down

1. Burgess to Pollock, undated, Pollock Letters.
2. Peter Parker, *Isherwood*, Picador, 2004, p. 404.

3. Leitch, p. 166.

4. Interview with Richard Scott, *Guardian* Archives, OHP/79/1.

5. Hewit, unpublished memoir. The harmonium had been recovered from a bomb-damaged house and Burgess had carried it on his back. Boyle, p. 335.

6. Hewit, quoted Leitch, p. 160.

7. *Empire News*, 25 September 1955.

8. Interview with Micky Burn, 15 August 1998 and Burn, p. 202.

9. Interview with Micky Burn, 15 August 1998.

10. Interview with Dadie Rylands, 1999.

11. Interview with Tony Burgess, 31 July 2012.

12. Jenny Rees to author, 17 May 2015.

13. *Chapter of Accidents*, p. 174.

14. Hartwell to Boyle, 21 September 1977, Add 9429/1G/115. Berry's *Party Choice: The Real Issue Between Parties* was published in 1948. See also 'When I shared a taxi with Guy Burgess and his apprentice fiancée, dropping him at his flat, he did not ask me up.' Hartwell to Boyle, 5 August 977, Boyle Papers, Add 9429/1G/112; cf. Boyle, p. 335.

15. Interview with Nigel Burgess, 16 October 1985.

16. Interviews with Nigel Burgess, 21 January 1986; Dadie Rylands, 1998; Fanny Carby, 17 October 1998. Jack Hewit in his unpublished memoir also writes that Clarissa Churchill was engaged to Guy.

17. Peter Wright, *Spycatcher*, Viking, 1987, pp. 242-3. Rees told MI5's Ronnie Reed 'that at one time Burgess was having an affair with Clarissa Churchill, now Lady Eden. I said I was well aware of this and that I agreed that it was a dangerous matter. I did not however know to what extent it was true and to what extent one could believe Burgess's claims. Rees also professed himself to be unable to shed any light upon this.' TNA, KV2/4113 15th March 1956. Burgess wrote to his mother on 9th March 1956 'Talking of girlfriends, I wonder what would happen if I sent my congratulations to Clarissa on her marriage to Sir Anthony Eden? The same of course applies to Esther – who I really should have married. Perhaps if she comes here with you we may change our minds – unless she's found someone, not better, but else. I hope she has.' TNA, KV2/4114.

18. Rees, *Chapter of Accidents*, p. 175.

19. Michael Burn, *The Debatable Land*, p. 234.

20. Rees, *Chapter of Accidents*, p. 176.

24. The Information Research Department

1. TNA, FO366/2759.
2. Imperial War Museum Sound Archive 12566, Reel 2, Christopher Mayhew interview, 1992, and Christopher Mayhew, *Time to Explain*, Hutchinson, 1987, p. 109. Email Gill Bennett to Andrew Lownie 17th December 2015.
3. Interview with Hugh Lunghi, 25 January 1999.
4. Mayhew, quoted Penrose, p. 323. See also Reel 2, Christopher Mayhew interview, Imperial War Museum Sound Archive 12566.
5. FO371/68068 A AN1614 TNA.
6. Andrew Defty, *Britain, America and Anti-Communist Propaganda 1945-1958: The Information Research Department*, Frank Cass, 2003, p. 76.
7. Nigel West, *Crown Jewels*, p. 177 and Driberg, p. 78.
8. Interview with Ronald Grierson, 27 July 2009. Cf. Ronald Grierson, *A Truant Disposition*, Weidenfeld, 1992, p. 20.
9. Rosemary Say and Noel Holland, *Rosie's War*, Michael O'Mara, 2011, pp. 272-3.
10. Interview with Michael Alexander, 7 September 1998.
11. Henry Brandon, *Special Relationships*, Atheneum, 1988, p. 49.
12. Ibid.
13. Nigel West, *Crown Jewels*, p. 178.
14. See TNA, FO371/70486, especially 16, 22 and 26 June 1948.
15. TNA, FO371/70486.
16. Driberg, pp. 72-3.
17. Nigel West, *Crown Jewels*, p. 178.
18. Brian Urquhart, *A Life in Peace & War*, Weidenfeld & Nicolson, 1987, p. 117.
19. Tim Milne, *Kim Philby: The Unknown Story of the KGB Master Spy*, Biteback, 2014, pp. 171-2.
20. Ibid., pp. 173-4.
21. Patrick Seale and Maureen McConville, *Philby: The Long Road to Moscow*, Hamish Hamilton, 1973, p. 192. Philby later remembered how Burgess showed considerable interest in Esther and 'speculated freely about her feelings for him. At the time, I took this for another flight of fantasy on his part and paid little attention to it.' TNA, KV2/4102 Philby unpublished memoir.
22. Milne, pp. 171-2. Burgess refers to the episode in an undated letter written to Harold Nicolson from Moscow, where he says he dove

'from my bedroom window on the first floor . . . nearly breaking my neck by hitting a dolphin'.

23. Ibid., p. 173.
24. Ibid.
25. Ibid., pp. 173-4.

25. The Far East Department

1. Nigel West, *Crown Jewels*, p. 178. Sir Esler Dening was the Under-Secretary responsible for the department.
2. Ibid., p. 179.
3. Margaret Anstee, *Never Learn to Type*, Wiley, 2003, p. 81.
4. Tom Driberg, *Guy Burgess*, pp. 80-1.
5. Christopher Andrew and David Dilks, *The Missing Dimension*, p. 189.
6. TNA, FO371/75747; cf. TNA, FO371/75749, 23 April 1949 minute on Chinese response.
7. Peter Hennessy and Kathleen Townsend, *The Documentary Spoor of Burgess and Maclean, Intelligence and National Security*, April 1987, p. 292.
8. TNA, FO371/75766, 26 May 1949.
9. Ibid.
10. Christopher Baxter, *The Great Power Struggle in East Asia, 1944-50: Britain, America and Post-War Rivalry*, Palgrave, 2009, p. 148.
11. Penrose, p. 324.
12. Liddell, *Diary*, 9 August 1949. Interview with Bill Freedman.
13. TNA, FO371/83315.

26. Disciplinary Action

1. Maugham Papers, Indiana University, Harold Nicolson to Robin Maugham, 14 February 1949. I am grateful to Selina Hastings for alerting me to this. In fact it was St Mary's not the Middlesex. Warner gave a different account to Boyle claiming by chance he came across Burgess after the accident, while looking in at the club to make sure Guy was OK, Boyle, pp. 318-19, but Hewit confirms the Maugham version, Leitch, p. 164.
2. *Irish Times*, 31 October 1967.
3. Terence de Vere White, *A Fretful Midge*, Routledge, 1959, p. 163.
4. *Dublin Evening Mail*, 4 March 1949.

5. *Dublin Evening Herald*, 4 March 1949; cf. *London Evening Standard*, 5 March 1949. Michael Killanin reviewing Michael Straight's autobiography gives a slightly garbled version with the wrong date. 'The last time I saw him was in Stephen's Green in 1951, when he was rolling down the street fairly late at night. He recognised me and I walked him back to the Shelbourne Hotel, where he was staying with his mother. She explained that he had had a nervous breakdown and was just recovering. Not knowing what to do with a drunk, I gave him another drink. Soon afterwards, in a Dublin evening paper, I read that a civil servant named Burgess had been in a car crash in O'Connell Street. He was whisked out of the country by the British embassy, and the next I heard was of his departure to the Soviet Union with Donald Maclean later that year.' He continued that he thought of all the Cambridge Spies, Burgess was 'the most important and dangerous. I never found him the Adonis he is frequently described as, but rather a grubby, chain-smoking alcoholic with black fingernails and a chip on his shoulder dating from the days at Eton when he was in the Sixth Form but was not elected to the Eton Society [Pop], the self-elected prefects of the school . . .' 'Voice of a Generation', *Irish Times*, 5 March 1983. According to Modin, in August 1949, 'while drunk and driving through a village in Ireland, he ran over and killed a pedestrian. His passenger, another Intelligence man, ended up badly injured and in hospital. Perry, *Fifth Man*, p. 169. There was a fatal collision in Dublin reported alongside Burgess's accident in March 1949 and the two may have been confused. James Liddy, *The Doctor's House*, Salmon Press, 2004, p. 37, describes Burgess being drunk on his trip to Arklow.

6. Rees, *Chapter of Accidents*, p. 182.

7. *How Do You Do*, Dil Rohan, unpublished memoir, pp. 259–60. Greaves was a homosexual Australian journalist, a long-time Tangier-based stringer for *Express* newspapers with close links to British intelligence, and figures as the MI6 head of station in Tangier in Roger Croft's novel *The Wayward Spy*.

8. Security Service archives, quoted *Defence of Realm*, p. 422. See also Rees, *Chapter of Accidents*, p. 180. It's thought Greaves also complained.

9. See TNA, KV2/98.

10. Guy Liddell, *Diary*, 23 January 1950.

11. Ibid., 17 February 1950.

12. Macmillan in debate, 7 November 1955, Hansard.

13. Chapman Pincher later claimed Burgess 'had been under deep suspicion before the Foreign Office made the blunder of posting him to the British

Embassy in Washington. While I was shooting in North Yorkshire, one of the guns, whom I had never met before, described how, as a young Army officer, he had been transferred against his will, to a post specially created for the purpose so that he could keep Burgess under surveillance, which he did for several months.' Chapman Pincher, *Pastoral Symphony*, Swan Hill Press, 1993, p. 46. The family of the army officer, Richard Birch-Reynardson, then in his mid-twenties, said they had no knowledge of this role, but he did serve in Washington at the right time.

14. Penrose, p. 326. Valentine Vivian wrote to Carey Foster on 19th January 1950 'We both agree that Burgess is not only an exceptional character but a very difficult problem. His knowledge both of MI5 and SIS, where he has numerous friends, is though perfectly legitimate, quite extensive. I do also understand that he has influential friends on high levels in the Foreign Office.' TNA, KV2/4101.

15. Nigel West, *Crown Jewels*, p. 181.

16. Ibid., p. 180.

17. Harold Nicolson, *Diary*, 24 January 1950.

18. Harold Nicolson, *Diaries 1945-62*, p. 184.

19. Nigel West, *Crown Jewels*, p. 184

20. Anthony Purdy and Douglas Sutherland, *Burgess & Maclean*, Secker & Warburg, 1963, p. 91.

21. Leven, IWM 05/59/1.

22. Fanny Carby interview, 17 October 1998.

23. TNA KV2/4101.

24. TNA, PREM 8/1524.

25. Hewit, unpublished memoir.

26. Bernard Burrows, *Diplomat in a Changing World*, The Memoir Club, 2001, p. 59. Burrows was a year ahead of Burgess at Eton. 'I am not in favour of a biography of Guy Burgess being written and therefore regret that I am unable to help you.' Letter from Burrows to author, 9 April 1999.

27. Robert Mackenzie interview, quoted Boyle, p. 352.

28. Fred was Anthony Blunt.

29. TNA, KV2/981, MI5 Papers Note from B Division section B2a to Mr B. A. Hill, 15 August 1950.

30. Hewit, unpublished memoir. Timing from Isaiah Berlin's invitation card.

31. Rees, *Chapter of Accidents*, p. 189.

32. Hewit, unpublished memoir. According to Douglas Sutherland, who knew Burgess and heard it from Rees, the man in the bottle incident was Peter Wilson, later chairman of Sotheby's, and the writer was

Harold Nicolson. Douglas Sutherland, *Portrait of a Decade: London Life 1945-1955*, Harrap, 1988, p. 186.

33. Hewit, unpublished memoir; cf. Boyle, pp. 352-3. Robeson was a black, homosexual communist actor.

27. Washington

1. Seale, p. 208.
2. Rees, *Chapter of Accidents*, p. 195. Philby later wrote in an unpublished memoir 'my wife found him a source of such constant irritation that I was forced, about Christmas or the New Year, to ask him to hurry in his search for alternative accommodation. He undertook to do so, and, after some delay, found a flat in Georgetown, for which he signed a contract with some effect from April 1st' TNA, KV2/4102. In the end Burgess was recalled before he could move.
3. Undated Pollock letters.
4. 'A Master Spy's Son', *Daily Mail*, 3 January 1998.
5. Nancy McDonald Hervey to the author, 25 February 2012.
6. Francis Thompson, *Destination Washington*, Robert Hale, 1960, p. 208.
7. Ben Macintyre, *A Spy Among Friends*, Bloomsbury, 2014, says he was the Information Officer, p. 142, but provides no evidence and it is not supported by any official documentation. The Information Officer as second secretary was Howard Smith, later Director General of MI5, 1978-81. Burgess's biographical entry in the Foreign Office List has him as a second secretary in the embassy, but he is not listed on the embassy roll call.
8. Denis Greenhill, *More By Accident*, privately published 1992, p. 73, and article draft TNA, FCO12/209.
9. According to Driberg, p. 83, 'He was also required to concern himself with Middle Eastern affairs.' The move to the Middle East section at the end of 1950 is supported by Burgess's personnel file, which also says he was 'reporting on United States internal politics'.
10. TNA, FO115/4483.
11. FBI interviews, 2/9, p. 77, Burfile 100-374183 sec 5/6.
12. FBI files, 100-374183, interview 14 July 1951.
13. Holzman, p. 318.
14. Greenhill, p. 73.
15. *The Times*, 7 September 1977. Copies of the original article and correspondence with the Foreign Office about publication can be found at TNA, FCO12/209.

16. Michael Marten, *Tim Marten: Memories*, Lulu Enterprises, 2010, p. 139.
17. Ibid., p. 129.
18 TNA, FCO 158/29 Philby unpublished memoir p.8.
19. Guy Burgess to Peter Pollock, undated, Pollock Letters.
20. FBI file, bufile 100-374183, p. 158.
21. Ibid., 2/42, pp. 88-9.
22. Driberg, p. 77.
23. One of the people the FBI interviewed said he had met Burgess there in early September 1950 and he claimed to be working with Jebb at the United Nations.
24. FBI interview with Valentine Lawford and interview with Costello, p. 538.
25. Newton, p. 281.
26. More details on Makayev can be found, Mitrokhin, p. 205.
27. Martin Young to the author, 4 September 2000. Members of the embassy took turns to take the fortnightly diplomatic bag to Cuba, as the King's Messengers only worked on a monthly rotation.
28. Martin Young to the author, 4 September 2000.
29. Interview with Stanley Weiss, 17 June 2015.
30. Brandon, pp. 109-10.
31. Two years before, Welles had been found semi-conscious in a field near his baronial 500-acre estate, Oxon Hill Manor, 10 miles south of Washington, his fingers and toes frozen by seven hours' exposure in 15° temperature, and his clothes, covered with mud and sand, were frozen to his body. It was assumed to have been some sort of homosexual encounter that had gone wrong.
32. Michael Berry, Lord Hartwell, to the author, 2 July 1998.
33. Newton, p. 312.
34. CUL, Boyle Papers, Michael Berry to Boyle, 27 April 1977.
35. David Martin, *Wilderness of Mirrors*, Collins, 1980, p. 53.
36. FBI files, interview with Jim Angleton.

28. Disgrace

1. Wilfred Mann, *Was There a Fifth Man?*, Pergamon Press, 1982, pp. 82-5. Accounts that he drew her with skirts hitched up and her naked pudenda showing are fanciful.
2. Ibid., p. 83. Newton, pp. 301-11.
3. Newton, p. 311.

4. Mann, p. 84. Holzman, p. 326, says Mann is the only witness to this scene and speculates that it is made up. Philby noted in his unpublished memoir 'Guy's misfortune was that however extravagant and noisy the company in which he found himself, there always lurked just below the skin an urge to commit that final outrage, the outrage that shocked and repulsed . . . on such occasions there was little to be done save try to limit the repercussions.' TNA, FCO 158/29 p.4.

5. Boyle, pp. 308-9. Michael Holzman, *James Jesus Angleton, The CIA & the Craft of Counterintelligence*, University of Massachusetts Press, 2008, p. 167.

6. Ibid., p. 310.

7. Bodleian Library, MS England, c.6920, Maclean: Burgess: Philby, p. 230. Reilly described Mann as 'an atomic spy', MS, Eng c. 6932, folio 57. A colleague of Mann, Arnold Kramish, 'nearly encountered' Burgess 'several times at Wilfrid Mann's home', suggesting the relationship was closer than Mann has claimed. Arnold Kramish, email to the author, 17 June 2003.

8. Nigel West, *Historical Dictionary of British Intelligence*, Scarecow Press,2014 pp 363-364 ; Jerry Dan, *Ultimate Deception: How Stalin Stole the Bomb*, Rare Books & Barry, 2003.

9. The CIA was not apprised of VENONA until 1952 although, according to CIA historian Hayden Peake, Harvey may have informed the CIA after he joined the agency in 1947.

10. Homer was identified because the cable revealed he was travelling to see his pregnant wife in New York. The identifying signal can be found at: https://www.nsa.gov/public_info/_files/venona/1944/28jun_kgb_mtg_donald_maclean.pdf.

11. In fact there had already been a warning, as Patrick Reilly noted in his memoirs. A Foreign Office employee Patience Maitland-Addison, who had served in MI5, 'felt bound to report to Robin Hooper, who had also been in Paris and who had now succeeded Middleton in the Personnel Department, that at a party in the early hours of the morning Maclean, by then drunk, had declared inter alia "I am the English Alger Hiss". Hooper had minuted this letter to Ashley Clarke, "It seems that Donald is up to his old tricks" and left it at that. This was alas typical of the way Maclean's case was handled by the Foreign Office Administration.' Bodleian, MS England, 6920, p. 239.

12. Seale, p. 211.

13. Pollock letters, Burgess to Pollock, postmarked 16 January 1951.

14. Driberg Papers, Christ Church, Burgess interview with Tom Driberg.

15. FBI, bufile 100-374183, interview, 14 July 1951.
16. Ibid.
17. TNA, FCO 158/29 Philby unpublished memoir pp16-17.
18. Patsy Jellicoe interview, 1 November 2003. Amongst those he proposititioned was Stewart Rockwell, the political adviser to the US Delegation to the UN General Assembly.
19. TNA, KV2/4102 Philby unpublished memoir. The proposal seems to have been made by 29th January 1951 when Eve Bassett wrote to her son 'I have not said anything about your marriage, it so hard really to write anything and I feel inclined to shelve it till I see you. I had such a very nice letter from Esther, so I really can't shelve it, as hers must be answered, though a very difficult letter to write. You say nothing more about the apartment you thought of taking.' TNA, KV2/4103. From Moscow Burgess would write to his mother of Esther 'I really should have married. Perhaps if she comes here with you we may change our minds – unless she's found someone, not better, but else. I hope she has. She deserves it.' TNA , FCO 158/10, Guy Burgess to Eve Bassett March 1956.
20. Interview with Alan Davidson, 7 April 1999.

29. Sent Home

1. In his FBI interviews on 13 and 19 June 1951, Turck claimed he had been picked up at 10 a.m. at Fredericksburg in Virginia, but in his affidavit of 28 February 1951, Turck admitted he had known Burgess for some time. 'I didn't have anything to do for a couple of days and agreed to go with him on this trip.' Turck had only just been released from prison the previous September on a rape charge changed to aggravated assault. TNA, KV2/4104.
2. Newton, p. 314. See also Turck statements, 13 June and 22 June, FBI vault 2/42, p. 4. Burgess later claimed he was insulted to be charged with driving at 80mph, 'as I was doing over a hundred'. Driberg, p. 85.
3. FBI files, interview with Turck, 19 June 1951.
4. The keynote speaker at the conference was the Deputy Director of the Office of West European Affairs at the State Department, Dr Francis Williamson, who spoke on 'The Problems of Europe in American Foreign Policy'. Other speakers included a second secretary from the French Embassy on 'Indo-China and Problems of Asia' and professors

from Duke and Princeton.

5. The *News and Courier*, Charleston, 1 March 1951, quoted Holzman, p. 330.

6. Telephone interview with Colonel Loma Allen 7th March 2016.

7. There are some suggestions the speech was only delivered, not written by Burgess. FBI vault 2/42, p. 41.

8. Emily Whaley, *Mrs Whaley & her Charleston Garden*, Algonquin Books, 1997, p. 174.

9. US National Archives, 601.4111/3-1451, 14 March 1951.

10. FBI files, quoted Holzman, pp. 331-2.

11. US Archives, 601.4111/4-1851, 18 April, C.E. Steel to John Symonds. TNA, PREM 8/1524.

12. Greenhill, p. 75. Hewit writes in his unpublished manuscript, though perhaps wise after the event, 'I remember one particular night when we had been out drinking, he said, "I don't think I shall be there very long." "What do you mean," I asked."Oh," he said. "I'll get myself made persona non grata." "How?" I asked. "Well," he said, "I'll get myself arrested or something." I thought he was joking and so we drunkenly enlarged on this and invented several ways he might get himself arrested. One way we enlarged upon was that he should have himself arrested for speeding while drunk in the company of a black homosexual, preferably somewhere in the South.' Robert Mackenzie told Carey Foster that one of the options might have been 'a direct transfer to one of the smaller and less pleasant posts in Latin America' TNA, FCO 158/20 22nd June 1951.

13. Robert Cecil, 'The Cambridge Comintern' in Christopher Andrew and David Dilks (eds.), *The Missing Dimension: Governments and Intelligence Communities in the Twentieth Century*, Macmillan, 1984, p. 193.

14. Straight, pp. 249-50.

15. Ibid., p. 251. In his account to the FBI in 1963, 'Straight told Burgess that he should get out of his employment with the British government within a period of three months and if he did not do so he, Straight, would go to the United States government and report the fact that Burgess was working for the British government and that he was a communist.' FBI Files.

16. For accounts see Carter, pp. 339-40. John Blamey in his taped interview with Miranda Carter surmises that Straight was a closet gay.

17. Perry, p. 239.

18. Greenhill, p. 73.
19. Thompson, p. 213.
20. Pollock letters, Burgess to Pollock, postmarked 28 April.
21. Philby, *My Silent War*, p. 171.
22. Luker, FBI files, Philby 6c, pp. 36ff, quoted Holzman, p. 334.
23. *Daily Mirror*, 1 November 1952.
24. FBI files, interview, 15 August 1951, probably with Norman Luker.

30. Back in Britain

1. There is no mention of a Bernard Miller in the passenger manifest, but a fellow passenger was a Donald Maclean.
2. Modin, p. 201.
3. Interview with Jenny Rees, 1999.
4. See Rees, *Chapter of Accidents*, pp. 197-201, for a full account of the visit.
5. Ibid., p. 199.
6. Ibid., p. 201, Rees was to recreate the visit in a screenplay *Influence*, which he wrote in the 1970s.
7. LSE archives, Morrison 8/5, Hannock to Morrison, 2 Sept 1955, and TNA, PREM 8/1524 . Burgess career note, D.F. Muirhead, 1 June 1962, released under Internal Review FOI 0023-15, 6 May 2015 confirms.
8. Hewit, unpublished memoir. Burgess had arranged for Murray Gladstone, an Old Etonian homosexual friend working in the 'Duty Free' department of Selfridges, to take his place in the flat whilst he was away. The two had become friendly again in 1935 when Gladstone had offered Burgess the use for holidays of a nine ton ketch which Gladstone kept on the Essex Coast. TNA, KV2/4110, Murray Gladstone interview 23rd November 1953.
9. Cyril Connolly, 'The Case of the Missing Diplomats' in *The Reporter*, 23 December 1952, p. 28 and *The Missing Diplomats*, p. 32.
10. Quentin Bell, *Elders and Betters*, John Murray, 1995, p. 205.
11. Leven, IWM 05/59/1.
12. Timothy Johnston to the author, 22 April 1988. There is no evidence, as suggested by some spy writers, that Kemball Johnston was anything but a loyal British subject.
13. Hewit unpublished memoir.
14. Philosophy at Cambridge newsletter, Issue 6, May 2009.
15. Rees, Mr Nobody, p. 186.
16. Burgess was elected to the RAC in 1946. Club records show he resigned

in November 1951. Driberg, pp. 93-4.

17. Bodleian, MS England, 6920, p. 241.

18. Ibid., p. 257.

19. Perry, *Fifth Man*, p. 190. The meeting was near the park lavatories by Ealing Common underground.

20. Robert Cecil, *A Divided Life: A Biography of Donald Maclean*, Bodley Head, 1988, p. 136.

21. Yuri Modin interview, October 2003.

22. Modin, p. 206.

23. *Deadly Illusions*, p. 338.

24. Security Service Archive, quoted Christopher Andrew, *Defence of the Realm*, p. 425. Chapman Pincher has claimed that seven other Britons were under surveillance at the same time: Blunt, Rees, Anthony Rumbold, David Footman, Philby, an unnamed MI6 officer, plus one other. Chapman Pincher, *Traitors*, Sidgwick, 1987, p. 243.

25. Bodleian, MS England, c.6932, Carey-Foster to Reilly, 18 November 1984, and interview with Bill Freedman.

26. Guy Liddell, *Diary*, Friday 18 May.

27. Tom Bower, *Dick White: The Perfect English Spy; Sir Dick White and the Secret War 1935-90*, Heinemann, 1995, p. 110.

28. Bodleian, MS England, 6920, Patrick Reilly, p. 242.

31. The Final Week

1. TNA KV2/4132, Pollock interview 12th June 1951.

2. TNA, KV2/4102 Esther Whitfield to Guy Burgess 18th May 1951.

3. Hewit, unpublished memoir.

4. Guy Liddell, *Diary*, 30 May 1951.

5. Hewit, unpublished memoir. Barley Allison claimed to have dined with him at the Gargoyle that night, one of several people who later claimed to have had that pleasure in the final week, telling her he wanted to start a new life in the Middle East or North Africa. Luke, p. 194.

6. CUL, Add 9429/1G/411(ii), Robert Birley interview with Andrew Boyle, 18 April 1977.

7. After Burgess fled, police came to the house and tore out the page from the visitor's book. Interview with the owner at the time, John Guest, 2 February 1999.

8. Interview with Fanny Carby, 17 October 1998.

9. Hewit, unpublished memoir.

10. Ibid.

11. Humphrey Carpenter, *W.H. Auden, a Biography*, Allen and Unwin, 1981, p. 369.

12. Rees, *Chapter of Accidents*, p. 205.

13. TNA, CAB 134/1325.

14. FBI files and Costello, pp. 550–1.

15. Connolly says blue jeans and gaudy collection of ties, whilst Penrose says Hewit's overcoat, which Hewit recognised Burgess wearing in Russia.

16. Nigel West, *Molehunt*, Weidenfeld & Nicolson, 1987, p. 137 and Costello, p. 556. Russell Lee, who was the Director General Sir Percy Sillitoe's personal assistant and was doing night duty, was emphatic MI5 knew of their escape on Friday evening. It was confirmed to Nigel West quite separately by Arthur Martin. E mail Nigel West to the author 4th January 2016. Candida Tobin in her autobiography *Lifting the Lid*, Helicon Press, 2003, pp. 72-3, claims she was invited by Jack Hewit, with whom she acted in the Kings Cross Players, to give a joint party that night. 'I was to provide the food and he would provide the wine.' When she turned up at Bond Street there was no answer. Later she rang and 'Guy (I knew his voice) whispered crossly down the phone, "Jack's not here. Don't phone again." He immediately put the phone down. That was the weekend Guy Burgess went missing . . .'

17. According to one contemporary account, a sixty-five-year-old London produce importer, William Lyons, reported a tall, clean-shaven man in a homburg and raincoat, had met the two men as they boarded, and escorted them to St Malo, returning to Britain. Mather, p. 68; More details, Donald Seaman to Donald McCormick, 20 January 1980, McCormick Papers.

32. The Bird Has Flown

1. Interview with Lady Williams, 27 January 2015. Churchill was only leader of the opposition – he would become Prime Minister in October – so it's strange he should be informed. Jane, now Lady Williams, continued to work for Churchill until 1955 and according to her, contrary to accounts, Churchill was to take a close interest in the case, advised by his private secretary, John Colville – Burgess's fellow member of the Trinity History Society.

2. Anthony Cavendish, *Inside Intelligence*, Collins, 1990, p. 62.

3. W.A.P. Manser, 'Do You Want Me to Kill Him?', *Spectator*, 20 May 1995.

4. Penrose, p. 354.
5. Interview with Mary Hardy, 23 May 2015.
6. Rees, *Mr Nobody*, p. 162; Cecil, p. 146.
7. Rees, *Chapter of Accidents*, p. 208.
8. Cecil, p. 145.
9. FBI interview with Melinda Maclean, 2 September 1981.
10. Genrikh Borovik and Phillip Knightley (eds.), *The Philby Files*, Little Brown, 1994, pp. 279-80; Damaskin, pp. 192-3; Modin, p. 203.
11. Modin, p. 207.
12. FBI 1955 Summary Report on Burgess and Maclean, Oetking interview 24th June 1954, quoted Costello, p. 556 and TNA, KV2/4151.
13. Bodleian, MS England, c.6920, p. 243.
14. Bodleian, MS England, c.6932, Maclean: Burgess: Philby, p. 82.
15. Ibid.
16. Hewit, unpublished memoir,
17. Bower, pp. 116-17 and TNA, KV2/2588.
18. Penrose, p. 358, based on an interview with Rosamond Lehmann, 1985, but this may just have been mischief making on Blunt's part.
19. Nigel West, *MI5 1945-1972*, Coronet edition, 1983, pp. 50-1; Chapman Pincher, *Too Secret Too Long*, Sidgwick & Jackson, 1984, p. 394; Chapman Pincher, *Their Trade is Treachery*, Sidgwick & Jackson, 1981, p. 142.
20. As Peter Benenson (his mother's maiden name) he founded Amnesty International in 1961.
21. Wright, *Spycatcher*, pp. 173, 260. Incensed by the anti-Israeli tone of Philby's articles for the *Observer* in 1962, she told Lord Rothschild about Philby's confession to her and subsequently was interviewed by MI5, also naming Tomas Harris and Dennis Proctor as fellow recruits. The concrete evidence for Philby's treachery had finally come from one of his oldest friends.
22. Pollock interview tape, by permission of Miranda Carter.
23. Bodleian, MS, c.6932, George Carey-Foster, 'Notes on Patrick's Maclean: Burgess: Philby', p. 83.
24. Philby, p. 172. Borovik, p. 286, places it as Wednesday or Thursday, but that is too late.
25. Borovik, p. 287.
26. Newton, p. 333.
27. Interview with Bill Freedman, 1995.
28. Alan Pryce Jones to Boyle, 2 December 1979, Add 9429/1G/369. The dinner is perhaps most memorable as the occasion when John Betjeman

and Lady Elizabeth Cavendish first met, which led to a love affair that continued until his death over thirty years later.

29. LSE Archives, Morrison 8/5.
30. Guy Liddell, *Diary*, 30 May 1951.
31. Ibid.
32. Ibid.
33. TNA KV2/4114. Playfair was cleared but speculation about Zaehner, who spent a year at Cambridge and served as an MI6 officer in Tehran during the Second World War, continues. See Costello p.506.
34. Penrose, p. 356.

33. The Story Breaks

1. See Arthur Christiansen, *Headlines All My Life*, Harper & Brothers, 1961, pp. 263-9, for a full account.
2. Mather and Seaman, p. 87.
3. Harold Nicolson, *Diary*, 7 June 1951.
4. Alan Maclean, p. 103.
5. Rees, *Chapter of Accidents*, pp. 214-15.
6. Georgetown University, Cave Brown Papers, Attached to letter to James Eastland, chairman Internal Security sub-committee, Committee of the Judiciary.
7. See Comments on 'Effect of Disappearance on Anglo-US relations in US press comments'. TNA, FO371/90931.
8. Nigel West, email to the author, 17 January 2015.
9. TNA, PREM 8/1524, 13 June 1951, briefing to PM. Bland's recommendations can be found, TNA, CAB 301/17 – CAB 301/23.
10. TNA, PREM 8/1524.
11. Harold Nicolson, *Diary*, 11 June 1951. Lord Simon, who had known Maclean's father, thought the two men had been drugged, kidnapped and then killed by Soviet agents. Bodleian Library, MS Simon 99, folios 141-7, 'The Mystery of Maclean and Burgess'.
12. TNA, PREM 11/4457.
13. Liddell, 12 June 1951.
14. TNA, KV2/4103.
15. Hewit, unpublished memoir.
16. TNA, KV2/1675 , interview with Rosamond Lehmann, August 1985.
17. TNA, KV2/2588/51.
18. TNA, KV2/3215.

19. TNA, KV2/1675, 3 August 1951 and KV2/790,

20. Andrew Sinclair, *War Like a Wasp: The Lost Decade of the Forties*, Hamish Hamilton, 1989, p. 276. Lehmann had got to know Burgess during the late 1930s and later wrote of him, 'He was an extremely intelligent, sanguine character, with a boisterous sense of fun and a malicious edge to his tongue. Not creative himself, he nevertheless had an immense interest in the writers who were my contemporaries, particularly Wystan Auden and Stephen Spender . . .' John Lehmann, *The Ample Proposition*, Eyre & Spottiswoode, 1966, p. 127.

21. Guy Liddell, *Diary*, 26 June 1951. Amongst those Victor Rothschild named as possible spies were Alister Watson and Jenifer Hart - both of whom later partially confessed.

22. Ibid., 12 June 1951.

23. Ibid.

24. Ibid., 18 June 1951.

25. FBI files. The car was eventually sold to a vintage car dealer five years later for $35 after being stored at taxpayer's expense. Burgess's pre-war open-top Ford V8 was sold to Goronwy Rees's parents-in-law in 1948 when he was given another car by the Russians and eventually ended up as 'a noble hen house' on a Devon farm. Interview with Mary Hardy, 23 May 2015.

26. FBI interview with Bernard Miller, 14 June 1951.

27. TNA, FO115/4524, Tim Marten to Roger Makins, 20 June 1951.

28. Bill Freedman interview, 1995.

29. Jim Angleton also produced an assessment of Philby's complexity but without coming to the same conclusions.

30. Interview with Nigel Clive, 20 November 1998. It seems to have been a favourite trick. Miriam Rothschild tells a similar story also about Pruniers.

31. Carter, p. 349, and Purdy, p. 148.

32. *Time* Magazine, 18 June 1951.

33. Carpenter, p. 369.

34. 'Seventh Eighth Men Uncovered', *London Review of Books*, Vol. 3, No. 8, 7 May 1981, p. 8. Grigson, who worked with Burgess at the BBC, later described him as 'Bumptious, to use an old-fashioned word. Always using the Christian names of the great, the politically great or prominent, the Whitehall people who were talked about and who talked to him, and had done so only that morning or the previous evening . . . And then his appearance. He glanced at you with quick rather shifty eyes, to see if you were taking proper notice of the way he was analysing

this or that situation.' Geoffrey Grigson, *Recollections*, Chatto and Windus, 1984, p. 170.

35. Stanley Karnow, *Paris in the Fifties*, Random House, 1997, p. 52. A rough translation is, 'I'm sorry to bother you, but are the English diplomats Burgess and Maclean here by any chance?'

36. *Irish Times*, 11 June 1951. One member of the public wrote to report the missing diplomats were 'dead and buried under my floor. This is a true statement and I claim the reward which still holds good. Now what about getting busy on this horrible murder at once. It will be four months next week, so you may guess what they are like by now.' TNA, FCO 158/25.

37. *Washington Star*, 17 June 1951; *Times Herald*, 19 July 1951.

38. *Washington Post*, 14 January 1952; *Irish Times*, 15 January 1952.

39. *Daily Graphic*, 30 June 1952.

40. *Washington Post*, 2 July 1951.

34. Repercussions

1. Guy Liddell, *Diary*, 27 June 1951.
2. Ibid., 7 July 1951.
3. Ibid., 10 July 1951.
4. Ibid., 13 July 1951.
5. Ibid., 1 October 1951.
6. Ibid., 7 December 1951.
7. Ibid., 9 August 1951. In fact Bedell Smith did know about VENONA through Bill Harvey. USCIB is the acronym for the U.S. Communications Intelligence Board, the body created in 1946 that co-ordinated American SIGINT resources but did not necessarily see all the product.
8. Ibid., 20 August 1951.
9. Ibid., 14 November 1951.
10. Interview with Robert Cecil, 16 March 1984, Cherry Hughes papers.
11. TNA, CAB 134/1325.
12. Guy Liddell, *Diary*, 19 December 1951.
13. Ibid., 3 April 1952. The fact that Cairncross had been seen by watchers discarding a copy of a recent copy of the *Communist Review* in a bin in a London park didn't help his protestations of innocence.
14. Ibid., 6 March 1952. TNA, KV2/4107, memo 29th January 1952.
15. Ibid., 21 April 1952.
16. Ibid., 5 September 1952. After allegations were made in *Time Life* and

Kenneth de Courcy's *Intellignce Digest* that Warner had had a homo-sexual relationship with both Burgess and Hewit, Warner was inter-viewed by Carey Foster on 29th May 1952. He denied the accusations but was sent to Rangoon to keep him out of the way. TNA, FCO 158/254. There, according to Harold Nicolsn's diary, he had an affair with Peter Townsend who had almost married Princess Margaret.

17. Ibid., 7 July 1952.
18. *Daily Express*, 7 June 1951.
19. *The American Weekly*, 25 January 1953, pp. 8, 11.
20. Initially MI5 thought Connolly might have privileged information and tapped his phone, but they concluded he knew as much as they did.
21. TNA, FO800/432, 21 June 1953.
22. I am grateful to Tony Burgess for providing this letter.
23. Duncan Webb, *Line-Up For Crime*, Muller, 1956, pp. 15, 16.
24. Webb, pp. 59-66 and *The People*, 19 December 1954. Anthony Gibbs, *In My Times*, Peter Davies,1969, pp. 188-221, has a similar story of how his colleague Charles Fry, a friend of Burgess at the publisher Allen Wingate, was approached by a Mr Farinetti offering to produce Burgess, in return for £11,000, if he went to a bar in Ravenna, where the owner would arrange a meeting with Burgess in Switzerland.

35. Petrov

1. KV2/3440. The files on the Petrov case are KV2/3439-KV2/3488. MI5 were worried that Philby might be exfiltrated at the same time and a watch was put on ports. It was hoped that Kislytsin would also defect. Vladimir Petrov, *Empire of Fear*, Andre Deutsch, 1956, pp. 271-2.
2. Eden, 24 September 1955, PREM 11/1578 and Sir Arthur De La Mare, *Perverse and Foolish*, La Haule Books, 1994, p. 104.
3. Nigel West, *Molehunt*, Weidenfeld & Nicolson, 1987, pp. 185-94, reproduces the paper with italics highlighting the parts known to be untrue.
4. *The Times*, 24 September 1955.
5. *Spectator*, 23 September 1955.
6. TNA, CAB 129/79, CP 55 (161).
7. *Daily Express*, 28 October 1955.
8. *The Times*, 5 November 1955.
9. TNA, CAB 134/1325, Arrangements for Security Conference of Privy Counsellers.

10. HC Deb, 7 November 1955, Vol. 545, cc.1483-611 for the whole debate.
11. House of Lords Debate, 22 December 1955.

36. The Missing Diplomats Reappear

1. Room 101 figures as the torture chamber in George Orwell's *1984* and one wonders if the Russians were having some sort of private joke.
2. Richard Hughes, *Foreign Devil*, Deutsch, 1972, p. 130.
3. *Foreign Devil*, p. 130. Weilland's account can be found in Nick Moore (ed.), *Frontlines: Snapshots of History*, Reuters, 2001, pp. 40-1.
4. Driberg, pp. 121-4, for whole text.
5. *Foreign Devil*, p. 130.
6. Interview with Sidney Weiland, 3 February 1999.
7. Pollock letters, Guy Burgess to Sheila Pollock, 20 May 1956.
8. *Sunday Express*, 19 February 1956. The Daily Mail subsequently offered £500 - the money to go to the Discharged Prisoners Aid Association - for Burgess to interview Boris Pasternak but Burgess said of Dr Zhivago, which had just been published, 'he was bored by it and put the book down after the first ten pages'. TNA, FCO 158/12.
9. TNA, PREM 11/1578, Hayter, 14 February 1956.
10. Rees, *Mr Nobody*, pp. 183-7, for a full account.
11. Ibid., p. 187.
12. British Library, Harrod Papers, Add 71192 f.3, Roy Harrod to Goronwy Rees, undated, about *A Chapter of Accidents*, which is based on the articles.
13. *Ruling Passions*, p. 233.
14. Bodleian Library, Conservative Party Archives, Joseph Ball papers, MS England c.6656, Crocker to People, 27 March 1956.
15. Driberg, pp. 4-5 and Wheen, p. 310.
16. Francis Wheen, *Tom Driberg: His Life and Indiscretions*, Chatto and Windus, 1990, p. 309.
17. Chapman Pincher, *Treachery*, Random House, 2009, pp. 411-12.
18. TNA, FO371/122850, 20 March 1956.
19. *Daily Express*, 25 July 1956. The *Express* seemed so anxious for any artefact connected with the story that they recovered Eve's cigarette stubs from her flight back.
20. Driberg, *Guy Burgess*, pp. 7-8.
21. Driberg, *Ruling Passions*, Cape, 1977, p. 232.

22. Ibid., p. 230.
23. Miller, *All Them Cornfields*, p. 54.
24. Modin interview, October 1994.
25. Mitrokhin Archive, pp. 523-4.
26. Driberg papers, Eve to Driberg, 3 October 1956.
27. Driberg, *Ruling Passions*, p. 236.
28. Ibid.
29. Ibid., p. 238.
30. The serial ran 22 October–1 November 1956. One consequence was the *Daily Telegraph* didn't review any of Weidenfeld's books for a year, so incensed was Michael Berry by the suggestion he had offered Burgess a job. George Weidenfeld, *Remembering My Good Friends*, HarperCollins, 1994, p. 406.
31. Pincher, *Treachery*, p. 415.
32. Bodleian Library, MS England, c.6656, folios 124 and 134-5. Reference to a 'brilliant Oxford historian friend' of Burgess also recruited by Ball, most likely Isaiah Berlin, was also removed.
33. *Daily Mail*, November 1956.
34. *Tribune*, 30 November 1956.
35. *New Statesman*, 1 December 1956.
36. *Time & Tide*, 15 December 1956.
37. *Spectator*, 30 November 1956. Noel Coward, after reading the book, noted in his diary, 'Burgess emerges, admittedly more intelligent than I had imagined, but no less of a fool . . . He is obviously a tiresome, wrong-headed, self-indulgent man with faulty emotional balance and little integrity.' Graham Payn and Sheridan Morley (eds.), *The Noel Coward Diaries*, Weidenfeld & Nicolson, 1982, p. 350.
38. Driberg, *Guy Burgess*, p. 96.
39. Ibid., pp. 98, 99.
40. Ibid., p. 99.
41. Ibid., p. 100.
42. Ibid., p. 101.
43. Ibid., p. 104.
44. Ibid., p. 105.

37. First Steps

1. Cecil, p. 144.
2. *Defence of the Realm*, p. 426; Jonathan Miles, *The Nine Lives of Otto*

Katz, Bantam, 2010, p. 281, claims they remained in Prague in connection with the trial of Otto Katz.

3. Guy Liddell, *Diary*, 12 June 1951.

4. Nigel Burgess interview, Penrose, p. 351. Nigel gave a similar version to Robert Cecil, p. 164.

5. Interview with Yuri Modin, October 2003. Haslam, drawing on Russian sources, claims the two men remained in Moscow for debriefing until October 1951. Haslam, p.170.

6. Miller, *All them Cornfields*, p. 53. One of the KGB officers responsible for resettling them was Valentin Mikhaylov, who had previously been Maclean's case officer in Washington and then was the Resident in Australia under the name Sadovnikov.

7. Interview with Sergei Humaryan, October 2003. Melinda Maclean, interviewed in 1981 by the FBI, said 'they lived in an apartment which was directly across the hall from the apartment of Guy Burgess. She said that Burgess and Maclean did not get along and Burgess soon returned to Moscow.' FBI report, Melinda Maclean, FBI files, 21 September 1981.

8. Humaryan interview, October 2003.

9. Lean, who knew Burgess at the Ministry of Information, in *The Napoleonists*, p. 348, suggests Burgess identified with the character's admiration for Napoleon and worship of his father. The last words of *War and Peace* are Andreyevitch's dedication of himself. 'Oh, father, father! Yes, I will do something with which even *he* would be satisfied . . .'

10. TNA, KV2/3440; Miller, *All Them Cornfields*, p. 54; Modin, interviewed in October 2003, said they were still there in 1956; Povolzhskaya State Social-Humanitarian Academy in Samara: http://cambridge5.pgsga.ru/guy/

11. John Goldsmith (ed.), *Stephen Spender Journals: 1939-1983*, Faber, 1985, p. 212.

12. Modin, pp. 243-4. The dacha was later pulled down and turned into a children's garden.

13. Ibid., p. 245.

14. Miller, *All Them Cornfields*, p. 54.

15. Driberg Papers, Guy Burgess to Tom Driberg, undated letter 1956.

16. Other books he read during this period included: Mrs Gaskell's *Life of Charlotte Bronte*; *Alice Through the Loooking Glass*; Henry James's *The Turn of the Screw* and *The Aspern Papers*; *Dr Jekyll and Mr Hyde*; Cyril Connolly's *The Unquiet Grave*; Gabriel Chevalier's *Clochmerle*; the novels of C.S. Forrester, Upton Sinclair and E.M. Forster; his friend Christopher Sykes's *Four Studies in Loyalty*; Nancy Mitford's *Noblesse Oblige*; the plays

of Oscar Wilde; Stephen Spender's *World with World*; Nicholas Pevsner's *The Cities of London and Westminster*; George Kennan's *American Diplomacy 1900-1950*; Gogol's *Dead Souls*; Anthony Powell's *Dance to Music of Time*; Angus Wilson's *Anglo Saxon Attitudes*; Evelyn Waugh's *Brideshead Revisited* and *Officers & Gentlemen*; William Golding's *Lord of the Flies*; C.P. Snow's *The New Men*; Somerset Maugham's *Of Human Bondage*; Anthony Blunt's *Philbert de l'Orme* and one of his favourite books – *The Writings of Walter Sickert*, edited by Osbert Sitwell; Jacob Burckhardt's *The Civilization of the Renaissance in Italy*; *Goya Etchings*; two volumes of annotated Marx and Engels; Kenneth Clark's *The Nude*; *The Origins of Christianity*; Lewis Sinclair's *Babbit* and several volumes of John Morley's works, inscribed and given by Blunt in 1946.

17. Piadyshev, *In the Service of a Foreign Power*, p. 181.
18. Ibid.

38. I'm Very Glad I Came

1. Driberg, *Guy Burgess*, p. 104.
2. Ibid., p. 117.
3. Modin, p. 255.
4. Miller, *All Them Cornfields*, p. 56.
5. Interview with Sergei Konsrashev, 24 November 2003.
6. Philby and Cairncross were also awarded the decoration which marked distinguished long service to the USSR. The order consisted of a white-enamelled badge, which had a golden Hammer and Sickle badge surrounded by two golden panicles of wheat on a Red Star backed by crossed hammer, lough, torch and a red flag bearing the motto Proletarians (Workers) of the World Unite!
7. British Library, Harrod Papers, Roy Harrod to Goronwy Rees, 1 March 1972.
8. Guy Burgess to Peter Pollock, undated, Pollock Letters. He also enclosed a list of recordings he wanted sent. Mozart's operas *Figaro, Don Juan, Magic Flute, Cosi* 'in English if tolerable versions exist', and his Jupiter and Haffner Symphonies, Beethoven's 5th, 6th, 7th, 9th (Toscanini) Symphonies, Emperor, Fidelio + piano sonatas, Bach D Minor Fugue, St Matthew Passion, Schubert Unfinished, Berlioz Fantastic Symphony, Gilbert & Sullivan's *Mikado, Patience, Trial by Jury*, Offenbach's *La Belle Hélène*, Hugo Wolf's song. Leonard Cassini was a visiting classical pianist.
9. The FBI subsequently interviewed Goodman on 27 August 1957. Cf.

Memphis Press Scimitar, 17 August 1957, and Londoner's Diary, *Evening Standard*, 27 July 1957.

10. Modin, p. 253.

11. Interview with Modin, 14 October 2003.

12. Golitsyn, unpublished memoir, p. 535.

13. Tennent Bagley, *Spymaster: Startling Cold War Revelations of a Soviet KGB Chief*, Skyhorse, 2013, pp. 181-2.

14. Bagley, pp. 181-2.

15. Interview with John Morrison, October 1994.

16. *BBC History* magazine, September 2005 and TNA, T 231/1145. In December 1959 Eve Bassett created a trust through the Royal Trust Company of Canada giving her elder son the £300 p.a. interest from the income. TNA, IR 40/12306.

17. See TNA, T326/1132 and TNA, T326/1133.

18. Lilly Library, Indiana, Robin Maugham's papers, Guy Burgess to Harold Nicolson, undated, but from references elsewhere in the letter to Nigel Nicolson's deselection at Bournemouth, just after February 1959.

19. Perry, *Fifth Man*, p. 236.

20. Modin, p. 255.

21. Interview with Terence Lancaster, 21 January 1999.

22. Ibid.

39. An Englishman Abroad

1. Though Peter Brook's production of *Hamlet* starring Paul Scofield had taken place two years earlier

2. Michael Redgrave, *In My Mind's Eye*, Coronet, 1984, pp. 234-5.

3. Redgrave, MI5 debrief, TNA, KV2/3822.

4. Coral Browne, *Daily Mail*, 3 December 1983. She gives slightly different versions in the *Sun*, 20 October 1983, and *Glasgow Herald*, 28 November 1983. Buchanan and Browne had enjoyed a brief affair.

5. Undated letter, Guy Burgess to Coral Browne, quoted Rose Collis, *Coral Browne: This Effing Lady*, Oberon Books, 2007, p. 123.

6. Guy Burgess to Coral Browne, 16 April 1959, quoted Collis, p. 124.

7. Rachel Kempson, *A Family and its Fortunes*, Duckworth, 1986, p. 184.

8. *Birmingham Post*, 7 January 1959; undated letter, Guy Burgess to Coral Browne, quoted Collis, p. 121.

9. Redgrave, pp. 234-5; cf. the accounts Redgrave gave to MI5 on his return, TNA, KV2/3822 and his article in the *Observer*, 11 January 1959.

Burgess wrote to Harold Nicolson after the visit, 'I am sure his is the best Hamlet I've ever seen – better than Gielgud, better than Olivier, much better than Schofield.'

10. *Stephen Spender Journals*, p. 211.

11. TNA, PREM 11/4457. Hugh Trevor-Roper has suggested, 'Once in Moscow, Burgess threatened to expose Blunt too. Wishing to return to England, he sought to negotiate a guarantee of immunity from prosecution there. Such a guarantee could only have been obtained against an undertaking to reveal all that he knew, which of course would have been fatal to Blunt. I suspect that it was this fear which prompted Blunt to make his confession – a confession which in fact may have been unnecessary, since Burgess then died in Moscow, having revealed nothing.' *Spectator*, 24 November 1979, p. 11. This doesn't make sense, as Blunt confessed only in April 1964, after Burgess's death.

12. *Evening Standard*, 23 February 1959.

13. TNA, CAB 21/3878.

14. TNA, CAB 129/96.

15. TNA, PREM 11/4461.

16. Princeton, Harold Nicolson papers, Guy Burgess to Harold Nicolson, undated.

17. Ibid.

18. Bodleian, MS England, c.6920, p. 259.

19. Guy Burgess to Coral Browne, 16 April 1959, Collis, p. 123.

20. Interviews with Robert Elphick, 19 January 1999 and 17 December 1985. According to MI5 files, Elphick later admitted that Burgess did not say he had made a mistake but 'anyone can be a failure'. TNA, KV2/4133.

21. TNA, FCO 158/12.

22. Ibid.

23. Ibid.

24. Ibid.

25. Erik Durschmied, *Shooting Wars*, Pharos, 1990, p. 225.

25. *Shooting Wars*, p. 227. It was broadcast on 11th March 1959. Further information emails Erik Durschmied to the author 1st and 3rd March 2016.

40. Visitors

1. Interview with Colonel E. Perry, *Fifth Man*, p. 269.
2. Driberg Papers, B10, Jack Hewit to Driberg, 5 August 1959.
3. *Stephen Spender Journals*, p. 210.
4. Ibid., p. 213.
5. Ibid., p. 214.
6. Ibid., p. 215.
7. Ibid., p. 211.
8. Robert Cecil Papers, Graham Greene to Robert Cecil, 14 February 1989.
9. Princeton, Harold Nicolson Papers, Guy Burgess to Harold Nicolson, 15 April 1960.
10. Joan Littlewood, Undated letter to author, c.1998.
11. Jan Morris, *Pleasures of a Tangled Life*, Random House, 1989, pp. 133-4. Morris began the transition from man to woman in 1964.
12. James Morris, 'Caviare with Burgess', *Guardian*, 2 September 1963.
13. Ibid. Morris gives a slightly different version of the Bolshoi episode in *Pleasures*, pp. 133-4.
14. On the trip to Ascona, Hill had drawn a picture of Burgess and Pollock which 'in a fit of feminine rage' Pollock had torn up. Public Record Office, Northern Ireland, D4400/C/2/52 , Guy Burgess to Derek Hill, undated letter.
15. Jose Manser, *Mary Fedden and Julian Trevelyan*, Unicorn Press, 2012, pp. 10-104.
16. Julie Kavanagh, *Secret Muses: Life of Frederick Ashton*, Faber, 1996, p. 457.
17. Interview with 'Brian', 15 March 2012.
18. Modin interview, 2003.
19. Driberg Papers, B10, undated, letter postmarked London, 4 January 1961.
20. Interview with May Harper, 22 December 1998.
21. Stephen Harper to the author, 15 December 1998; cf. Harper, 'The Burgess I Knew in Moscow', unpublished memoir, p. 9.
22. Sebastian Faulks, *Three Fatal Englishmen*, Hutchinson, 1996, pp. 254-5.
23. Ian McDougall, *Foreign Correspondent*, Muller, 1980, pp. 110-11, and interview with Ian McDougall, 23 April 1999. The argument had been over McDougall's Catholicism — Burgess 'could not understand how an adult man could allow the Pope to decide what he should read'. Nora Beloff, *Transit of Britain: A Report on Britain's Changing Role in*

the Post-War World, Collins, 1973, p. 109. Debriefed by the Foreign Office on his return, McDougall reported he had 'found it difficult to follow everything he said since all his teeth have fallen out and his false ones do not fit very well.' TNA, FCO 158/12 PA Rhodes to PG Adams 4th August 1960.

24. According to the Mitrokhin Archive, the Russians unsuccessfully tried to blackmail Crankshaw after they photographed him in 'sexual frolics'. Mitrokhin, p. 530; Beloff, pp. 133, 108.

25. Interview with Norman Dombey, 17 October 2003.

26. Harold Nicolson, *Age of Reason*, Constable, 1960, p. 312. Burgess wrote of Youssopoff, 'When I knew him in the 1930s he did not look quite the same. He was making scent, before he made £20,000 out of libel actions against Hollywood for its film of the assassination of which he gave me his account.' Undated letter to Harold Nicolson from Moscow.

27. Undated letter, Guy Burgess to Harold Nicolson.

28. *Daily Telegraph* and *The Times*, 11 October 1961.

41. 'I'm a communist, of course, but I'm a British communist, and I hate Russia!'

1. Harold Nicolson to Burgess, 17 May 1960, describes one such visit. 'I remained there an hour and we talked about you and the past and the future. It was an agreeable conversation and I hope that she enjoyed it as much as I did.'

2. King's College, Cambridge, RNL/1/1/1/7, Rosamond Lehmann's Commonplace notebook, 1 January 1958.

3. Ibid.

4. Peter Keen to the author, 17 September 1998.

5. Ibid.

6. Ibid. The photos duly appeared in the *Daily Express*, 'The picture Burgess sent his mother', on 3 September 1963.

7. TNA, PREM 11/4461.

8. Burgess claimed that the Dutch Secret Service had started the rumour to divert attention from a Soviet scientist who had returned to Russia from Holland, TNA, T326/1133.

9. Miller, *All Them Cornfields*, p. 49.

10. *Daily Express*, 21 April 1962.

11. Harper, 'The Burgess I Knew in Moscow', chapter in unpublished memoir.

12. 'The Burgess I Knew in Moscow', p. 5. Harper gives a slightly different version of events, *Daily Telegraph*, 23 April 1962.

13. *Daily Mail*, 19 April 1962.

14. Mossman unpublished memoir, pp. 108-9.

15. Mossman interview, 3 February 1999 and unpublished memoir, p. 110.

16. Mark Frankland, *Child of My Time*, Chatto &Windus, 1999, pp. 63-4.

17. Ibid., p. 64.

18. Harold Nicolson papers, Princeton, undated letter to Harold Nicolson.

19. Ibid., Burgess to Nicholson, 23 May 1962.

20. I'm grateful to Tony Burgess for showing me the letter. Burgess claimed he had presented this magnificent set of Imperial Russian china to the Hermitage Museum 'in grateful thanks' for being allowed to live in the USSR. Miller, *All Them Cornfields*, p. 56.

21. Letter from William Seymour to the author, 16 August 2000. Interview with William Seymour, 25 August 2000.

22. Interview with Francis Haskell, 3 June 1999.

23. H. Honour interview, quoted Carter, p. 441. Haskell confirmed this in his interview with the author.

24. Jim Riordan, *Comrade Jim*, Fourth Estate, 2008, p. 157.

25. Ibid., p. 166.

26. A full account is given in Riordan, pp. 155-60.

27. Erik de Mauny, *Russian Prospect: Notes of a Moscow Correspondent*, Macmillan, 1969, p. 196. See also the account by Mauny in *Independent*, 17 July 1994.

28. Miller, *All Them Cornfields*, p. 57.

29. Letter from John Golding to the author, 1 August 1998.

30. Modin, p. 256 and Perry, *Fifth Man*, p. 269.

31. Eleanor Philby, *Kim Philby: The Spy I Loved*, Hamish Hamilton, 1968, p. 74; Seale, p. 270; Kondrashev interview, 24 November 2003.

32. Jeremy Wolfenden, *Daily Telegraph*, 5 September 1963.

33. Seale, p. 273; Nigel Burgess interview, 21 January 1986; John Miller interview, 4 February 1999. For other accounts of the funeral see *Irish Times*, 5 September 1963, a rather inaccurate one in Riordan, pp. 168-70, and Hughes, *Foreign Devil*, p. 145.

34. In January 1960 International Literary Management had suggested Burgess write an autobiography. TNA, KV2/4131. Nigel Burgess interview, 21 January 1986. Anthony Purdy's *Burgess and Maclean* with Burgess's annotations was one of the items which went missing, probably removed by the KGB. Cf. Miller, *All Them Cornfields*, pp. 56-7. Purdy interviewed by MI5 , shortly after visiting Burgess in June 1963,

told them Burgess was writing a memoir which would name Blunt 'as having been the man who warned him that the security net was closing around him' and 'that Wolfenden and Burgess were currently involved in a close homosexual liaison.' TNA, KV2/4139.

35. Probate records and *Express*, 27 November 1963.
36. TNA, T326/1132.
37. Eleanor Philby, p. 76.
38. Eve survived her elder son by only a few months, dying on 7 January 1964 and she was buried, with all his letters to her, alongside him in West Meon. She left £143,998 in her will, mostly to Nigel, with a legacy to Esther Whitfield, though this was cancelled, and £300 to Anthony Blunt 'in gratitude for all his kindness'.

42. Summing Up

1. Alan Bennett, *Single Spies and Talking Heads*, Samuel French, 1991, introduction.
2. NA, RG218, 'National Security Implications Resulting from the Defection of British Diplomats, Donald Duart Maclean and Guy De Moncy Burgess'.
3. NA, RGA 46, Box 13, Memo 15 January 1957, 'Records of the United States Senate, Committee on the Judiciary, Subcommittee on Internal Security, Names files (first series) Burgess–Maclean.
4. West, *The Crown Jewels*, p. 171.
5. *A Chapter of Accidents*, original typescript, p. 82.
6. Ibid., pp. 49, 52.
7. Modin, p. 254, and interview, November 2003.
8. Kondrashev interview, 24 November 2003.
9. Ibid.
10. Penrose, p. 216.
11. Quoted Inigo Thomas, *London Review of Books*, 11 March 2015.
12. Philby, *Silent War*, foreword.
13. Rees, *Chapter of Accidents*, p. 121.
14. Weidenfeld, pp. 157–8.
15. Ibid. Michael Straight said much the same to Noel Annan when explaining his treachery, reminding him of 'the response of the historian who was asked to assess the French Revolution and who answered "It's too soon to tell"'. King's College, Cambridge archives, NGA 5/1/950, Straight to Annan, 24 April 1989.

16. Connolly, pp. 15-16.
17. Miriam Rothschild, letter to the author, 6 January 1999.
18. Rosamond Lehmann interview, 1986, Costello, p. 30.
19. Margaret Anstee interview.
20. Brian Sewell letter to author, 25 October 1998. He gives a slightly different account dating the meeting two years later to May 1951. 'A day or two later he waylaid me and invited me to dinner, after which he inflicted the traumatic experience of taking me to his "club", which was not in Pall Mall, but in some cellar haunt where I was more or less compelled to dance with him – more food stains and foul breath and an overwhelming discomfort at the very idea of doing such a thing. I fled.' Brian Sewell, *Outsider: Always, Almost Never Quite*, Quartet, 2011, p. 69.
21. John Waterlow, letter to author, 20 December 1998.
22. Mather, pp. 35-6.
23. Cecil, pp. 131-2.
24. *Daily Herald*, 7 November 1955.
25. Boyle, p. 118.
26. Rees, *Chapter of Accidents*, pp. 140-1.
27. Penrose, pp. 195-6.
28. Steven Runciman interview, 2 August 1998.

Appendix

1. Rodney Garland, *The Troubled Midnight*, W.H. Allen, 1954, pp. 37, 192. William Fairchild, who had been at Dartmouth, just after Burgess had plans to make a film *The Traitors* based on the Burgess and Maclean story in 1955.
2. Godfrey Smith, *The Flaw in the Crystal*, Gollancz, 1954; Richard Llewellyn, *Mr Hamish Gleave*, Michael Joseph, 1956; Nicholas Monsarrat, *Smith and Jones*, Morrow, 1963; Michael Dobbs, *Winston's War*, Collins, 2002.
3. John Banville, *The Untouchable*, Picador, 1997; Rufus Gunn, *A Friendship of Convenience*, Gay Men's Press, 1997.
4. Nancy Mitford, *Don't Tell Alfred*, Hamish Hamilton, 1960, p. 192; Terrance Dicks, *Endgame*, BBC Books, 2000.
5. *Influence*, pp. 28, 113. Esther Whitfield was forty in 1951. Burgess told Robert Rushmore, a *Voice of America* journalist, in September 1950 that he considered marrying Esther. FBI Eric Kessler file p. 7. The FBI

interviews also reveal a Burgess girlfriend in the Washington area. Phillips is Philby.

6. The role of Guy Burgess was first offered to Robert Stephens, who wasn't available. From a subsequent short list, which included Michael Caine, Tom Baker, Edward Fox and Dirk Bogarde, Alan Bates was chosen.

Selected Bibliography

Books

Aldrich, Richard (ed.), *British Intelligence, Strategy and the Cold War*, Routledge, 1992.

Aldrich, Richard and Hopkins, Michael (eds.), *Intelligence, Defence and Diplomacy*, Frank Cass, 1994.

Aldrich, Richard, *Espionage, Security and Intelligence in Britain 1945-70*, Manchester University Press, 1998.

Aldrich, Richard, *The Hidden Hand: Britain, America and Cold War Secret Intelligence*, John Murray, 2001.

Allen, Peter, *The Cambridge Apostles*, Cambridge University Press, 1979.

Alsop, Joseph, *I've Seen the Best of It*, Norton, 1992.

Alsop, Susan Mary, *To Marietta from Paris 1945-1960*, Doubleday, 1975.

Anderson, Courtney, *Seagulls in my Belfry*, Pentland Press, 1997.

Andrew, Christopher, 'F.H. Hinsley and the Cambridge Moles: Two Patterns of Intelligence Recruitment' in R.B. Langhorne (ed.), *Diplomacy and Intelligence during the Second World War: Essays in Honour of F.H. Hinsley*, Cambridge, 1985.

Andrew, Christopher, *Secret Service*, Heinemann, 1985.

Andrew, Christopher and Dilks, David (eds.), *The Missing Dimension: Governments and Intelligence Communities in the Twentieth Century*, Macmillan, 1984.

Andrew, Christopher and Gordievsky, Oleg, *KGB: The Inside Story*, Hodder & Stoughton, 1990.

Andrew, Christopher and Gordievsky, Oleg (eds.), *Instructions from the Centre: Top Secret Files on KGB Foreign Operations 1975-1985*, Hodder & Stoughton, 1990.

Andrew Christopher and Gordievsky, Oleg (eds.), *More Instructions from the Centre: Top Secret Files on KGB Foreign Operations 1975-1985*, Frank Cass, 1991.

Andrew, Christopher and Mitrokhin, Vasili, *The Mitrokhin Archive: The KGB in Europe and the West*, Penguin, 1999.

Andrew, Christopher and Mitrokhin, Vasili, *The Mitrokhin Archive II: The KGB and the World*, Penguin, 2005.

Andrew, Christopher, *The Defence of the Realm: The Authorized History of MI5*, Allen Lane, 2009.

Andrew, Christopher, 'Cambridge Spies: The Magnificent Five 1933–45' in Sarah J. Ormrod (ed.), *Cambridge Contributions*, Cambridge University Press, 1998.

Andrew, Christopher, 'The VENONA Secret' in K.G. Robertson (ed.) *War, Resistance and Intelligence: Essays in Honour of M.R.D. Foot*, Pen & Sword, 1999.

Andrew, Christopher, 'Intelligence and the Cold War' in Melvyn Leffler and Odd Arne Westad (eds.), *The Cambridge History of the Cold War Vol. 2*, Cambridge University Press, 2009.

Angel, Barbara, *The Coral Browne Story*, Bookbound, 2007.

Annan, Noel, *Our Age*, Weidenfeld & Nicolson, 1990.

Annan, Noel, *The Dons*, Collins, 1999.

Anstee, Margaret, *Never Learn to Type*, John Wiley, 2003.

Ayer, A.J., *Part of my Life*, Collins, 1977.

Ayer, A.J., *More of my Life*, Collins, 1984.

Bagley, Tenent, *Spymaster: Startling Cold War Revelations of a Soviet KGB Chief*, Skyhorse, 2013.

Baker, Anne, 'Guy Burgess' in C.S. Nichols (ed.) *Dictionary of National Biography: Missing Person*, OUP, 1993.

Bamville, John, *The Untouchable*, Picador, 1997.

Barclay, Roderick, *Ernest Bevin and the Foreign Office*, pp, 1975.

Barden, Ruth, *A History of Lockers Park: Lockers Park School, Hemel Hempstead 1874-1999*, Sacombe Press, 2000.

Baxter, Christopher, *The Great Power Struggle in East Asia, 1944-50: Britain, America and Post-War Rivalry*, Palgrave, 2009.

The BBC Year-book 1943-1953, London, British Broadcasting Corporation.

Bell, Quentin, *Elders & Betters*, John Murray, 1995.

Beloff, Nora, *Transit of Britain: A Report on Britain's Changing Role in the Post-War World*, Collins, 1973.

Bennett, Alan, *Single Spies*, Samuel French, 1991.

Benson, Robert Louis and Warner, Michael (eds.), *Venona: Soviet Espionage and The American Response 1939-1957*, Aegean Press, 1996.

Berlin, Isaiah, *Flourishing: Letters 1928-1946*, Henry Hardy (ed.), Chatto & Windus, 2004.

Berlin, Isaiah, *Enlightening: Letters 1946-1960*, Henry Hardy (ed.), Chatto, 2009.

Berlin, Isaiah, *Personal Impressions*, Hogarth Press, 1980.

Bethell, Nicholas, *The Great Betrayal: The Untold Story of Kim Philby's Biggest Coup*, Hodder & Stoughton, 1984.

Bloch, Michael, *James Lees Milne*, John Murray, 2009.

Bloomfield, Paul, *BBC*, Eyre & Spottiswoode, 1941.

Blunt, Wilfred, *Married to a Single Life*, Michael Russell, 1983.

Blunt, Wilfred, *Slow on the Feather*, Michael Russell, 1986.

Booth, Martin, *A Magick Life*, Hodder, 2000.

Borovik, Genrikh and Knightley, Phillip (eds.), *The Philby Files*, Little Brown, 1994.

Boston, Richard, *Osbert: Portrait of Osbert Lancaster*, HarperCollins, 1989.

Bower, Tom, *Dick White: The Perfect English Spy; Sir Dick White and the Secret War 1935-90*, Heinemann, 1995.

Bowra, Maurice, *Memories*, Weidenfeld & Nicolson, 1966.

Boyle, Andrew, *The Climate of Treason*, Hutchinson, 1979, revised edition, Coronet, 1980.

Brandon, Henry, *Special Relationships*, Atheneum, 1988.

Branon, Noreen and Heinemann, Morgot, *Britain in the Nineteen Thirties*, Weidenfeld & Nicolson, 1973.

Brett, Lionel, *Our Selves Unknown*, Gollancz, 1985.

Briggs, Asa, *The History of Broadcasting in the United Kingdom Vol. 3*, OUP, 1970.

Brook-Shepherd, Gordon, *The Storm Petrels*, Collins, 1977.

Brook-Shepherd, Gordon, *The Storm Birds: Soviet Post-War Defectors*, Weidenfeld & Nicolson, 1989.

Brook-Shepherd, Gordon, *Iron Maze: The Western Secret Services and the Bolsheviks*, Macmillan, 1998.

Bryans, Robin, *The Dust Has Never/Not Yet Settled,* Honeyford Press, 1992.

Bryans, Robin, *Let the Petals Fall*, Honeyford Press, 1993.

Bryans, Robin, *Checkmate*, Honeyford Press, 1994.

Bucknell, Katherine, *Christopher Isherwood Diaries 1939-60*, Methuen, 1996.

Bucknell, Katherine (ed.), *Lost Years: A Memoir 1845-1951,* Chatto, 2000.

Burke, David, *The Lawn Road Flats: Spies, Writers and Artists*, The Boydell Press, 2014.

Burn, Michael, *The Debatable Land*, Hamish Hamilton, 1970.

Burn, Michael, *Turned Towards the Sun: An Autobiography*, Michael Russell, 2003.

Burns, Jimmy, *Papa Spy*, Bloomsbury, 2010.

Burrows, Bernard, *Diplomat in a Changing World,* The Memoir Club, 2001.

Bush, Eric, *How to Become a Naval Officer and Life at the Royal Naval College Dartmouth*, Gieves, Matthews & Seagrove, 1924.

Byrne, L.S.R. and Churchill, E.L., *Changing Eton*, Cape, 1937.

Cain, Frank, *The Australian Security Intelligence Organization: An Unofficial History*, Frank Cass, 1994.

Cairncross, John, *The Enigma Spy*, Century, 1997.

Calvocoressi, Peter, *Threading My Way*, Duckworth, 1994, Columbia University Press, 2013.

Card, Tim, *Eton Renewed*, John Murray, 1994.

Carney, Michael, *Stoker: The Life of Hilda Matheson*, M. Carney, 1999.

Carpenter, Humphrey, *W.H. Auden, a Biography*, Allen and Unwin, 1981.

Carter, Miranda, *Anthony Blunt: His Lives*, Macmillan, 2001.

Cave Brown, Anthony, *Bodyguard of Lies*, W.H. Allen, 1976.

Cave Brown, Anthony, *Treason in the Blood: St John Philby, Kim Philby and the Spy Case of the Century*, Robert Hale, 1995.

Cavendish, Anthony, *Inside Intelligence*, Collins, 1990.

Cecil, Hugh and Mirabel, *Clever Hearts*, Gollancz, 1990.

Cecil, Robert, *A Divided Life: A Biography of Donald Maclean*, Bodley Head, 1988.

Christiansen, Arthur, *Headlines All My Life*, Heinemann, 1957.

Clark, Adrian and Dronfield, Jeremy, *Queer Saint: The Cultured Life of Peter Watson*, John Blake, 2015.

Coats, Peter, *Of Generals and Gardens: The Autobiography of Peter Coats*, Weidenfeld & Nicolson, 1976.

Colletta, Lisa (ed.), *Kathleen and Christopher: Christopher Isherwood's Letters to His Mother*, University of Minnesota Press, 2005.

Collis, Rose, *Coral Browne: This Effing Lady*, Oberon Books, 2007.

Connolly, Cyril, *The Missing Diplomats*, Queen Anne Press, 1952.

Connon, Bryan, *Somerset Maugham and the Maugham Dynasty*, Sinclair-Stevenson, 1997.

Cookridge, E.H., *The Third Man*, Arthur Barker, 1968.

Costello, John, *Mask of Treachery*, Collins, 1988.

Costello, John and Tsarev, Oleg, *Deadly Illusion*, Century, 1993.

Craddock, Percy (ed.), *Recollections of the Cambridge Union 1815-1939*, Bowes & Bowes, 1953.

Critchlow, James, *Radio Liberty*, American University Press, 1995.

Crowson, N.K. (ed.), *The Journals of Collin Brooks 1932-1940*, CUP, 1998.

Cullen, Tom, *The Man Who Was Norris: The Life of Gerald Hamiton*, Dedalus, 2014.

Cuningham, Cyril, *Beaulieu: The Finishing School for Secret Agents*, Leo Cooper, 1998.

Damaskin, Igor and Elliott, Geoffrey, *Kitty Harris: The Spy with Seventeen Names*, St Ermin's Press, 2001.

Dan, Jerry (Nigel Bance), *Ultimate Deception: How Stalin Stole the Bomb*, Rare Books, 2003.

Davenport-Hines, Richard, *Auden*, Heinemann, 1995.

David, Hugh, *Stephen Spender: A Portrait With Background*, Heinemann, 1992.

David, Hugh, *On Queer Street*, HarperCollins, 1997.

David, Hugh, *The Fitzrovians*, Michael Joseph, 1988.

Davison, Peter, *George Orwell Diaries*, Harvill/Secker, 2010.

Day, Peter, *Klop: Britain's Most Ingenious Spy*, Biteback, 2014.

Deacon, Richard, *The British Connection*, Hamish Hamilton, 1979.

Deacon, Richard, *The Cambridge Apostles*, Robert Royce, 1985.

Deacon, Richard, *The Greatest Treason*, Century, 1989.

Defty, Andrew, *Britain, America and Anti-Communist Propaganda*, Routledge, 2004.

De Hegedus, Adam, *Don't Keep the Vanman Waiting: A Chapter of Autobiography*, Staples Press, 1944.

De la Mare, Sir Arthur, *Perverse and Foolish*, La Haule Books, 1994.

De-la-Noy, Michael, *Edward Sackville-West*, Arcadia, 1999.

Delmer, Sefton, *Black Boomerang: An Autobiography*, Secker & Warburg, 1962.

De Mauny, Erik, *Russian Prospect*, Macmillan, 1969.

Dobbs, Michael, *Winston's War*, Collins, 2002.

Dorril, Stephen, *MI6*, Fourth Estate, 2000.

Driberg, Tom, *Guy Burgess: A Portrait with Background*, Weidenfeld & Nicolson, 1956.

Driberg, Tom, *Ruling Passions*, Cape, 1977.

Duff, William, *A Time for Spies: Theodore Stephanovich Mally and the Era of the Great Illegals*, Vanderbilt University Press, 1999.

Durschmied, Erik, *Don't Sheet the Yanqui: The Life of a War Cameraman*, Grafton, 1990.

Durschmied, Erik, *Shooting Wars*, Pharos, 1990.

Eckersley, Miles, *Prospero's Wireless*, Myles Books, 1997.

Elliott, Nicholas, *Never Judge a Man by his Umbrella*, Michael Russell, 1991.

Elliott, Nicholas, *With My Little Eye*, Michael Russell, 1993.

Faligot, Roger and Kauffer, Remi, *Histoire mondiale du renseignement, 1870-1939*, Robert Lafont, 1993.

Farson, Daniel, *Francis Bacon*, Century, 1993.

Faulks, Sebastian, *Three Fatal Englishmen*, Hutchinson, 1996.

Ferns, H.S., *Reading from Left to Right*, University of Toronto Press, 1983.

Fiber, Sally, *The Fitzroy: The Autobiography of a London Tavern*, Temple House, 1995.

Fisher, John, *Burgess and Maclean*, Robert Hale, 1977.

Frankland, Mark, *Child of My Time*, Chatto & Windus, 1999.

Garland, Rodney, *The Heart in Exile*, W.H. Allen, 1953.

Gazur, Edward, *Secret Assignment*, St Ermin's Press, 2001.

Gibbs, Anthony, *In My Good Time: An Autobiography*, Peter Davies, 1969.

Gillies, Donald, *Radical Diplomat: The Life of Archibald Clark Kerr, Lord Inverchapel, 1882-1951*, I.B. Tauris, 1999.

Gladwyn, Lord, *Memoirs*, Weidenfeld & Nicolson, 1972.

Glees, Anthony, *Secrets of the Service*, Cape, 1987.

Goldsmith, John (ed.) and Spender, Stephen, *Journals 1939-1983*, Faber, 1985.

Grant Duff, Sheila, *The Parting of the Ways: A Personal Account of the Thirties*, Peter Owen, 1982.

Green, Martin, *Children of the Sun: A Narrative of 'Decadence' in England after 1918*, Constable, 1977.

Greenhill, Denis, *More By Accident*, privately published, 1992.

Grierson, Roland, *A Truant Disposition*, Weidenfeld, 1992.

Griffiths, Richard, *Fellow Travellers of the Right*, Constable, 1980.

Grigson, Geoffrey, *Recollections: Mainly of Artists and Writers*, Chatto & Windus, 1984.

Grubb, Kenneth, *Crypts of Power*, Hodder & Stoughton, 1971.

Haden Guest, Carmel (ed.), *David Guest*, Lawrence & Wishart, 1939.

Hamilton, Gerald, *The Way it Was With Me*, Leslie Frewin, 1969.

Hamrick, S.J., *Deceiving the Deceivers: Kim Philby, Donald Maclean and Guy Burgess*, Yale, 2004.

Hardy, Henry (ed.), *The Book of Isaiah: Personal Impressions of Isaiah Berlin*, Boydell & Brewer, 2009.

Harris, John (ed.), *Goronwy Rees: Sketches in Autobiography*, University of Wales Press, 2001.

Harrison, Edward, *The Young Kim Philby: Soviet Spy and British Intelligence Officer*, University of Exeter Press, 2012.

Harrold, Jane and Porter, Richard, *Britannia Royal Naval College, Dartmouth*, Richard Webb, 2007.

Hart, H.G. (ed.), *The New Annual Army List*, John Murray, 1896.

Hart, Jennifer, *Ask Me No More*, Peter Halban, 1998.

Haslam, Jonathan, *Near and Distant Neighbours: A New History of Soviet Intelligence*, OUP, 2015.

Hastings, Selina, *Rosamond Lehmann*, Chatto, 2002.

Hayes, Jock, *Face the Music*, Pentland Press, 1991.

Haynes, John Earl and Klehr, Harvey, *Venona*, Yale, 1999.

Hearnden, Arthur, *Red Robert*, Hamish Hamilton, 1984.

Hennessy, Peter, *The Secret State: Whitehall and the Cold War*, Allen Lane, 2002.

Hennessey, Thomas and Thomas, Claire, *Spooks: The Unofficial History of MI5*, Amberley, 2009.

Henniker, John, *Painful Extractions*, Thornham Books, 2002.

Hermiston, Roger, *The Greatest Traitor: The Secret Lives of Agent George Blake*, Aurum, 2013.

Hewison, Robert, *Under Siege: Literary Life in London 1939-45*, Weidenfeld & Nicolson, 1977.

Heygate, John, *Decent Fellows*, Gollancz, 1930.

Hill, George, *Reminiscences of Four Years with the NKVD*, Hoover Institution Archives, 1968.

Hill, Heywood and Anne, *A Bookseller's War*, Michael Russell, 1997.

Hinsley, F.H. et al., *British Intelligence in the Second World War*, HMSO, 1979.

Hoare, Goffrey, *The Missing Macleans*, Cassell, 1955.

Hobsbawm, Eric, *Interesting Times: A Twentieth-Century Life*, Allen Lane, 2002.

Hodgkin, Alan, *Chance and Design*, Cambridge University Press, 1992.

Hollander, Paul, *Political Pilgrims*, Oxford University Press, 1981.

Holzman, Michael, *James Jesus Angleton, The CIA & the Craft of Counterintelligence*, University of Massachusetts Press, 2008.

Holzman, Michael, *Guy Burgess: Revolutionary in an Old School Tie*, Chelmsford Press, 2013.

Holzman, Michael, *Donald and Melinda Maclean: Idealism and Espionage*, Chelmsford Press, 2014.

Houlbrook, Matt, *Queer London*, University of Chicago Press, 2005.

Howard, Michael, *Captain Professor*, Continuum, 2006.

Howarth, T.E.B., *Cambridge Between the Wars*, Collins, 1978.

Howe, Ellic, *The Black Game*, Michael Joseph, 1982.

Hughes, E.A., *The Royal Naval College, Dartmouth*, Winchester Publications, 1950.

Hughes, Richard, *Foreign Devil*, Deutsch, 1972.

Hughes, Richard, *Don't You Sing!*, Kangaroo Press, 1994.

Hussey, Christopher, *Eton College*, Country Life, 1926.

Hynes, Samuel, *The Auden Generation*, Bodley Head, 1976.

Ignatieff, Michael, *Isaiah Berlin*, Chatto & Windus, 1998.

Isherwood, Christopher, *The Condor and the Crowns*, Random House, 1949.

Jeffery, Keith, *The Official History of the Secret Intelligence Service 1909-1949*, Bloomsbury, 2010.

Jenks, John, *British Propaganda and News Media in the Cold War*, Edinburgh University Press, 2006.

Johnson, Peter, *Roving Reuter Reporter Among the Communists 1958-59*, Tagman, 2000.

Karnow, Stanley, *Paris in the Fifties*, Random House, 1997.

Kaufman, Victor, *Confronting Communism: US and British Policies Towards China*, University of Missouri Press, 2001.

Kavanagh, Julie, *Secret Muses: The Life of Frederick Ashton*, Faber, 1996.

Kempson, Rachel, *A Family and its Fortunes*, Duckworth, 1986.

Kern, Gary, *A Death in Washington: Walter C. Krivitsky and the Stalin Terror*, Enigma Books, 2003.

Kerr, Sheila, 'NATO's First Spies: The Case of the Disappearing Diplomats – Guy Burgess and Donald Maclean' in R. O'Neil and B. Heuser (eds.), *Securing Peace in Europe 1945-1982*, Macmillan, 1991.

Kerr, Sheila, 'The Secret Hotline to Moscow: Donald Maclean and the Berlin Crisis of 1948' in Ann Deighton (ed.), *Britain and the First Cold War*, Macmillan, 1990.

Kirkup, James, *I of All People: Autobiography of Youth*, Weidenfeld & Nicholson, 1988.

Knightley, Phillip, *Philby: The Life and Views of the KGB Masterspy*, Andre Deutsch, 1988.

Koch, Stephen, *Double Lives*, HarperCollins, 1995.

Lamphere, Robert and Shachtman, Tom, *The FBI-KGB War*, Random House, 1986.

Lampen, Ambrose, *The Gilded Image*, privately published, 1978.

Lancaster, Marie-Jacqueline, *Brian Howard: Portrait of a Failure*, Anthony Blond, 1968, and Timewell, 2005.

Lancaster, Osbert, *With an Eye to the Future*, John Murray, 1967.

Lashmar, Paul and Oliver, James, *Britain's Secret Propaganda War*, Sutton, 1998.

Lean, Edward Tangye, *The Napoleonists: A Study in Political Disaffection, 1760-1960*, Oxford University Press, 1970.

Leeming, David, *Stephen Spender*, Duckworth, 1999.

Lees-Milne, James, *Ancestral Voices, Diaries 1942-1945*, Chatto & Windus, 1975.

Lees-Milne, James, *Deep Romantic Chasm: Diaries 1979-81*, John Murray, 2000.

Lees-Milne, James, *Fourteen Friends*, John Murray, 1996.

Lees-Milne, James, *Harold Nicolson: A Biography*, Vol. 2, 1930-68, Chatto and Windus, 1981.

Lehmann, John, *The Ample Proposition*, Eyre & Spottiswoode, 1966.

Lehmann, Rosamond, *Rosamond Lehmann's Album*, Chatto, 1985.

Lewis, Jeremy, *Cyril Connolly*, Jonathan Cape, 1997.

Liddy, James, *The Doctor's House*, Salmon Press, 2004.

Lloyd-Jones, Hugh (ed.), *Maurice Bowra: A Celebration*, Duckworth, 1974.

Lowe, John, *The Warden*, Collins, 1998.

Lowe, Peter, *Containing the Cold War in East Asia: British Policies Towards Japan, China and Korea 1948-54*, Manchester University Press, 1997.

Luke, Michael, *David Tennant and the Gargoyle Years*, Weidenfeld & Nicolson, 1991.

McDonald, Deborah and Dronfield, Jeremy, *A Very Dangerous Woman: The Lives, Loves and Lies of Russia's Most Seductive Spy*, Oneworld, 2015.

McDougall, Ian, *Foreign Correspondent*, Muller, 1980.

McIntyre, Ben, *A Spy Among Friends*, Bloomsbury, 2014.

Maclaine, Ian, *Ministry of Morale*, Allen & Unwin, 1979.

Maclean, Alan, *No I Tell a Lie, It Was the Tuesday . . . A Trudge Through His Life and Times*, Kyle Cathie, 1998.

Maclean, Fitzroy, *Take Nine Spies*, Weidenfeld & Nicolson, 1978.

McMeekin, Sean, *The Red Millionaire: Moscow's Secret Propaganda Tsar in the West*, Yale, 2003.

MacNamara, Jack, *The Whistle Blows*, Eyre & Spottiswoode, 1938.

Manchester, William, *American Caesar: Douglas MacArthur 1880-1964*, Little Brown, 1978.

Mann, Wilfrid, *Was There A Fifth Man?*, Pergamon, 1982.

Manser, Jose, *Mary Feden and Julian Trevelyan*, Unicorn Press, 2012.

Marten, Michael, *Tim Marten: Memories*, Lulu, 2009.

Martin, David, *Wilderness of Mirrors*, Collins, 1980.

Mather, John and Seaman, Donald, *The Great Spy Scandal*, Daily Express, 1955.

Maugham, Robin, *Escape From the Shadows*, Hodder & Stoughton, 1972.

Mayhew, Christopher, *Time to Explain*, Hutchinson, 1987.

Mayhew, Christopher, *A War of Words*, Tauris, 1998.

Miles, Jonathan, *The Nine Lives of Otto Katz*, Bantam, 2010.

Miller, John, *All Them Cornfields and Ballet in the Evening*, Hodgson, 2010.

Milne, Tim, *Kim Philby: The Unknown Story of the KGB Master Spy*, Biteback, 2014.

Modin, Yuri, *My Five Cambridge Friends*, Headline, 1994.

Monsarrat, Nicholas, *Life is a Four Letter Word*, Cassel, 1966.

Moore, Nick, *Frontlines: Snapshots of History*, Reuters, 2001.

Moran, Christopher, *Classified: Secrecy and the State in Modern Britain*, CUP, 2013.

Morris, Jan, *Pleasures of a Tangled Life*, Random House, 1989.

Morris, Jan, *Contact! A Book of Glimpses*, Faber, 2009.

Muggeridge, Malcolm, *Chronicles of Wasted Time: The Infernal Grove*, Collins, 1973.

Muggeridge, Malcolm, *Like It Was: The Diaries of Malcolm Muggeridge*, John Bright-Holmes (ed.), Collins, 1981.

Mure, David, *The Last Temptation*, Buchan & Enright, 1984.

Nelson, Michael, *A Room in Chelsea Square*, Cape, 1958.

Nelson, Michael, *War of the Black Heavens: The Battles of Western Broadcasting in the Cold War*, Brassey's, 1997.

Newton, Verne, *The Cambridge Spies*, Madison Books, 1991.

Nicholls, Christine, *Elspeth Huxley: A Biography*, HarperCollins, 2002.

Nicholls, Richard, *Radio Luxembourg: The Station of the Stars*, Comet, 1983.

Nicolson, Harold, *Diaries and Letters, 1930-1964*, Collins, 1966.

Nicolson, Harold, *Diaries and Letters 1939-1945*, Nigel Nicolson (ed.), Collins, 1966.

Nicolson, Harold, *Diaries and Letters 1945-1962*, Collins, 1968.

Nicolson, Harold, *The Age of Reason*, Constable, 1960.

Nixon, Edna, *John Hilton: The Story of His Life*, Allan & Unwin, 1946.

Owen, Charles, *Plain Yarns from the Fleet*, Sutton, 1997.

Pack, S.W.C., *Britannia at Dartmouth*, Redman, 1966.

Page, Bruce, Leitch, David and Knightley, Phillip, *Philby: The Spy Who Betrayed a Generation*, Andre Deutsch, 1968.

Parker, Peter, *Isherwood*, Picador, 2004.

Parkin, Sophie, *The Colony Room Club 1948-2008*, Palmtree, 2012.

Paul, Septimus, *Nuclear Rivals: Anglo-American Atomic Relations 1941-1952*, Ohio State University Press, 2000.

Payn, Graham and Morley, Sheridan (eds.), *The Noel Coward Diaries*, Weidenfeld & Nicolson, 1982.

Penrose, Barrie, and Freeman, Simon *Conspiracy of Silence: The Secret Life of Anthony Blunt*, Grafton, 1986.

Perry, Roland, *The Fifth Man*, Sidgwick & Jackson, 1994.

Perry, Roland, *The Last of the Cold War Spies*, Da Capo, 2005.

Petrov, Vladimir, *Empire of Fear*, Andre Deutsch, 1956.

Philby, Eleanor, *Kim Philby: The Spy I Loved*, Hamish Hamilton, 1968.

Philby, Kim, *My Silent War*, MacGibbon and Kee, 1968.

Philby, Rufina, with Peake, Hayden and Lyubimov, Mikhail, *The Private Life of Kim Philby*, Fromm, 2000.

Pincher, Chapman, *Their Trade is Treachery*, Sidgwick & Jackson, 1981.

Pincher, Chapman, *Too Secret, Too Long*, Sidgwick & Jackson, 1984.

Pincher, Chapman, *Traitors*, Sidgwick, 1987.

Pincher, Chapman, *Pastoral Symphony*, Swan Hill Press, 1993.

Pincher, Chapman, *Treachery*, Mainstream, 2012.

Potter, Karen, 'British McCarthyism', Jeffreys-Jones, Rhodri and Lownie, Andrew (eds.), *North American Spies: New Revisionist Essays*, University Press of Kansas, 1991.

Powell, Anthony, *Journals 1982-1986*, Heinemann, 1995.

Prokosch, Frederic, *Voices: A Memoir*, Faber, 1983.

Purdy, Anthony and Sutherland, Douglas, *Burgess & Maclean*, Secker & Warburg, 1963.

Purvis, Stewart and Hulbert, Jeff, *When Reporters Cross the Line*, Biteback, 2013.

Purvis, Stewart and Hulbert, Jeff, *Guy Burgess: The Spy Who Knew Everyone*, Biteback, 2016.

Putlitz, Wolfgang zu, *The Putlitz Dossier*, Allan Wingate, 1957.

Putt, S. Gorley, *Wings of a Man's Life*, Claridge Press, 1990.

Quennell, Peter, *The Wanton Chase: An Autobiography from 1939*, Collins, 1980.

Quennell, Peter (ed.), *A Lonely Business: A Self-Portrait of James Pope-Hennessy*, Weidenfeld & Nicolson, 1981.

Redgrave, Corin, *Michael Redgrave, My Father*, Richard Cohen, 1995.

Redgrave, Michael, *In My Mind's Eye*, Weidenfeld & Nicolson, 1983.

Rees, Goronwy, *A Bundle of Sensations*, Chatto, 1960.

Rees, Goronwy, *A Chapter of Accidents*, Chatto & Windus, 1972.

Rees, Jenny, *Looking for Mr Nobody*, Weidenfeld & Nicolson, 1994.

Reibling, Mark, *Wedge: The Secret War Between the FBI and the CIA*, Knopf, 1994.

Richardson, John, *The Sorcerer's Apprentice*, Knopf, 1999.

Riordan, Jim, *Comrade Jim*, Fourth Estate, 2008.

Rogers, Ben, *A.J. Ayer*, Chatto, 1999.

Romerstein, Herbert and Breindel, Eric, *The Venona Secrets: Exposing Soviet Espionage and America's Traitors*, Regnery Publishing, 2001.

Rose, Kenneth, *Elusive Rothschild: The Life of Victor, Third Baron,* Weidenfeld & Nicolson, 2003.

Rose, Norman, *Harold Nicolson*, Jonathan Cape, 2005.

Rothschild, Lord, *Random Variables*, Collins, 1984.

Rothschild, Victor, *Meditations of a Broomstick*, Collins, 1977.

Say, Rosemary and Holland, Noel, *Rosie's War*, Michael O'Mara, 2011.

Seale, Patrick and McConville, Maureen, *Philby: The Long Road to Moscow*, Hamish Hamilton, 1973.

Seaman, Donald, *The Defector*, Hamish Hamilton, 1975.

Seaman, Mark, *Special Operations Executive: A New Instrument of War*, Routledge, 2005.

Sewell, Brian, *Outsider: Always Almost: Never Quite*, Quartet, 2011.

Shelden, Michael, *Friends of Promise: Cyril Connolly and the World of Horizon*, Hamish Hamilton, 1989.

Sinclair, Andrew, *The Red and the Blue: Intelligence, Treason and the Universities*, Weidenfeld & Nicolson, 1986.

Sinclair, Andrew, *War Like a Wasp: The Lost Decade of the Forties*, Hamish Hamilton, 1989.

Sloan, Pat (ed.), *John Cornford: A Memoir*, Cape, 1938.

Smith, James, *British Writers and MI5 Surveillance, 1930-1960*, Cambridge University Press, 2013.

Smith, Michael, *New Cloak, Old Dagger*, Victor Gollancz, 1996.

Solomon, Flora and Litvinof, Barnet, *Baku to Baker Street*, Collins, 1984.

Spender, Stephen, *World Within World*, Faber, 1951.

Spotts, Frederic (ed.), *Letters of Leonard Woolf*, Weidenfeld & Nicolson, 1990.

Stansky, Peter and Abrahams, William, *Journey to the Frontier*, Constable, 1966.

Strachan, Alan, *Secret Dreams: A Biography of Michael Redgrave*, Weidenfeld, 2004.

Straight, Michael, *After Long Silence*, Collins, 1983.

Sulzberger, C.L., *A Long Row of Candles*, Macdonald, 1969.

Sutherland, Douglas, *The Fourth Man*, Secker & Warburg, 1980.

Sutherland, Douglas, *Portrait of a Decade: London Life 1945-1955*, Harrap, 1988.

Sutherland, John, *Stephen Spender*, Oxford University Press, 2005.

Sweet, Matthew, *The West End Front*, Faber, 2011.

Sweet-Escott, Bickham, *Baker Street Irregular*, Methuen, 1965.

Tangye, Nigel, Facing the Sea, William Kimber, 1974.

Taylor, Philip, *British Propaganda in the 20th Century: Selling Democracy*, Edinburgh University Press, 1999.

Tennant, Emma, *Girlitude: A Memoir of the 50s and 60s*, Jonathan Cape, 1999.

Thomas, Hugh, *John Strachey*, Eyre Methuen, 1973.

Thompson, Francis J., *Destination Washington*, Robert Hale, 1960.

Thurlow, Richard, *The Secret State*, Blackwell, 1994.

Tobin, Candida, *Lifting the Lid*, Helicon Press, 2003.

Tracey, Herbert (ed.), *The British Labour Party*, Caxton, 1948.

Trevelyan, Philip, *Julian Trevelyan:Picture Language*, Lund Humphries, 2013.

Urquhart, Brian, *A life in Peace & War*, Weidenfeld & Nicolson, 1987.

Volodarsky, Boris, *Stalin's Agent: The Life and Death of Alexander Orlov*, OUP, 2014.

Webb, Duncan, *Line-Up For Crime*, Muller, 1956.

Weidenfeld, George, *Remembering My Good Friends*, HarperCollins, 1994.

Weinstein, Allen and Vassiliev, Alexander, *The Haunted Wood*, Random House, 1999.

West, Nigel, *MI5: British Security Service Operations 1909-1945*, Bodley Head, 1981.

West, Nigel, *A Matter of Trust: MI5 1945-72*, Weidenfeld & Nicolson, 1982.

West, Nigel, *MI6: British Secret Intelligence Service Operations 1909-1945*, Weidenfeld & Nicolson, 1983.

West, Nigel, *Molehunt*, Weidenfeld & Nicolson, 1987.

West, Nigel, *The Friends, Britain's Post-War Secret Intelligence Operations*, Weidenfeld & Nicolson, 1988.

West, Nigel and Tsarev, Oleg, *The Crown Jewels: The British Secrets at the Heart of the KGB Archives*, HarperCollins, 1998.

West, Nigel, *Venona: The Greatest Secret of the Cold War*, HarperCollins 1999.

West, Nigel (ed.), *The Guy Liddell Diaries, Vol. 1 1939-1942; Vol. 2 1942-1945*, Routledge, 2005.

West, Nigel and Tsarev, Oleg, *Triplex:Secrets from the Cambridge Spies*, Yale, 2009.

West, Rebecca, *The New Meaning of Treason*, Penguin, 1985.

West, W.J., *Orwell: The War Broadcasts*, BBC Books, 1985.

West, W.J., *Truth Betrayed: Radio and Politics Between the Wars*, Duckworth, 1987.

West, W.J., *The Truth About Hollis*, Duckworth, 1989.

West, W.J., *The Larger Evils*, Canongate, 1992.

Whaley, Emily, *Mrs Whaley and Her Charleston Garden*, Algonquin, 1997.

Wheatcroft, Geoffrey, *Absent Friends*, Hamish Hamilton, 1989.

Wheen, Francis, *Tom Driberg: His Life and Indiscretions*, Chatto and Windus, 1990.

White, Terence de Vere, *A Fretful Midge*, Routledge & Kegan Paul, 1959.

Windmill, Lorna Almonds, *A British Achilles*, Leo Cooper, 2006.

Wolfe, Kenneth, *The Churches and the British Broadcasting Corporation 1922-1956*, SCM Press, 1984.

Wood, Neal, *Communism and the British Intellectuals*, Gollancz, 1959.

Wright, Adrian, *John Lehmann: A Pagan Life*, Duckworth, 1998.

Wright, Peter, *Spycatcher*, Viking, 1987.

Articles

Ambler, Eric, 'Trail of the Disappearing Diplomats', *The American Weekly*, 25 January 1953.

Annan, Noel, 'Scamp into Scoundrel', *Times Literary Supplement*, 11 February 1972.

Annan, Noel, 'The Clutches of Comradeship', *Times Literary Supplement*, 11 March 1983.

Annan, Noel, 'Et Tu, Anthony', *New York Review of Books*, 22 October 1987.

Annan, Noel, 'The Upper Class and the Underworld', *New York Review of Books*, 13 April 1989.

Annan, Noel, 'The Spy with No Excuse', *The Independent*, 13 May 1989.

Annan, Noel, 'The Fabulous Five', *New York Review of Books*, 12 January 1995.

Bisher, Jamie, 'Colonel Modin on Philby, Burgess, and Blunt', *Foreign Intelligence Literary Scene 12*, No. 6: 1-2.

Blunt, Anthony, 'From Bloomsbury to Marxism', *Studio International*, November 1973.

Boyle, Andrew, 'Odd Man Out Among the Spies', *Observer*, 13 January 1980.

Boyle, Andrew, 'The Brotherhood of Bentinck Street', *Observer*, 20 January 1981.

Burn, Michael, 'Guy Burgess: The Spy Who Loved Me and the Traitor I Almost Unmasked', *The Times*, 9 May 2003.

Carver, George, 'The Fifth Man', *The Atlantic*, No. 262, pp. 26-9, September 1988.

Carver, George 'A Fresh Look at the Cambridge Comintern', *Intelligence and Counter Intelligence*, Vol. 5, No. 1.

Cecil, Robert, 'Legends Spies Tell', *Encounter*, No. 50, pp. 9-17, April 1978.

Cecil, Robert, 'C's War', *Intelligence and National Security*, Vol. 1, No. 2, May 1986.

Cecil, Robert, 'Philby's Spurious War', *Intelligence and National Security*, Vol. 9, No. 4, October 1994.

Clive, Nigel, 'From War to Peace in SIS', *Intelligence and National Security*, Vol. 10, No. 3, July 1995.

Cockburn, Claud, 'Spies, Sanctions and a Ship', *Irish Times*, 11 October 1967.

Cockburn, Claud, 'Spying in Spain and Elsewhere', *Grand Street*, Vol. 1, No. 2, Winter 1982.

Connolly, Cyril, 'A Personal Study of the Missing Diplomats', *Sunday Times*, 21 and 28 September 1952.

Doder, Dusko, 'Of Moles & Men', *The Nation*, 18 February 2002.

Driberg, Tom, 'Guy Burgess in Moscow', *The Times,* 18 June 1977.

Edwards, Willard, 'Impact of Burgess-Maclean Treachery Still Felt', *Human Vents*, Vol. 28, No. 9.

Fallowell, Duncan, 'The Spies Who Loved Me', *Sunday Times Magazine*, 7 April 1991.

Flaxman, Erwin, 'The Cambridge Spies: Treason and Transformed Ego Ideals', *The Psychoanalytic Review*, Vol. 97, No. 4, pp. 607-31.

Fluegel, Dr Edna, 'The Burgess-Maclean Case', *American Mercury*, Part I, February 1957, pp. 7-13; Part II, March 1957, pp. 127-34; Part III, April 1957, pp. 68-77.

Girelli, Elizabetta, 'The Traitor as Patriot: Guy Burgess, Englishness and Camp in Another Country and An Englishman Abroad', *Journal of European Popular Culture*, Vol. 2, No. 2, 2011.

Gordievsky, Oleg, 'The KGB Archives', *Intelligence and National Security*, Vol. 6, No. 1, January 1991.

Greenhill, Dennis, *The Times*, 7 September 1977.

Hennessy, Peter, 'Burgess Knew US Analysis of Russian Aid: Files Disclose Extent of Spy's Access to Sensitive Far East Intelligence', *The Times*, 2 February 1981.

Hennessy, Peter and Brownfield, Gail, 'Britain's Cold War Security Purge: The Origins of Positive Vetting', *The Historical Journal*, Vol. 25, No. 4, 1982, pp. 965-73.

Hennessy, Peter and Townsend, Kathleen, 'The Documentary Spoor of Burgess and Maclean', *Intelligence and National Security*, April 1987, pp. 291-301.

Hewit, Jack, 'The Spies Who Loved Me', *Sunday Times Magazine*, 7 April 1991.

Kerr, Sheila, 'Familiar Fiction, Not the Untold Story', *Intelligence and National Security*, Vol. 9, No. 1, January 1994, pp. 128-35.

Kerr, Sheila, 'KGB Sources on the Cambridge Network of Soviet Agents: True or False?', *Intelligence and National Security*, Vol. 11, No. 3, July 1996, pp. 561-85.

Kerr, Sheila, 'Investigating Soviet Espionage and Subversion: The Case of Donald Maclean', *Intelligence and National Security*, Vol. 17, No. 1, Spring 2002, pp. 101-16.

Kerr, Sheila, 'Oleg Tsarev's Synthetic KGB Gems', *International Journal of Intelligence and Counter Intelligence*, Vol. 14, pp. 89-116.

Kiernan, Victor, 'On Treason', *London Review of Books*, Vol. 9, No. 12, 25 June 1987, pp. 3-5.

Knightley, Phillip, 'Turning the Philby Case on its Head', *New York Review of Books*, 26 April 2007.

MacGibbon, Hamish, 'Diary', *London Review of Books*, 16 June 2011, p. 40.

Manser, W.A.P., 'Do You Want to Kill Him?', *Spectator*, 20 May 1995.

Maugham, Robin, 'Extraordinary Character', *The People*, 22 February to 22 March 1970.

Mayne, Richard, 'Bad Boys: Another Country and An Englishman Abroad', *Sight and Sound*, Vol. 53, No. 2, 1984, pp. 148-9.

Mills, William, 'Sir Joseph Ball, Adrian Dingli and Neville Chamberlain's "Secret Channel" to Italy 1937-1940', *IHR*, Vol. 24, No. 2, 2002, pp. 278-317.

Morris, James, 'Caviare with Burgess', *Guardian*, 2 September 1963.

Ovendale, Ritchie, 'Britain, the United States, and the Recognition of Communist China', *The Historical Journal*, Vol. 26, No. 1, March 1983, pp. 139-58.

Piadyshev, Boris, 'Burgess (In the Service of a Foreign Power)', *International Affairs: A Russian Journal of World Politics, Diplomacy and International Relations*, 30 April 2005, Vol. 51, No. 2, pp. 179-90.

Pronay, Nicholas and Taylor, Philip M., 'An Improper Use of Broadcasting . . . The British Government and Clandestine Radio Propaganda Operations against Germany during the Munich Crisis and After', *Journal of Contemporary History*, Vol. 19, 1984, pp. 357-78.

Rees, Goronwy, 'The Fatal Friendship', *Sunday Times*, 9 January 1972, pp. 33-4.

Rees, Goronwy, 'How Time Ran Out for Guy Burgess', *Sunday Times*, 16 January 1972, pp. 25-6.

Rees, Goronwy, 'Spies and Their Society', *Times Literary Supplement*, 23 December 1977, p. 1496.

Smith, Lyn, 'Covert British Propaganda; the Information Research Department 1947-77', *Millennium: Journal of International Studies*, Vol. 9, No. 1, 1980, pp. 67-83.

Steiner, George, 'Reflections: The Cleric of Treason', *New Yorker*, 8 December 1980, p. 183.

Teagarden, Ernest M., 'The Cambridge Five: The End of the Cold War Brings Forth Some Views from the Other Side', *American Intelligence Journal*, Vol. 18, No. 1/2, 1998, pp. 63-8.

Trevor-Roper, Hugh, 'Acts of the Apostles', *The New York Review of Books*, 31 March 1983.

Trilling, Diana, 'Goronwy Rees – and Others: A Remembrance of England', *The Partisan Review*, 1996, Vol. LXIII, No. 1, pp. 11-47.

Wilford, H., 'The Information Research Department: Britain's Secret Cold War Weapon Revealed', *Review of International Studies*, Vol. 24, No. 3, 1998, pp. 353-69.

Willmetts, Simon and Christopher Moran, 'Filming Treachery: British Cinema and Television's Fascination with the Cambridge Five', Journal of British Cinema and Television, Volume 10, Issue 1, pp49-70.

Theses

Garner, James John, 'Deviance and Disloyalty: Historical Discourses in Representations of the Cambridge Spies', University of Newcastle, NSW, 2003.

Hemmingsen, Clarissa, 'From Russia With Love: The Motives and Achievements of Guy Burgess and The Anglo-American Intelligence Decay', MA Intelligence and International Security, King's College, London, 2010.

Kerr, Sheila, 'An Assessment of a Soviet Agent: Donald Maclean 1940-1951', PhD, LSE, 1996.

Mellon, Jerome, 'How Seriously Did the Cambridge Spies Damage British Interests During World War Two?', Salford University, 2002.

Schlaepfer, Christian, 'British Governance, Intelligence and the Communist Threat c.1945-1962', MPhil thesis, University of Cambridge, 2009.

Walton, Calder, 'British Intelligence and Threats to National Security 1941-1951', PhD dissertation, University of Cambridge, 2006.

Acknowledgements

A large number of people, over a period of thirty years, have helped me in the research and writing of this book, ranging from friends and family of Guy Burgess to archivists around the world and I'm enormously grateful to them, though sadly many of them are now dead. They include:

Richard Aldrich; Michael Alexander; Lorna Allen; Geoff Andrews; Noel Annan; Margaret Anstee; Jamie Arkell; Benjamin Baker; Frith Banbury; Ruth Barden at Lockers Park; Dennis Bardens; Mrs Roger Bassett; Virginia, Marchioness of Bath; Julian Beaumont; Richard Beddington; Michael Bloch; Piers Brendon; Christopher Brooke; Rebecca Bronson, the FOIA Negotiator at the FBI; Clare Brown at Lambeth Palace Library; Joyce Brown; Robin Bryans; William Buchan; Ronald Bulatoff at the Hoover Institution Archives; Nigel and Constance Burgess; Michael Burn; Peter Burton; Peter Calvocoressi; Angus Cameron on Eton and who supplied the picture of the Eton Football team, 1930; Jamie Campbell; Rosamund Campbell, the librarian at St Antony's, Oxford; Kathlee Cann at Cambridge University Library; Fanny Carby; Michael Carney; Christine Carpenter; Miranda Carter; Lord Cawley; Alexander Chancellor; Lord Chatfield; Nigel Chiltern-Hunt; Sally Chilver; Robert Clifford at the National Archives; Nigel Clive; John Cloake; Andrew Cook; Gordon Corera; Jacqueline Cox at Cambridge University Library; M.C. Creagh-Osborne; Judith Cresswell; Tim Crossley; Judith Curthoys at Christ Church, Oxford;

Alan Davidson; Jill Davidson at the Bodleian Library; Bill Davies; Cliff Davies at Wadham College, Oxford; Minoo Dinshaw for information on Steven Runciman; Michael Dobbs; Christopher Dobson; Norman Dombey; Stephen Dorril; Denise Dowdall for research in Dublin; Jaqueline Dupree; Erik Durschmied; Piu Eatwell for French research; Clarissa, Countess of Avon; Robert Eddison; Mark Eden-Bushell; Robert Elphick; David Elstein; Charles Elwell; Rob Evans; Sir Frederick Everson; Lord Farringdon; Sir Nicholas Fenn; Harriet Fisher at the Roald Dahl Museum; Dennis Fitzgerald; Sir Edward Ford; Enrique Frankfort; Bobby Furber;

Claire Gale; Philip Gale at the Church of England Record Centre; Philip Gell; Sir John Gilmour; John Golding; Michael Goodman; George Goring; Alex Goudie, the FOI Assessor at the National Archives; Glyn Gowans for his advice on FOIA; Robert Graham-Harrison; Michael Grant; Barbara Green; John Green; Lady Greenhill; Sir Ronald Grierson; Phillipa Grimstone; Penelope Hatfield, Eleanor Cracknell and Michael Meredith at Eton College Library; Dr John Guest at Ascot Hill House; Ken Gunderson;

Lord Hailsham; Stuart Hampshire; James Hanning; Henry Hardy; Mary Hardy; Stephen and May Harper; Anita Harris; Colin Harris and colleagues at the Bodleian Library; Ross Harrison at King's College, Cambridge, who let me look at Apostles minute books for the 1930s; Wilhemina, Lady Harrod; Jane Harrold and colleagues at Britannia Royal Naval College; Lord Hartwell; Elizabeth Haselfoot; Francis Haskell; Lord Hastings; Lance Hattat; Jayne Haynes; Sir Gilbert 'Simon' Heathcote; Clarissa Hemmingsen; W.B. Hermondhalgh; Nancy McDonald Hervey; Boyd Hilton; Jaqueline Hope Wallace; Richard Hopkinson at Bonhams for sending me copies of two Burgess etchings; Sergei Humaryan; Philip Hunt; Christopher Huntley; Reverend John Hurst;

Nicholss Jacobs; Captain J. Jacobsen; Lady Jellicoe; Mark Johnson; William Johnston; Alan Judd; Peter Keen for photographs; Sheila Kerr; Alan King, Historical Collections Librarian, Portsmouth Central Library; James King at the University of Warwick; Steven Kippax; Angus Konstam with help on Malcolm Burgess's naval career; Sergei Kondrashev; Olga Krepysheva for research in Russia; Col. Boris Labusov, SVR Press Department; Robert Lacey; Ambrose Lampton; Terence Lancaster; Helen Langley, Curator, Modern Political Papers, Bodleian; Christopher Layton; Carol Leadenham at Hoover Institution Archives; Celia Lee; Brian Lieberman; Thomas Lloyd for Sir John Philipps; Svetlana Lokhova for translation of material in the Mitrokhin archive in Cambridge; Bill Lubenow on the Apostles; Michael Luke; Hugh Lunghi;

Ian McDougall; Hamish McGibbon; Donough McGillycuddy of the Reeks; Iain McIntyre; John Maclaren; Alan Maclean; Jamie Macphail; Michael Mallon; Stephen Marris; Christopher Marsden-Smedley; Patrick Matthews; Dominick Matter for research in Swiss archives; Jessica Bueno De Mesquita, archivist at the RAC Club; Leonard Miall; John Miller; Rosalind Moad at King's College Library; Yuri Modin; Anthony Moncrieff; Gene Morris; John Morrison; John Mossman; Jenny Mountain at Churchill Archives Centre; Rudolf Muhs; Mary Murphy at MIT Institute Archives and Special Collections; Verne Newton; Christie Nicholls; Jim Nicoll; Richard Norton Taylor;

Michael Pearce for Dartmouth research; Lady Penn; Barrie Penrose, who kindly gave me some of his own research files; Lance Pettit; Charlotte Philby; Roland Philipps; Edward Playfair; Claire Pollock; Gale Pollock; Monica Porter; Dr Richard Porter on Dartmouth; Robert Porter, who interviewed Bill Freedman; Pascal Praplan at the University of Geneva for information on Bernard Miller; Stuart Preston; Martin Tucker and Mary Pring, FOIA unit at Foreign Office; Roland Pym; Elizabeth Ray; Norman Reddaway; Corin Redgrave; Daniel Rees; Jenny Rees; Thomas Rees; Maurice Renshaw; Geoff Roberts; Veronica Rodwell for access to her father's research on Donald Maclean; Katharine Ronan for information on Jack Hunter; Cameron Rose, Hon. Sec. of Old Etonian Association; Jacob, Lord Rothschild; Miriam Rothschild; Margaret Rothwell at Password; Sir Steven Runciman; Dadie Rylands;

Nicholas Scheetz at Georgetown University; Brian Sewell; William Seymour; Desmond Shawe-Taylor; Dorothy Sheridan at University of Sussex; Lucy Shedden, State Library of Victoria; John Shedden; Peter Shore; Harry Shukman; Andrew Sinclair; Kenneth Sinclair-Loutit; Adam Sisman; Don Skemer, Curator of Manuscripts at Firestone Library, Princeton; Dr Jonathan Smith, Trinity College, Cambridge; Margaret Sneesby, Winchester Library; Neil Somerville at BBC Caversham; Rick Stapleton, Librarian, McMaster University; Gloria Stewart for Russian research; Richard Stirland; Ray Stone for photos of West Meon; Charles Strachey; Margot Strickland; Duncan Stuart, SOE adviser;

Stephen Talbot; Jackie Tarrant-Barton at Old Etonian Association; Scott Taylor at Georgetown University; Hannah Thomas, Special Collections Librarian, Courtauld; Sir Peter Thorne; Richard Thorpe; Lord Thurlow; Sir David Tibbits; Stephen Toulmin; Lawrence Toynbee; Sally Toynbee for access to her husband Philip's diary; Philip Trevelyan; Oleg Tsarev; Anne Valery; Hugo Vickers; Jeff Walden at BBC Written Archives; Ken Walker; Philip Walker for research on John Bassett; Bernard Ward; Professor John Waterlow; Lord Weidenfeld; Sid Weiland; Stanley Weiss; Earl of Wemyss and March; Adrian Whitfield, Dick Whitfield, Wendy Guiffre, Mary Edwards and Diana Bridge for information on Esther Whitfield; Kristen Wilhelm at NARA; Nigel Wilkinson for information on Jack Macnamara; Jane, Lady Williams; Paul Willets; Jean Withinshaw; Geoffrey Wright; Martin Young.

My particular thanks to Burgess's former boyfriend Peter Pollock and his partner Paul Danquah, who entertained me royally in Tangiers and talked to me at length about Burgess and his circle; to Burgess's nephews Simon and Tony Burgess, who gave me some family papers and kindly

lent photographs; to Ann Shukman who also kindly lent photographs from Sir Steven Runciman's photo albums; to Caroline Walker, who conducted the initial Russian research and found several KGB officers who had not spoken before and Andrew Malec, who over twenty years has passed me invaluable cuttings on the Burgess story.

Mark Seaman read the chapters on Section D; David Haviland, Jeremy Dronfield and my sister Helen Leatherby read the final script and made many useful comments, as did Hayden Peake, formerly of the CIA, and Dan Mulvenna, formerly of the Security Service of the Royal Canadian Mounted Police, who also fixed for me to meet Sergei Kondrashev. I am especially grateful to Nigel West, who not only read the script but has patiently answered numerous questions over the years. That said, any mistakes are mine and I would be grateful if corrections could be sent to: Lownie@globalnet.co.uk.

I have worked with great pleasure as an agent with Rupert Lancaster for thirty years and I'm delighted he is now also my editor. He has moved with great speed to buy and publish the book and has also made it great fun. I'm also grateful to his colleagues Maddy Price, Kerry Hood, Vickie Boff, Daniel Fraser and Juliet Brightmore for their professionalism, and to Barry Johnston who copy edited the book with such skill and sensitivity.

My mother, wife and children have lived with 'Guy' as an extra member of the family for over twenty years without complaining and the book is dedicated with love to them.

Picture Acknowledgements

© AP/Press Association Images: 19 above right, 24 above and centre. The Bodleian Library, University of Oxford: 10 below (MS.Photogr. c78, fol.37). Courtesy of Britannia Museum Archive: 3 above. Reproduced by kind permission of Anthony and Simon Burgess: 1, 16 below. Cambridge Daily News, 17th November, 1933: 6 below. Photograph by Mrs Trude Johnston, courtesy of Professor Christine Carpenter: 15 above right. © Corbis: 15 above left, 17 above right/Car Culture. The Trustees of Tom Driberg's copyrights: 20 above, 21 above left. Reproduced by permission of the Provost and Fellows of Eton College: 3 below. © Mary Evans Picture Library: 7 above left/Epic, 13 below left/Illustrated London News Ltd, 21 below left/AGIP. © Getty Images: 10 above/Keystone, 16 above/Topical Press Agency, 18 above, 20 below. © Peter Keen: 23. © Andrew Lownie: 17 above, 22 above right, 24 below. Courtesy of Locker's Park School Archives: 2. © Ramsey and Muspratt: 6 above, 7 above right and below left, 8 above left, 12 below, 15 below right. Courtesy of private collections: 5 below, 8 above right and below right, 9, 11, 13 above left, 14, 15 below left, 17 below left, 18 below right, 21 above right, 22 above. Courtesy of the Rees family collection: 8 below left. © Steven Runciman Estate with thanks to Dr Ann Shukman: 4, 5 above. Reproduced by permission of the late Mrs Yvonne Spencer-Churchill: 13 above right. © TopFoto: 18 above left, 19 above and below left. Courtesy of Philip Trevelyan: 22 below left. Courtesy of the Whitfield family: 12 above.

Cartoons by Guy Burgess within the text are reproduced by kind permission of Anthony and Simon Burgess.

Every reasonable effort has been made to trace copyright holders, but if there are any errors or omissions, Hodder & Stoughton Publishers will be pleased to insert the appropriate acknowledgement in any subsequent printings or editions.

Index